For Marciarose & Jerry —
Welcome to Houston!

We are delighted to
have you with us and
in our home at last ♡

With deepest affection —
Barbara + Blake

February 4, 1997

After the ABA — of course!
Mid-winter meeting
San Antonio

A Permanent Legacy

THE MUSEUM OF FINE ARTS, HOUSTON

A Permanent Legacy

150 WORKS FROM THE COLLECTION
OF THE MUSEUM OF FINE ARTS, HOUSTON

Introduction by Peter C. Marzio

Hudson Hills Press, New York
IN ASSOCIATION WITH THE MUSEUM OF FINE ARTS, HOUSTON

First Edition

© 1989 by The Museum of Fine Arts, Houston

All rights reserved under International and Pan-American Copyright Conventions.

Published in the United States by Hudson Hills Press, Inc., Suite 1308, 230 Fifth Avenue, New York, NY 10001-7704.

Distributed in the United States, its territories and possessions, Canada, Mexico, and Central and South America by Rizzoli International Publications, Inc.

Distributed in the United Kingdom, Eire, Europe, Israel, and the Middle East by Phaidon Press Limited.

Distributed in Japan by Yohan (Western Publications Distribution Agency).

The Museum of Fine Arts, Houston
Organizing Curator and Editor: Celeste Marie Adams

Hudson Hills Press
Editor and Publisher: Paul Anbinder
Copy Editor: Kathleen Preciado
Indexer: Karla J. Knight
Designer: Binns & Lubin/Betty Binns
Composition: U.S. Lithograph, typographers
Manufactured in Japan by Toppan Printing Company

Library of Congress Cataloguing-in-Publication Data
Museum of Fine Arts, Houston.
A permanent legacy: the Museum of Fine Arts, Houston/
introduction by Peter C. Marzio.—1st ed.
 p. cm.
Bibliography: p.
Includes index.
ISBN 1-55595-022-1 (alk. paper)
1. Museum of Fine Arts, Houston—Catalogues. 2. Art—Texas—
Houston—Catalogues. I. Marzio, Peter C. II. Title.
N576.H7A63 1989
708.164′1411—dc20 LC 89-83701
 CIP

Permission for reproduction has been granted by the following agencies and individuals:
Julian Bach Literary Agency, Ms. Ann Rittenberg, for Edward Steichen, *Trees, Long Island*, 1905
Mrs. Noya Brandt for Bill Brandt, *Maid Preparing the Evening Bath*, c. 1932
Center for Creative Photography, Terence Pitts, Acting Director, for Edward Weston, *Epilogue*, 1919
Estate of André Kertész, Robert Gurbo, for André Kertész, *In Les Halles*, 1929
Ms. Hatulla Moholy-Nagy for László Moholy-Nagy, *At Coffee*, n.d.
Estate of Georgia O'Keeffe, Juan Hamilton, Personal Representative, for Alfred Stieglitz, *Portrait of Georgia O'Keeffe*, 1933
Pace/MacGill Gallery for Robert Frank, *Hoboken*, 1955
Esther Parada for Esther Parada, *Past Recovery*, 1979

Photography
Michael Bodycomb: Project Photographer
Lynn Diane DeMarco: silver objects
Hickey-Robertson: Bertel Thorvaldsen, *Venus*, 1816–20
Allen Mewbourn: Paul Gauguin, *Arearea II (Joyfulness)*, c. 1892

Contents

Acknowledgments 9

A Permanent Legacy: A History of the Museum of Fine Arts, Houston
by Peter C. Marzio 11

Art of the Americas and Tribal Arts

Olmec, *Effigy Vessel in the Form of a Duck* 40

Maya, *Lidded Bowl, 350–500* 42

Maya, *Relief of a Figure Holding an Offering, 702–64* 44

Ulúa, *Tripod Vase* 46

Aztec, *Standard-Bearer, 1425–1520* 48

Moche, *Effigy Container in the Form of a Woman, 1–700* 50

Sicán, *Beaker, 850–1050* 52

Casas Grandes, *Effigy Bowl in the Form of a Macaw* 54

Pueblo, *Jar, 1880–85* 56

Maria Martinez and Julian Martinez, *Jar, 1934–43* 58

Dogon, *Ceremonial Trough, 1720–1820* 60

Karawari, *Crocodile, 1900–1950* 62

Near and Far Eastern Art

Assyrian, *Eagle-Headed Winged Deity, 883–859 B.C.* 66

Indian, *Vishnu and His Avatars, tenth century* 68

Indian, *Śīva Nataraja, thirteenth century* 70

Chinese, *Standing Court Lady, seventh century* 72

Japanese, *Haniwa Warrior, late sixth century* 74

Japanese, *Honen Shonin Eden (Biography of the Monk Honen), early fourteenth century* 76

Japanese, *The Tale of Genji, late seventeenth–early eighteenth century* 78

Ancient and Early European Art

Painter of the Yale Oinochoe, *Hydria, 470–460 B.C.* 82

Greek, *Laurel Wreath, 330–27 B.C.* 84

Roman, *Portrait Head of Plautilla, 200–220* 86

Roman, *Portrait of a Ruler, 200–225* 88

Byzantine, *Plaque with the Koimesis, tenth century* 90

French, *Crozier Head with Saint Michael Trampling the Serpent, 1225–50* 92

French, *Head of an Apostle, c. 1235* 94

French, *Virgin and Child, early fourteenth century* 96

Master of the Straus Madonna, *Madonna and Child, before 1405* 98

Franco-Netherlandish, *God the Father, early fifteenth century* 100

German, *Reliquary Monstrance from the Guelph Treasure, early fifteenth century* 102

Fra Angelico, *Saint Anthony the Abbot Tempted by a Lump of Gold, c. 1430* 104

Giovanni di Paolo, *Saint Clare Saving a Child Mauled by a Wolf, mid-1450s* 106

Rogier van der Weyden, *Virgin and Child, after 1454* 108

Attributed to the Master of Georg Muehlich's Meisterlin Chronicle, *The Crucifixion,* *c. 1465–70* 110

Hans Memling, *Portrait of an Old Woman, 1468–70* 112

Italian, *Meeting of Solomon and the Queen of Sheba, c. 1470* 114

North German, *Double Mazer Cup, late fifteenth century* 116

Bernardino Zaganelli, *The Virgin and Child Enthroned with Saints Michael, Catherine,* *Cecilia, and Jerome, late fifteenth–early sixteenth century* 118

Antico, *Hercules Resting after Slaying the Nemean Lion, c. 1500* 120

Style or workshop of Simon Bening, *Triptych with the Virgin and Child and* *Saints Catherine and Barbara, c. 1500–1550* 122

Riccio, *Chained Satyr, c. 1510* 124

Bartolommeo Veneto, *Portrait of a Gentleman, 1512–20* 126

Sebastiano del Piombo, *Portrait of Anton Francesco degli Albizzi, c. 1524/25* 128

Veronese, *The Dead Christ with Angel and a Donor as Saint Francis, c. 1585* 130

Antonio Susini, *Madonna and Child, c. 1600* 132

Later European Art

Juan van der Hamen y Léon, *Still Life, 1626* 136

Claude Lorrain, *Pastoral Landscape with a Rock Arch and a River, c. 1630* 138

Ferdinand Bol, *Portrait of Saskia (Vanitas), c. 1640* 140

Philippe de Champaigne, *The Penitent Magdalen, 1648* 142

Willem Claesz. Heda, *Still Life, 1656* 144

Mattia Preti, *The Martyrdom of Saint Paul, c. 1656–59* 146

Luca Giordano, *Allegory of Prudence, 1682* 148

Canaletto, *Grand Canal, Entrance Looking West, c. 1730* 150

Canaletto, *Grand Canal, Looking Southwest from near Rialto Bridge, c. 1730* 150

Charles-Joseph Natoire, *Bacchanal, c. 1747* 152

Bernardo Bellotto, *The Marketplace at Pirna, c. 1750* 154

Jean-Baptiste-Siméon Chardin, *The Good Lesson, c. 1753* 156

Pompeo Batoni, *Portrait of William Fermor, 1758* 158

Jean-Étienne Liotard, *Portrait of Jean-Louis Buisson-Boissier, c. 1764* 160

Clodion, *Infant Satyrs, late eighteenth century* 162

Bertel Thorvaldsen, *Venus, 1816–20* 164

Théodore Chassériau, *Woman and Little Girl of Constantine with a Gazelle, 1849* 166

Eugène Delacroix, *Andromeda, c. 1852* 168

Charles-François Daubigny, *Sluice in the Optevoz Valley, 1854* 170

Jean-Baptiste-Camille Corot, *Orpheus Leading Eurydice from the Underworld, 1861* 172

Étienne-Pierre-Théodore Rousseau, *The Great Oaks of Old Bas-Bréau, 1864* 174

Jean-Baptiste-Armand Guillaumin, *The Seine at Paris, 1871* 176

Pierre-Auguste Renoir, *Still Life with Bouquet, 1871* 178

Mary Cassatt, *Susan Comforting the Baby, c. 1881* 180

Paul Cézanne, *Madame Cézanne in Blue, 1885–87* 182

Vincent van Gogh, *The Rocks, 1888* 184

Paul Sérusier, *Landscape at Le Pouldu, 1890* 186

Paul Gauguin, *Arearea II (Joyfulness), c. 1892* 188

Paul Signac, *The Bonaventure Pine, 1893* 190

Édouard Vuillard, *The Promenade, 1894* 192

Prints and Drawings

Albrecht Dürer, *Saint Eustace, c. 1500–1501* 196

Abraham Bloemaert, *The Gateway to a Town, c. 1630* 198

Jean Restout, *A Seated Faun, 1750s(?)* 200

John Hoppner, *Portrait of a Lady, 1780s(?)* 202

Jean-Honoré Fragonard, *Rodomonte and Mandricardo State Their Case before Agramante, 1780s* 204

Théodore Géricault, *Boxers, 1818* 206

James Abbott McNeill Whistler, *Black Lion Wharf, 1859* 208

Winslow Homer, *Fly Fishing on Saranac Lake, 1889* 210

Odilon Redon, *The Trees, n.d.* 212

Hilaire-Germain-Edgar Degas, *Woman Drying Herself, c. 1905* 214

Amedeo Modigliani, *Caryatid, c. 1914* 216

Pablo Picasso, *Three Women at the Fountain, 1921* 218

Paul Klee, *Marjamshausen, 1928* 220

Decorative Arts

John Ruslen, *Two-handled Covered Cup, 1672–73* 224

American, *High Chest of Drawers, 1690–1730* 226

John Coney, *Tankard, c. 1695–1711* 228

Movement by Peter Stretch, *Tall Clock, c. 1725–40* 230

American, *Card Table, 1730–45* 232

American, *High Chest of Drawers, 1730–50* 234

American, *Armchair, 1750–90* 236

American, *High Chest of Drawers, 1760–75* 238

Worcester Porcelain Factory, *Candlestick with Two Canaries, c. 1770* 240

American China Manufactory, *Sauceboat, 1770–72* 242

Attributed to John Linnell, *Armchair, c. 1775–78* 244

Attributed to John Townsend, *Bureau Table, c. 1785–95* 246

American, *Side Chair, 1790–1800* 248

Attributed to John and Thomas Seymour, *Lady's Writing Table with Tambour Shutters, 1790–1810* 250

American, *Sofa, 1810–30* 252

Andrew E. Warner, *Tureen, 1817* 254

American, *Sideboard, c. 1855* 256

American Art

John Singleton Copley, *Mrs. Paul Richard, 1771* 260

Charles Willson Peale, *Self-Portrait with Rachel and Angelica Peale, c. 1790* 262

Gilbert Stuart, *John Vaughan, 1795* 264

James Peale, *Still Life with Vegetables, 1826* 266

Edward Hicks, *Penn's Treaty with the Indians, 1830–40* 268

John Frederick Kensett, *A View of Mansfield Mountain, 1849* 270

Frederic Edwin Church, *Cotopaxi, 1855* 272

William Merritt Chase, *The First Portrait, c. 1888* 274

John Singer Sargent, *Mrs. Joshua Montgomery Sears, 1899* 276

George Bellows, *Portrait of Florence Pierce, 1914* 278

Photography

Edward Steichen, *Trees, Long Island, 1905* 282

Christian Schad, *Schadograph, 1918* 284

Constantin Brancusi, *View of the Studio: Column [1918], The Golden Bird [1919], 1920–22(?)* 286

Edward Weston, *Epilogue, 1919* 288

André Kertész, *In Les Halles, 1929* 290

Bill Brandt, *Maid Preparing the Evening Bath, c. 1932* 292

László Moholy-Nagy, *At Coffee, n.d.* 294

Alfred Stieglitz, *Portrait of Georgia O'Keeffe, 1933* 296

John Heartfield, *The Thousand-Year Reich, 1934* 298

Walker Evans, *Roadside Sandwich Shop, Ponchatoula, Louisiana, 1936* 300

Robert Frank, *Hoboken, 1955* 302

Esther Parada, *Past Recovery, 1979* 304

Twentieth-Century Art

André Derain, *The Turning Road, L'Estaque, 1906* 308

Georges Braque, *Fishing Boats, 1909* 310

Henri Matisse, *The Backs I–IV, 1909–c. 1930* 312

Henri Matisse, *Portrait of Olga Merson, 1910* 316

Pablo Picasso, *The Rower, 1910* 318

Wassily Kandinsky, *Sketch 160 A, 1912* 320

Pierre Bonnard, *Dressing Table and Mirror, c. 1913* 322

Marsden Hartley, *Abstraction, c. 1914* 324

Constantin Brancusi, *A Muse, 1917* 326

Piet Mondrian, *Composition with Gray and Light Brown, 1918* 328

Fernand Léger, *Man with a Cane, 1920* 330

Georgia O'Keeffe, *Gray Line with Black, Blue, and Yellow, c. 1923* 332

Pablo Picasso, *Two Women in Front of a Window, 1927* 334

Henri Matisse, *Woman in a Purple Coat, 1937* 336

Stuart Davis, *Gloucester Harbor, 1938* 338

Marino Marini, *The Pilgrim, 1939* 340

Jackson Pollock, *Number 6, 1949* 342

Morris Louis, *Loam, 1958* 344

Alberto Giacometti, *Large Standing Woman I, 1960* 346

Mark Rothko, *Painting, 1961* 348

David Smith, *Two Circle Sentinel, 1961* 350

Richard Diebenkorn, *Ocean Park #124, 1980* 352

Georg Baselitz, *The Lamentation, 1983* 354

Jasper Johns, *Ventriloquist, 1983* 356

Index 358

Index of Donors 364

Honor Roll of Contributors to *A Permanent Legacy* 365

The Museum of Fine Arts, Houston: Chronological Listings of Board Presidents/ Chairmen, Directors, and Curators 366

Acknowledgments

In 1981 the Museum of Fine Arts, Houston, published its first guide to the collection, with 351 entries illustrated in black and white. This publication marked the rapid growth of the collection during the preceding two decades. In the eight years since the handbook was published, the collection has continued to grow, guided by a purchasing policy dedicated to acquiring individual works of art of outstanding quality and importance.

During the 1980s the museum has expanded to serve the varied and complex demands of a major cosmopolitan city with a population of 1.7 million. As the museum has become a cultural hub for the community, the need to document and celebrate the collection has become apparent. This publication, fully illustrated in color, presents 150 works of art selected to reflect the artistic variety and art-historical scope of the collection and includes a number of important objects acquired since 1981.

The curatorial staff has skillfully revised and edited existing entries and drafted new entries for recent acquisitions. I am grateful to David B. Warren, director, Bayou Bend; Michael K. Brown, curator, Bayou Bend; Katherine S. Howe, curator, decorative arts; George T. M. Shackelford, curator, European painting and sculpture; Carolyn N. Wilson, research curator, Renaissance art; Anne Wilkes Tucker, curator, photography; Anne-Louise Schaffer, assistant curator, art of Africa, Oceania, and the Americas; Alison de Lima Greene, associate curator, twentieth-century art; and Celeste Marie Adams, curator, oriental art. I also wish to thank Miss Adams for her thorough and patient efforts in coordinating and overseeing the project. The information presented here is based on the professional contributions and scholarly research of many previous curators, all of whom are listed in the Appendix.

The preparation of this publication involved the dedicated efforts of many staff members. Charles Carroll, registrar, provided data for all works of art illustrated; Kara Gustafson, assistant to the registrar for photography, capably coordinated the long and complex process of photographing each object; and Dave Purtee, preparator, assisted the photographer. We are enormously proud of the photography by Michael Bodycomb, whose superb work has made this book so beautiful. Kathleen Hartt, museum archivist, was invaluable in assembling accurate information and materials on the history of the museum. My thanks go also to Mary Christian, Ann Wood, Carrie Springer, and Maggie Olvey, the curatorial assistants who assembled entries; to Carolyn Vaughan, editor of museum publications, and Anne Feltus, who proofread the manuscript; and to Susan Sink, who typed the manuscript. Frances Marzio provided a great amount of help with the introductory essay.

Finally, I am most grateful to the many patrons and contributors who have made this publication possible, among whom the most important is the Museum Guild, a volunteer organization of more than five hundred dedicated individuals who committed their full energy to a special campaign to fund this project.

PETER C. MARZIO
Director

This publication is dedicated to patrons of the Museum of Fine Arts, Houston, whose commitment to the quality of life in their community resulted in the establishment and growth of a fine museum collection. Their generosity and devotion to the museum through the decades is a source of pride for all who live in Houston and share the pleasure that vital works of art provide.

A Permanent Legacy

A HISTORY OF
THE MUSEUM OF FINE ARTS, HOUSTON

PETER C. MARZIO

*I would ask you to define the function of this museum as first
and foremost to bring art into . . . everyday life.*

HOMER SAINT-GAUDENS
remarks at the opening of the Museum of Fine Arts, Houston, April 12, 1924

The origin and history of the Museum of Fine Arts, Houston, are most clearly understood through the growth of the permanent collection. This book illustrates 150 masterworks in the collection and represents a fraction of the museum's more than twenty thousand works of art. The collection has exceptional depth in early American decorative arts and twentieth-century European and American art. In addition, Renaissance and late nineteenth-century works as well as fine-art photography and English decorative arts distinguish the collection. The full story of how this museum came into existence cannot be told here, but this brief introduction can serve to reveal the sacrifices, joys, and successes of the diverse men and women who built an institution that is their permanent legacy to the Houston community.

1900–1944

The Museum of Fine Arts, Houston, was the first art museum founded in Texas. Begun as a privately supported institution dedicated to the collection and exhibition of art and to instruction in all art-historical fields, it opened to the public on April 12, 1924, with fewer than fifty objects on display. Unlike museums created by great collectors or established to lure major collections

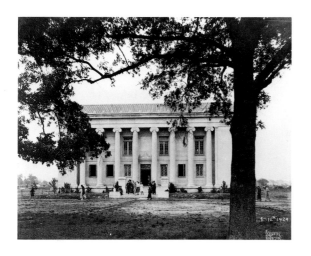

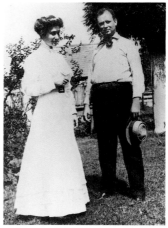

from patrons, Houston's museum was dedicated with the hope that the citizens would be inspired to learn about and collect fine art.

The Museum of Fine Arts, Houston, is a direct descendant of the Houston Public School Art League, which was founded on March 24, 1900, and re-christened the Houston Art League in 1913. The league was like many of the public-school reform movements flourishing throughout the United States during the nineteenth and early twentieth centuries. The original mission of the league was to encourage "art culture" by installing reproductions of old-master oil paintings in classrooms. Since the 1840s public-school reformers like Horace Mann in Massachusetts and Henry Barnard in Washington, D.C., had considered fine art an essential element in the basic curricula of elementary-school education. They advocated instruction in drawing and the use of lithographic copies of original works of art to introduce students to the old masters. The art-education movement in Houston followed this example but was unique in that it resulted in the establishment of a museum.

The museum that was created mirrors the history and personality of the city of Houston itself. Legends abound that tell of the powerful business pioneers who met periodically in downtown hotels and clubs to plan the future for community growth. Founded in 1836, the city carried the nineteenth-century ideal of rugged individualism well into the twentieth century, maintaining the infectious optimism of early urban boosters. Houston has always been the home of visionaries who sometimes tried to speed the city into the future a little faster than economic forces dictated. And yet, despite the hyperbole, the historic reality often surpassed all the tall talk of promotional real-estate brochures and Fourth of July speeches. The history of the Museum of Fine Arts, Houston, is a clear example.

The first major gift of art to the museum was made in 1919 in the will of George M. Dickson. The son of Irish immigrants and a lifelong bachelor, Dickson amassed a small fortune as a manufacturer of locomotive iron wheels. He assembled an art collection that included paintings by Anton Mauve, Jean-Léon Gérôme, and William Merritt Chase. A museum building did not exist in Houston in 1919, so the Houston Art League displayed the Dickson pictures in the offices of the mayor and city council members as well as in the homes of

selected league members. These works served as focal points throughout the city for an ambitious program of art exhibitions, musical evenings, lectures, and discussions.

At the time of the Dickson bequest, the opening of a museum building was more than five years away. In 1917 the land that now serves as the site of the museum was dedicated by the Houston Art League for a building to be constructed in ten years or less for at least twenty thousand dollars. The land had been donated partially by the estate of George Hermann, a native Houstonian, whose wealth came from cattle, land, and oil.

To secure the land from the Hermann estate required an additional thirty-three hundred dollars. This came as a cash contribution from Joseph S. Cullinan, who was then developing a residential area called Shadyside near the future site of the museum. Cullinan, born of Irish immigrant parents in Pennsylvania, built an oil refinery at Corsicana, Texas, and was one of the founders of the Texas Company (now Texaco). In addition to helping purchase the land for the museum, Cullinan contributed to the building fund chaired by William C. Hogg, older brother of Ima Hogg who years later would play a major role in the development of the museum's collection.

William C. Hogg was a businessman, real-estate developer, and avid proponent of city planning. He also assembled a fine collection of paintings by Frederic Remington that hung in his downtown offices. His building-fund goal was two hundred thousand dollars, and he raised the money from Houston's rapidly growing business community.

More than 150 patrons contributed, including Robert Lee Blaffer, Harry C. Wiess, William Stamps Farish, and Frank Prior Sterling, founders of Humble Oil and Refining Company. William L. Clayton, whose Anderson, Clayton Company became one of the largest cotton brokerages in the world, was a major contributor as well. In every instance the families of these generous patrons have continued to support the museum.

From its inception the museum has been the product of the businessmen and women who built the city and who understood the importance of an art museum in a community. At the dedication of the museum on April 12, 1924, Homer Saint-Gaudens, son of the American sculptor Augustus Saint-Gaudens,

13

echoed the sentiments of these business people: "If this country is to continue to go forward through coming ages, it must nourish and stimulate its imaginative and emotional side, as it has already trained its practical sense."

When the building opened, it was only partially finished, and during the 1920s different sections were added as funds were raised. Construction needs dominated, acquisition funds were not available, and few collectors seemed ready to turn over their works of art to the nascent institution. This slow beginning nearly came to a halt in the 1930s. While the local economy survived the early years of the Great Depression, Houston businesses eventually succumbed. In the mid-thirties the museum reduced its already tiny staff to six part-time employees; even this measure did not prevent ten years of budget deficits. The Garden Club of Houston, established in 1924, offered in 1930 to maintain the museum grounds. That tradition of philanthropy has continued to the present day.

Although the 1930s was the most difficult financial period in the museum's history, the decade began and ended with gifts from two extraordinary women, Annette Finnigan and Ima Hogg. In 1931 Miss Finnigan began to donate works of art from Egypt, Greece, Rome, Turkey, and Spain as well as a collection of lace. Her gold Hellenistic laurel wreath is one of the rarest objects in the museum's collection. Born in West Columbia, Texas, Miss Finnigan moved to Houston with her family in 1876. Her father, Captain John C. Finnigan, established a profitable tannery in Houston. When he died in 1909, she managed the family firm and other interests. The first director of the museum, James H. Chillman, Jr., described her as "modest. . . . She would always ask me what I would want or whether I would want a certain thing, rather than imposing her ideas on the museum."

The decade of the thirties ended on a rising note struck in 1939 by the legendary Ima Hogg. Miss Hogg was fifty-seven years old at the time, a professionally trained concert pianist, founder of the Houston Symphony Society, and ardent collector of early American decorative arts. She was born in East Texas to Sarah Stinson Hogg and James Stephen Hogg, the first native-born Texan to serve as governor. She never married. Her family accumulated its

wealth through oil and real estate; her brothers, Will and Mike, developed the prestigious areas of River Oaks and Homewood in Houston. Although Ima Hogg is best known for her donation of her estate, Bayou Bend, and its great collection of American decorative arts, she never ceased to surprise people with her encyclopedic tastes and her quest for excellence. Her 1939 gift comprised more than one hundred works on paper including drawings, watercolors, and gouaches by such major Europeans and Americans as Sargent, Cézanne, Picasso, Nolde, and Feininger. Paul Klee's *Marjamshausen*, 1928, is an example of the high quality of these gifts.

World War II stimulated the Houston economy. During the 1940s the city's population increased by fifty-four percent, and in 1948 Houston was rated the fastest-growing city in the United States. The museum also prospered. In 1943, in honor of her brothers, Ima Hogg gave the museum a major Remington collection of fifty-three oil paintings, ten watercolors, and one bronze. The collection had been assembled by Will Hogg and was divided between his brother and sister at the time of his death in 1930. When Mike Hogg died in 1940, Ima Hogg became the owner of the entire collection.

A year after the Remington gift, Ima Hogg contributed a fine collection of American Indian art, rich in Southwestern objects from the Navajo and Pueblo cultures. The gift included 190 terra-cotta vessels from both the archaeological and modern eras; 125 kachina dolls; 95 watercolors and temperas by contemporary Native American artists; and various other objects such as jewelry, music sticks, helmet masks, and tablitas. Ima Hogg had assembled this collection on a series of trips to New Mexico with the help of Director James Chillman.

In 1944 the trustees received the most important bequest since 1924, the Edith A. and Percy S. Straus collection. Composed primarily of Italian Renaissance works of art, with Flemish, German, French, and British as well as Roman and medieval examples, the fifty-nine paintings and works on paper and twenty-eight sculptures and reliefs elevated the permanent collection to a new level of quality. At the time of the bequest Chillman said that in Houston "the foundations of understanding and appreciation have already

Front-page coverage of Straus collection gift, December 7, 1941. Museum Archives.

been laid, but . . . because of its distance from present art centers, the opportunity to see original works of other ages is relatively limited." The Straus gift transformed the collection.

Percy Selden Straus was one of three sons of Mr. and Mrs. Isidor Straus, who had acquired R. H. Macy & Co., New York, in 1888. Percy Straus eventually served as vice-president, president, and chairman of the board of Macy's.

All the museum's works of art from the Straus collection were purchased between 1921 and 1939. Straus, Sr., bought through dealers in New York and Europe and relied on expert advice. Scholars and connoisseurs such as Richard Offner, Langton Douglas, and F. Mason Perkins guided him in his selection of Italian paintings, and Leo Planiscig focused on small bronzes. Straus corresponded and visited frequently with the American art historian Bernard Berenson and helped finance the publication of Offner's monumental *Critical and Historical Corpus of Florentine Painting* (1930–34).

The Strauses had three sons, one of whom, Percy S. Straus, Jr., had moved to Houston in 1939. When the elder Straus pledged his collection to the Museum of Fine Arts, Houston, in 1941, he expressed a desire to help establish his son in the Houston community as well as a confidence in the economic future of the Southwest and belief in the importance of stimulating the growth of art centers in regions of the United States outside New York. Straus, Sr., was a friend of Jesse H. Jones, one of the most important leaders in Houston history, publisher of the *Houston Chronicle*, founder of the National Bank of Commerce (now Texas Commerce Bank), real-estate entrepreneur, and builder of many of Houston's tallest office buildings in the 1940s. In 1937 he established his own foundation, Houston Endowment, Inc., which, supported by his friend Percy Straus, Sr., would become a major benefactor to the museum.

The Straus gift was announced in the newspapers on December 7, 1941, the day Pearl Harbor was bombed. Amid frightening front-page reports of Nazi troops preparing to invade Moscow and President Roosevelt warning the Japanese to quiet their saber rattling, Jesse Jones's *Houston Chronicle* headlined: "Magnificent Straus Collection of Art Given to Houston Museum—Works of Masters of Many Ages to Make City Great Art Center." How rare and wonderful to see the front page of a newspaper dominated by news of Italian bronzes by

Riccio, Antico, and Susini; rare ivories; master prints; trecento and quattrocento paintings including works by Giovanni di Paolo, Fra Angelico, and the Master of the Straus Madonna; northern Renaissance paintings by Rogier van der Weyden, Corneille de Lyon, and Hans Memling; and later works from the eighteenth century, including examples by Clodion and Houdon.

The Straus bequest signaled the start of a new era in the institution. For twenty years Chillman and the trustees had struggled with finances, with little hope of being able to purchase important works of art. During this period public education had dominated. In 1939 the Museum Guild had been established to arrange for "volunteer assistance of women interested in the promotion and furtherance of museum activities and art education." Four years later the Junior League Docent Program had been organized to conduct school tours of the collection. Both organizations remain vital forces in the museum today.

The arrival of the Straus collection initiated a series of growing pains, which still persist. From 1944 the expanding collection demanded spacious galleries, more specialists in art history and conservation, an intensified educational program, a better library, and public amenities for an expanding audience. While the successes and challenges of the 1924–44 era were enormous, the developments after World War II were greater than anyone could have imagined.

1945–1957

Post–World War II Houston was affluent and growing at a rapid pace. The museum followed the city and benefited from the addition of the Robert Lee Blaffer Memorial Collection, the Samuel H. Kress Collection, and the Bayou Bend Collection.

Robert Lee Blaffer was among the Texas entrepreneurs associated with the 1901 Spindletop oil strike, a find that formed the basis of wealth for many Texans who would later support the museum. Blaffer served as the first treasurer and later as president of Humble Oil Company. He helped build the original museum in 1924 and expressed a lifelong interest in the institution. Five years after his death in 1942 his wife, Sarah Campbell Blaffer, established at the museum the Robert Lee Blaffer Memorial Collection and contributed Cézanne's

17

Marjorie Selden, Percy Selden (Percy S. Straus, Jr.), and James Chillman at 1953 opening reception for Blaffer Wing. Museum Archives.

superb portrait *Madame Cézanne in Blue*, 1885–87. This gift was followed by additional masterpieces from Sarah Blaffer and other members of the family, including Pierre-Auguste Renoir's *Still Life with Bouquet*, 1871, as well as important works by Canaletto, Degas, and Vuillard. The collection, which grew to thirty-three works, was not restricted to a specific period, style, or region, and many of these paintings remain keystones in the permanent collection, guiding the institution to the highest standards of connoisseurship.

The growing Blaffer Memorial Collection had very little exhibition space and marked the beginning of a dilemma. Which should come first: increased gallery space or works of art? Happily, a solution came with the gift of more than 250 thousand dollars from Mr. and Mrs. John Blaffer, permitting the museum to add the Robert Lee Blaffer Memorial Wing to the building in 1953.

More than twenty years earlier, another great collector, Samuel H. Kress, began giving works of art to the Museum of Fine Arts, Houston. Kress was no stranger to Houston. As early as the fall of 1930, he had donated Lorenzo Lotto's *Holy Family with Saint Catherine*, 1520s. This was the first important Renaissance painting in the collection. Later, in 1934, Kress contributed two panels of an altarpiece by an unknown fifteenth-century Lombard artist. Kress's early gifts to the museum were due in large measure to his friendship with newspaper publisher Jesse Jones.

In October 1953 fortune again smiled when the Samuel H. Kress Foundation placed thirty-three paintings on permanent loan to the museum. Kress's internationally known collection of Renaissance, baroque, and eighteenth-century masters had toured the United States during the 1930s, stopping in cities in which the Kress chain stores were located. In the spring of 1933 part of this large collection was exhibited at the museum. The Museum of Fine Arts, Houston, was one of seventeen institutions to benefit from the Kress Foundation contribution. The impact of this philanthropy on the cultural life of Houston was enormous. With the addition of the Kress loans to the Straus gifts, the Museum of Fine Arts, Houston, suddenly became an important center for the appreciation of Renaissance and baroque art.

The trustees were informed of Kress's intention to lend some of his paintings in 1949, but a public announcement was not released until April 1951. The lack

of exhibition space had been, once again, a major stumbling block in receiving the Kress works. This changed in 1950 when the trustees received the proceeds from the sale of the land and home of Frank Prior Sterling. Sterling had contributed to the museum's original building campaign in 1924, and his home had been given to the museum in 1948 by the Sterling family. The funds from its sale were used to renovate an area of the museum that had been opened in 1926 but not finished as a gallery. The Sterling Wing became the home of the Kress paintings.

Today, there are twenty-six Kress paintings in the permanent collection, including such major works as Bernardo Bellotto's *Marketplace at Pirna*, c. 1750; Juan van der Hamen y Léon's *Still Life*, 1626; Sebastiano del Piombo's *Portrait of Anton Francesco degli Albizzi*, c. 1524/25; and Pompeo Batoni's *Portrait of William Fermor*, 1758. The legal status of the Kress works was changed from a loan to a gift in 1961.

Construction and building-renovation projects for the Blaffer and Kress collections in the early 1950s provided high-quality exhibition galleries. In 1953 Nina Cullinan, a trustee who would serve on the board for nearly fifty years and the daughter of museum benefactor Joseph Cullinan, gave more than six hundred thousand dollars for a major addition to the building and pledged one hundred thousand dollars for a maintenance endowment. Ludwig Mies van der Rohe was hired to design and carry out the plan.

The choice of Mies van der Rohe to design a master plan, direct renovation projects in the older sections of the building, and create a major addition signaled an important moment in the institution. The architect of the original museum building was William Ward Watkin, head of the architecture department at Rice Institute (now University). His design was in the conservative beaux-arts tradition of many American museums built in the early 1920s. Mies van der Rohe, by comparison, was a controversial and internationally prominent architect. His plans for Houston called for a radical departure from traditional museum architecture, including a seven-thousand-square-foot gallery with a thirty-one-foot ceiling. When Cullinan Hall was dedicated in 1958, it symbolized a new, daring spirit and a desire to define and experience the art of the present day. Indeed, when one stands at the junction of the Watkin and

Mies van der Rohe structures, the dual nature of the permanent collection is evident: a reverence for the old masters and a desire to present the new.

At virtually the same time that the museum hired van der Rohe, trustee Olga Keith Wiess, in memory of her husband, Harry C. Wiess, donated one hundred thousand dollars to renovate a portion of the original building. Jesse Jones and his wife, Mary Gibbs Jones, and Harris and Carroll Masterson III also provided renovation funds. These galleries—Wiess, Jones, and Masterson —reopened to the public in January 1958. Amid the construction and renovation, Ima Hogg announced in 1957 that she planned to give her fourteen-acre estate, Bayou Bend, its collection of early American art and decorative arts, and an operation endowment fund of 750 thousand dollars to the museum. This remains the largest gift to the museum's permanent collection.

Bayou Bend is located five miles from the museum building in the residential area of Homewood. Ima Hogg continued to live in the twenty-eight-room house after 1957 and supervised the gradual transition from personal home to house-museum. She left Bayou Bend in 1965, opened it to the public in March 1966, and continued to add major works to the collection until her death in 1975 at age ninety-three.

Ima Hogg was an avid collector of early American paintings, furniture, works on paper, metals, ceramics, glass, and textiles. Representing the period 1650–1870, these works constitute one of the finest and most comprehensive collections of American decorative arts in the world. Furniture made in Boston, Newport, New York, and Philadelphia between 1730 and 1810 forms the core of the collection. Portraits by the leading artists of the colonial and early Federal periods are also important. There are about 250 textiles, including bed hangings, curtains, clothing, quilts, embroidered pictures, coverlets, and antique carpets. The 308 objects of silver, 125 of brass, and 100 of pewter comprise a major metals collection. Ima Hogg also collected Chinese export ware; European decorative arts used in colonial America; and pottery, glass, prints, and furniture unique to Texas. In her remarks at the dedication of Bayou Bend in 1966, she clearly defined her goal and attitude about collecting: "Texas, an empire in itself, geographically and historically, sometimes seems to

be regarded as remote or alien to the rest of our nation. I hope in a modest way Bayou Bend may serve as a bridge to bring us closer to the heart of an American heritage which unites us. . . . While I shall continue to love Bayou Bend and everything here, in one sense I have always considered I was holding Bayou Bend only in trust for this day. Now Bayou Bend is truly yours.''

In the 1962 deed of gift, Ima Hogg issued a mandate for the continual strengthening of the collection. The high standards she had established with masterpieces such as Gilbert Stuart's portrait *John Vaughan*, 1795, Charles Willson Peale's *Self-Portrait with Rachel and Angelica Peale*, c. 1790, and the beautiful neoclassical Massachusetts side chair meant that additions and changes could take place only with great care. Nevertheless, the growth of the collection has been impressive. In 1957 about three thousand objects were in the collection. Today there are more than forty-six hundred. During Ima Hogg's lifetime numerous important works were added, including the lady's writing table attributed to the Boston cabinetmakers John and Thomas Seymour; the spectacular early baroque high chest of drawers; the late baroque card table from Boston; the Philadelphia armchair dating from the second half of the eighteenth century; the Newport bureau table attributed to John Townsend; and the silver tankard by John Coney, the highest expression of this craft at the turn of the seventeenth century.

One aspect of Ima Hogg's legacy was her ability to teach by example. Since her death the trustees and supporters of the museum have continued her tradition of collecting and improving Bayou Bend by adding more than fourteen hundred objects. Trustee Alice C. Simkins donated in memory of her aunt Alice Nicholson Hanszen—long-time museum trustee, patron, and sister-in-law of Ima Hogg —*Penn's Treaty with the Indians*, 1830–40, by Edward Hicks. Many other gifts followed, including the Empire-style New York sofa from the Houston chapter of Kappa Alpha Theta. Proceeds from Houston's annual Theta Charity Antiques Show, founded by Mrs. Fred Thomson Couper, Jr., are used to purchase important accessions, including an 1817 silver tureen by Andrew E. Warner of Baltimore, a Peter Stretch tall clock from Philadelphia, and James Peale's *Still Life with Vegetables*, 1826, in honor of Mrs. Couper. Another source of help has

been the Friends of Bayou Bend, a group dedicated to the growth of the collection. The Philadelphia soft-paste porcelain sauceboat is a fine example of their generosity.

Ima Hogg was also a knowledgeable and enthusiastic gardener. The beautiful gardens at Bayou Bend have been maintained and improved over the years by the generosity and energy of the River Oaks Garden Club.

1958–1989

During the first thirty years of the institution's history the trustees accessioned about four thousands works of art, including the splendid paintings and sculptures in the Straus, Kress, and Blaffer collections. During the next thirty-five years the total rose to more than twenty thousand. From 1970 to 1989 the number of objects in the collection more than doubled.

Within the museum four developments led to the rapid expansion of the permanent collection: (1) Individual patrons and foundations began contributing money designated for the acquisition of important works of art, four accession endowment funds were established to provide for art purchases, and generous bequests brought works of art and funds to the museum. (2) Art collecting became more popular among Houstonians, and numerous local collections were donated or promised as gifts. (3) In the early 1970s the trustees began hiring full-time curators for specialized areas of the permanent collection. (4) In the 1970s and 1980s corporations became important patrons of the museum.

This new momentum was stimulated by the exhibition and educational programs of the Museum of Fine Arts, Houston, the Contemporary Arts Museum, and the university art museums; the evolution and strengthening of studio and art-history departments in area universities; the growth of libraries and slide collections throughout the city; the commitment of local newspapers to report art activities; the rise of private art galleries and dealers in the area; and the steadily increasing number of artists who decided to make Houston their home. By the 1960s the museum was becoming an integral part of Houston's cultural life, symbolizing the city's commitment to excellence in the fine arts.

The late 1950s–early 1960s also marked the evolution of the museum as a professionally run institution. The first director, James Chillman, served for thirty years on a part-time basis while teaching art history at Rice Institute. During his three decades as director he molded the institution into a comprehensive museum with a strong commitment to education. The art objects that entered the collection during his tenure show Chillman's work and vision.

From 1954 to 1959 Lee H. B. Malone served as director, overseeing the construction of Cullinan Hall, working with the Kress Foundation on the final selection of paintings, and arranging the eventual opening of Bayou Bend. Yale-educated, with a specialization in the Italian Renaissance, Malone guided the museum in originating more exhibitions and in working with other museums around the country. He was the museum's first full-time director and was responsible for beginning the changeover to a full-time staff of qualified professionals.

Malone was succeeded by the legendary James Johnson Sweeney, a Brooklyn-born writer, critic, and museum professional who was best known for his promotion of avant-garde art. Associated with the Museum of Modern Art, New York, since its founding in 1929, he served there as director of the department of painting and sculpture from 1945 to 1946; later he was the director of the Solomon R. Guggenheim Museum, New York, from 1952 to 1960. Sweeney's tenure in Houston dates from 1961 to 1968.

Controversial, energetic, and visionary, Sweeney might be described as a "citizen of the world." His international reputation helped elevate the image of the Museum of Fine Arts, Houston, as a general art museum with an unusually fervent commitment to contemporary art. In Houston a solid foundation for this preference had been established as early as 1924–25 when Chillman staged no fewer than twelve small exhibitions of contemporary art. Over the years twentieth-century and contemporary art, especially local and regional, remained a major element of the exhibition program. With the arrival of James Johnson Sweeney in 1961, the commitment to contemporary art was intensified and internationalized.

Sweeney encouraged the museum trustees to collect contemporary art from Spain, Italy, France, England, and the United States. He maintained friendly

relations with working artists and saw the museum as a patron of their creativity. For example, when the Houston Endowment wanted to commission a sculpture in honor of the opening of a new concert hall named for Jesse and Mary Jones, Sweeney selected the Spaniard Eduardo Chillida to create a sixty-ton work of art for the museum's south garden. Sweeney collected thirteen Jean Tinguely kinetic sculptures and important works by such artists as Matta, Alechinsky, Fontana, Rothko, Picasso, and Oldenburg. Sweeney devoted most of his work in Houston to the field of contemporary art and imprinted the permanent collection with his singular point of view.

The major patrons of the permanent collection during this era were primarily prominent trustees who dedicated time and money to the cause. Most had wide-ranging interests reflecting the nature of the museum. The daughter of Mr. and Mrs. Harry C. Wiess, Mrs. Theodore N. Law, became a trustee of the museum in 1963. Continuing her parents' tradition of supporting the museum, she purchased and donated Pablo Picasso's *Two Women in Front of a Window*, 1927, the first painting by Picasso in the permanent collection. Since that time Mr. and Mrs. Law have contributed generously to all aspects of the institution, including accessions such as *The Crucifixion*, c. 1465–70, attributed to the Master of Georg Muehlich's Meisterlin Chronicle, *A Vase of Chrysanthemums*, 1871, by Henri Fantin-Latour, and *The Rape of Europa*, 1644, by Laurent de la Hyre. Their most recent accessions reflect their commitment to contemporary and twentieth-century art and include *Composition*, 1921, by Vilmos Huszár and *Red Banner*, 1979, by Susan Rothenberg. Mrs. Law has also been a leading donor to the museum's capital campaigns for modernization and expansion of the facilities as well as major land acquisitions for future growth.

Other major patrons included John and Dominique de Menil. Mrs. de Menil, the daughter of Conrad Schlumberger, a major French entrepreneur in oil-field technology, and her husband, a prominent member of the Schlumberger company, were born in France and moved to Houston in 1942. They were early sponsors of the Contemporary Arts Museum, chartered in 1948, and played active roles in the Museum of Fine Arts, Houston, beginning in the 1950s. Discerning collectors, they donated important works to the museum's permanent collection and stimulated public interest in quality art by spearheading myriad activities —from collectors' clubs to exhibitions.

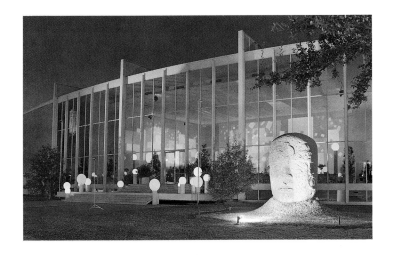

*Night view of Cullinan Hall
with Olmec head displayed
on north lawn, 1963.
Photo by Hickey & Robertson.
Museum Archives.*

Many of the de Menil gifts to the collection came in the 1960s during the directorship of James Johnson Sweeney. The list includes a dazzling number of important contemporary works, including Alexander Calder's great mobile, *International Mobile*, 1949, donated in 1962 in memory of Conrad Schlumberger's brother, Marcel, and Jackson Pollock's *Number 6, 1949*, which came to the permanent collection in 1964.

The de Menils had individual and eclectic tastes and rigorously high aesthetic standards. Their heroic bronze nude of the Roman Severan period entered the collection in 1962. It remains the premier work of art in the antiquity collection. Their Dogon ceremonial trough and additional tribal arts reflect the breadth of their interests.

Other trustees and benefactors focused on pre-Columbian art and North American Indian cultures. In late 1962 the museum received from Arthur T. McDannald a large collection of Indian artifacts, the most noteworthy coming from Spiro, a prehistoric eastern Oklahoma ceremonial center, and from other Eastern Woodland Indian mounds.

In 1965 the McDannald collection was exhibited in the museum as part of the permanent collection, and in that same year trustee Alice Nicholson Hanszen donated approximately two hundred pre-Columbian objects, which Sweeney had asked her to purchase. Sweeney had stimulated the public's imagination about the pre-Columbian civilizations when he excavated a sixteen-ton, nine-foot-high Olmec head from the jungles of Mexico and exhibited it in front of the museum. This project had been financed by the world-famous, Houston-based Brown & Root construction firm, which built a road into the Mexican jungle to retrieve the enormous block.

A native of Dallas, Alice Hanszen moved to Houston in 1929 with her husband, Mike Hogg. After his death she married an independent oil operator, Harry C. Hanszen. Alice Hanszen began collecting art seriously in the 1960s, and her interests were wide-ranging. As a trustee during and after the Sweeney era, she generously contributed accession funds and continued a steady involvement in the museum until her death in 1977. Ferdinand Bol's *Portrait of Saskia*, c. 1640, Odilon Redon's *The Trees*, and Bernardino Zaganelli's *The Virgin and Child Enthroned* are but three of the numerous important works credited to her in the permanent collection.

Beginning in the late 1950s, a growing number of patrons chose to support the institution. Life trustee Oveta Culp Hobby, first director of the U.S. Women's Army Corps and secretary of the Department of Health, Education, and Welfare as well as a successful businesswoman and wife of Texas governor William P. Hobby, began contributing to the permanent collection in 1958 and over the next thirty years donated twenty-two artworks, including splendid works on paper by such masters as Degas, Gris, Matisse, Picasso, and Renoir; Amedeo Modigliani's *Caryatid*, c. 1914; and a lidded bowl from the Maya culture in Guatemala.

Raymond H. and Esther Goodrich and the Esther Florence Whinery Goodrich Foundation also contributed important works by the old masters and nineteenth-century artists. An active trustee, Esther Goodrich supported the various projects and accessions of directors Malone and Sweeney.

Following Sweeney's departure in 1968, Mary Hancock Buxton served as administrator for eighteen months while the trustees recruited a new director. Finally, the trustees chose Philippe de Montebello from the Metropolitan Museum of Art, New York. Despite a brief term of four and a half years, he had a profound impact on the permanent collection.

Upon de Montebello's arrival in Houston, the museum received a generous bequest from the estate of Laurence H. Favrot, which de Montebello used as an acquisition fund to strengthen the collections of classical, medieval, and baroque art. Favrot was a close friend of museum trustee Margaret Brown. His funds were used to help those areas of the collection that had not received attention since 1957 when Raymond and Esther Goodrich contributed Willem Claesz. Heda's splendid *Still Life*, 1656. Between 1969 and 1972 Director de Montebello purchased thirty-three works with the Favrot gift, including a third-century Roman marble bust, a thirteenth-century crozier head from Limoges, France, a limestone *Virgin and Child* from Normandy, an early fifteenth-century reliquary monstrance from the Guelph Treasure of Lower Saxony, a late fifteenth-century double mazer cup from northern Germany, and a Mattia Preti oil painting, *The Martyrdom of Saint Paul*, c. 1656–59.

Shortly after the news of the Favrot bequest reached the trustees, the first accessions endowment fund at the museum was established in honor of Agnes

Cullen Arnold. Daughter of one of the state's most successful oil developers, Hugh Roy Cullen, and educated at Rice Institute, Agnes Arnold attended art-history classes taught by James Chillman and developed a lifelong interest in painting and sculpture. After her death in 1969 various members of the Cullen family donated important works of art in her honor. George Bellows's *Portrait of Florence Pierce*, 1914, contributed by Mr. and Mrs. Meredith J. Long, is a stunning example of this benevolence.

A series of masterworks from the Agnes Cullen Arnold Accessions Endowment Fund reflects the character of the permanent collection. The first purchase supported by the Arnold fund, *The Penitent Magdalen*, 1648, by Philippe de Champaigne, was made in 1970 by de Montebello. Over the next nineteen years works by other great French artists, including Chassériau, Claude, Corot, Matisse, and Théodore Rousseau, were acquired. American masterworks purchased with revenue from the Arnold fund include paintings by Stuart Davis and Georgia O'Keeffe. Cullen Foundation purchases also included an 883–859 B.C. Assyrian relief, a bronze plaque from the Benin culture of Nigeria, and a master oil painting by the Neapolitan Luca Giordano.

In addition to the accession fund, Agnes Arnold's commitment to the museum sparked the interest of the Cullen and Arnold families, who over the years have served as docents, trustees, patrons, and fund-raisers. Mrs. Arnold's son, Isaac Arnold, Jr., for example, has been the longest-serving chairman of the museum's board of trustees. Her niece, Mrs. Meredith J. Long, and her husband have been among the most generous patrons of the permanent collection over the past two decades. The Cullen Foundation has given grants in virtually all areas of the museum's activities.

The 1950s brought another great Houston family into the museum. Brothers Herman and George R. Brown owned and operated Brown & Root, a heavy-construction company founded in 1917. The brothers and their families became major philanthropists. Mrs. Herman Brown and George and Alice Brown served as museum trustees and supported major exhibitions and accessions planned by directors Malone and Sweeney during the late 1950s and 1960s. Margaret Brown together with Mrs. William Stamps Farish purchased *A Muse*, 1917, by Constantin Brancusi for the museum in 1962. George and Alice Brown

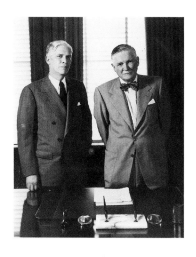

supported Sweeney's famous Olmec exhibition. The Brown Foundation, established in 1951, contributed one million dollars in 1968 to purchase land that is now the site of the Lillie and Hugh Roy Cullen Sculpture Garden and the Glassell School of Art. In 1970 the Brown Foundation again contributed four million dollars to complete phase two of the Mies van der Rohe building and establish a maintenance endowment for it. The building—the Brown Pavilion—opened to the public in 1974 and doubled the museum's exhibition space. Then, in 1976, the Brown Foundation announced a ten-year annual challenge grant of 1.6 million dollars to build an operations endowment and accessions endowment. In 1981 the grant was extended to 1995.

Alice Pratt Brown served on the board of trustees for twenty-five years. Born in Siloam Springs, Arkansas, she graduated from Southwestern University in Georgetown, Texas, and married George R. Brown in 1925. Together they traveled frequently, combining business and leisure, which sparked Alice Brown's interest in art and led to her extraordinary devotion to the museum.

Accessions were a special passion of Alice Brown. She continually provided personal funds for purchases, encouraged the family foundation to do so as well, and urged her friends to follow. *Loam*, a 1958 Veil painting by Morris Louis, was purchased for the museum in 1976 by the Brown Foundation. In 1984 Alice Brown's friend Mrs. Charles W. Engelhard contributed her fine 1920 painting by Fernand Léger, *Man with a Cane*. In addition, thanks to trustee Susan O'Connor, the Charles W. Engelhard Foundation has given to the museum many contemporary paintings and sculptures. Georg Baselitz's *The Lamentation*, 1983, for example, came to the museum as a result of a challenge grant from the Engelhard Foundation.

Over the years the Browns have given important works in honor of various family members. In 1963 Margaret Brown purchased Auguste Rodin's *The Walking Man*, 1906, in honor of her daughter, Louisa Stude Sarofim. In 1980 George R. Brown donated several works in honor of his wife. These included John Singer Sargent's *Mrs. Joshua Montgomery Sears*, 1899, and Richard Diebenkorn's *Ocean Park #124*, 1980. When George R. Brown died in 1983, Alice Brown and her children purchased for the permanent collection in his memory the quietly stirring *Good Lesson*, c. 1753, by Jean-Baptiste-Siméon Chardin.

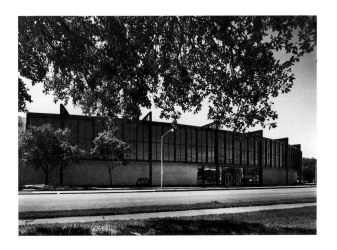

Earlier, Alice and George R. Brown's daughter, Maconda, and her husband, Ralph O'Connor, contributed Marsden Hartley's *Abstraction*, c. 1914, in honor of Maconda's parents. After Alice Brown's death in 1984 her children contributed a gold pre-Columbian beaker from Peru and the Brown Foundation purchased David Smith's *Two Circle Sentinel*, 1961, both in her memory. In 1986 the Brown Foundation and Mr. and Mrs. M. S. Stude commissioned Ellsworth Kelly's first monumental bronze, in honor of Alice and George R. Brown.

The Brown family also established the Alice Pratt Brown Museum Fund. This endowment for accessions received large contributions from the wills of Alice and George R. Brown and resulted in bringing important works to the collection, including a rare Olmec effigy vessel, an Ulúa tripod vase from Honduras, a Philip Guston oil painting of 1977, and a life-size neoclassical *Venus*, 1816–20, by Bertel Thorvaldsen.

Alice Brown also was interested in supporting the construction of a sculpture garden situated between the museum building and the newly opened Glassell School of Art. The trustees had operated the Museum School of Art since 1927. Classes met in various locations, including the museum itself and rented buildings in the Montrose neighborhood. During the 1970s life trustee Alfred C. Glassell, Jr., contributed funds to build the present school, which opened to the public in 1979. Alice Brown envisioned a sculpture garden that would connect the school and museum, forming a campus setting. American sculptor Isamu Noguchi was chosen to create the garden because the trustees, particularly Alice Brown, admired his Billy Rose Sculpture Garden in Jerusalem. The Cullen Foundation pledged a majority of the funds for construction, and the garden was named for Lillie and Hugh Roy Cullen. Other major donors included the Brown Foundation, Mr. and Mrs. Isaac Arnold, Jr., Mr. and Mrs. Meredith J. Long, William James Hill, the River Oaks Garden Club, Mr. and Mrs. M. S. Stude, the Garden Club of Houston, Mr. and Mrs. Theodore N. Law, and Douglas B. Marshall, Jr. The Lillie and Hugh Roy Cullen Sculpture Garden was dedicated in 1986.

The first accession for the Cullen Sculpture Garden was the most expensive work of art purchased by the museum in its history. In 1980 the museum acquired Henri Matisse's *The Backs I–IV* for more than two million dollars. *Back*

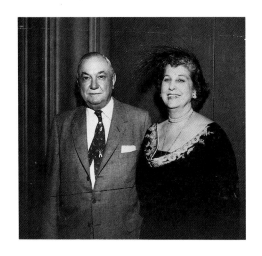

I, 1909, was sponsored by Mr. and Mrs. Theodore N. Law in memory of Mrs. Law's parents, Mr. and Mrs. Harry C. Wiess. *Back II*, 1913, was donated by Gus and Lyndall Wortham. Wortham built a successful insurance business in Houston and contributed generously to the museum over the years. The Wortham Foundation continued this philanthropy after the Worthams' deaths with numerous contributions, including the first endowed curatorial chair, named in memory of Gus and Lyndall Wortham. *Back III*, 1916–17, was a gift of the Cullen Foundation, and *Back IV*, c. 1930, was purchased for the garden by the Brown Foundation in memory of Herman and Margaret Brown. Within a few years sculptures for the Cullen Sculpture Garden by French artists Antoine Bourdelle and Aristide Maillol were donated by Mr. and Mrs. Isaac Arnold, Jr. The year 1986 brought Alberto Giacometti's *Large Standing Woman I*, 1960, from the Brown Foundation Accessions Endowment Fund, and in 1988 the Hobby Foundation contributed the unique 1939 bronze equestrian by Marino Marini, *The Pilgrim*. Other Cullen Sculpture Garden accessions include: Frank Stella, *Decanter*, 1987, acquired by the Alice Pratt Brown Museum Fund; Bryan Hunt, *Arch Falls*, 1981, courtesy of the Charles W. Engelhard Foundation; Anthony Caro, *Argentine*, 1968, funds provided by the Brown Foundation Accessions Endowment Fund; and Louise Bourgeois, *Quarantania I*, 1947–53, and Robert Graham, *Fountain Figures #1, #2, #3*, 1983, purchased through grants from the Charles W. Engelhard Foundation, Mr. and Mrs. Theodore N. Law, and Mr. and Mrs. Meredith J. Long. In less than a decade the trustees had built a garden around a core of masterpieces.

One of the most important and popular contributions to the permanent collection is the John A. and Audrey Jones Beck collection of nineteenth- and early twentieth-century paintings. This collection first came to the museum as a temporary exhibition in 1974. Since then, it has never left the museum. Fifteen years later, it forms the nucleus of a group of artworks representing early modernism and the avant-garde movements developed in Paris. The Beck collection was conceived as an entity by Audrey Beck, who actively collects and chooses additions. The spirit of the collection revolves around artistic innovation and the exhilarating life of France, particularly Paris. Superb examples of impressionism, pointillism, and fauvism abound in the collection, which includes

Honoré Daumier's *Lawyers' Meeting*, c. 1860, Jean-Baptiste-Armand Guillaumin's *Seine at Paris*, 1871, Mary Cassatt's *Susan Comforting the Baby*, c. 1881, Vincent van Gogh's *Rocks*, 1888, Paul Gauguin's *Arearea II*, c. 1892, Paul Signac's *Bonaventure Pine*, 1893, André Derain's *Turning Road, L'Estaque*, 1906, Georges Braque's *Fishing Boats*, 1909, Wassily Kandinsky's *Sketch 160 A*, 1912, Pierre Bonnard's *Dressing Table and Mirror*, c. 1913, and Henri Matisse's *Woman in a Purple Coat*, 1937.

Audrey Beck is a granddaughter of Jesse Jones, who played a prominent role in securing both the Straus and Kress collections for the museum. Her husband, John Beck, was raised in Wisconsin and met Audrey while he was stationed in Texas. Audrey Beck encountered impressionist paintings on her first European tour. After World War II she and John traveled frequently to Europe and taught themselves about art and the art market. John Beck was the businessman in this partnership and Audrey the connoisseur. They bought and sold art regularly until the early 1970s, when the collection began to assume its special character.

The Becks opened their home to college students to study the paintings and then in 1973 established the John A. and Audrey Jones Beck Fund to help the museum purchase impressionist art. John served as a museum trustee for ten years. After his death in 1973 Audrey joined the board. She now serves as a life trustee. Her goal has remained constant: to assemble a fine collection that will instruct as well as delight. In the second edition of the Beck collection catalogue, authored by Audrey Beck, she summed up the philosophy she shared with her husband: "We worked together to tell the story of impressionism and hope that everyone who views the collection may find in it his or her special painting." In 1988 the Houston Endowment donated the Audrey Jones Beck Galleries to the museum for the purpose of exhibiting together the major impressionist and expressionist works of art in the permanent collection.

As the collection of European art from antiquity to the early modern era continued to grow, it was clear that Houston had a unique opportunity in the Southwest. The museum was capable of creating a permanent exhibition of important paintings, sculptures, and works on paper that would help visitors learn about the history of European art. Individual accessions; the Kress and Straus bequests; the Hanszen, Hobby, and Hogg gifts; and the Beck and Blaffer

collections had formed an orderly, chronological survey from antiquity to the
early modern period. The process of building the collection was aided immensely
by a priority list for European accessions drawn up by de Montebello and his
curators in 1972. The list has served ever since as a general guide to the trustee
accessions committee and is updated and altered as art-market conditions
change. In 1985, 450 works from the collection were installed chronologically on the
upper level of the Brown Pavilion, providing a panoramic survey of European art.

The founding documents of the museum called for a "collection . . . of
objects of the fine arts: from all important civilizations," but special emphasis
was directed to works of "American creation." Despite this mandate, American
paintings were not a high priority for the first forty years of the museum's
existence. Ima Hogg's gifts of Bayou Bend and the Frederic Remington collection
were two prominent exceptions. The Remington gift forms the core of about
one hundred paintings by Western and Southwestern artists including
Hennings, Hart, Wiggins, and Ufer. James Johnson Sweeney created interest in
the field of contemporary American art and added several masterpieces by
Americans such as Pollock and Rothko, but it was William C. Agee, successor
to Director Philippe de Montebello, who focused on the needs of the collection
of twentieth-century American art.

Agee had been the associate curator of painting and sculpture at the
Museum of Modern Art from 1968 to 1970 and director of the Pasadena Art
Museum in 1971–74 before coming to Houston in 1974. The economy of the
city was at the beginning of a boom, and during Agee's tenure the collection
grew rapidly. Thanks to the Brown and Cullen accession endowment funds, a
supportive board of trustees, and an excellent eye for quality, Agee added more
than one hundred twentieth-century American paintings to the collection.
Abstract American art before World War II was one of his specialties, and
he collected exemplary works by Hartley, Russell, Macdonald-Wright, Bruce,
O'Keeffe, Storrs, and Bolotowsky. Among the works by pre–World War II
artists that the museum accessioned were major paintings by Bellows, Marin,
Davis, and Avery. Post–World War II works were accessioned in even greater
numbers, particularly abstract paintings and sculptures. Among the painters
whose work was acquired were Still, Krasner, Tobey, Louis, Noland,

Motherwell, Stella, Frankenthaler, Nancy Graves, Mangold, and Rothenberg. The American sculptors whose work entered the collection were also primarily abstract artists: Ferber, Bell, and Judd. This drive to collect the work of living Americans was stimulated by a series of matching grants from the National Endowment for the Arts, a federal agency. These grants, which began in 1973, required a match in funds on a one-to-one ratio. The results tremendously benefited the cause of contemporary American art in the museum's collection: 201 photographs, 20 paintings, 5 mixed-media works, 3 prints, 3 sculptures, and 2 drawings for a total of 234 works.

The American collection has continued to expand through purchases and gifts. The generous contribution in 1985 by Mr. and Mrs. David Wintermann of sixty American paintings dating from 1880 to 1925 helped fill an important gap in the collection. Major contemporary works also have been acquired thanks to the museum's Brown and Cullen accession endowment funds; the Long Endowment for American Art, created by Mr. and Mrs. Meredith J. Long; and generous grants from the Charles W. Engelhard Foundation and the McAshan Educational and Charitable Trust.

In addition to the individuals and foundations who contributed to the museum in the 1970s and 1980s, corporations became an important source of funds. The first large gift from a corporation was Tenneco's sponsorship of the opening of the Brown Pavilion in 1974. Shell Oil Company began contributing a series of gifts in 1954 and remains the largest corporate donor to the institution. Target Stores, a division of Dayton Hudson, has contributed generously as well, through the Dayton Hudson Foundation, to establish important photography collections. The first Target grant in 1976 founded the photography department at the museum, and since that time more than 260 photographs have been acquired with Target funds. Among the masterpieces in the Target collections are Alfred Stieglitz's *Portrait of Georgia O'Keeffe*, 1933, Edward Weston's *Epilogue*, 1919, and Esther Parada's *Past Recovery*, 1979.

The museum's photography department has developed a national constituency of donors from New York to Minneapolis to Los Angeles. Houstonians Isabell and Max Herzstein have been major contributors of works such as a rare Christian Schad Schadograph, 1918, László Moholy-Nagy's *At Coffee*, and John

Peter C. Marzio and Isamu Noguchi in the Lillie and Hugh Roy Cullen Sculpture Garden.

Heartfield's *The Thousand-Year Reich*, 1934. Brown Foundation contributions include Edward Steichen's *Trees, Long Island*, 1905, and André Kertész's *In Les Halles*, 1929. In thirteen years more than 170 donors have contributed more than four thousand photographs to the collection, which is particularly strong in European works dating from 1900 to 1945 and American prints made after 1945. Two photographers represented in depth are Moholy and Robert Frank. Major donors to the photography collection not previously mentioned here are Raphael Bernstein, Mr. and Mrs. Stanford Alexander, Clint Willour, Louisa Sarofim, the Blaffer Foundation, Sonia and Kaye Marvins, the Mundy Companies, and Mr. and Mrs. S. I. Morris.

The museum's holdings of works by Texas and Southwestern artists have expanded through a series of grants from the Houston-based Texas Eastern Corporation. These grants began in 1981 and have given the museum the rare opportunity to assemble an acclaimed collection of paintings by important artists of the region, including Glasco, Fisher, Staley, Boshier, Miller, Biggers, Surls, Stack, and Bess.

This same spirit of giving has been expressed by individual collectors in virtually all areas of the collection. For example, in addition to the decorative-arts objects at Bayou Bend, the museum houses a collection of late nineteenth- and twentieth-century American objects contributed by numerous trustees and friends. The American sideboard donated in 1983 by trustee Anaruth Gordon and her husband, Aron, is a prime example of the high-quality objects in this selective collection. Trustee William James Hill also has been a steady supporter of American decorative arts. In the field of European decorative arts the museum owns one of the finest collections of Worcester porcelain in North America. More than seven hundred pieces have been donated by life trustee and former chairman of the board Harris Masterson III and his wife, Carroll, daughter of the early museum patron Frank Prior Sterling. For more than thirty years the Mastersons have been major contributors to the permanent collection and have given funds for the construction and maintenance of the galleries. European silver is well represented thanks to gifts and long-term loans from trustee Dr. George S. Heyer, Jr. The sterling silver two-handled

covered cup, 1672–73, made by John Ruslen in London, is one of the major donations to the museum from Dr. Heyer.

The print collection has had many patrons over the years, particularly Alvin Romansky and Drs. Marjorie G. and Evan C. Horning. Specializing in old-master prints, the Hornings have established an endowment fund to ensure the growth of the print collection. The Mavis P. and Mary Wilson Kelsey collection of Winslow Homer prints encompasses a vast array of wood engravings from the print shop of *Harper's Weekly* magazine. The Asian collections are small but owe an enormous debt to Carol and Robert D. Straus, who contributed a number of significant objects including a Tang dynasty ceramic *Standing Court Lady* and a thirteenth-century Indian bronze *Śiva Nataraja*.

A goal of all these collectors has been to encourage a philanthropic spirit throughout the community and a belief in teamwork for the benefit of the permanent collection. This has been achieved in Houston's own style. Ever since 1900, when the Houston Public School Art League began to meet in members' homes for lectures and art discussions, Houston patrons have worked in groups, combining social activity, education, and fund-raising. The museum's permanent collection has benefited enormously from such group activities as the Theta Charity Antiques Show, which has made contributions to the museum since 1970; "One Great Night in November," a men's smoker originated by William James Hill in 1984 to choose works for purchase; and the Tri-Delta Art Show, which has provided funds for the purchase of master drawings. The Museum Collectors, a group of dedicated patrons formed in 1979, meet to learn about art and the art market and to raise funds for museum art purchases.

Many patrons have established specialized groups focusing on specific areas of the collection. The Photo Forum was begun in 1987 to increase the museum's holdings of contemporary photographs. The Costume Institute was organized in 1986 to collect and exhibit costumes. The Friends of Bayou Bend has continued to maintain a long-standing relationship with the museum. The number of these specialized committees undoubtedly will increase in the future.

General and Mrs. Maurice Hirsch. Photo courtesy of the Houston Chronicle.

The story of the Museum of Fine Arts, Houston, does not end here. It is a dynamic institution built by the citizens and friends of the city. Some founders were second-generation immigrants; many were born outside Texas. In every case, succeeding generations have continued a family tradition of philanthropy.

With the collection growing at the rate of nearly nine hundred objects per year since 1980, long-range plans for the 1990s call for a major addition that will nearly double the size of the present museum complex. In 1985, thanks to grants from the Wortham Foundation and numerous trustees, a block of land adjacent to the museum was purchased. In 1988/89 Mr. and Mrs. Theodore N. Law provided funds to purchase another adjacent block. These two acquisitions of contiguous properties have secured the future of the museum, permitting the trustees to plan for greater use of the museum's resources by all sectors of the community.

The rapid growth of the collection has triggered an expansion of the entire organization. A symbol of this development has been the museum library. In 1980 the trustees decided to find funds to make major improvements. The response was almost immediate. In 1981 General and Mrs. Maurice Hirsch endowed the library and made numerous additional gifts to build the book collection. Mrs. Hirsch later provided funds to install computers and link the library via computer to other important art-research centers in the United States. The library collection has doubled in size in eight years. General Hirsch had been a museum trustee for twenty-nine years at the time of his death in 1983. Mrs. Hirsch currently serves on the board as a life trustee. She and General Hirsch also contributed significantly over the last thirty-five years to the growth of the permanent collection with a wide array of works, including a hydria from Athens, 470–460 B.C.; a pen, wash, and chalk drawing of the 1780s by Jean-Honoré Fragonard; thirteen oil paintings by Southwestern artist Walter Ufer; and many other objects.

One cannot help wondering what those intrepid reformers of the Houston Art League would think of the museum today. In their first annual report in 1925 members of the league voiced pride in their "infant," a term that expressed hope as well as anxiety. The elation of seeing the museum open to the public was tempered by the daily efforts required to make the institution vital. The

annual report speaks openly to this issue: "The members of the Houston Art League are realizing, probably more vividly than before, that the opening of the Museum doors was to them not an end, but a beginning. . . . At present we have a beautiful home, but it is somewhat of an empty shell. We have few possessions."

The dynamic patrons who followed the lead of the Houston Art League filled that "empty shell" with masterpieces. Because of the willingness of these patrons to carry on the work of the league, the museum has beautiful works of art from six continents and from many civilizations throughout history. This encyclopedic world view is a distinguishing characteristic of Houstonians and of the permanent collection of the Museum of Fine Arts, Houston.

Note: The museum's name changed several times. From 1916 to 1923 it was called the Houston Art Museum; from 1924 to mid-1925, the Museum of Fine Arts; from late 1925 to the early 1960s, the Museum of Fine Arts of Houston (this change was legalized by state charter in May 1929). In the early 1960s the trustees again changed the name, to the Museum of Fine Arts, Houston.

Art of the Americas
and Tribal Arts

Effigy Vessel in the Form of a Duck

The Olmec culture, the oldest highly developed civilization in Mesoamerica (extending from central Mexico to western Honduras), was centered in the tropical lowlands of the Mexican states of Veracruz and Tabasco. Because of the region's high humidity and water-soaked ground, stone sculptures are the only works of art to have survived the millennia. In the arid central highlands of Mexico, however, where the Olmec are believed to have established trading centers, high-quality pottery exhibiting Olmec iconography has been found well preserved and in great numbers.

This duck pot is one of about a dozen known large examples from Las Bocas and Tlatilco. All have an opening in the head, and most are incised with markings on the wings. The vessel is unique for its elegant, long, broad body and neck.

The marshy Gulf Coast teems with bird life. While it is not known if the ancient Olmec hunted ducks, it is certain that they held these birds in high esteem. After humans and human-feline creatures called "were-jaguars," birds—and in particular ducks—were the most important subject matter in their art. The duck vessels from central Mexico, which were used as tomb offerings, may have been created to evoke water associations in an environment subject to drought.

Ceramic, incised grayware; 8⅛ × 9¼ × 6¾in. (20.7 × 23.5 × 17.1 cm)
Museum purchase with funds provided by the Alice Pratt Brown
Museum Fund 86.393

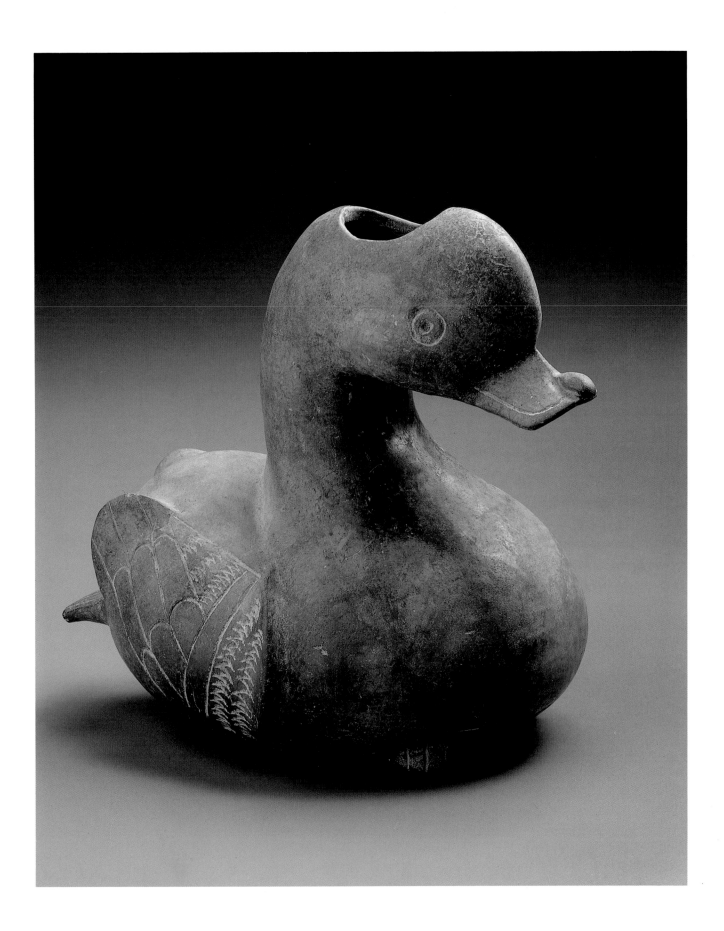

Lidded Bowl, 350–500

T he basal-flanged bowl was among the most favored vessel shapes of the Early Classic Maya, particularly in the Petén area of northern Guatemala. Named for the ridge around the bottom of the vessel, such bowls were often large, lidded, and formally inventive. They were made in two types of ceramic ware: incised blackware and polychromed orangeware.

This bowl is one of the latter variety, painted in white, gray, black, orange, and red-orange. The handle has been ingeniously modeled in the shape of a human head, the asymmetric face painting and topknot giving it a jaunty air. The three-dimensional head emerges from a two-dimensional necklace on the lid, and the white background surrounding the necklace actually may be a decorated collar worn by the individual depicted.

As with much Maya pottery, the flat areas of the lid and bowl are divided into rectangular sections containing the design units. In this bowl are three such sections around the rim of the lid and two around the side of the bowl; each is painted with a profile human head facing down toward the foot of the bowl. These heads allude to the watery underworld where the elite went after death and may represent underworld gods or dead souls breaking the water's surface during their descent to that world.

Ceramic, polychromed orangeware; 10½ × 12⅞ in. (26.7 × 32.7 cm)
Museum purchase with funds provided by the Brown Foundation and Oveta Culp Hobby 76.426

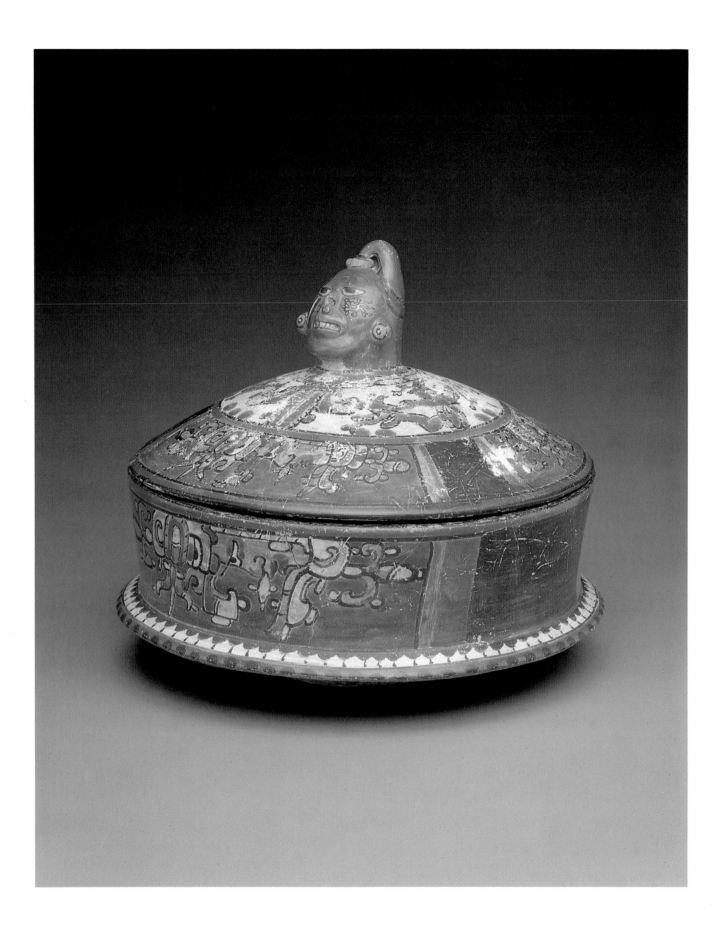

Maya stonework is renowned for its high-quality workmanship, elaborate style, and complex iconography. The easy availability of soft limestone allowed Maya carvers free rein to exploit the medium to its fullest, whether as full-standing stelae for plazas or relief panels for the walls of buildings.

This relief carving comprises only the lower left corner of what was a large three-figured panel that once graced the interior of a temple or palace. The extremely low relief, buttery soft surface, and fine detail are characteristic of reliefs produced in the workshops of the great city of Palenque. The lower right corner of the original panel (now in the Museo Nacional de Antropología, Mexico City) depicts a similar seated figure. He is identified in the accompanying glyphic inscriptions as Chan-Bahlum of Palenque, who reigned from 684 to 702 and is described as deceased. Between them once stood a frontal figure, most likely another ruler of the city.

The identity of the Houston seated figure is unknown. As is common in Palenque art, he wears the accouterments of a god, in this case the feathered headdress of God L, a lord of the Maya underworld. He otherwise is dressed simply in a fringed kilt and loincloth, one end of which drapes elegantly over his front thigh. He offers to the central figure a shallow bowl decorated with sky symbols and containing a cloth draped over the sides and two Tlaloc (rain god) heads stacked on top of each other. All these iconographic elements point to a theme of death, the underworld, vegetal fertility, and eventual rebirth into the heavenly realm.

Limestone; 39⅛ × 26½ in. (99.4 × 67.3 cm)
Museum purchase 62.42

44

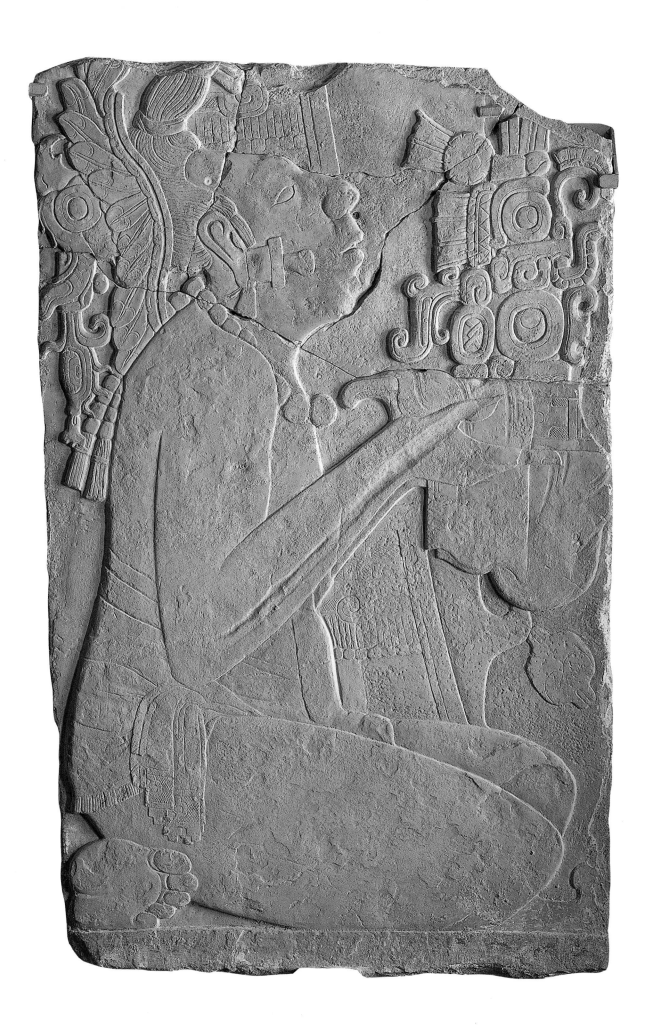

Tripod Vase

On the eastern frontier of Maya territory is the Ulúa Valley of northwestern Honduras. This valley is famous for a group of travertine vases (usually mistakenly called marble) that were made there by non-Maya people and traded to sites as far away as the Petén in Guatemala and the Nicoya Peninsula of Costa Rica. Although fewer than one hundred are extant, they are well known to scholars and popular among museums and collectors.

There are two main types of such vessels: vertical vases with a ring base and horizontal bowls with three feet. The majority are cylindrical, with straight sides, flat bottom, and two projecting handles carved as animals or animal heads. The decoration on the sides is relegated to one wide band usually edged above and below by a ring of overlapping scales. The chief design element of this band is the scroll, which is arranged in rows and columns and into which are worked stylized frontal and profile faces. The handles in this example are birds with down-turned beaks, holding in their talons scrolls that may represent stylized serpents. The head in high relief flows seamlessly into the body, which is rendered in low relief on the sides of the vessel.

Travertine; 5¾ × 13 in. (14.6 × 33.0 cm)

Museum purchase with funds provided by the Alice Pratt Brown Museum Fund 87.189

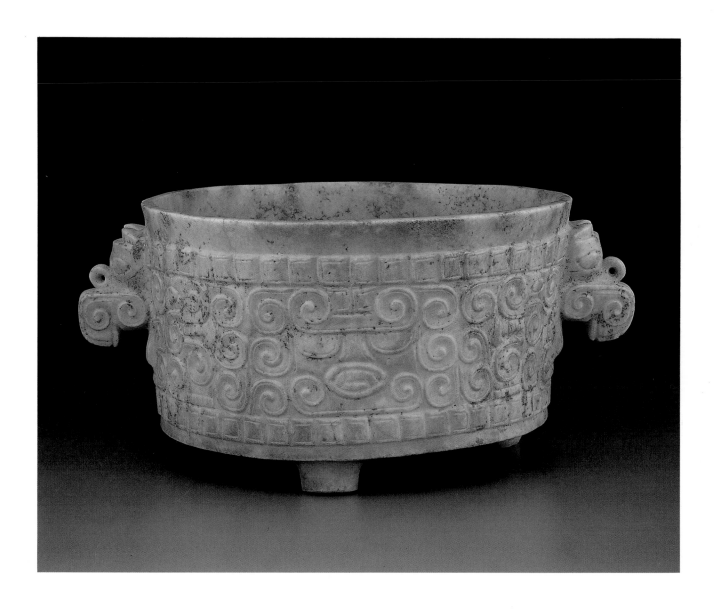

Standard-Bearer, 1425–1520

The Aztecs were latecomers to the rich cultural heritage of central Mexico. Formerly desert nomads, they settled in the Valley of Mexico by the early fourteenth century and ravenously assimilated everything they encountered, including artistic traditions. Among the various stone sculpture types that they borrowed were standard-bearers, seated or standing male figures carved fully in the round that flanked entrances and stairways. They originally carried standards or banners in the openings in their hands.

The Houston standard-bearer illustrates well the conservative nature and formal simplicity characteristic of Aztec stone sculpture. The figure stands rigidly frontal with its legs closely spaced and its arms held next to the torso, barely free of the original stone block. A geometric solidity dominates; no hint of movement is apparent. This hardened, austere appearance is heightened further by the blank facial expression and squat proportions of the figure, with its oversized feet and barely evident neck. The figure was meant to keep its distance while asserting its presence—just as a proper guardian should.

In order not to interfere with this effect, the figure's clothing and accessories are minimal: a loincloth tied in a stylized knot in front, large plaquelike ear ornaments, and a crescent nose ornament representing the moon covering the mouth. This nose ornament—associated with the gods of pulque, the maguey beer of Mexico—gives the standard-bearer the authority of the gods as well as of men.

Stone; 47⁷⁄₁₆ × 16 in. (120.5 × 40.7 cm)
Gift of D. and J. de Menil 66.8

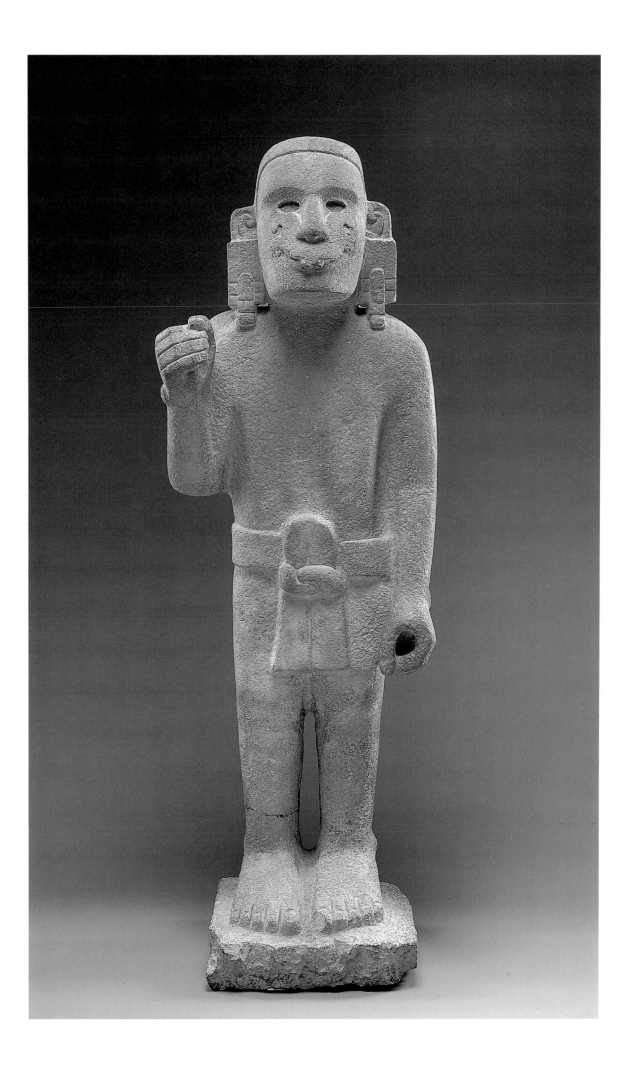

Effigy Container in the Form of a Woman, 1–700

The Moche culture dominated the northern coast of Peru both politically and artistically during the first few centuries of our era. For the Moche, ceramic vessels were the prime medium for artistic expression.

Perhaps the best-known vessel type made by the Moche is the realistically modeled portrait head or full figure topped with a stirrup-shaped spout. The Houston female figure is unique in Moche art. Although reminiscent of the figures that form the bodies of Moche open vessels, it is larger and is actually a closed container, having a small piece at the back of the head and upper back that once fastened closed with cords threaded through pairs of holes.

The red-orange clay is highly burnished and set off by bits of cream slip delineating the whites of the eyes, fingernails, and necklace. The ears are pierced for ear ornaments that were probably metal; except for this jewelry, the figure is naked. The figure's nudity, odd arm position, large size, and unusual closure at the back have led scholars to develop different theories about its use. It may represent a weaver at a loom and may have once held tools for weaving and sewing, or it may be a small mannikin that was dressed in examples of textiles to be woven. At present there is nothing comparable in any medium to help further identify the object.

Ceramic, orangeware with cream slip painting;
11½ × 8¼ × 9 in. (29.1 × 21.0 × 22.9 cm)
Museum purchase with funds provided by Mr. and Mrs. Wallace S. Wilson
86.503

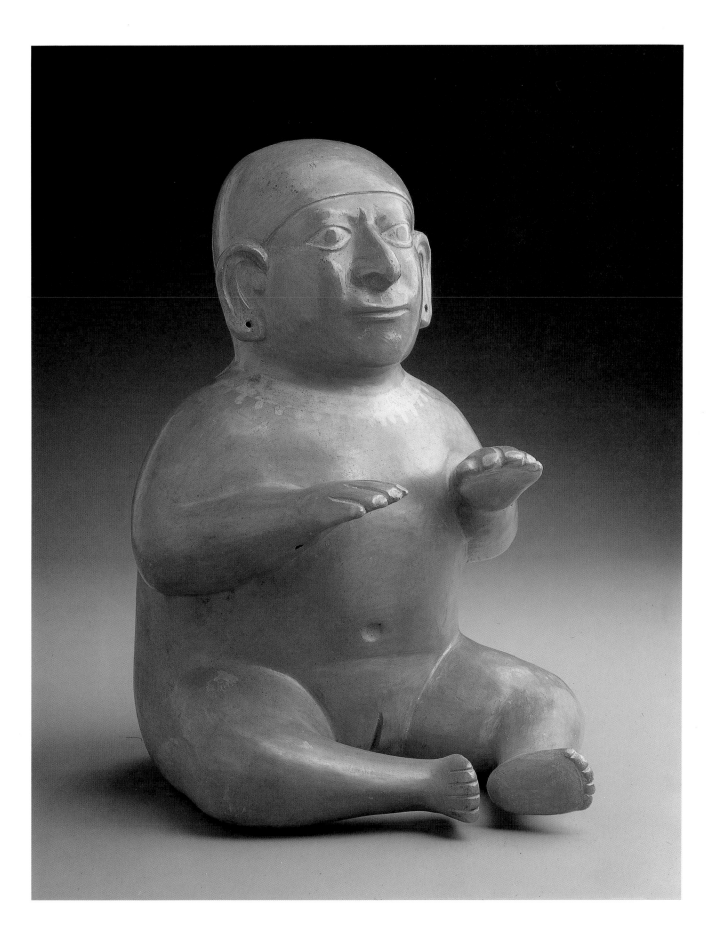

Beaker, 850–1050

On the northern coast of Peru, the Sicán culture (formerly known as Lambayeque) bridged the gap in time between the better-known Moche and Chimú cultures. Centered in the Lambayeque Valley, Batán Grande, its largest site, is among the most extensive cemeteries in the New World. Here the elite were buried with great quantities of hammered gold objects.

The objects most commonly found in the tombs were beakers such as this one. As many as 176 are known to have come from a single grave. They were stacked in groups of about ten, each group containing beakers of similar size and iconography. Stylized heads of the principal Sicán deity are frequently depicted.

While these beakers clearly were made as tomb offerings, they also may have been used by the elite in rituals, perhaps involving chicha, the maize beer of the Andes. Many of those found stacked in tombs are crudely made and seem to have been created hastily specifically for burial. This example stands apart in its fine execution and meticulous detail.

Gold; 5⁵⁄₁₆ × 4¹¹⁄₁₆ in. (13.4 × 12.0 cm)
Given in memory of Alice Pratt Brown by her children 86.320

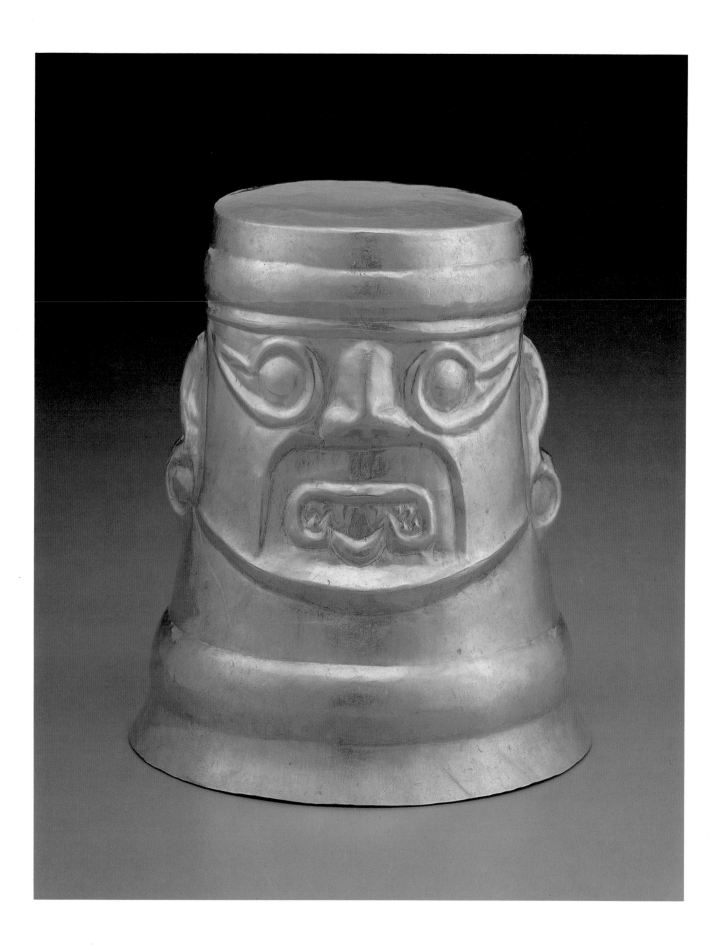

The prehistoric cultures of the American Southwest extended into present-day northern Chihuahua in Mexico. Between 1000 and 1350 these cultures enjoyed a golden age, when influences from the sophisticated civilizations of central Mexico far to the south reached the area.

The town of Casas Grandes, at the southern edge of the region, occupied an advantageous position for transmitting these influences to the north. It developed as an important trading center for such Mesoamerican products as copper bells and ornaments, seashells, and tropical birds. Macaws especially were prominent in Casas Grandes, where their brilliantly colored feathers were prized for ceremonial offerings. The birds were bred and raised in special structures with furnaces to keep them warm during the chilly desert nights.

The bowl illustrated here has been transformed into an effigy of a macaw by the simple addition of a head and tail to the standard Casas Grandes bowl shape. The geometric designs covering the entire surface in bold diagonal patterns are found on most Southwest pottery at this time, but here they are chosen carefully and placed to evoke the wings of the macaw. The crisp painting is especially fine, a result of direct influence from the Mimbres culture to the north. The expressive head with squawking beak gives the bowl a presence greater than its small size would normally command.

Ceramic, polychrome buffware; 5⅛ × 14½ in. (13.0 × 36.8 cm)
Gift of Miss Ima Hogg 44.107

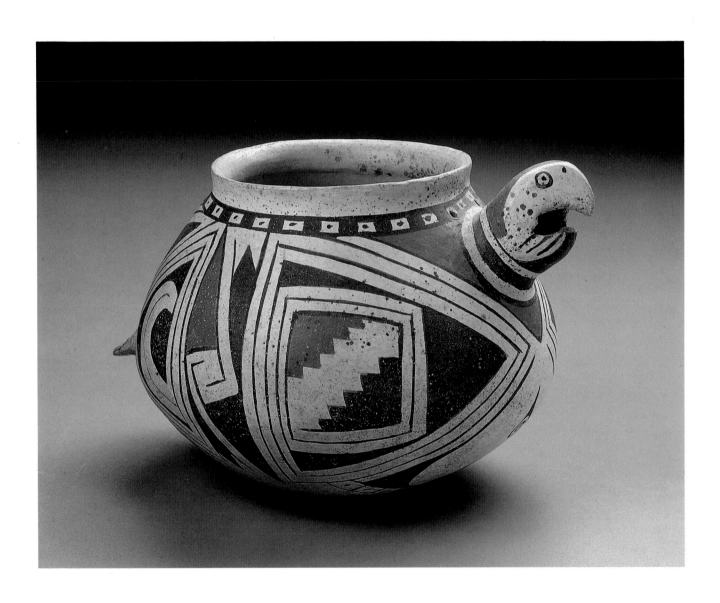

The Pueblo peoples of northern Arizona and New Mexico share an unbroken cultural tradition that began at least two thousand years ago. During this time pottery developed as one of the primary forms of artistic expression. Individual pueblos, or towns, had their own distinct styles, but all were dominated by geometric motifs. The large storage jar for food and water eventually became the preferred shape for experimentation in painted decoration.

About 1850 Zuni Pueblo experienced a renaissance of ceramic production that peaked during the last two decades of the nineteenth century in an elaborate arabesque style. The new style utilized traditional forms as well as floral and animal motifs borrowed from foreign sources.

The Houston jar beautifully exemplifies this last great phase of Zuni pottery. A double line around the shoulder divides it into two primary zones—the neck and body. Below this line is the main design, dominated by three large rosettes, a motif probably adapted from Spanish woodworking. Alternating with these are groupings of animals in a three-tiered arrangement framed by arcs composed of traditional hooked-feather motifs. The two profile deer in each group are shown naturalistically except for a red heartline, a motif probably introduced into the Southwest by the Navaho and Apache tribes, who originated in Canada. Between the deer are stylized birds whose graceful, curvilinear lines repeat the hooks of the feathers and the scrolls on the neck. All these forms are executed with elegance and precision, giving a marvelous sense of quick, rhythmic energy to the entire design.

Ceramic, polychrome buffware; 9⁵⁄₁₆ × 13 in. (23.6 × 33.0 cm)
Gift of Miss Ima Hogg 44.96

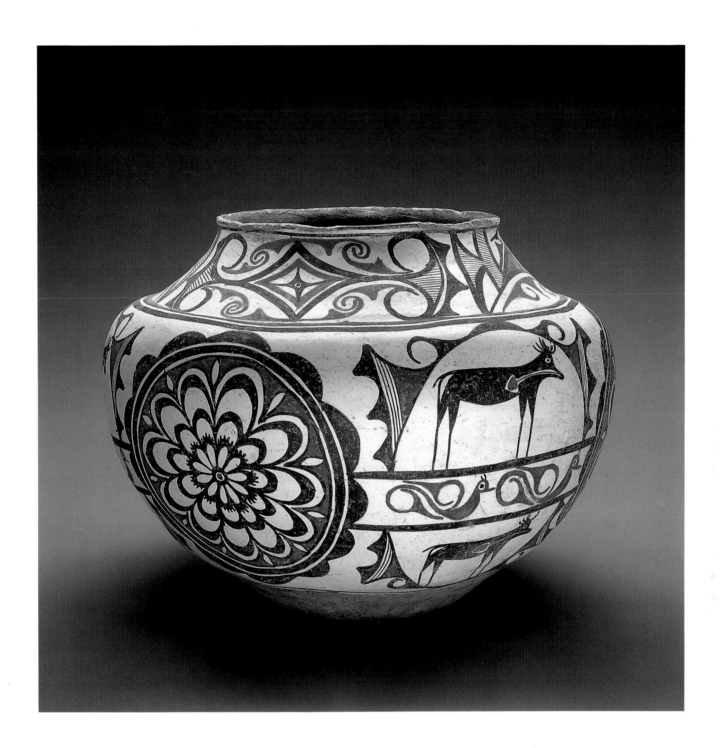

MARIA MARTINEZ (1887–1980) and JULIAN MARTINEZ (1885–1943)

Pueblo; United States, New Mexico, San Ildefonso Pueblo

Jar, 1934–43

The completion of the cross-country railroad line through Albuquerque in 1880 brought an influx of tourists to northern New Mexico, the home of the Pueblo peoples for two millennia. This event sparked a resurgence in the ceramic art of the area, as potters responded to the new commercial stimulus. Pottery changed from sturdy, serviceable wares to curio sales items and finally, in the twentieth century, to objects of great aesthetic value.

Perhaps the most famous of these modern potters were Maria Martinez and her husband, Julian. Working as a team, Maria formed the pots and Julian painted them. Their earliest work, done in the early 1900s, followed the traditional polychrome style of their pueblo, San Ildefonso, but was distinguished for its imaginative shapes, colors, and motifs. By 1920 Julian developed a new style and technique that resulted in a mat black-on-black ware, with the designs visible as negative forms. This style was so immediately popular that it caused a renaissance in all Pueblo pottery during the 1920s.

The large Houston water jar exhibits the characteristics of balance and grace associated with these artists: the form is simple and perfectly modeled, the designs crisp and clean. Repeated around the shoulder of the vessel is an ancient feather motif. Encircling the body at its greatest diameter is the mythical Avanyu, a horned, plumed sky serpent associated with rain. The placement of all these elements is calculated to accentuate the graceful contours of the vessel. A final elegant touch is the subtle contrast of the mat black forms with the highly polished black ground; this polish was attained only by the laborious process of rubbing the surface with a stone before the vessel was fired.

Ceramic, mat black-on-black technique; 14¼ × 18⅝ in. (36.2 × 47.2 cm)
Gift of Miss Ima Hogg 44.171

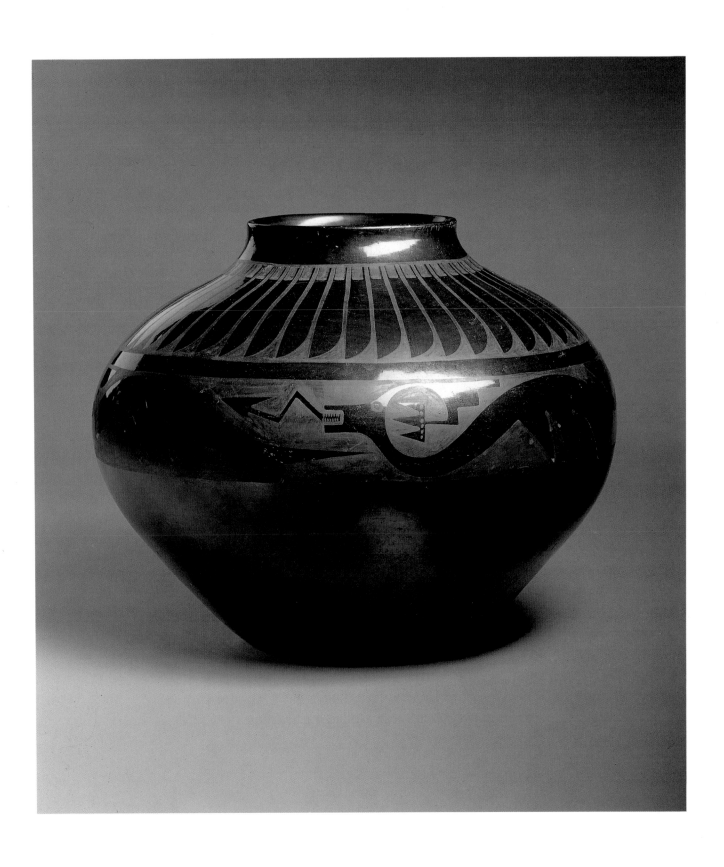

Ceremonial Trough, 1720–1820

Along the Bandiagara Cliffs in central Mali live the Dogon, a farming people who struggle to raise their crops on poor soil with little water. The control of rains and land fertility are primary concerns, forming the main focus of their religion, and water spirits, or *nommos*, are very important in their beliefs. According to their traditions, in the beginning of the world there were eight *nommos*; one, the blacksmith, descended to earth in an ark, bringing with him tools, seeds, animals, and the first ancestral human beings. One version of this origin myth describes the ark as having the head of a horse.

This trough, with its horse head and tail, represents the ancient mythical ark. Its iconography and large size indicate that it was used for ceremonial purposes, perhaps holding sacrificial meat, purifying water, or some other substance. On each side are carved the eight *nommos*, split into two groups by a series of shafts overlaid by a tied bundle of grain. Befitting primordial beings, their appearance is androgynous, each having the beard of a man and the breasts of a woman.

Despite its great size, the entire vessel is carved from a single tree trunk. Its rectangular form is echoed by the rhythmic repetition of figures and shafts. The figures themselves are columnar and are composed of geometric volumes: cylinders, cones, and spheres. Because of the extremely arid climate in Dogon territory, wood sculpture has lasted much longer there than in other parts of Africa. The polish and wear on this object attest to its long use and importance in the community.

Wood; length 76¾ in. (195.0 cm)
Gift of D. and J. de Menil 64.11

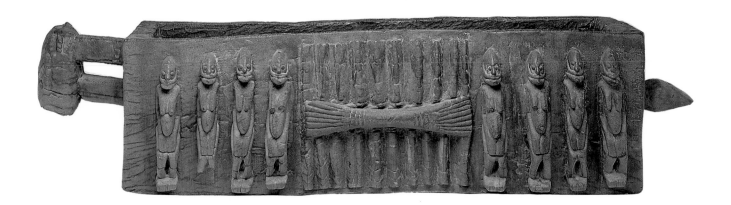

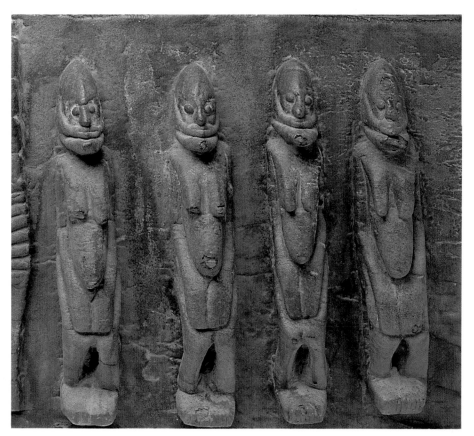

DETAIL

Crocodile, *1900–1950*

The Sepik River region in northeastern New Guinea is one of the most prolific art-producing areas in the world. Along the river's numerous tributaries are some two hundred different tribes whose lives revolve around the river and its annual fluctuations. The most ferocious predator in this environment is the crocodile, a creature that plays a leading role in Sepik mythology as creator and ancestor.

Monumental crocodiles such as this one, carved of one piece of wood, are made only by the Karawari people of the Middle Sepik area. Only about ten such examples are known today. Kept in pairs in men's ceremonial houses, they represent the brothers who founded the village clans. They were used in initiation ceremonies for young men and in preparations for headhunting. Before headhunting raids the men danced with the crocodile, supporting it with poles inserted through the five pairs of holes piercing the sides of the body. After the raid the captured heads were placed in the animal's jaws, symbolizing the victim's defeat.

Although this crocodile is rendered in a highly stylized manner, the spirals and overlapping scales carved in relief over its entire surface give the uncanny effect of an animal moving through water. The rhythm established by these curvilinear designs is further carried out by the repetition of human and bird heads along the back and sides of the body. Paint and raffia tassels, now gone, added the final touch, combining with the sculptural forms to produce a work of drama, magic, and spiritual power.

Wood and paint; length 275 in. (699.0 cm)
Gift of Houston Endowment, Inc. 61.46

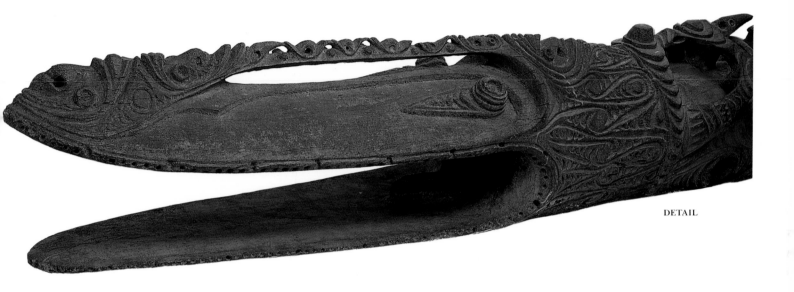

DETAIL

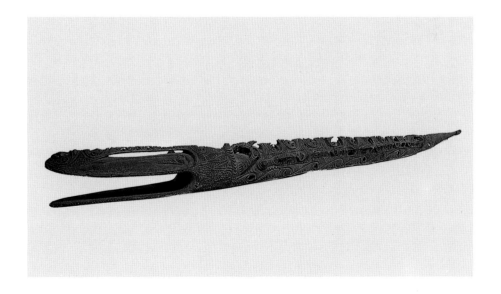

Near and Far Eastern Art

Eagle-Headed Winged Deity, 883–859 B.C.

The Assyrians won control of Mesopotamia in the thirteenth century B.C. In the eleventh century they began to expand, eventually conquering the ancient city of Babylon, holding what is now Syria, Lebanon, and Israel and entering Egypt in 663 B.C. Fifty years later the empire disappeared, falling to a resurgent Babylonian dynasty.

Assyrian art generally is carved in relief, although there are occasional statues in the round. Most sculpture involves the monarch and either records his successes in the hunt and victories in war or invokes protective deities. Although scenes of hunting and warfare are often portrayed with astounding naturalism and movement, the standard Assyrian depiction of the gods employs a powerful, static representational convention.

The museum's relief comes from the Northwest Palace of King Ashurnasirpal II (883–859 B.C.) at Nimrud, which had replaced Nineveh as the Assyrian capital. The palace was discovered by Sir Austen Henry Layard in the 1840s and excavated by him over succeeding years. The subject of this relief has been identified as a rite either of purification or of fructifying the palm tree. Despite its savage mien, appropriate for works made by the warlike Assyrians, the eagle-headed deity was a beneficent force, a protector of the ruler and of crops.

Gypsum; irregular 42⅛ × 26 in. (107.0 × 66.1 cm)

Museum purchase with funds provided by the Agnes Cullen Arnold Endowment Fund 80.53

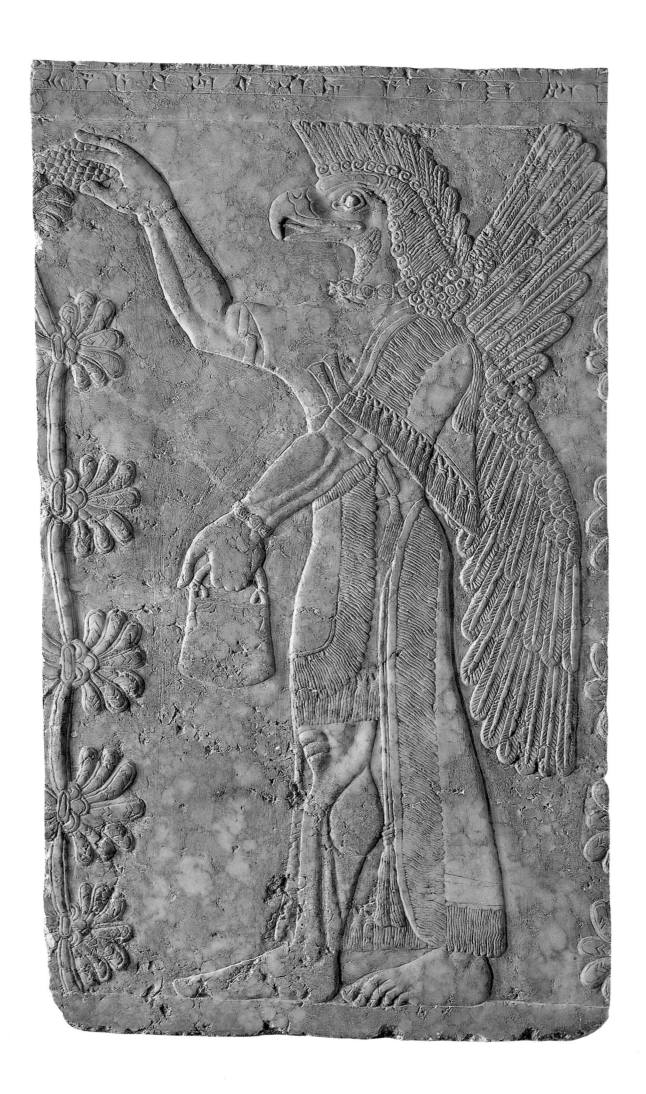

Vishnu and His Avatars, tenth century

In the third century B.C. in the Mathura region of India's central heartland an indigenous style of sculpture, abundant and life affirming, established a presence that continues throughout the course of the Indian sculptural tradition. Carved from the red sandstone of the area, confident and weighty figures of male and female fertility gods evolved into Hindu and Buddhist deities. Broad shouldered and swelling with *prāna*, or life breath, this figure of Vishnu, the Hindu god who preserves the world, is a summation of the Mathura style.

The sandstone relief is most probably from the state of Madhya Pradesh, famed for its stupa and railings at Bharhut and the temple complex at Khajuraho. The central standing figure of Vishnu forms a *trimurti* (trinity) with the gods Sīva and Brahma described at the top of the relief on the extreme left and right. Vishnu's avatars, framing the central figure, embody the various physical forms he assumed in his heroic mission as preserver.

Red sandstone; height 54½ in. (138.4 cm)
Museum purchase with funds provided by the Agnes Cullen Arnold Endowment Fund 71.1

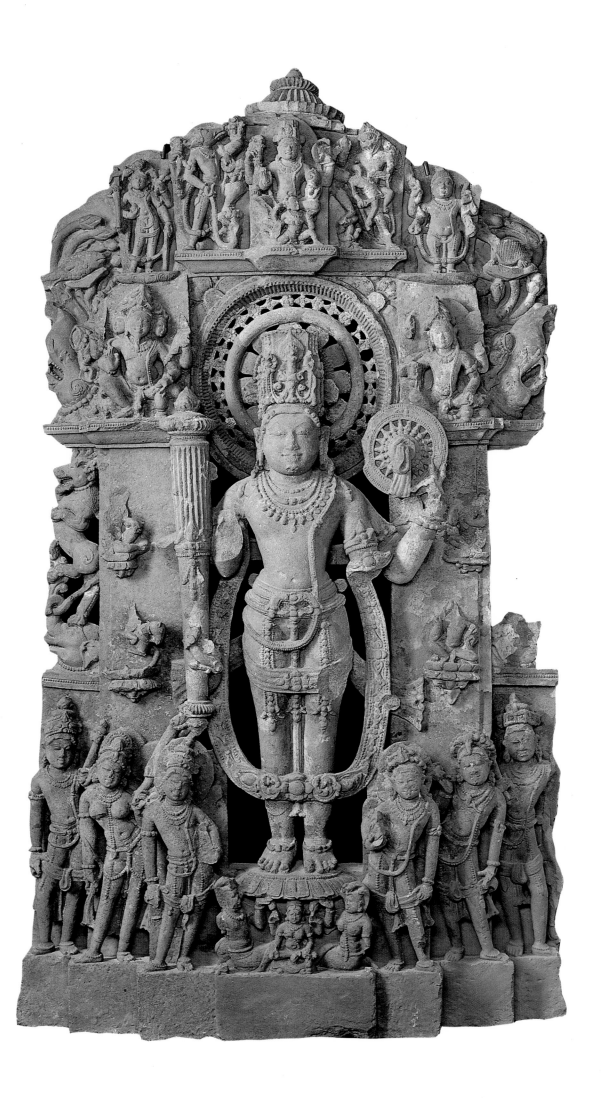

Śiva Nataraja, thirteenth century

Bronze sculptures of south India almost exclusively describe the Hindu pantheon. Śiva, the god of dance and cosmic movement, is the most dramatic and popular deity. His multiple arms gesture to protect the worshiper and express his dual nature by holding the fire of destruction and the drum of creative vibration. His right leg, bent at the knee, presses underfoot a prostrate demon representing ignorance, as he performs the dance of bliss, *ananda tandava.*

Bronze, a material esteemed for its lustrous elegance, is the preferred medium of south Indian sculptors. Poised in an exquisite moment of eternal motion, Dionysian yet aristocratic, the god Śiva resolves the opposites of his nature in a single image. Intricate jewelry and body ornaments emphasize Śiva's smooth leonine form; the intertwining serpents of his headdress and arms connote life and fertility. Śiva dances a cosmic dance in which the universe is the light reflected by his limbs as he moves in the orb of the sun.

Bronze; height 29½ in. (74.3 cm)
Gift of Carol and Robert Straus 73.77

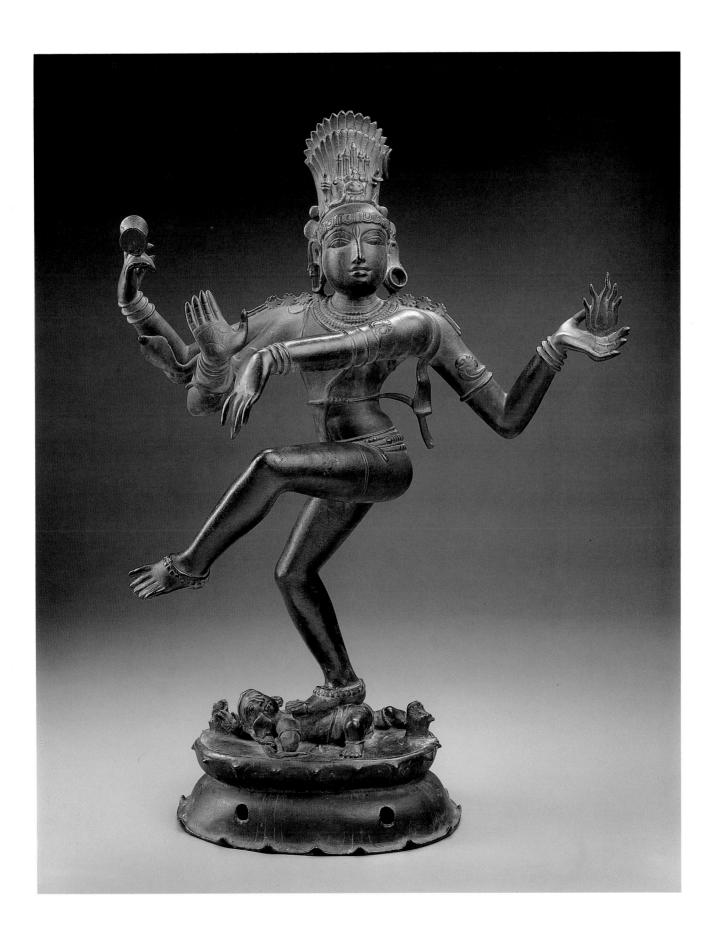

Standing Court Lady, *seventh century*

During the Tang dynasty, when China's capital city Changan was the cosmopolitan center of Asia, court life provided a theatrical array of wealth, beauty, and entertainments. Stylishly extreme coiffures completed the impeccable appearance of court ladies and their attendants. Flowing diaphanous gowns and slippers with curling toes were the mark of exquisite court fashion. Burial ceramics for the elite provided lively and precise descriptions of the people who surrounded the deceased in life.

This attenuated court lady, who also may be a musician, is a very fine example of early Tang style. Ceramic sculptures dating before the ninth century are characteristically devoid of the vivid glazes associated with later Tang style. Yet, for their unusual delicacy and refinement, works of the early Tang period such as this lady successfully rival the grand, richly colored works of high Tang. Delicately applied pigments in red, green, black, and white define individual facial features and enliven costume details. Gold, applied to works of particular quality, is evident on the coiffure.

Ceramic with pigment and gold leaf; height 14⁹⁄₁₆ in. (36.1 cm)
Gift of Carol and Robert Straus 73.73.1

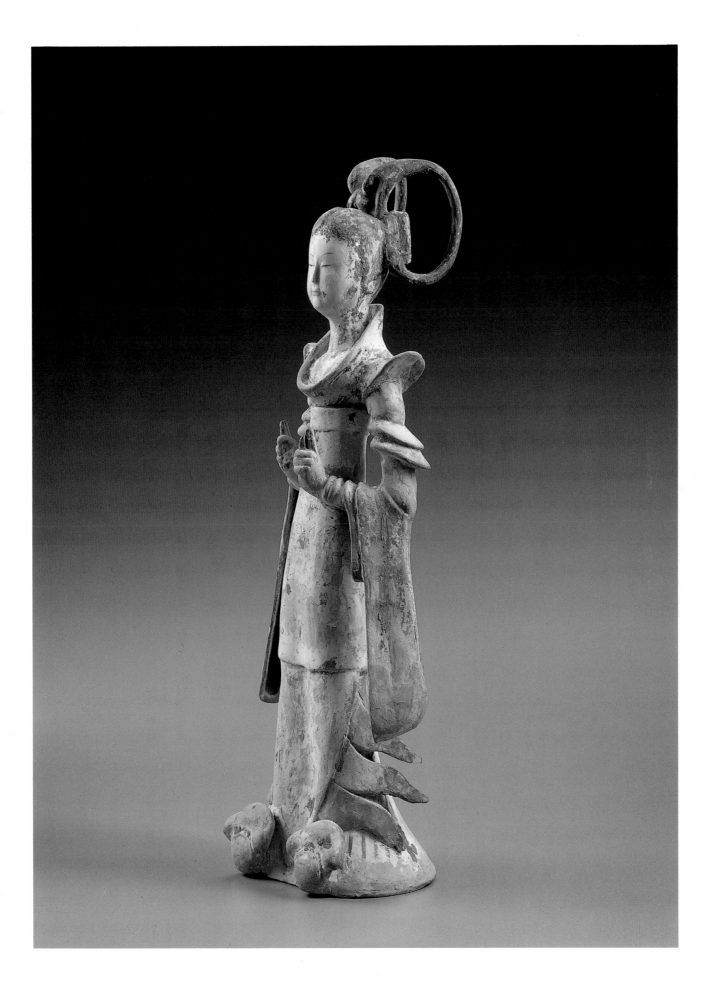

JAPANESE
Proto-Historic period (third–sixth century)

Haniwa Warrior, late sixth century

The most intriguing arts of early Japan are those of the Haniwa era, when the ancient land of Yamato established its central authority over local states, developed a writing system and written history, and defined many cultural characteristics of the Japanese. During this period, sometimes referred to as "Tumulus" because of the burial mounds constructed for the imperial Yamato clan, Japanese society evolved from an agrarian to an equestrian culture of distinctly stratified classes. It was at this time that the Japanese produced a unique category of clay sculpture, completely native in style and inspiration.

The word *haniwa* means circle of clay. These low-fired clay figures of farmers, women, priestesses, horses, and warriors were placed on the slopes and along the perimeter encircling grave mounds, where they stood watch over the deceased and, in time, fell prey to the elements. Haniwa sculpture reflects the Japanese preference for natural materials and a simple, uncomplicated aesthetic. This warrior, dating toward the end of the Proto-Historic period, powerfully summarizes the equestrian age of early Japan and the warrior code that became an integral part of Japanese culture. Its geometric simplicity is curiously modern, yet its taut pose and posture describe an affectingly spiritual military discipline.

Terra-cotta with pigment; height 27 in. (68.6 cm)
Museum purchase with funds provided by the McAshan Educational
and Charitable Trust and the Agnes Cullen Arnold Endowment Fund 88.58

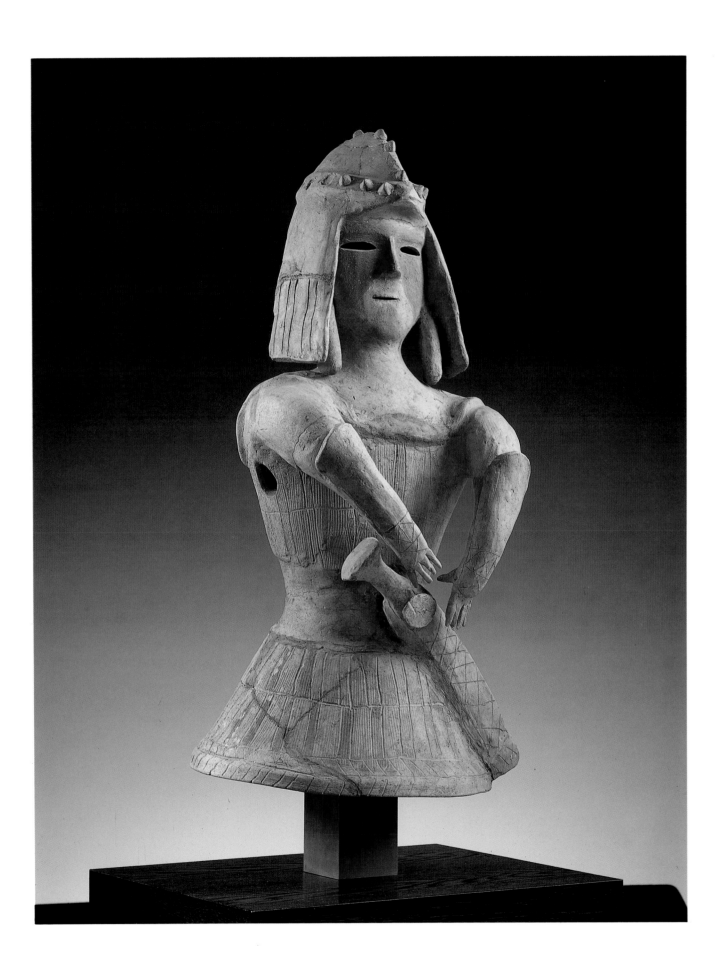

Honen Shonin Eden (Biography of the Monk Honen),
early fourteenth century

Japanese *emaki* are long horizontal scrolls viewed section by section as unrolled from right to left. These scrolls were sometimes cut into vignettes and remounted as hanging scrolls, such as this section from the *Honen Shonin Eden*. The monk Honen (1133–1212) established the Pure Land sect of Japanese Buddhism. Also termed "Jodo," Pure Land teaching promised rebirth in paradise through nembutsu, the practice of repeating the name of the Amida Buddha. Miraculous apparitions were often featured in Pure Land arts, affirming the principle of salvation for all by simple faith in the Amida.

Honen's biography chronicles his birth, his entry into the priesthood at the age of eleven, the supernatural powers of his preaching, his conversions of emperors and nobles, his exile, the persecution of his monks, and, finally, his veneration as a Buddhist saint. This scene describes an apparition of the Amida. The blues and greens of the landscape remain fresh and vivid, and the touches of gold add finesse to an otherwise unaffectedly naturalistic scene representing a traditional Japanese house in the countryside.

Ink and pigment on paper; 11¾ × 27 in. (30.2 × 68.6 cm)
Museum purchase 67.9

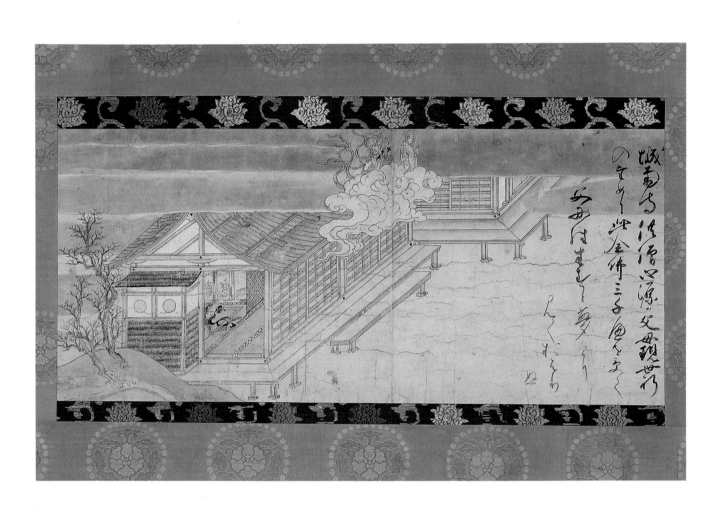

城南なる法皇の源の父母現世行
のうめに此金佛三千個を宝く

みのはまして夢なり

んくをもきり
や

The Tale of Genji, late seventeenth–early eighteenth century

The Tale of Genji is the first novel of world literature. Written in the early eleventh century by Lady Murasaki Shikibu, the tale narrates the lives of courtiers during the Heian period (784–1185). The work begins with a sumptuous description of court life and meticulous definition of characters. Focusing on the escapades of the young Prince Genji, the beginning of the novel is worldly and elegant. As Genji matures the tone of the work changes, and by the final chapter, "The Bridge of Dreams," a distinctly Buddhist character pervades the dreamlike lives of the characters.

This unusual pair of screens rendered in *hakubyō*, or ink outline technique, depicts ten scenes from the novel, five on each screen. The painting style of the Tosa school was oriented strongly to narrative subjects usually depicted in a colorful miniature technique. These screens, however, represent a unique large-scale treatment of the subject of Genji in monochrome. Painted on a gold ground, vignettes from the novel are described as if seen from above, glimpsed through clouds flecked with silver, gold leaf, and mica, creating an impression of gossamer artistry echoing the spirit of the novel.

Ink with pigment, gold leaf, and mica on paper mounted on pair of six-fold screens; each 137½ × 66½ in. (349.2 × 168.9 cm)

Museum purchase with funds provided by Mr. and Mrs. Harris Masterson III, Mr. and Mrs. John R. Moran, Carl Detering, Mr. and Mrs. Gary Levering, Mr. and Mrs. M. S. Stude, Continental Oil Company, Mary Alice Wilson, Mr. and Mrs. William Coates, Jr., Texas Pipe and Supply Company, Mrs. Barbara K. Sandy, Mr. and Mrs. Lee B. Stone, and Mr. and Mrs. J. R. Thomas 80.149.1–2

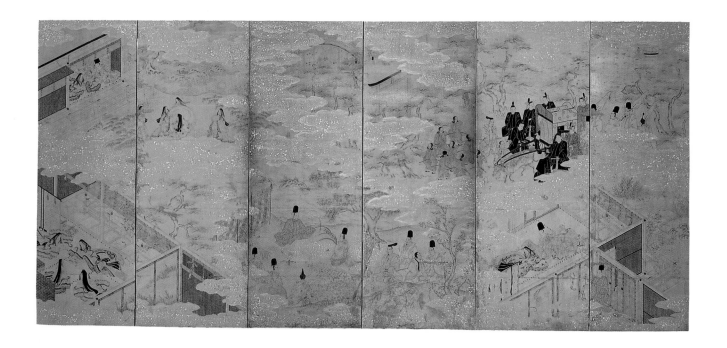

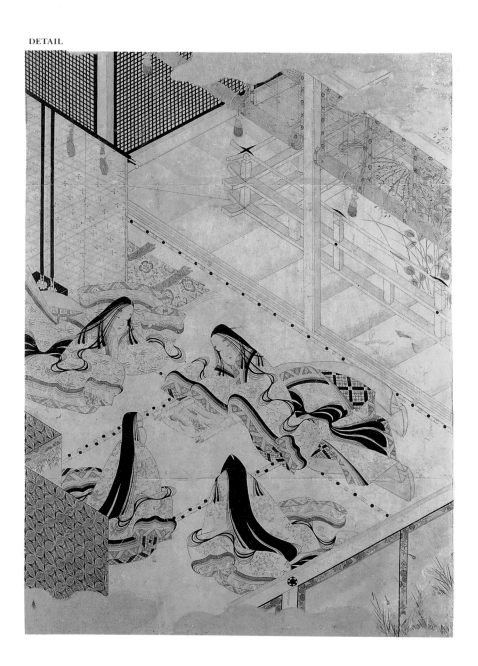

DETAIL

Ancient and Early
European Art

Hydria, 470–460 B.C.

The earliest classical Greek pottery was decorated primarily with mythological scenes. The figures were rendered in black on the natural orange-red clay, their contours and details incised with a sharp instrument. Toward the end of the sixth century B.C., artists became more and more interested in depicting the life around them; they sought a technique that allowed for greater fluidity of line and more vibrant figures. Thus the red-figure technique was invented. With the figures left in the natural color of the clay, the black paint then could be used to cover the background and create—using a thin, supple brush—all the details of the figure. Anatomy became livelier, drapery softer, and figures more animated.

This hydria, or water jar, exemplifies the best of the newfound artistic freedom. The scene depicts women performing their household duties. The woman on the left holds two alabastra, or unguent bottles, one of which she passes toward the woman at the far right. Beneath them is a third woman, who stoops over a wicker basket, placing in it or removing from it a large bundle of wool. The folds of their garments are fluidly drawn, and their faces are serious and intent. A charming touch is provided by the graceful heron. Herons were kept as pets in ancient Athens, and the presence of one here fixes the setting in a home.

Twenty-eight vases and fragments have been attributed to the Painter of the Yale Oinochoe. Of those, six are hydriae, four of which illustrate scenes of women's daily life. They are considered to be the painter's most mature and accomplished works.

Ceramic, red-figure technique; 13 11/16 × 13 1/8 in. (34.8 × 33.3 cm)
Museum purchase with funds provided by General and Mrs. Maurice Hirsch 80.95

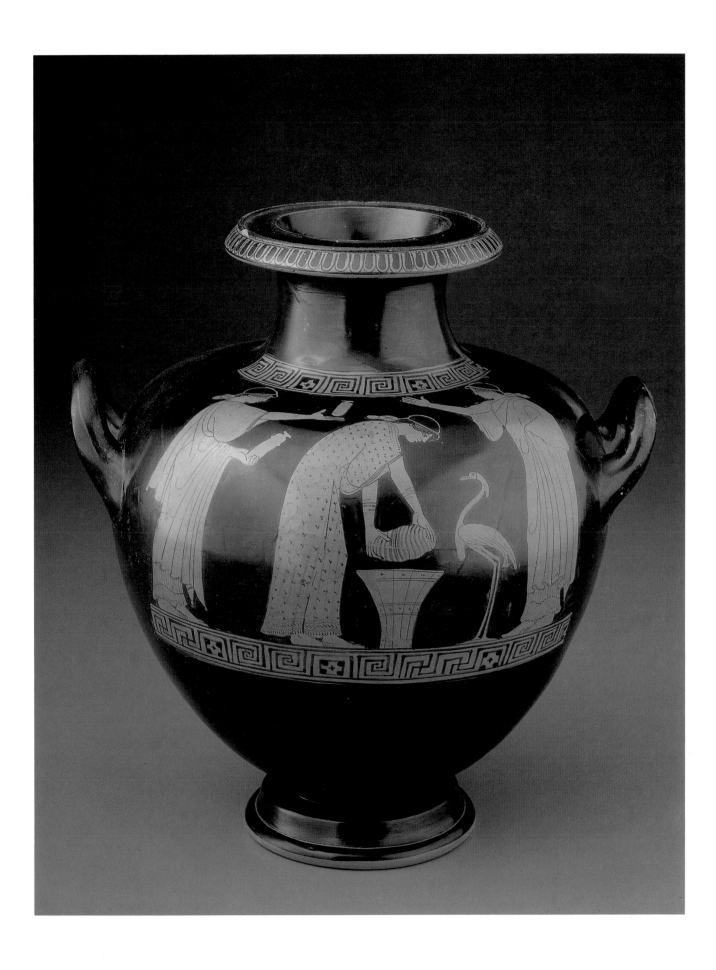

Laurel Wreath, 330–27 B.C.

Gold and silver wreaths patterned after those made of actual leaves have a long history in Greece from the seventh century B.C. through the Hellenistic period. They were given as prizes, worn in processions, left as votives at temples, and buried with the dead as permanent symbols of the laurels won during life. The few surviving examples were found in tombs, where they served as grave offerings. Hellenistic wreaths, made of gold foil, are too fragile to have been worn by the living and must have been made especially for funerary use.

This gold wreath was found in the Peloponnesus not far from Corinth, although it appears to be of Macedonian workmanship. The leaves and blossoms, cut from thin sheet metal and finished with stamped and incised details, are individually wired onto the shoots. Originally, beads of glass or semiprecious stone were fastened by a wire loop to the center of each blossom. The delicacy and naturalism of the wreath demonstrate the virtuosity of the goldsmith who made it.

Plants of many different types were reproduced as wreaths: laurel, strawberry, myrtle, olive, oak, vine, and ivy. Laurel, the attribute of Apollo, was the plant from which the victorious athlete's crown was made. It was a particularly apt choice for a funerary wreath, since it signified victory both in life and over death.

Gold; diameter 12 in. (30.5 cm)
Gift of Miss Annette Finnigan 37.5

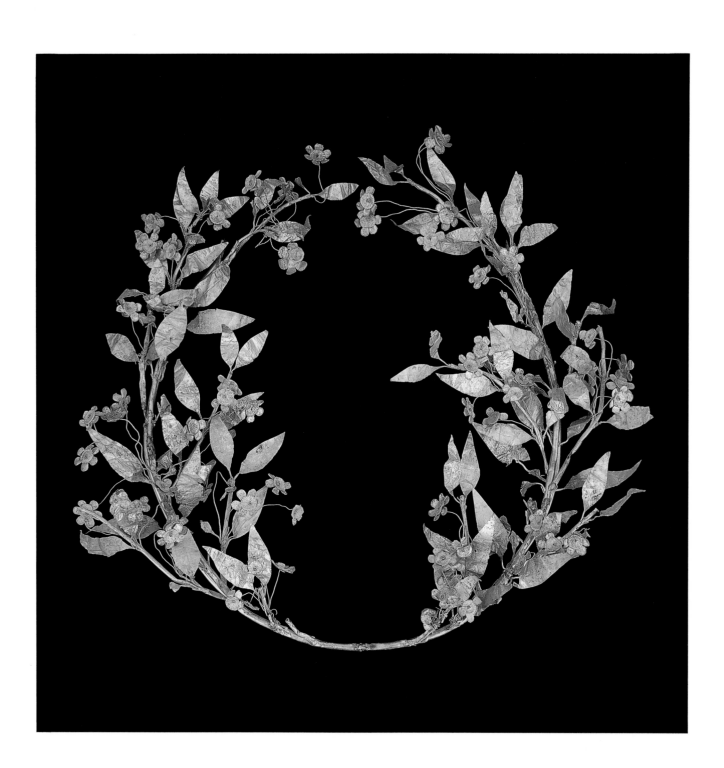

Portrait Head of Plautilla, 200–220

The art of portraiture was Rome's most important contribution to sculpture. Although portraits were produced continuously from the first century B.C. to the third century A.D., some of the greatest portraits were sculpted in this last century, when the preference for an ideal classical serenity was beginning to be supplanted by a new sense of naturalism and animation.

The new approach to capturing the likeness of a person in stone is beautifully exemplified by this head of a young woman. The traditional blank eyes are now drilled and incised; the head is turned questioningly to her left; and the subtly modeled cheeks break up the light falling on the surface. The result is an intense alertness coupled with girlish charm.

The portrait is of Plautilla, first wife of Emperor Caracalla. The daughter of Emperor Septimius Severus's powerful prefect of the guards, she was married to Caracalla against his wishes in 202. In 203–4 he banished her to a remote island, and when he succeeded to the throne in 211, he ordered her execution. Her political fall from grace resulted in the destruction of most of her portraits; this head is one of only two known other than those on coins. It still retains the original smooth, glossy surface achieved with great difficulty using ancient polishing methods.

Marble; height 14⁷⁄₁₆ in. (36.7 cm)
Museum purchase with funds provided by the Laurence H. Favrot Bequest 70.39

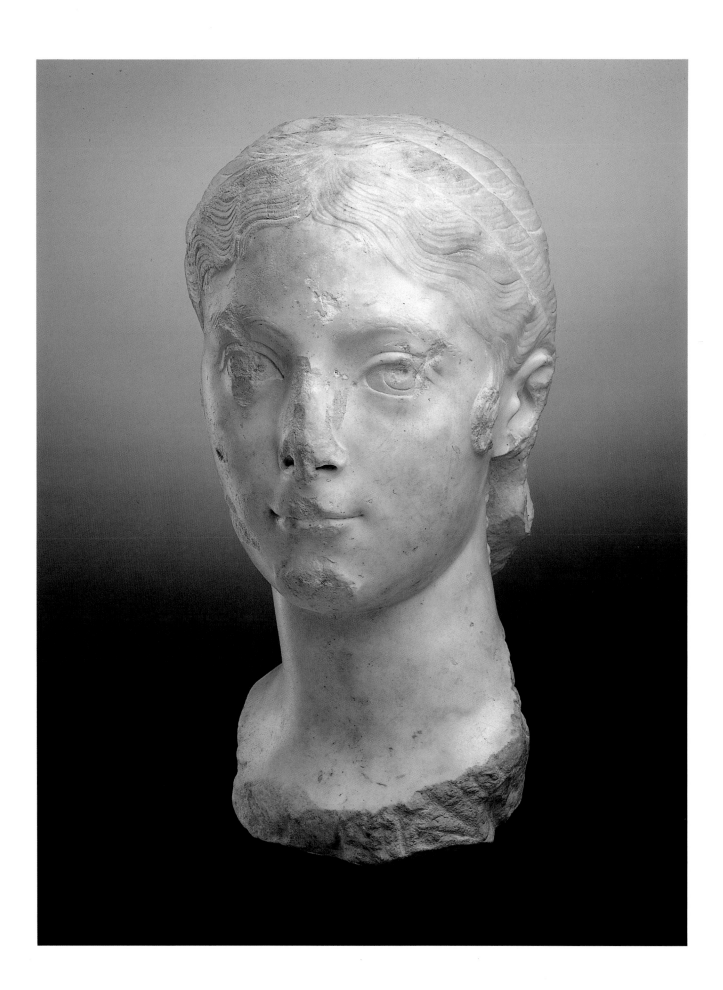

Roman emperors beginning with Augustus followed the precedent set by Alexander the Great of declaring themselves divine. During their lifetimes they bore divine titles, and at their deaths they were promoted to cult veneration by senate vote. The imperial cult was especially popular in Rome's eastern provinces, where for more than two thousand years kings had traditionally been considered gods. Roman emperors were depicted in statues as physically perfect men in their prime, regardless of their actual appearance in life.

This heroic nude figure is based on a copy of a famous lost sculpture by Lysippus (c. 360–c. 320 B.C.), known as *Alexander with the Lance*. Although the head of the figure is now missing, making precise identification impossible, the reference to Alexander the Great and comparison with other identified bronzes indicate that it is an idealized Roman ruler. The monumental scale, superb casting, and majestic ease of the figure support this identification.

The statue came from the single most important find of larger-than-life-size Roman bronzes in Asia Minor. The group includes figures, busts, and heads dating to the Antonine (96–192) and Severan (193–235) dynasties, all probably representing the emperors and members of their families. Although found as a cache at Bubon, a tiny site in southeastern Turkey in the former Roman province of Lycia, these may have been made originally for an imperial cult temple located elsewhere. It has been suggested that they were salvaged from their original site during a period of unrest and brought to this hiding place for safekeeping.

Bronze; height 82 in. (208.3 cm)
Gift of D. and J. de Menil in memory of Conrad Schlumberger 62.19

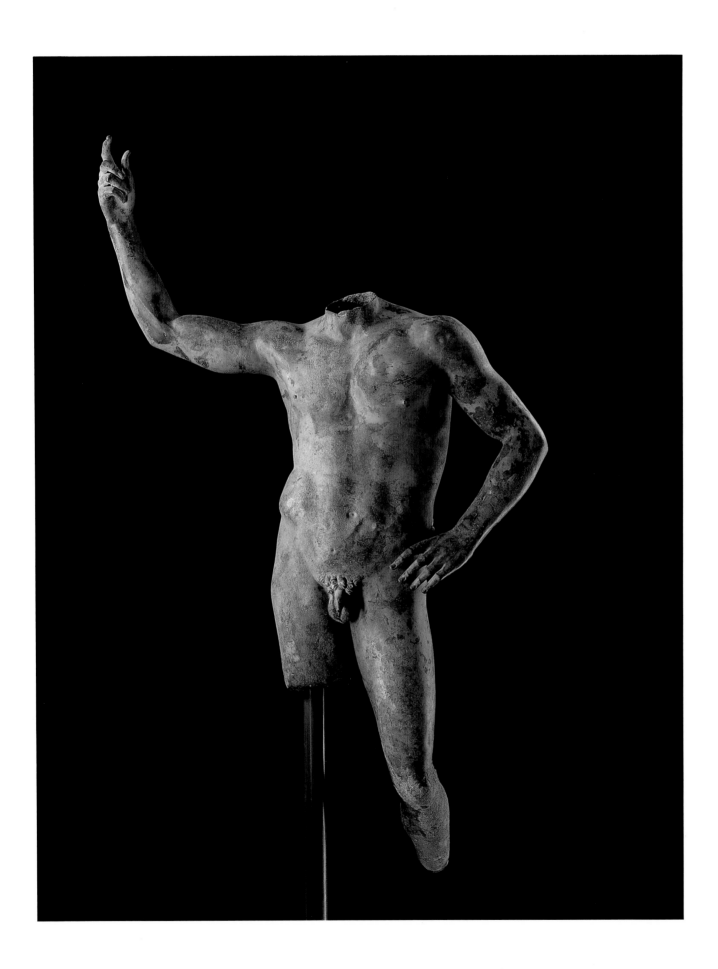

Plaque with the Koimesis, tenth century

Duxing the Middle Ages ivory carving played a principal role in ecclesiastical art and often achieved the highest quality of workmanship found in any medium. From the ninth to the twelfth century in both the East and the West, the imperial workshops of ivory carvers primarily produced individual objects and elaborate ensembles for church decoration and use.

This relief plaque, representing the Koimesis, or Dormition of the Virgin, displays the sophistication of ivory carving during the middle period of imperial Byzantium (330–1453). Its disciplined style results from an adherence to dominant court workshop traditions in tenth-century Constantinople. Evident in this plaque is the Byzantine tendency to enhance the spiritual value of a religious representation by abstracting the forms and establishing a hierarchy among the figures. It also demonstrates strong classical elements, the virtues of which Byzantine artists discovered anew during the late ninth century and with which the Byzantine style is infused. The plaque is from a portable diptych or possibly a triptych representing major feasts of the Greek Orthodox church.

Ivory; 4³⁄₁₆ × 3⁷⁄₁₆ in. (10.5 × 8.7 cm)
Museum purchase with funds provided by the Laurence H. Favrot Bequest 71.6

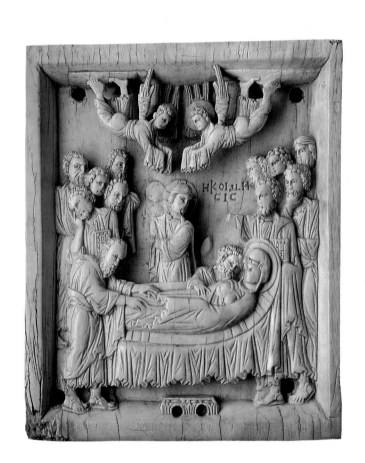

Crozier Head with Saint Michael
Trampling the Serpent, 1225–50

Late twelfth- and early thirteenth-century Limoges metalworkers formed workshops that flourished as modern-day supply houses for persons requiring superior liturgical objects of various descriptions. From gilded copper and bronze they fashioned crosses, reliquaries, and other ecclesiastical items ornamented with brightly colored enamels applied to recesses in a raised ground (champlevé). These objects were circulated throughout Europe.

The continued popularity of Limoges crozier heads for bishops' staves is demonstrated by the large number found buried with their bishop-owners, often beneath tomb slabs in the cathedral pavements carved with the bishops' effigies. The subject of Saint Michael, especially suitable for a bishop whose duty was to be constantly vigilant against evil before his flock, is here represented in a manner more advanced than other Limoges models of the subject. The serpent, emblematic of Satan and evil, forms the crook of the crozier itself; within the spiral of its elongated neck, the figure of the winged archangel Michael wrestles against the monster. Other reptilian creatures encircle the base of the crozier head.

Copper-gilt and champlevé enamel; height 10¾ in. (27.3 cm)
Museum purchase with funds provided by the Laurence H. Favrot Bequest 70.38

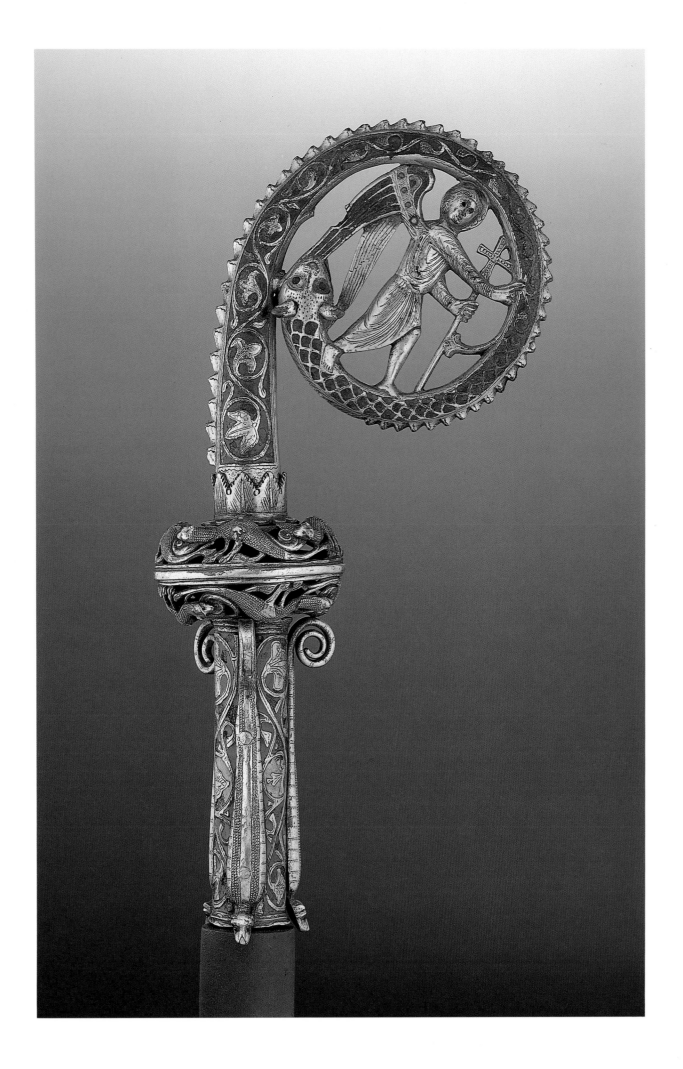

Head of an Apostle, c. 1235

During the thirteenth century in France the art of monumental sculpture underwent a crucial evolution. In the great cathedral cities of Sens, Chartres, and Reims or in Paris in the Île-de-France, monumental sculpture groups were carved to decorate the exteriors of the massive edifices rising to the greater glory of God. By the second quarter of the century there was a move toward a greater realism and expressiveness in carving, as sculpted figures began to be conceived in fully volumetric terms.

About 1235 the facade of the cathedral of Thérouanne, a provincial capital in northeastern France, was adorned with a program of large-scale sculptures, now known only from a few remaining fragments. In 1553, following prolonged hostilities between the French bastion at Thérouanne and neighboring territories of the Holy Roman Empire, Emperor Charles V laid siege to the town. At its surrender, the entire town, including its cathedral church, was systematically destroyed. Portions of the cathedral's decoration, however, were obtained by the canons of the collegiate church in the nearby town of Saint-Omer, where they still are preserved.

The museum's *Head of an Apostle* is one of five monumental stone heads unearthed in 1923 from the wall of a house in Saint-Omer. Because of the place in which they were found and their resemblance to the remaining pieces of Thérouanne sculpture, it seems most likely that these five heads originally adorned the exterior of the destroyed cathedral of Thérouanne. The head is an expressive work of Gothic sculpture, in which the dignity and monumental grace of French medieval art are beautifully expressed despite the ravages of time and war.

Limestone; height 17½ in. (44.4 cm)
Museum purchase with funds provided by Harry W. McCormick in honor of
Ursula DeGeorge McCormick 80.148

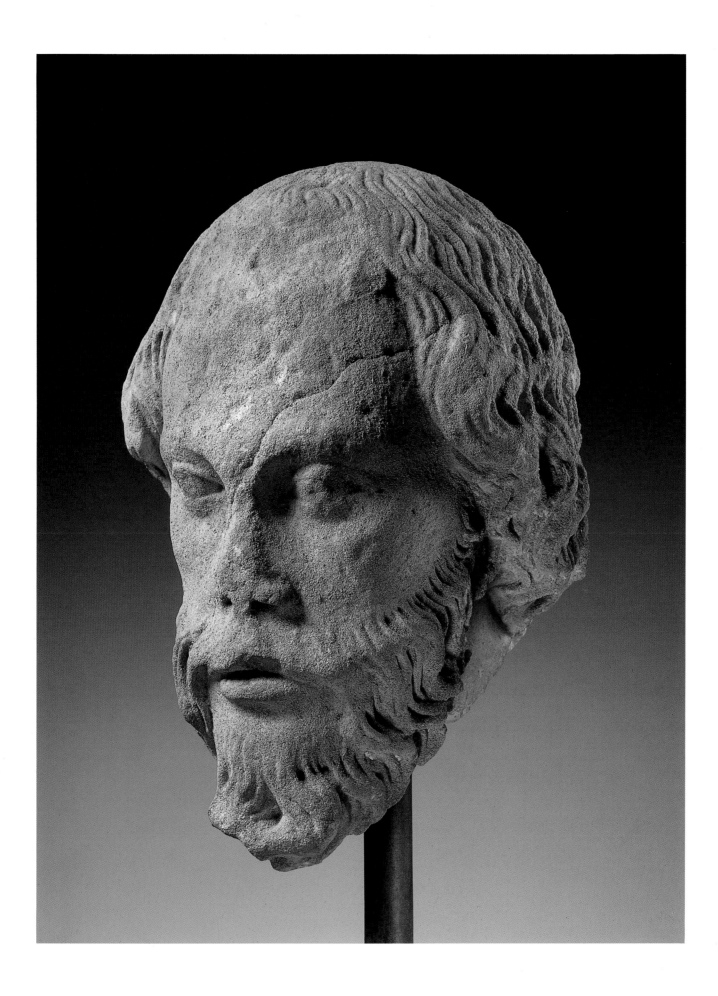

Virgin and Child, early fourteenth century

The province of Normandy on the northwestern coast of France was an important stone-carving region during the fourteenth century. Norman sculpture is, however, less well known than sculpture from the Île-de-France and Burgundy, perhaps because many Norman works are still preserved in their original sites. French fourteenth-century sculpture, Norman included, is noted for its decorativeness, intimate scale, synthesis of naturalism and stylization, and sentimentality. The museum's *Virgin and Child*, with its decorative drapery folds, rhythmic, unnatural stance, and lively interplay of figures who have stock facial expressions, epitomizes these Norman characteristics. The moderate size of the piece is also characteristic of Norman sculpture, although its painted surface is unusual and suggests that the artist was influenced by painted ivory figures.

This sculpture may have been a devotional figure in a parish church, for a strong Norman tradition emphasized the role of such churches. It may come from a fifteenth-century château in the tiny village of Golleville, near Cherbourg, a likely but undocumented provenance. Since this work is related to an important Benedictine figure of mercy known as Notre-Dame-de-Montroud from Bélâbre, now in the parish church of Saint-Jacques-de-Néhou, it may have been sent to Golleville by the Benedictine order.

Limestone with remains of original pigment; height 40⅜ in. (102.5 cm)
Museum purchase with funds provided by the Laurence H. Favrot Bequest 71.15

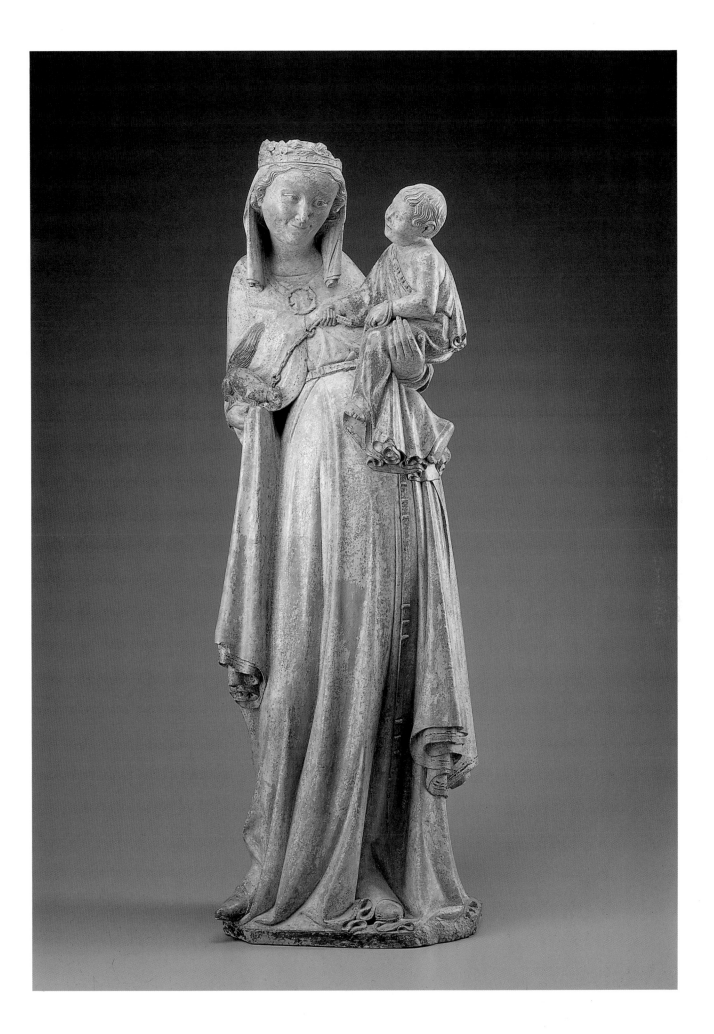

Madonna and Child, before 1405

About three dozen works have been attributed to an anonymous fourteenth-century painter who was active in Florence as late as 1405. The artist is now known only by the name Master of the Straus Madonna, from this work, formerly in the collection of Edith and Percy Straus. In the painting archaizing reminiscences of the style of Agnolo Gaddi (1350–1396), a follower of Giotto (1266/67–1337), mix with the ornamental features of the elegant and courtly manner of the late fourteenth-century International Style. At the same time the modeling of the Madonna and Christ Child demonstrates the artist's awareness of early Renaissance developments in painting the human figure as a volume in space.

The Master of the Straus Madonna also is distinguished for his traditional patterning of the gold ground, striking combinations of rich colors, and skill in rendering diaphanous drapery. In this beautifully preserved panel the Christ Child holds a goldfinch, a common symbol of the Resurrection, and wears a coral pendant, a talisman believed since ancient times to protect against evil. The painting has a beautifully carved engaged frame, an original architectonic surrounding integral with the painted panel.

Tempera and gold leaf on panel; 35⅝ × 20¾ in. (90.5 × 52.7 cm)
The Edith A. and Percy S. Straus Collection 44.565

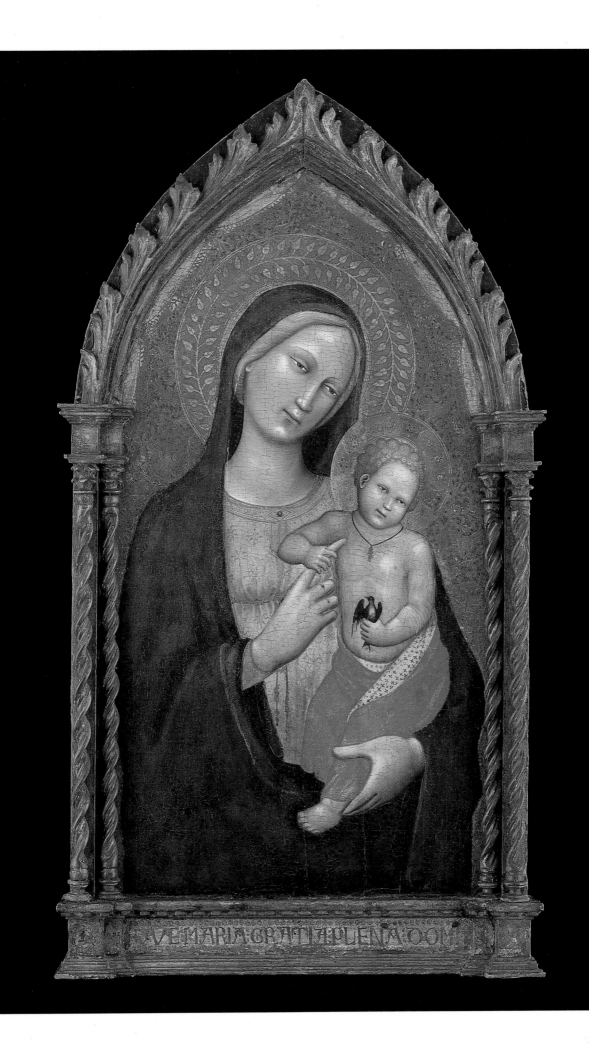

God the Father, early fifteenth century

The revolution wrought upon the art of sculpture at the turn of the fourteenth century in France by a number of Netherlandish sculptors, headed by Claus Sluter (active 1379/80–1405/6) and his assistant Claus de Werve (active 1380–1439), can be appreciated in the museum's exceptionally rare ivory figure *God the Father*. The brilliant carving of the figure suggests that it must have been an important commission despite its diminutive size. The abundant spilling drapery folds that intensify the feeling of volume and weight in the figure, the fleeting quality bespoken by the figure's stance and hand gesture, and the realistically expressive facial features suggest a direct connection with the art of Sluter. The figure was once part of a group depicting the Trinity. God the Father most likely held in his outstretched hands a cross supporting the body of the crucifed Christ, and the Holy Spirit was represented by a dove.

The figure reflects the elegance and sophistication of the International Style that arose about 1400 and was characterized by a love of calligraphic outline and curvilinear patterns and by a marked tendency toward realistic detail. Originating in the wake of social change that enabled not only princes and dukes but also the lesser nobility to become patrons of the arts, the International Style catered to aristocratic tastes throughout western Europe.

Ivory; height 9¹³⁄₁₆ in. (24.9 cm)
The Edith A. and Percy S. Straus Collection 44.581

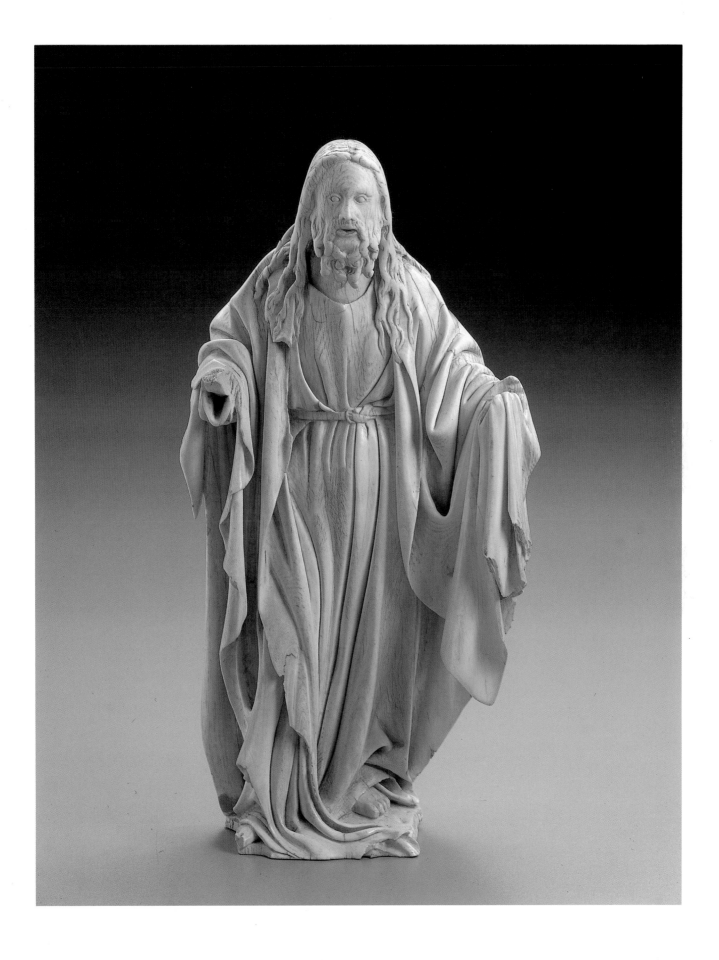

Reliquary Monstrance from the Guelph Treasure,
early fifteenth century

Since 1264, when Pope Urban IV established the Feast of Corpus Christi, a liturgical object known as an ostensorium, or monstrance (both terms derive from Latin verbs meaning "to show"), has been a common sight in the solemn processions held in conjunction with that feast, celebrated in June on the Thursday after Trinity Sunday. The museum's monstrance, an important example of the work of late medieval German goldsmiths, combines its original function of displaying the consecrated Holy Wafer with that of a reliquary containing the wrapped relics of saints.

This monstrance is from the Cathedral of Saint Blaise in Hildesheim, where it formed part of the celebrated collection of the ducal house of Brunswick-Lüneburg known as the Guelph Treasure. Its upper structure, which simulates the tower and crossing of a late Gothic church, derives from Lower Saxon architectural prototypes. Its decoration, including overlapping roof designs and a crowned pomegranate on each of the four fields of the foot, is based very closely on contemporaneous work of Cologne goldsmiths. In addition to the stationary, crescent-shaped metal holder for the Blessed Sacrament and loosely arranged relics, the elaborately framed, double-windowed capsule contains a hand-colored, miniature woodcut on parchment, a pilgrim's souvenir of a Jubilee Year visit to Rome, possibly taken in 1475.

Engraved copper-gilt, silver, translucent enamel; height 21⅛ in. (53.7 cm)
Museum purchase with funds provided by the Laurence H. Favrot Bequest 70.16

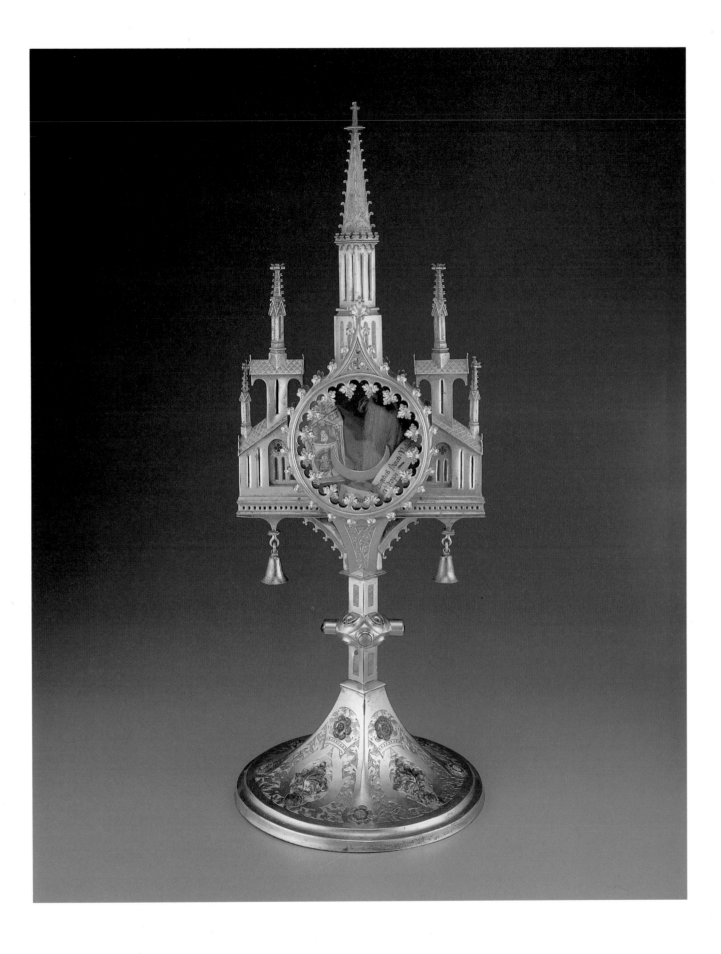

Saint Anthony the Abbot Tempted by a
Lump of Gold, c. 1430

First recorded as a painter in 1417, Fra Angelico entered the Dominican order between 1420 and 1422. His choice of a monastic life did not, however, remove him from the world; on the contrary, Fra Angelico became one of the leading painters of his generation. His fame is attested to by a letter written in 1438 by Domenico Veneziano (1405–1461), who referred to him as one of the most important painters in Florence.

Influenced by the innovative ideas of Masaccio (1401–1428), particularly by his frescoes in the Brancacci Chapel at Santa Maria del Carmine in Florence, Fra Angelico applied Masaccio's concepts of volume and space to the spiritual aims that confer on his own work an ethereal quality and mystical significance. The pivoting motion of Saint Anthony as he turns away from the temptation of a heap of gold placed in his path by the Devil and the aerial perspective of the luminous horizon are advanced Renaissance aspects of the painting, while the schematic rocks and out-of-scale buildings are deliberate archaisms. This small panel is almost certainly one of several that together formed the predella of an altarpiece.

Tempera on panel; 7¾ × 11⁷⁄₁₆ in. (19.7 × 28.0 cm)
The Edith A. and Percy S. Straus Collection 44.550

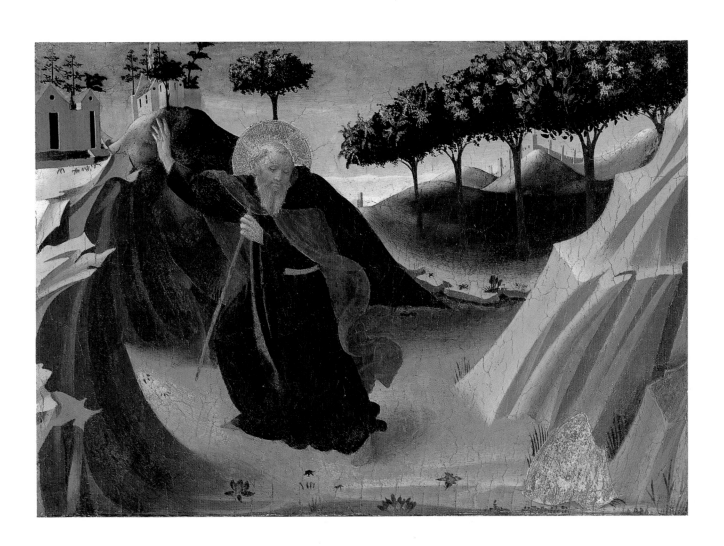

Saint Clare Saving a Child Mauled by a Wolf, mid–1450s

Giovanni di Paolo, first known from a signed altarpiece of 1426, was the most individualistic Sienese painter of the fifteenth century. He probably traveled to Florence in the 1430s, where he quickly mastered one-point perspective. Knowledge of such mathematical formulas is demonstrated in the museum's panel by the orthogonals delineating regular fields of grain in the background. Giovanni di Paolo's style is distinguished by the idiosyncratic way he altered the rules of scientific perspective to infuse his pictures with a mystical feeling. *Saint Clare Saving a Child* represents a turning point between his fidelity to perspectival formulas and the expressionism of his later narrative scenes. Giovanni also worked as a manuscript illuminator; this experience became crucial to the supreme narrative inventiveness that constitutes his most important contribution to Renaissance art in Siena.

This small panel is from the base, or predella, of an altarpiece depicting the life of Saint Clare, the first female disciple of Saint Francis and with him the founder of the religious order known as the Poor Clares.

Tempera on panel; 8⅛ × 11½ in. (20.6 × 29.2 cm)
The Edith A. and Percy S. Straus Collection 44.571

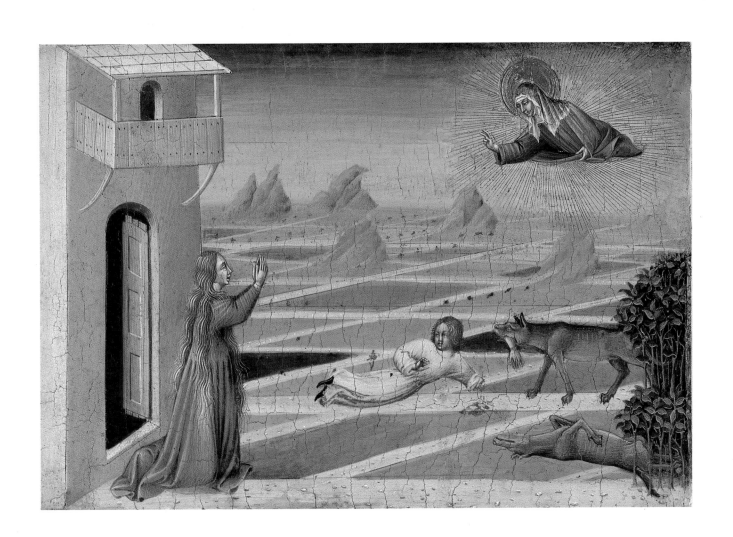

Virgin and Child, after 1454

The most important artist of mid-fifteenth-century Flanders, Rogier
van der Weyden is renowned for the deep emotionalism of his
paintings, in contrast to the more reserved works of his older contemporary Jan
van Eyck (c. 1390–1441). Rogier is believed to have studied in the workshop of
Robert Campin (1378/79–1444), a master painter working in Tournai, near
Brussels. Rogier eventually settled in Brussels and by the 1440s was painting
large and impressive devotional images as well as distinguished portraits. There
he became city painter and achieved considerable commercial success.

By the next decade, when *Virgin and Child* was probably painted, Rogier was
responding to a growing taste for small devotional panels, particularly for
half-length representations of Mary and the Christ Child. In painting images
of this type Rogier turned for inspiration to Italo-Byzantine icons. This panel
reflects his familiarity with such works, including the often copied *Notre-Dame-
de-Grâce* of Cambrai, an icon venerated because it had been painted, according
to legend, by Saint Luke himself.

Oil on panel; 12⁹⁄₁₆ × 9 in. (31.9 × 22.9 cm)
The Edith A. and Percy S. Straus Collection 44.535

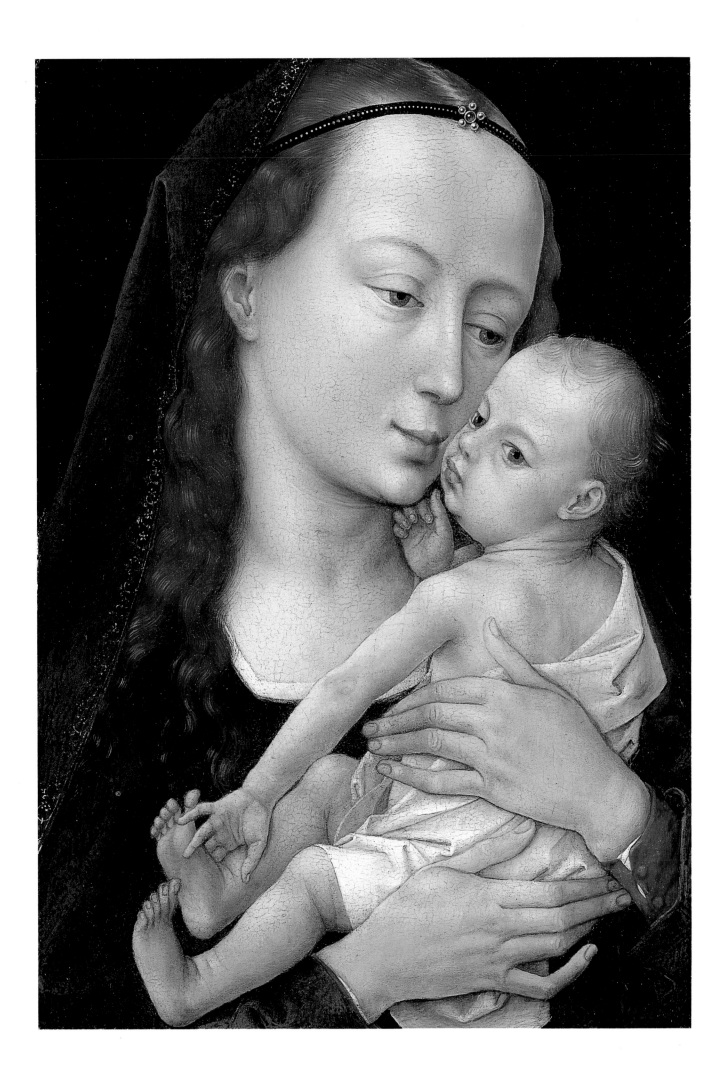

Originally this depiction of the Crucifixion was probably a component of an altarpiece, either one scene among many in the wings of a large polyptych of the Passion of Christ or the central panel of a triptych. The crucified Christ towers over the assembly of onlookers in the foreground and over the city of Jerusalem, represented as a large, sophisticated, thriving German town of the late fifteenth century.

The painter displays an amazing grasp of the realistic landscape style developed among Franco-Flemish manuscript painters during the early fifteenth century. His use of tiny figures in the background—riding horses down winding paths and crossing bridges—suggests an awareness of paintings in the Flemish tradition of Robert Campin, Jan van Eyck, and Rogier van der Weyden.

The panel has been attributed to the anonymous Master of Georg Muehlich's Meisterlin Chronicle, a painter who illustrated a text composed by Sigmund Meisterlin and written in script by Georg Muelich of Augsburg in 1457. The manuscript illustrations, probably completed sometime after 1460, exhibit technical and stylistic parallels with this painting. The sophistication of the background landscapes in both panel and chronicle, if both works are by the same hand, indicates not only that the artist had received Netherlandish or Lower Rhenish training but also that he was the most progressive interpreter of landscape painting in the Germany of his day.

Tempera and oil on panel; 28¾ × 19⁷⁄₁₆ in. (73.0 × 49.5 cm)
Anonymous gift in memory of James H. Chillman, Jr. 72.32

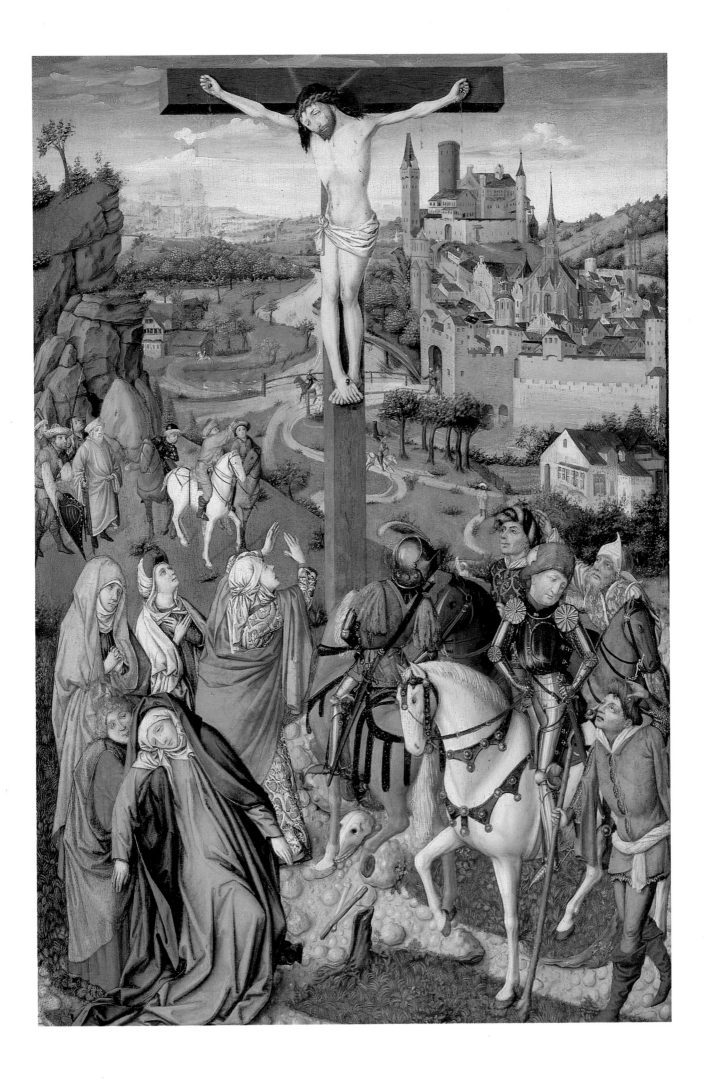

Portrait of an Old Woman, 1468–70

Hans Memling, a painter of German birth who probably apprenticed
with Rogier van der Weyden in Brussels, made a most original
and impressive contribution to Flemish portraiture. This painting is thought to
represent a wealthy middle-class citizen of Bruges, an important commercial
center in Renaissance Flanders. Scholars believe that the panel is the pendant
to a portrait of a man now in the Metropolitan Museum of Art, New York; the
two are believed to be Memling's earliest portraits.

Despite certain similarities to Rogier's portrait style, this *Portrait of an Old
Woman* more clearly reveals the influence of the precise realism of Jan van
Eyck. Although the painting surface has been greatly abraded over time,
the diminutive panel discloses Memling's remarkable ability to render a
vivid likeness.

Oil on panel; 10⅛ × 6¹⁵⁄₁₆ in. (25.6 × 17.7 cm)
The Edith A. and Percy S. Straus Collection 44.530

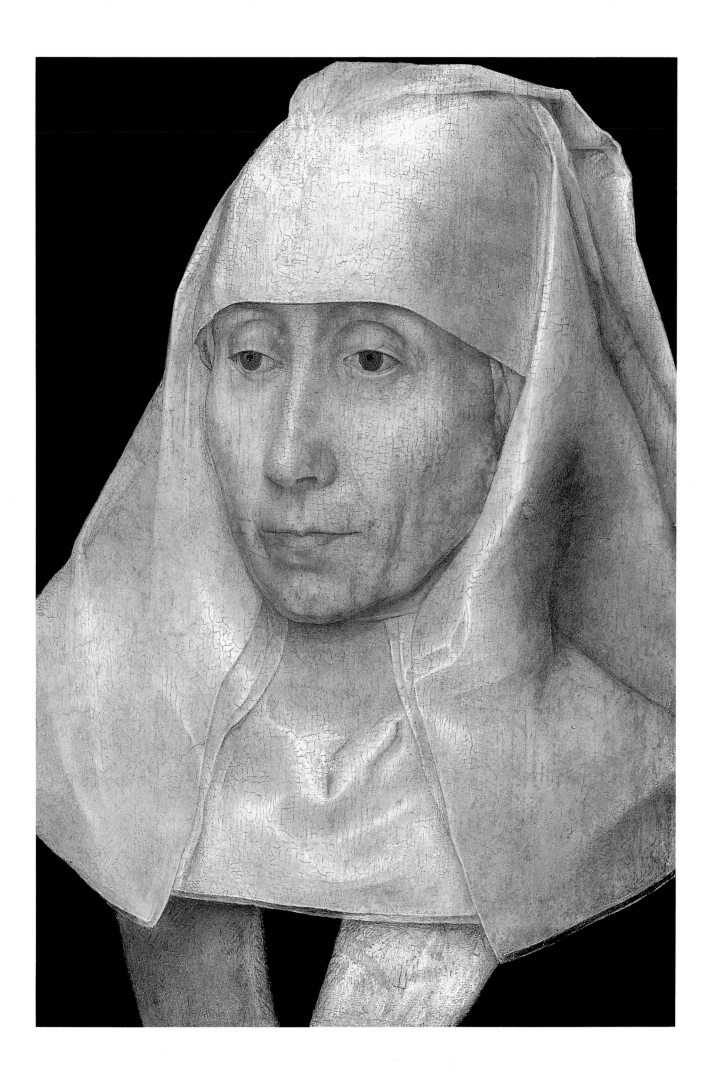

The meeting of Solomon and the Queen of Sheba was a subject widely used among Renaissance artists to commemorate weddings. Although the artist of this panel remains unknown, he probably was associated with the Ferrarese court painters Francesco del Cossa (c. 1436–c. 1478) and Cosimo Tura (c. 1430–1495), for his style is similar to that of their frescoes in the Palazzo di Schifanoia in Ferrara.

Solomon's aristocratic company—defined by strict outlines, gilded and punched surfaces, bright colors, and naturalistic details—is representative both artistically and socially of the court taste of the Este family, who ruled fifteenth-century Ferrara. The rationalized architectural space of Solomon's temple, with its central vanishing point located in the altar chalice, is evidence of the permanent mark left on Ferrarese painting by the Tuscan artists Leon Battista Alberti (1404–1472) and Piero della Francesca (c. 1416–c. 1492), who were invited to the Este court during the 1440s and were famed proponents of linear perspective.

Tempera on panel; diameter 36⅜ in. (92.3 cm)
The Edith A. and Percy S. Straus Collection 44.574

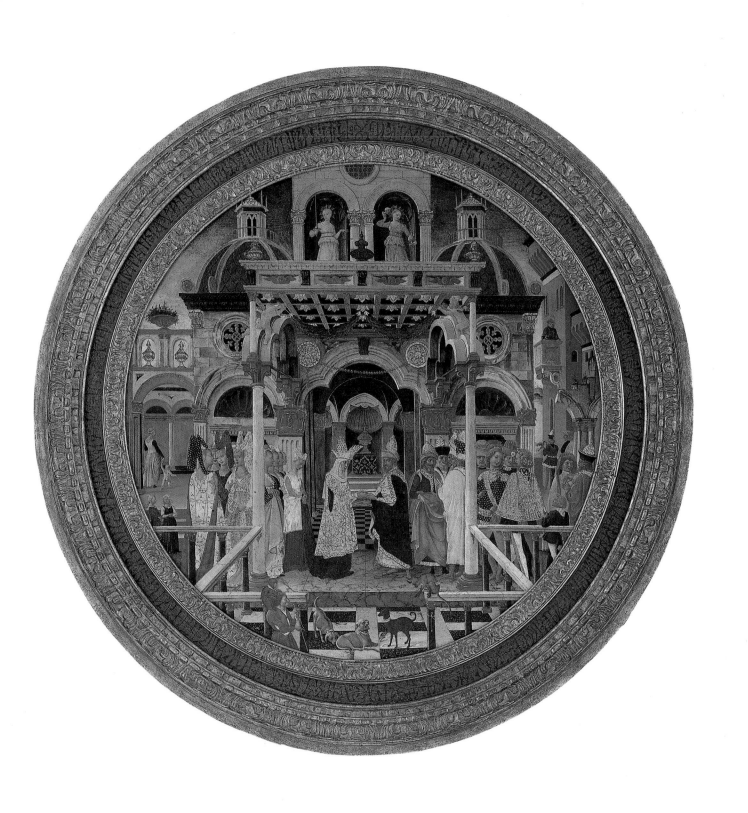

Double Mazer Cup, late fifteenth century

One of the finest Gothic works in the collection, this double mazer cup is made of turned burl wood ornamented with copper-gilt mounts. The piece consists of two roughly spherical cups made of mazer, a knotty wood that was thought to absorb and neutralize any poison poured into it. Both parts of the cup are supported by mounts of copper-gilt, which enhance the beauty of the object and signal its function.

The base, with incised foliate ornament, is coupled with a remarkable handle in the form of a small fortified chapel on which are mounted crockets, finials, and a trumpeting angel. The handle is the most ingenious and elaborately conceived element of the piece: the chapel's tiny windows open into an articulated interior, which is reached by a tiny footbridge. The copper-gilt is engraved to indicate the stonework of late Gothic architecture. The cup's wooden lid is surmounted by a raised crown encircling an enameled blazon thought to represent the arms of the counts of Eutin in Schleswig-Holstein. When inverted, the lid is supported by the crown so that it, too, may be used as a cup.

The metal portions of the piece are more intricate than the simple turned wood cups. The artist's use of elements drawn from religious architecture indicates the prevalence of spiritual concerns in everyday life during the late Middle Ages.

Wood, copper-gilt, champlevé enamel; with lid 8³⁄₁₆ × 6¹⁵⁄₁₆ in. (20.8 × 17.6 cm)
Museum purchase with funds provided by the Laurence H. Favrot Bequest 71.11

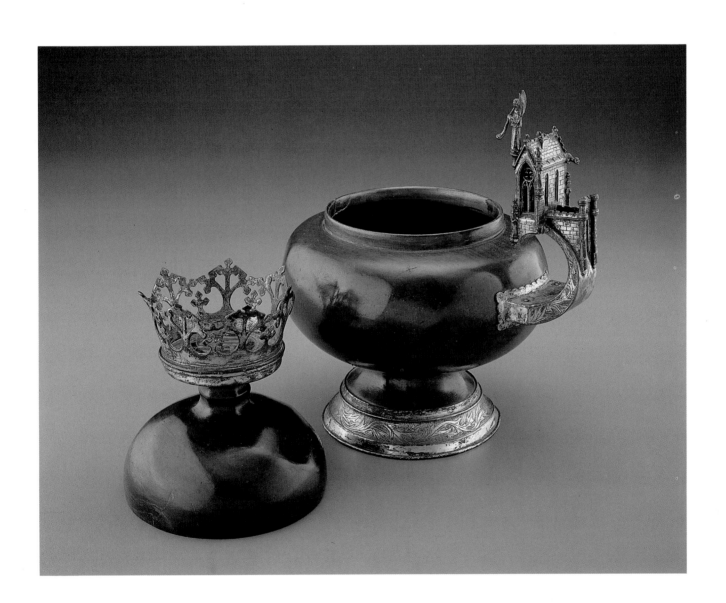

The Virgin and Child Enthroned with
Saints Michael, Catherine, Cecilia, and Jerome,
late fifteenth–early sixteenth century

The Zaganelli brothers were born in the province of Umbria, and their work reflects the multiple influences that prevailed there. The brilliant colors of this painting link it to the manuscript miniatures of northern Italy; the art of that region is also suggested by the depiction of the Virgin and Child enthroned before a landscape. The figures themselves, however, reflect Florentine influences, including the sweet expressions characteristic of Raphael (1483–1520), the great master of the High Renaissance. The painting also hints at the High Renaissance goal of depicting a synthesis of realism and idealism in which nature and humanity are presented to demonstrate life in a perfect world. This small work, which carries all the power of a large altarpiece, was probably a private devotional commission.

Bernardino Zaganelli often collaborated with his brother Francesco (died 1532). Because he rarely signed his paintings, scholars have not yet been able to distinguish his hand from that of Francesco, and it was only after Bernardino's death in 1510 that Francesco's paintings exhibited a more personal style.

Oil on panel; 9⅞ × 8 in. (25.1 × 20.3 cm)
Museum purchase with funds provided by Alice N. Hanszen 78.1

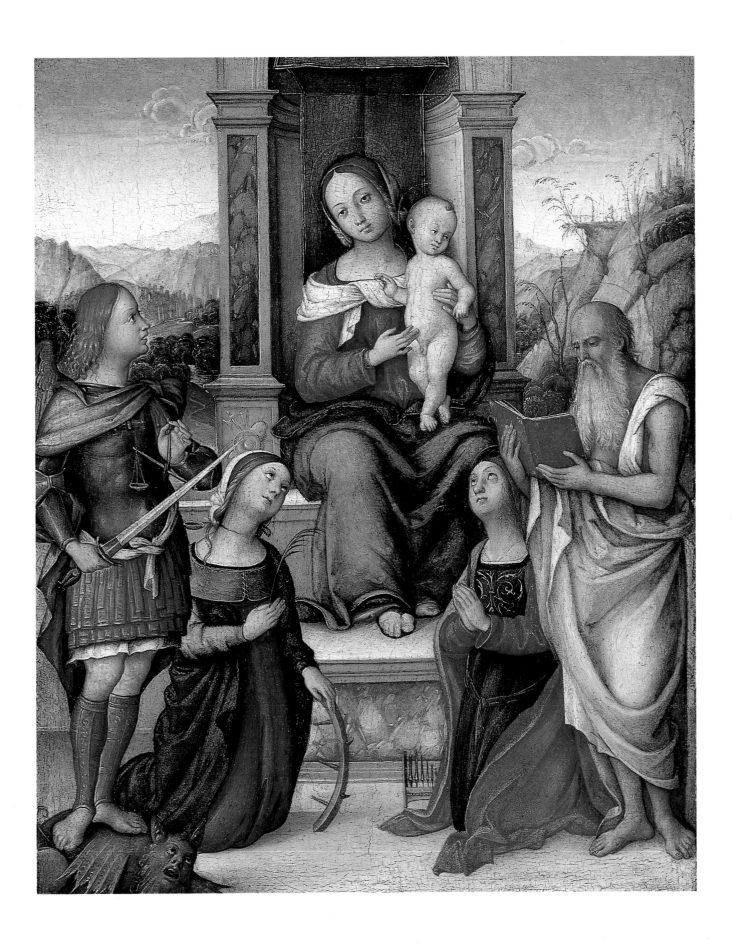

Hercules Resting after Slaying the Nemean Lion, c. 1500

At the end of the fifteenth century Mantua ranked among the most sophisticated courts of Europe; poets, humanists, painters, and sculptors, under the patronage of Isabella d'Este, wife of Gianfrancesco Gonzaga, contributed to its flourishing and helped make it one of the most intellectually active centers of the Renaissance. The artists shared with the Mantuan rulers a deep interest in the rediscovery and preservation of antique monuments; recently excavated pieces were avidly collected and restored, and works in the antique style were commissioned.

Like Andrea Mantegna (1431–1506), the sculptor Pier Jacopo Alari-Bonacolsi was affiliated with the court of Mantua. He owed his nickname, Antico, to his astonishing ability to create beautifully modeled small bronzes evocative of antiquity. Employed by the Gonzaga family to restore ancient sculpture and design commemorative medals and jewels, he also produced small bronzes inspired by classical themes, which survive today as his greatest accomplishments.

Antico is one of the great bronze sculptors of the Renaissance. The smooth surfaces of his bronzes are unique. His style is classicizing, in contrast to the naturalism of contemporary Florentine and Paduan bronze modelers.

Bronze inlaid with silver; 11 × 5 ¹³⁄₁₆ in. (27.9 × 14.8 cm)
The Edith A. and Percy S. Straus Collection 44.582

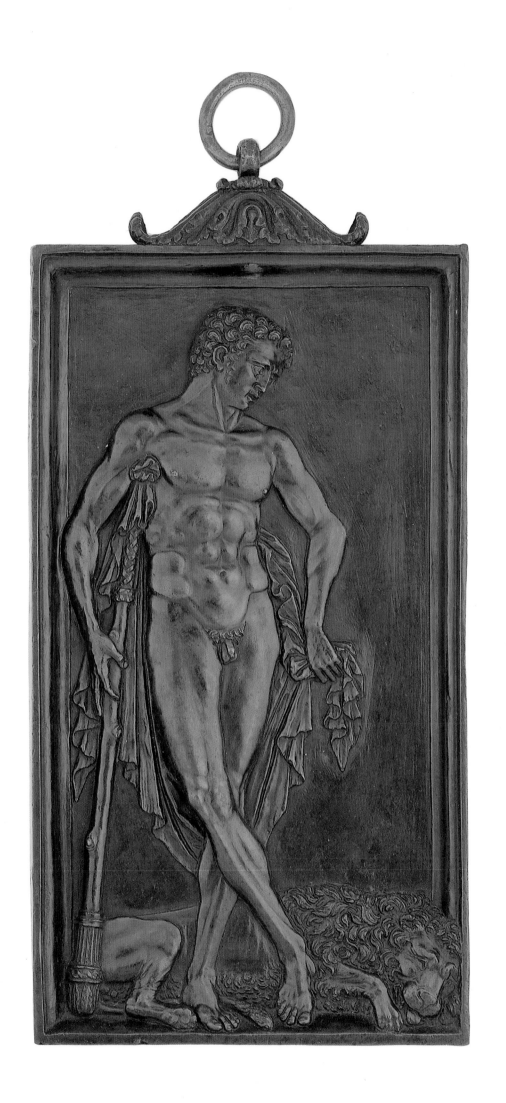

Style or workshop of **SIMON BENING**

Flemish; Bruges, 1483/84–1561

Triptych with the Virgin and Child and
Saints Catherine and Barbara, c. 1500–1550

By the late fifteenth and early sixteenth century, Flanders was one of Europe's great centers of manuscript illumination. Flemish workshops supplied brilliantly decorated texts, distinguished by a high degree of technical innovation, to markets far beyond the boundaries of Flanders. The artists Gerard Horenbout (c. 1465–c. 1540) and Simon Bening were among those who built great reputations by adapting to the format of book illustration the famous compositions of leading panel painters—Hugo van der Goes (c. 1440–1482) and Gerard David (c. 1460–1523) included.

This small triptych is composed of three exquisitely painted sheets of parchment, which reveal the minaturist's great skill in the handling of radiant light, harmonious color, and naturalistic detail. The central image, based on a painting by Gerard David, is flanked by representations of Saints Catherine of Alexandria (left) and Barbara (right), each bearing symbols of her martyrdom, depictions of which are represented by narrative vignettes in the backgrounds.

Tempera on vellum; center, 9⅞ × 7¼ in. (25.1 × 18.4 cm);
left, 9¾ × 2¾ in. (24.8 × 7.0 cm); right, 9¹³⁄₁₆ × 2¾ in. (24.2 × 7.0 cm)
The Edith A. and Percy S. Straus Collection 44.529

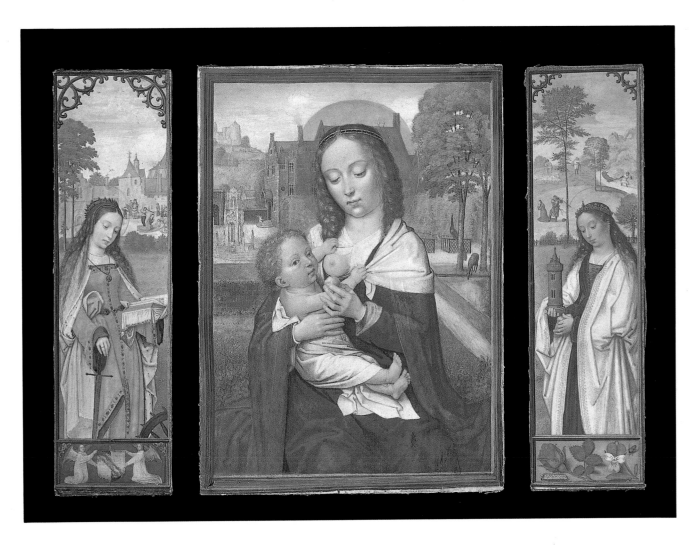

Trained as a goldsmith in Padua, Andrea Briosco became the city's most important bronze sculptor and among the most important makers of small bronzes of the Renaissance. The source for this *Chained Satyr* and for many bronzes by Riccio and his followers was a work of monumental scale, the twelve-and-one-half-foot-tall bronze paschal candlestick made by Riccio for the Basilica of Saint Anthony in Padua. In that important work, commissioned by the humanist philosopher Giovanni Battista de Leone and executed between 1507 and 1515, Riccio used the mythological iconography of satyr and sphinx in a religious context, displaying the classical erudition cherished by humanists in the university city of Padua.

The form of the goat-legged satyr is derived from Pan, the Greek god of shepherds and hunters who was known to Renaissance artists through Hellenistic and Roman sarcophagi. Small bronzes representing such sylvan and bacchic beasts were prized by learned collectors as adornments for their desks and libraries, where they were often displayed beside and compared with Greek and Roman objects.

Bronze; height 5⁹/₁₆ in. (14.2 cm)
The Edith A. and Percy S. Straus Collection 44.594

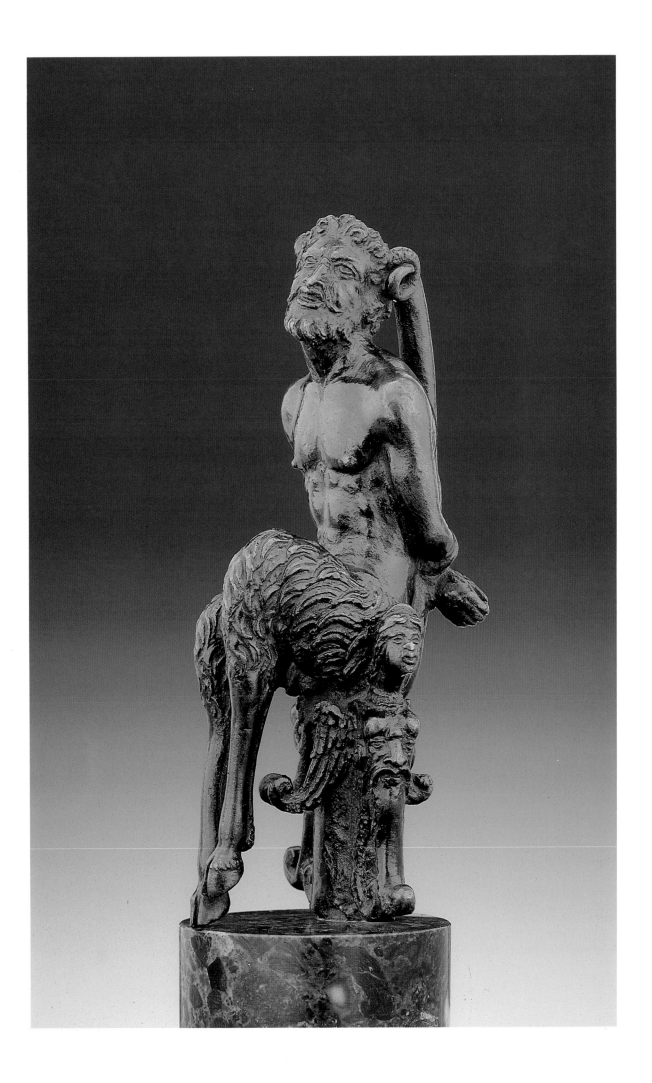

Asignature on an early Madonna by Bartolommeo described the painter as "half Venetian and half Cremonese," leading scholars to conclude that the artist was born in Cremona, part of the Republic of Venice from 1499 to 1509. Almost nothing is known of the exact circumstances of Bartolommeo's life. He records himself in another inscription as the student of Gentile Bellini (c. 1429/30–1507), one of a famous family of Venetian painters of the early Renaissance. Despite his identification as a Venetian master, Bartolommeo left Venice and died in Turin in December 1531.

His portrait of an unknown man is a typical and superb example of his mature portrait style, in which the characteristically Venetian concern with opulent color and rich adornments is blended with a north Italian or even Germanic simplicity. Standing against a red curtain, the sitter averts his gaze, his firmly set jaw contrasting with the slightly wistful expression in his eyes. The young man's costume bespeaks his aristocratic rank: his cloak is trimmed with rich fur, the border of his tunic is shot through with threads of gold, and he wears an elaborate cap badge of gold and enamel.

Oil on panel; 27⅞ × 21½ in. (70.8 × 54.6 cm)
The Edith A. and Percy S. Straus Collection 44.573

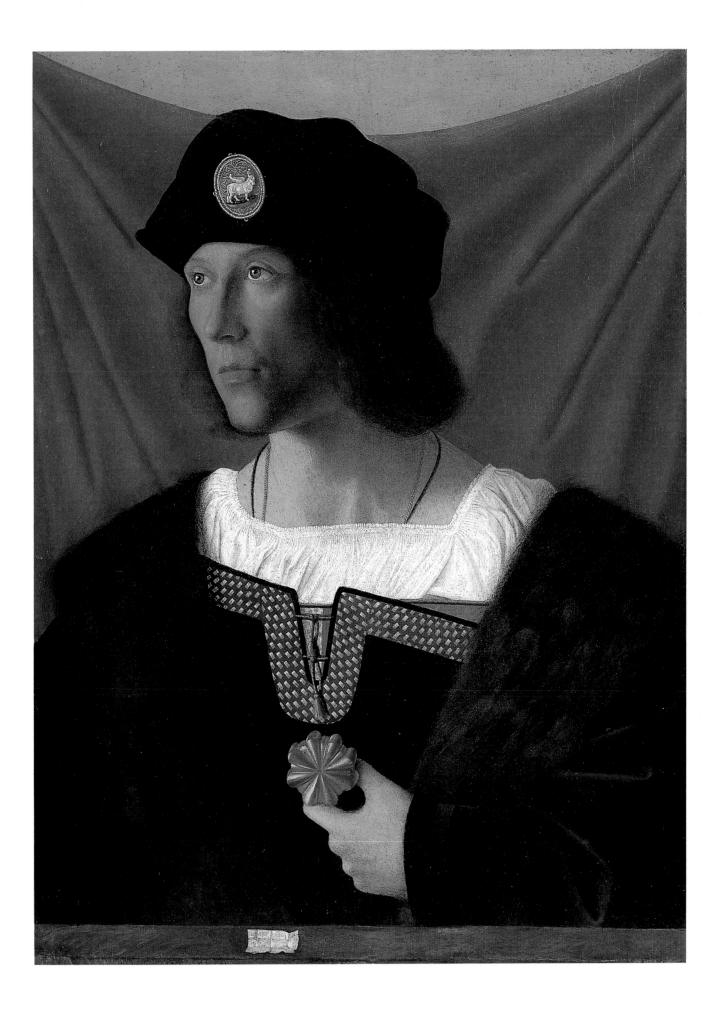

Portrait of Anton Francesco degli Albizzi, c. 1524/25

Little is known of Sebastiano del Piombo's training or early career. He was probably born in Venice and, according to Vasari, was apprenticed to Giovanni Bellini (c. 1429/30–1516) and Giorgione (1477/78–1510). Sebastiano worked mostly in Rome after his arrival there in 1511. He became a close friend and protégé of Michelangelo (1475–1564), who was at that time completing his famous decorations in the Sistine Chapel. After the death of Raphael in 1520, Sebastiano was considered to be the most gifted portraitist working in Rome.

Sebastiano's aesthetic preferences led him toward a lavish manner that reflects Michelangelo's powerful style; the features of his sitters are often exaggerated to enhance their psychological characteristics or amplify their physical presence. The imposing, richly dressed gentleman of this portrait has been identified as the Florentine diplomat Anton Francesco degli Albizzi, who commissioned the painting from Sebastiano while on a visit to Rome. The work can be dated about 1524/25, for Sebastiano described it as finished in a letter of April 29, 1525, to Michelangelo, who was then in Florence. The opulent materials and vibrant quality of light within a dense atmosphere recall Sebastiano's early Venetian heritage, while the scale, breadth, and monumentality of the figure characterize his personal style, reinforced by the Roman example of Michelangelo.

Oil on canvas transferred from panel; 53 × 38⅞ in. (134.6 × 98.7 cm)
The Samuel H. Kress Collection 61.79

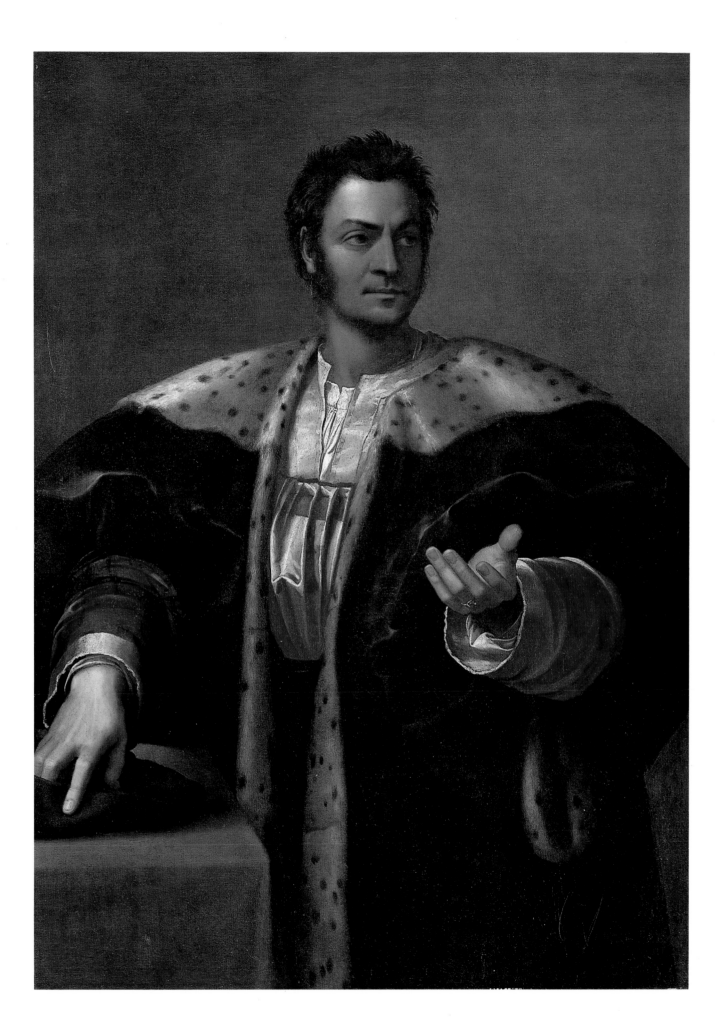

*The Dead Christ with Angel and a Donor
as Saint Francis, c. 1585*

The eclectic cultural background of Verona provided the young Veronese with abundant models from which he rapidly created his own style. Although he first adopted the refinements of drawing and composition of the mannerist school, he did so with great freedom and a highly personal and bold sense of color. These qualities became more evident in the work Veronese painted after his move to Venice about 1553. His brightly colored compositions were universally admired, and his early accomplishments culminated in his decorations of 1561 for the Villa Barbaro, a country villa in Maser designed by Andrea Palladio (1508–1580). Veronese's ensemble is a major monument of sixteenth-century Venetian painting.

After 1575 the artist's compositions changed considerably. More intensely personal or dramatic elements replaced the brilliance of his youthful works. The museum's painting, rediscovered in the 1970s, adds significantly to the body of late canvases by Veronese.

The painting represents a vision of the body of the dead Christ supported by angels, a subject relatively familiar in Venetian iconography. Yet Veronese insists on the physicality of the dead body, and the introduction of a donor wearing the monk's habit of Saint Francis indicates the artist's intention to blend the earthly and supernatural worlds into a single image. Christ is represented as a dead man whose arm—the center of attention and of the composition— hangs lifelessly, while the human and living donor is shown as a saint bearing the stigmata. This spiritual intermingling of the earthly and divine is indicative of the intellectual complexity of Veronese's late works. The heavy, dark colors, enhanced by the delicately painted, transparent garb of the angel, establish a deeply emotional atmosphere.

Oil on canvas; 33⅞ × 49⅞ in. (85.9 × 126.6 cm)

*Gift of Mr. and Mrs. Isaac Arnold, Jr., in memory of
Hugh Roy and Lillie Cullen 79.254*

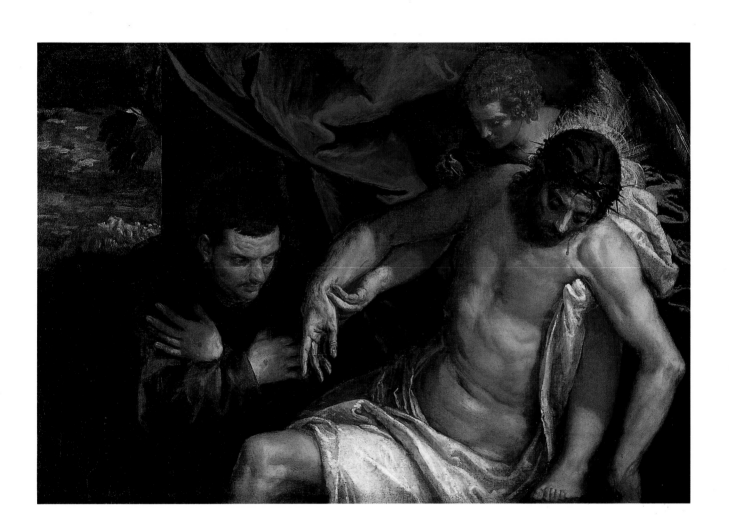

Antonio Susini was the chief assistant and follower of the Flemish sculptor Giambologna (1529–1608), who worked in Florence and became the city's most important mannerist sculptor after the death of Michelangelo in 1564. Jacopo Salviati, Susini's patron, introduced him to Giambologna in the early 1580s. Susini was a specialist in all aspects of bronze mold making, casting, and finishing. It was largely due to his collaboration with the technically gifted Susini that Giambologna acquired his reputation for bronze sculptures of antique-inspired figures and animals in combat.

This sculpture previously has been attributed to Giambologna, because the figure and stylized drapery patterns are very close to those of Susini's master. In the detailed posthumous 1609 inventory of Salviati's collection, however, it is recorded as having been designed and cast by Susini. A testament to his artistic and technical proficiency, it may have been made about 1600, when Susini opened his own studio and began to produce his first independent work.

Bronze; height 15³⁄₁₆ in. (38.6 cm)
The Edith A. and Percy S. Straus Collection 44.586

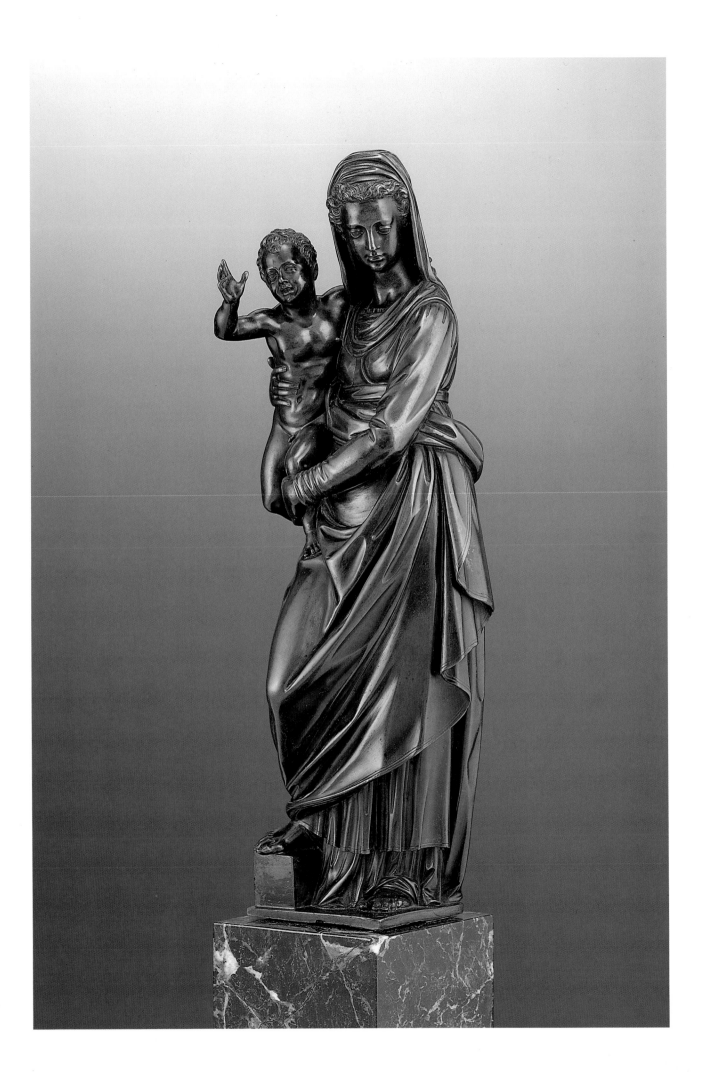

Later European Art

Still Life, 1626

Juan van der Hamen was born in Madrid, the son of an aristocrat from Brussels who was a member of the Burgundian Guard at the courts of Philip II and Philip III. Despite his northern origins, van der Hamen's training was entirely Spanish and his work belongs to that school. His early apprenticeship is not documented, although he was probably influenced by the painter Juan Sánchez-Cotán (1561–1627). Like Sánchez-Cotán, van der Hamen is best known for his still lifes, although he also executed religious and historical pictures.

In this beautiful still life of 1626 van der Hamen strives for formal clarity and a precise design that allows him to display a stupendous technical ability. In the artificial composition, with elements raised on a stepped ledge and a plinth, the artist abandons conventional symmetry to give each object its full weight. Melons and pomegranates, dense and heavy, contrast with the evanescent clarity of the Venetian-style glass vessels. Unlike many artists of the baroque period, van der Hamen does not confer symbolic overtones on his still-life paintings. The quietly austere atmosphere, which highlights each object, enhances the illusionistic quality of the picture.

This painting was owned in the seventeenth century by Diego Felipez de Guzmán, marquis of Leganés, one of the most important early connoisseurs of Spanish still-life painting.

Oil on canvas; 33 × 44⅝ in. (83.0 × 113.4 cm)
Signed and dated lower left: Ju van der Hammen fa. 1626
The Samuel H. Kress Collection 61.78

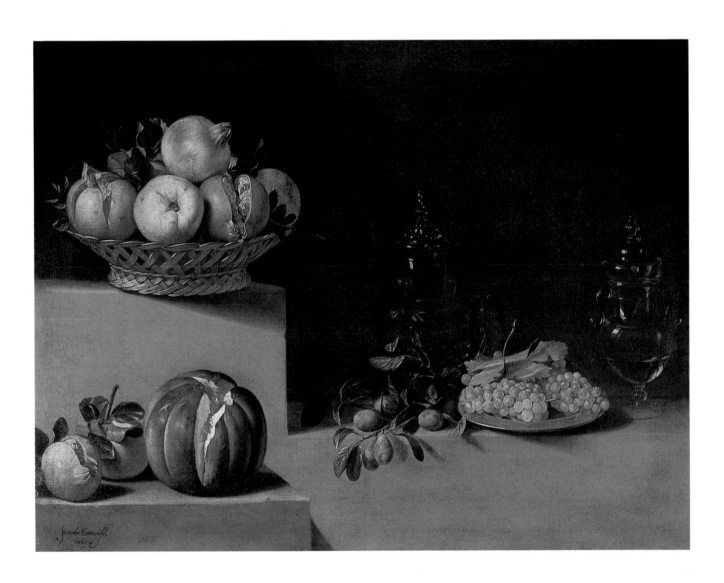

Pastoral Landscape with a Rock Arch and a River, c. 1630

Claude Gellée was born near Nancy in Lorraine, a province to which such diverse artists as Jacques Callot (1592–1635) and Georges de La Tour (1593–1652) were native. At an early age he arrived in Rome and worked as a pastrycook in the home of the painter Agostino Tassi (1565–1644). He graduated promptly from the kitchen to the studio and became Tassi's pupil. Through Tassi, who had worked with the Flemish landscape painter Paul Bril (1554–1626), Claude was introduced to the new naturalistic landscape styles popularized by northern artists working in Italy during the late sixteenth century. Claude himself returned to his native country only once, in 1625–26/27. By 1640 he had achieved considerable success in Rome as a landscape painter. He died there, highly respected by all, in 1682.

Pastoral Landscape is an important work of Claude's early style. Its composition is still conventional, and the organization of the landscape recalls the paintings of Bril and Tassi with trees framing the composition, cattle in the foreground, and a clear definition of successive planes. In its details and general atmosphere, however, the painting prefigures the achievements of the artist's maturity. A gentle mood is conveyed by the most delicate color nuances. The rock arch, although based on natural prototypes, seems an almost theatrical invention, expanding the composition and giving it a mysterious depth typical of Claude's later paintings. The artist demonstrates the ideal forms of ancient architecture and the everyday events of country life in southern Italy. In such poetic paintings Claude brings to life the landscape of Virgil.

Oil on canvas; 37⅝ × 52⅞ in. (95.5 × 134.3 cm)
Museum purchase with funds provided by the Agnes Cullen Arnold Endowment Fund 73.172

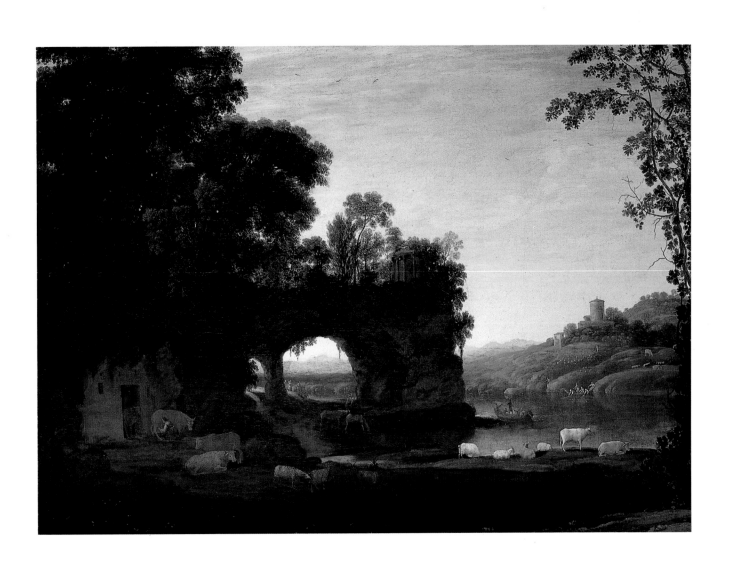

At an early age Ferdinand Bol moved to Amsterdam, where he became the pupil, closest associate, and friend of Rembrandt van Rijn (1606–1669). Bol worked in Rembrandt's studio between 1633 and 1640, and his early work closely reflects the style of his master. This portrait of a young woman ranks among Bol's most successful achievements. Following a tradition well established during the baroque period, the portrait is at the same time a costume piece and an allegory. The sitter, thought to be Saskia van Uylenborch, Rembrandt's wife, is represented looking at a mirror that stands on a table laden with jewels. Both mirror and jewels are standard features of *vanitas* pictures, images with a moralistic content intended to remind the viewer of the transitory nature of earthly life.

To enhance the impact of the portrait Bol has adopted Rembrandt's somber manner, devoting special attention to the beautiful face bathed in light. Against the dark background of the picture, the face and glistening details of the brocade and jewels are luminescent, imparting a psychological power to the composition.

Oil on canvas; 50⁹⁄₁₆ × 36⅛ in. (128.4 × 91.7 cm)
Gift of Mrs. Harry C. Hanszen 69.4

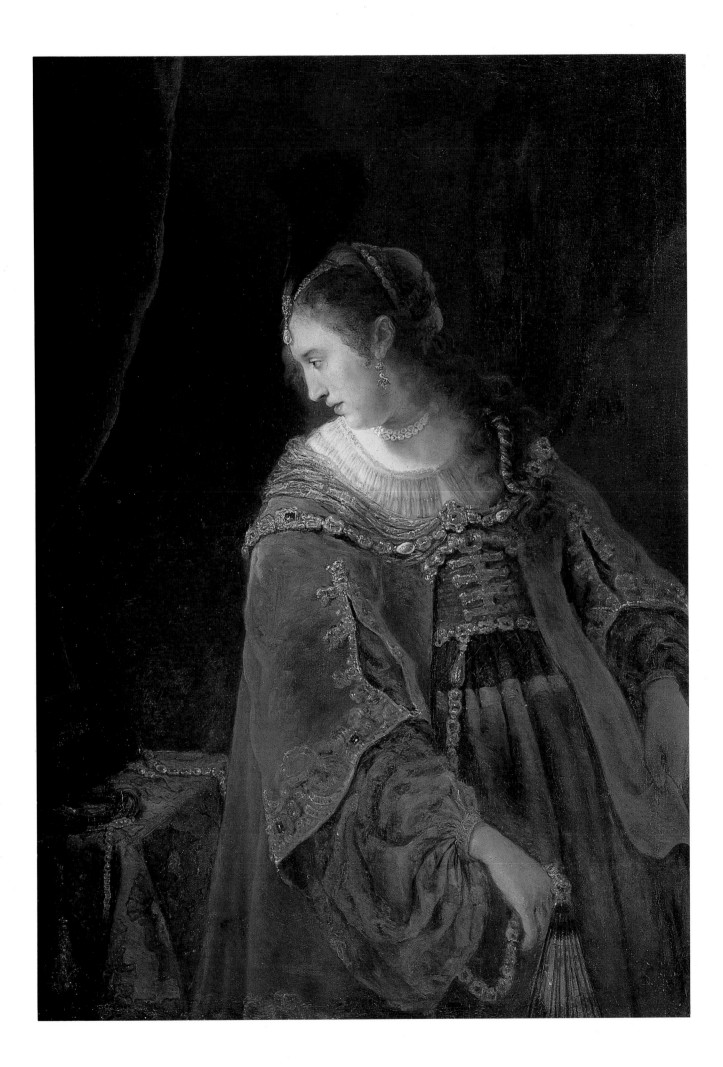

The Penitent Magdalen, *1648*

The religious paintings of Philippe de Champaigne evoke a world of piety and private devotion. Born in Brussels to a family of French descent, Champaigne was an extremely devout man of fierce integrity. He studied with the landscape artist Jacques Fouquières (1580–1659) and, as early as 1621, was employed by the French court. Champaigne enjoyed the patronage of Cardinal Richelieu, Louis XIII, Anne of Austria, and Louis XIV. Private patrons were also numerous, and about 1643 Champaigne came in contact with the convent of Port Royal, a center of ascetic Jansenist thought. His own daughter became a nun there, and the austere rules of the convent as well as its moral rectitude are often reflected in Champaigne's devotional pictures and stern portraits, both infused with a strong spirituality.

The Penitent Magdalen was executed for the Parisian convent of the Dames-du-Saint-Sacrément in 1648, the year Champaigne became one of the twelve founding members of the Acádemie Royale de Peinture et de Sculpture. Champaigne's representation of the Magdalen is indebted to a famous composition by Titian (1477–1576), known to him either through engravings or through freely executed copies done by such artists as Anthony van Dyck (1599–1641). Its crisp drawing, somber color, and porcelainlike surface are characteristics that perhaps betray the influence of northern art or the artist's early Flemish painting. A reductive classicism and pious sobriety are combined in a dignified and poignant image that expresses with directness and sincerity the artist's personal faith.

Oil on canvas; 45⁹⁄₁₆ × 35 in. (115.9 × 88.9 cm)
Museum purchase with funds provided by the Agnes Cullen Arnold
Endowment Fund 70.26

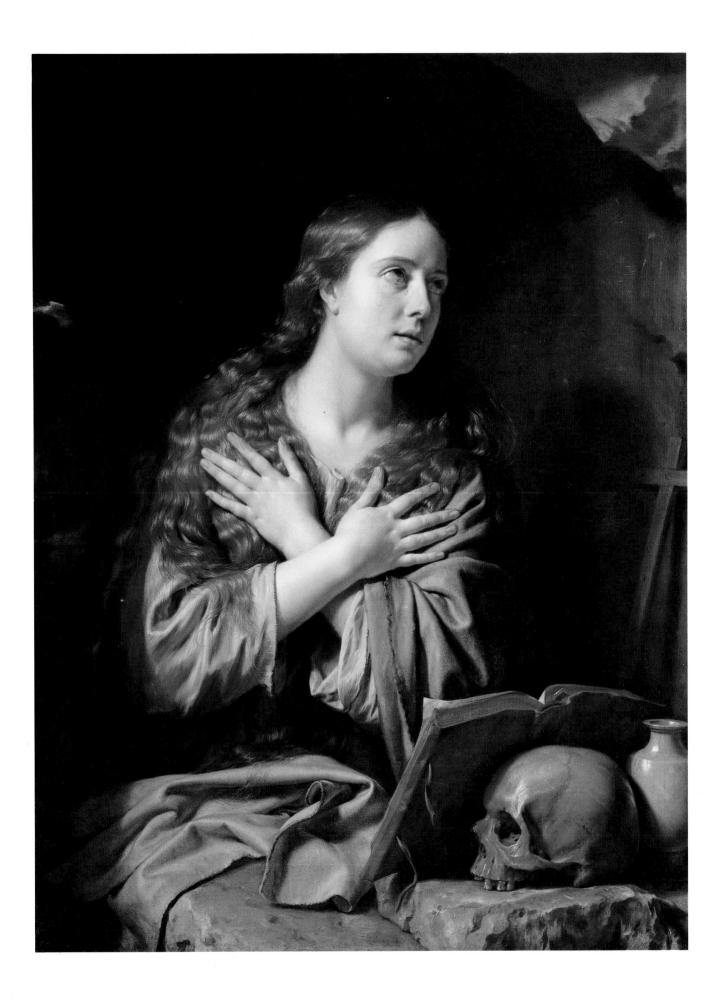

Willem Claesz. Heda began his career as a figure painter but rapidly became the leading representative of the Dutch school of still life. He created a genre that he brought to perfection by repeating his compositions, changing only slightly from one to another the arrangement of objects he had chosen to depict. His arrangements of objects painted in a close range of grays, browns, and whites were known as *monochrome ontbijt* (monochromatic breakfast pieces).

In this still life Heda juxtaposes glassware, silver vessels, and oyster shells on a white tablecloth. Their monochromatic harmony is subtly countered by the pink ham, light blue decoration of the Delft plate, and acid yellow rind of the half-peeled lemon. It is characteristic of Heda not to give a rigorous order to the components of his still life but to paint them instead as if a real breakfast had been abruptly abandoned; a beaker is upset, plates are negligently piled up, glasses are half-emptied, and the lid of the silver pitcher is left open. A symbolic overtone can be perceived in this profusion of detail, which might suggest that the enjoyments of life are interrupted, perhaps by death, or abandoned for higher ideals.

Heda's self-contained painting expresses simultaneously an appetite for worldly goods, so lusciously depicted, and a desire for intellectual rigor, conveyed through an economy of color. Only the light falling through unseen windows barely reflected in glass and silver and caressing the linen tablecloth and oyster flesh alludes to a world outside this quiet interior.

Oil on canvas; 44 × 60 in. (111.7 × 152.3 cm)
Signed and dated lower center on tablecloth: Heda 1656
Gift of Mr. and Mrs. Raymond H. Goodrich 57.56

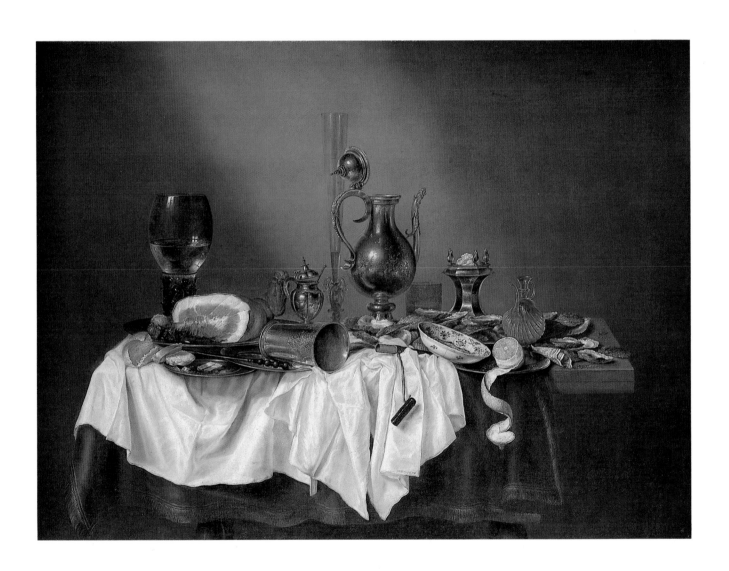

The Martyrdom of Saint Paul, c. 1656–59

The political changes that affected Naples and its strategic position in the Mediterranean world during the seventeenth century made the city a gathering place for artists from all over Italy and Europe. Spanish, Dutch, German, and Flemish artists were as much a part of the artistic life of Naples as were her native painters. Mattia Preti, born in Calabria, first studied and worked in Rome, where he was entrusted in 1650 with the fresco decoration of the apse of the Church of Saint Andrea della Valle. His move to Naples may be linked to the fact that in 1656 the city had been stricken by the plague and its artistic community had been greatly reduced. His first large commission there, in fact, dealt with plague-related subjects.

Although not a native of Naples, Preti is rightly considered one of the founders of the Neapolitan baroque. In his most characteristic work Preti affected broad compositions, strongly organized along geometric lines. He borrowed from Caravaggio (1573–1610) dramatic effects of light and shade painted thinly on coarse canvases. Perhaps the Spaniard Jusepe de Ribera (1588–1652), then active in Naples, influenced Preti in his choice of violent subjects. *The Martyrdom of Saint Paul* is one of a set of three paintings commissioned from Preti by Ferdinand van den Einden, a Flemish merchant settled in Naples.

The somber and tragic mood of these paintings, befitting a post-plague period, dominates all of Preti's works as well as most Neapolitan paintings of the time before the emergence of Luca Giordano (1632–1705), who was to introduce a richer palette, more brilliant execution, and less dramatic subject matter. By the time these changes had occurred Preti was no longer active in Naples but was working in Malta, where he died.

Oil on canvas; 70¹¹⁄₁₆ × 73¾ in. (179.6 × 187.3 cm)
Museum purchase with funds provided by the Laurence H. Favrot Bequest 69.17

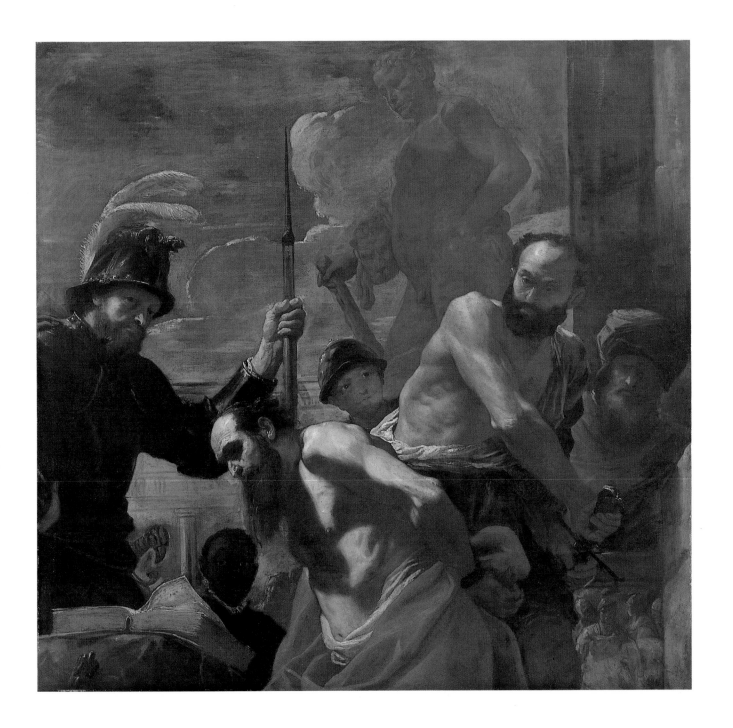

Giordano studied under Ribera in his native Naples, but his style matured through his contacts with the works of Pietro da Cortona (1596–1669) and admiration for the Venetian painters, above all Veronese. Cosmopolitan in his education, Giordano led an international career; he worked in Naples, Venice, and Florence and in Spain, at the invitation of Charles II. Giordano's greatest achievements reside in his large decorative programs, for which he attained unequaled fame. His swift execution was proverbial, earning him the nickname "Fa presto." Unlike Cortona, Giordano shunned traditional ways of working. He seldom made preparatory drawings, for instance, and preferred to paint directly on the canvas. As with many artists of the baroque, however, it was his habit to paint smaller studies, or *modelli*, for works he intended to carry out on a larger scale.

In 1682 Marchese Francesco Riccardi decided to have the gallery and library of his palace in Florence decorated with frescoes and entrusted the illustrious Giordano with this commission. The project was not completed until 1685, but *modelli* such as the *Allegory of Prudence* were executed in 1682 and submitted to Marchese Riccardi for his approval. Giordano's iconographical program for this series represents Mankind's Progress by Means of Wisdom: Science, personified by Minerva, assisted by the Virtues, enables Man to rise above the material world. The museum's painting represents Prudence, one of the Virtues, holding her attributes, a mirror and a serpent twisted around an arrow. Around Prudence, other allegorical figures, including personifications of Fraud, Obstinancy, Grace, Abundance, Health, Order, and Experience, complete the elaborate tableau.

Oil on canvas; 36⁹⁄₁₆ × 36⁹⁄₁₆ in. (92.9 × 92.9 cm)
Museum purchase with funds provided by the Agnes Cullen Arnold
Endowment Fund 75.33

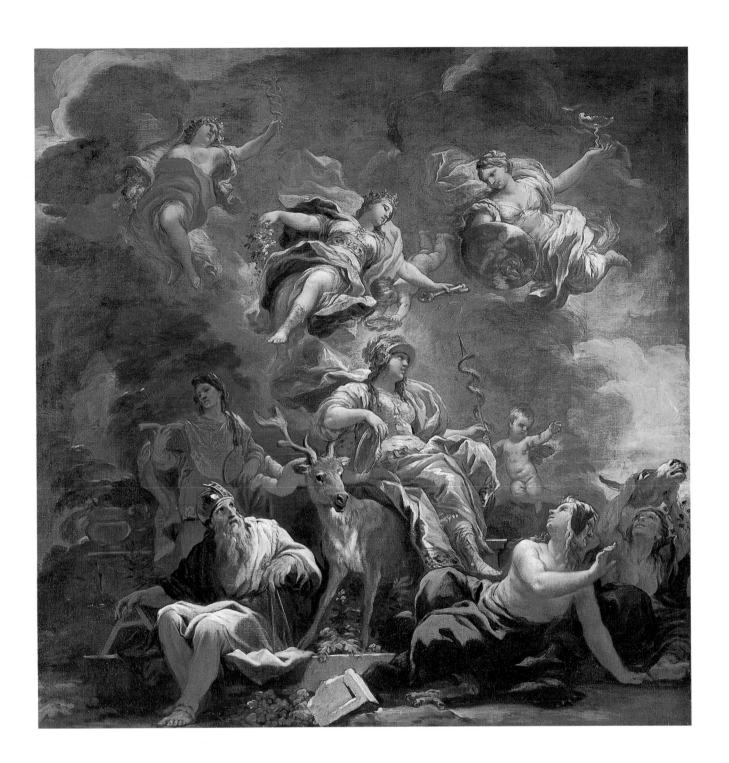

ANTONIO CANAL, called CANALETTO

Italian; Venice, 1697–1768

Grand Canal, Entrance Looking West, c. 1730

Grand Canal, Looking Southwest from near Rialto Bridge, c. 1730

C analetto was the son of Bernardo Canal, a painter of theater sets, with whom he worked and from whom he presumably learned the rules of perspective, so important for his own compositions. In 1719 he went to Rome, where he may have become familiar with the paintings of Giovanni Panini (1695–1768), an artist known for his Roman cityscapes and imaginary topographical views using Roman landmarks as motifs. A year later Canaletto was back in Venice, attracting an international clientele, especially wealthy English patrons. This association, and the effects of the War of Austrian Succession, which greatly reduced the number of visitors to Venice, prompted Canaletto to travel to England, where he resided almost without interruption from 1746 until 1755.

Canaletto's works can be grouped into two major categories: topographic views depicting with extreme precision particular aspects of Venice and other European cities; and imaginary views, or capricci, in which architectural monuments have been displaced and rearranged according to the painter's fancy. The two Venetian landscapes in the museum's collection belong to the first category. One depicts the entrance to the Grand Canal, with the Church of Santa Maria della Salute on the left; the other is a view of the Grand Canal, looking southwest from near the Rialto Bridge toward the Palazzo Foscari. These views were popular among travelers in the eighteenth century, and it is not surprising that these paintings were intended for a British client who purchased them from Joseph Smith, an English merchant who settled in Venice at the beginning of the century and worked as an agent for Canaletto.

Despite the self-defined limits of his subject matter, Canaletto was an extraordinarily brilliant artist who delicately enhanced his subject by a careful selection process in which details are omitted in order to focus on an essential image. His fine colors subtly combine all the hues associated with the real Venice as much as with the idea, or memory, of the city. Executed in his studio after studies from the motif, his paintings are, therefore, more than topographic records. They are pure, intellectual re-creations.

Oil on canvas; 19 ¼ × 29 in. (49.6 × 73.6 cm) 56.2
Oil on canvas; 19 9/16 × 28 ¾ in. (49.7 × 73.0 cm) 55.103
The Robert Lee Blaffer Memorial Collection, gift of Sarah Campbell Blaffer

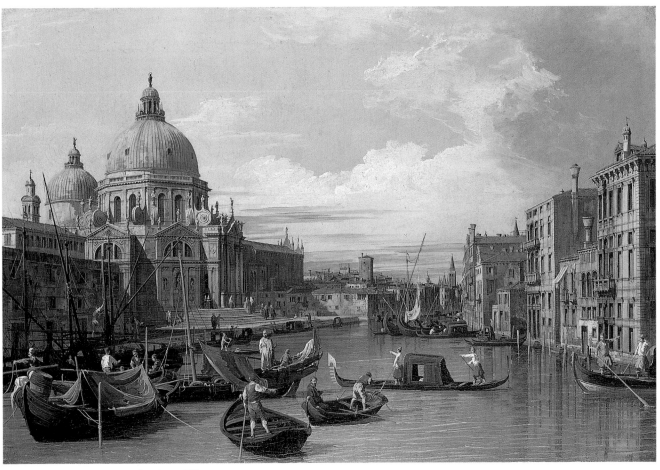

Grand Canal, Entrance Looking West

Grand Canal, Looking Southwest from near Rialto Bridge

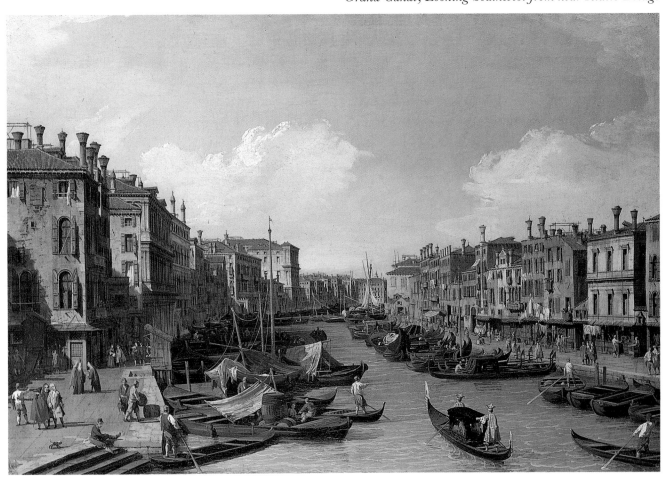

Bacchanal, c. 1747

Natoire was the son of an architect and sculptor. In 1721 he went to Italy after winning the coveted Prix de Rome, which entitled him to a scholarship to study there, and returned to Paris only in 1729. In the next two decades he became one of the most successful painters of his day. Following his reception into the Académie Royale in 1734, he received both state and private commissions for a remarkable variety of work, but he was particularly famous as a decorative painter. He ended his career as director of the Académie Française in Rome.

This *Bacchanal* was commissioned by Ange-Laurent de La Live de Jully, one of the most distinguished collectors of the mid-eighteenth century. Together with its pendant, a *Triumph of Amphitrite* (private collection, Paris), it celebrated La Live's wedding in 1747.

This is an excellent example of Natoire's exuberant rococo style, characterized by an elegant, graceful draftsmanship, richly worked oily paint, and luxurious sense of color matched only by the work of his rival, François Boucher (1703–1770). In its classical subject and brilliant color and composition, it is related to sixteenth-century Venetian painting, most notably to the mythological scenes by Titian (1477–1576); it also recalls the seventeenth-century bacchanals of Nicolas Poussin (1594–1665). Its sensuous, elaborately decorative design and atmospheric, sometimes transparent, pigments are expressive of the most advanced taste of French art in the mid-eighteenth century.

Oil on canvas; 31⅞ × 39⅞ in. (81.0 × 101.2 cm)
Museum purchase 84.200

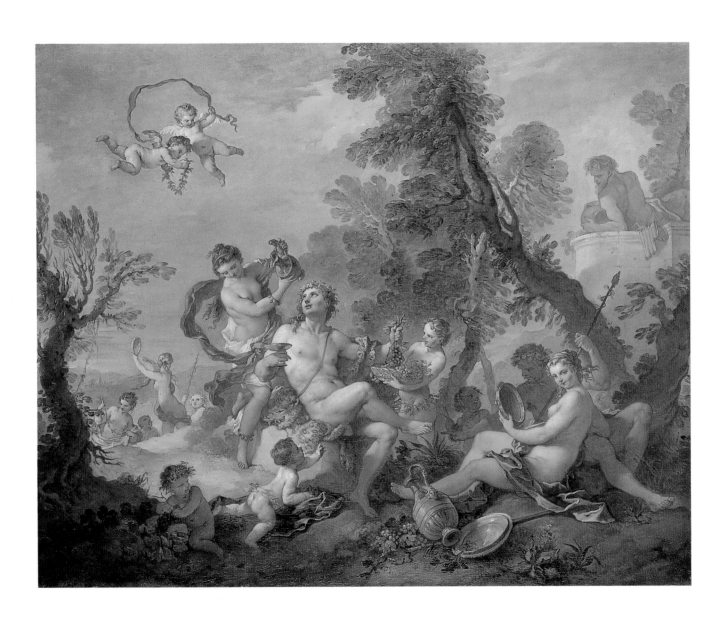

The Marketplace at Pirna, c. 1750

Bellotto was the nephew of Canaletto, with whom he studied. In 1738 Bellotto entered the Venetian painters' guild and during the 1740s traveled to Rome, Tuscany, and northern Italy. In 1747 he left Italy for eastern Europe, where he worked for the courts of Dresden, Vienna, Saint Petersburg, and Warsaw.

Between 1752 and 1755 Bellotto painted ten large views of Pirna, a small town a few miles from Dresden. Some of these large views (today in the Dresden Gemäldegalerie Alter Meister) were repeated by Bellotto on a small scale. Although replicas were also executed by other artists, the best examples, like this painting, are considered to be by Bellotto.

Bellotto did not seek the theatrical effects found in the work of his uncle Canaletto. His views instead are based on direct and careful observation, and their compositions are neither artificial nor repetitive. In Bellotto's palette dark tones predominate. He excelled at rendering the particular transparency of the cold light of eastern Europe. His urban views are extraordinary historical documents, with architectural details precisely rendered.

Oil on canvas; 19 × 31⅝₆ in. (48.4 × 79.6 cm)
The Samuel H. Kress Collection 61.71

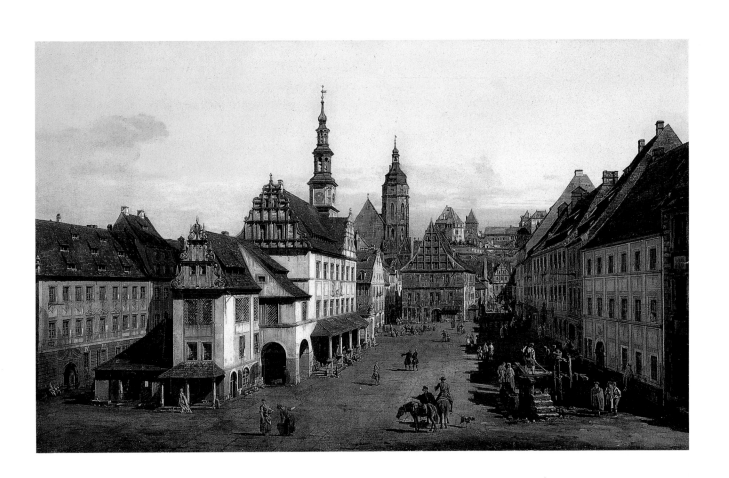

JEAN-BAPTISTE-SIMÉON CHARDIN

French; Paris, 1699–1779

The Good Lesson, c. 1753

Chardin was first known for his delicate and subtly composed still lifes, which he began to paint in the 1720s following an apprenticeship in the atelier of a little-known painter of historical subjects. His early works have an unusual surface characterized by crustlike accumulations of overlaid pigments. In the 1730s Chardin turned his attention to genre themes in the tradition of seventeenth-century Dutch and Flemish painting, at the same time reviving the genre imagery of the golden age of seventeenth-century French art, notable in the work of the Le Nain brothers, Antoine (1588–1648), Louis (1593–1648), and Mathieu (1607–1677).

The Good Lesson is among Chardin's last genre pictures, painted just before he turned once more to the practice of still life. A young mother or governess, her embroidery temporarily put aside, listens attentively while a girl, who stands dutifully before her, recites a lesson from Holy Scripture. Chardin takes delight in recording the most subtle gestures and expressions: the woman holds the pages of the Bible delicately between thumb and forefinger while she looks tenderly at the girl; the young girl looks down at the book, her hands gently clasped. The scene is illuminated by a gentle, hazy light that falls through the panes of a red-curtained window at the left.

It is the action of the light, transforming and enlightening Chardin's woman and child, that sets this late genre painting apart from those of the artist's precursors. To achieve the gentle, almost palpable illumination, Chardin eschewed the scumbled, layered brushstrokes of his earlier work, painting his figures with an enameled smoothness that recalls the manner of the seventeenth-century Dutch painter Gerard Terborch (1617–1681). He renders various textures not through the physical mimicry of sculptured paint but by a delicate illusionism, sensitive to the most refined nuances of reflected light and color. Humble, simple, but rich in tender emotion, *The Good Lesson* is one of Chardin's most evocative late figure pieces.

Oil on canvas; 16⁵⁄₁₆ × 18⁵⁄₈ in. (41.5 × 47.3 cm)
Gift in memory of George R. Brown by his wife and children 85.18

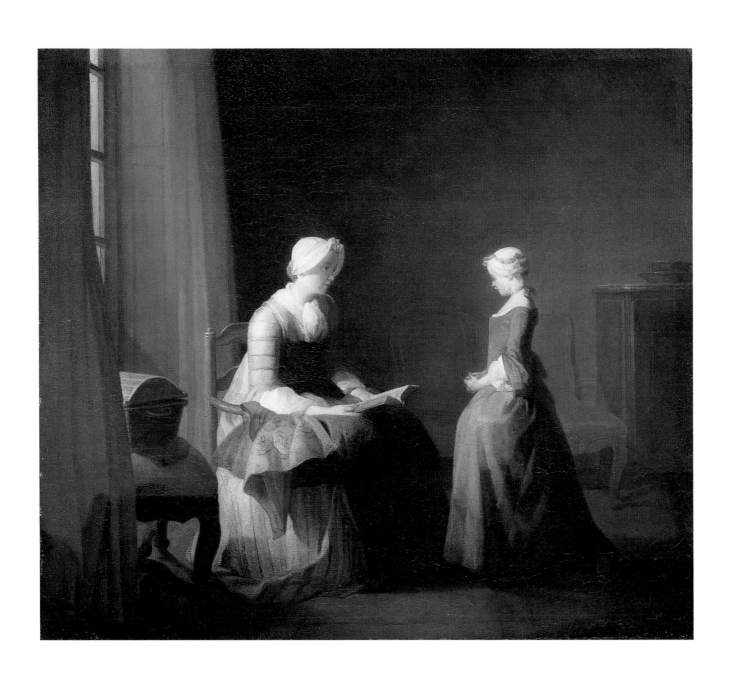

Portrait of William Fermor, 1758

Pompeo Batoni, born in Lucca, arrived in Rome in 1727. There he established himself as a painter of mythological, historical, and religious pictures in the late baroque manner. It was not as a history painter that he achieved his greatest success, however, but as a portraitist. Batoni was known through Europe as the most famous artist in Rome, and sitters flocked to him to have their portraits painted in the grand and stylish manner that he evolved in the 1730s and 1740s. Batoni's best portraits, whether of royalty, nobility, or the merely wealthy, blended realistically described features and ennobling details of costume and composition.

This work is representative of the half-length portraits in which Batoni specialized. Batoni posed his sitter in a rich cloak of fur-lined velvet, a letter in hand, against a dark background. The pose and accessories of the portrait suggest both a traveler reading a business document and a ruler reading a royal decree.

Fermor was, in fact, the very type of patron favored by Batoni: a young Englishman on the grand tour. Born in 1737 to a Catholic family in Oxfordshire, Fermor sat also for Batoni's younger contemporary, the German-born Anton Mengs (1728–1779), who had settled in Rome in 1755. By studying Mengs's portrait of Fermor (Ashmolean Museum, Oxford) scholars were able to identify Batoni's portrait of the young man. Given Fermor's clothing, it is likely that it was painted in the winter, before the sitter's return to England in 1758.

Oil on canvas; 39⅛ × 28¹⁵⁄₁₆ in. (99.4 × 73.5 cm)
Signed and dated verso: Pompeo Batoni Fecit 1758
The Samuel H. Kress Collection 61.76

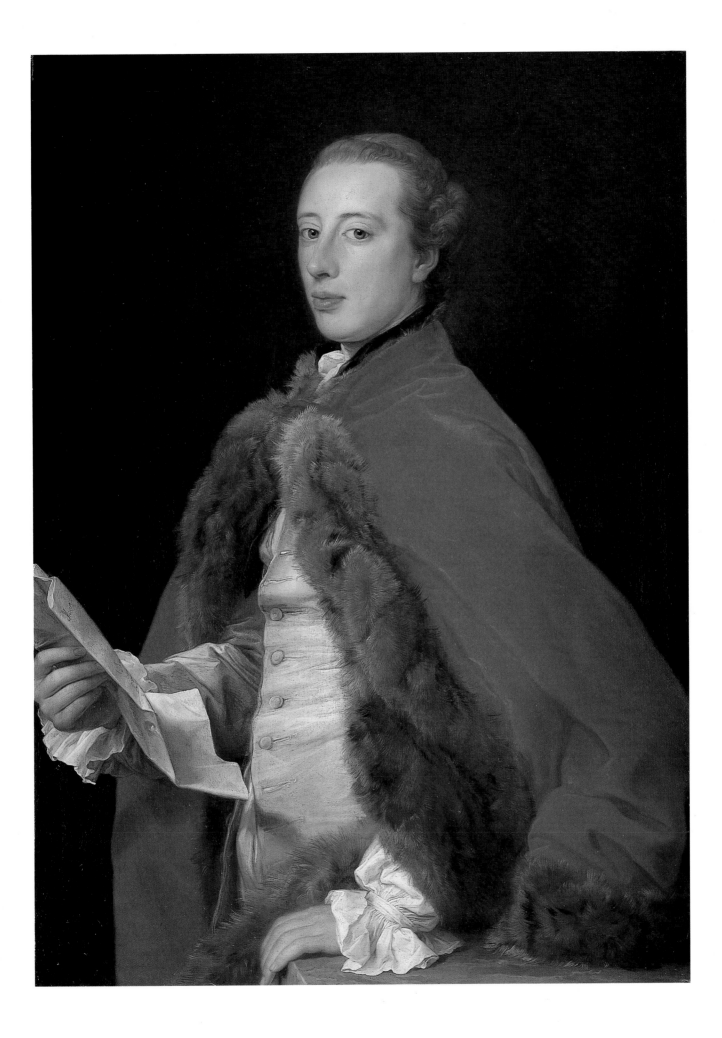

Jean-Étienne Liotard was well known throughout European art circles in the eighteenth century. Although he was active principally in France, which he considered "the greatest of Empires," and in his native Switzerland, he traveled extensively; he resided in England, the Netherlands, and Italy and journeyed to the Near East for an extended period. In Constantinople he began to affect the curious beard and orientalizing costume that earned him the nickname "le Turc." His greatest fame was as a pastelist: Liotard was so well known in the mid-eighteenth century that the American John Singleton Copley (1738–1815) wrote to him from Boston in 1762 to ask for pastel crayons and for Liotard's counsel on using them.

Liotard's sitter, Jean-Louis Buisson-Boissier, was born in 1731. By profession a lawyer, Buisson was forced to declare bankruptcy in 1797, eight years before his death in 1805. Although his own fortunes were not happy, his descendants continued to enjoy prosperity and to inhabit his Geneva town house.

The picture represents the epitome of the eighteenth-century pastel portrait. The pastel is applied to the suede side of a sheepskin for optimum richness of surface and greatest adherence of the medium. Impeccably preserved, the brilliantly colored chalks are worked by Liotard's harmonious, blending touch to suggest the differing surfaces of velvet, flesh, and hair. The rich pinks and whites of the face and coiffure are applied in meticulous hatchings; the lavender of the coat reflects light on the fabric; and the astonishing chartreuse and olive green background has a smooth, uninterrupted surface.

Pastel on vellum; 24⅞₆ × 19¼ in. (62.1 × 48.9 cm)
Museum purchase 86.28

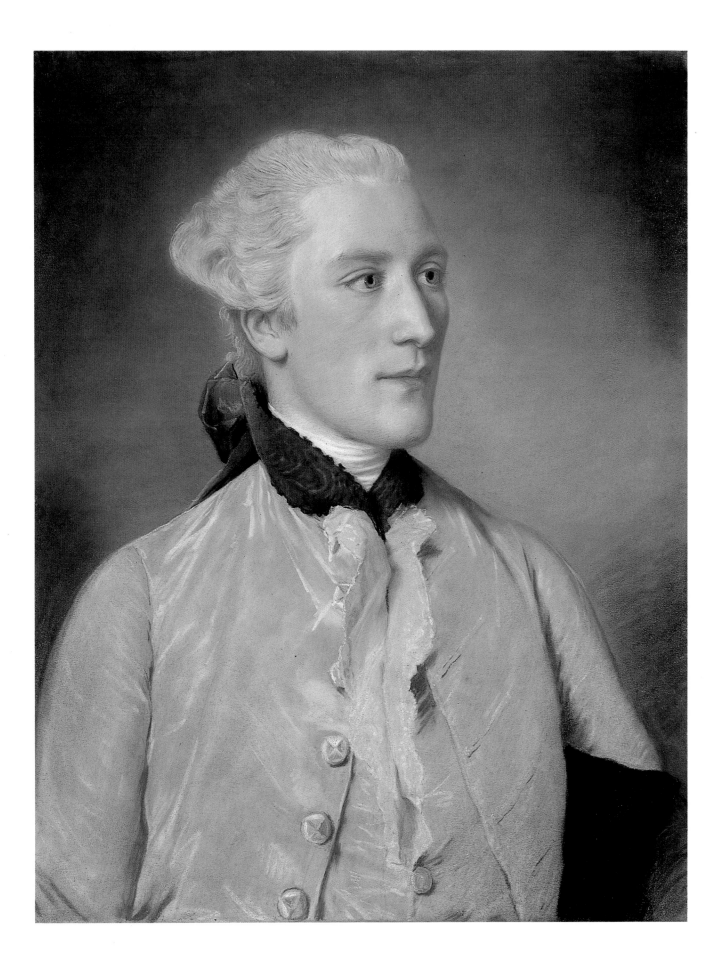

Infant Satyrs, late eighteenth century

Claude Michel, better known as Clodion, was born to a family of sculptors. He studied first with his uncle, Lambert Sigisbert-Adam (1700–1759), and then with Jean-Baptiste Pigalle (1714–1759). In 1759 he won the Prix de Rome and in 1762 went to Italy, where he remained for nine years. While in Italy Clodion forged his reputation and established the repertoire of subjects for which he would become noted. He usually represented small mythological figures—putti, satyrs, or nymphs—with erotic overtones. Clodion copied his mythological subjects from antique vases, cameos, or reliefs and embellished them with effects borrowed from Peter Paul Rubens (1577–1640) and contemporary French painters. For the generations after the French Revolution, and notably for the *amateurs* of the late nineteenth century, Clodion epitomized the spirit of eighteenth-century France.

These two figures holding birds are typical of his production. Several versions are recorded in terra-cotta, marble, and bronze. Indeed, Clodion's infant satyrs were so popular that they were often translated into decorative bronzes and used even as candelabra.

Terra-cotta; height each including base 16 in. (40.6 cm)
Signed on each trunk: Clodion
The Edith A. and Percy S. Straus Collection 44.576–77

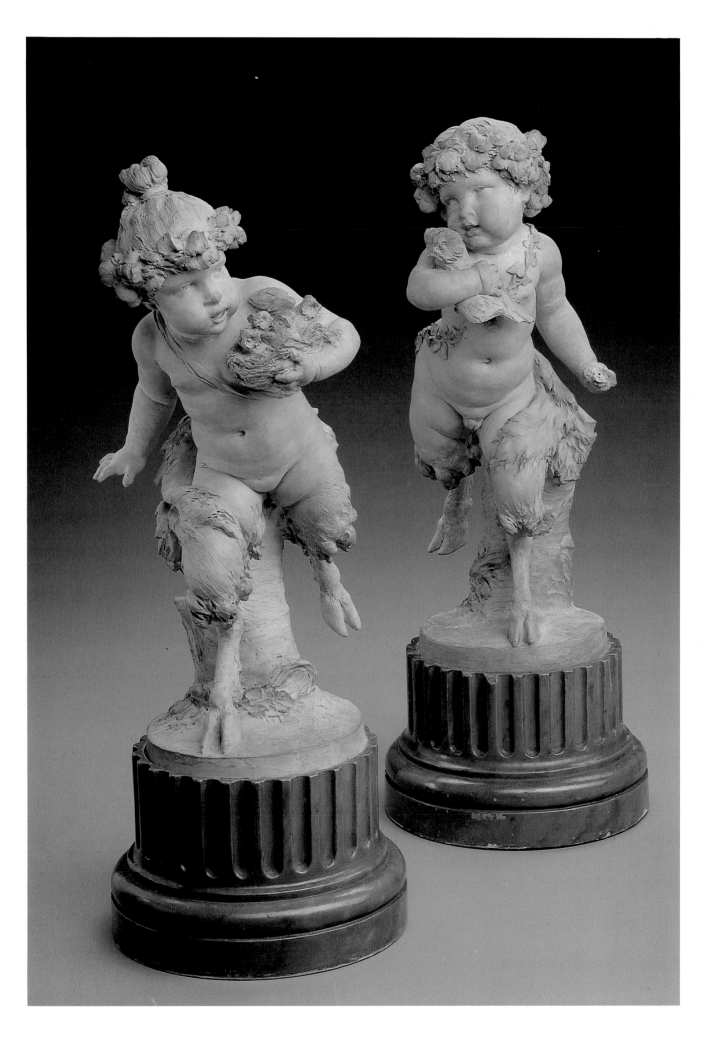

One of the great sculptors of the nineteenth century, Thorvaldsen was the son of a wood-carver. At the age of eleven he entered the Academy of Fine Arts in Copenhagen, where he quickly won the approval of his teachers. At seventeen he was sent by the academy to study in Rome. The classical world opened his eyes to a new vision of art, and for the rest of his life Thorvaldsen would celebrate the anniversary of his first arrival in Rome. His work was widely admired and collected by Europeans visiting Rome in the first decades of the nineteenth century. He returned in glory to his native Copenhagen in 1838 and died there six years later.

Following in the tradition of the Italian neoclassical sculptor Antonio Canova (1757–1822), whose place he was to fill as the senior sculptor in Rome, Thorvaldsen sculpted pure white marbles inspired by the greatest works of antiquity. He admired most the classically ideal forms of fourth-century B.C. Greek sculpture, which he knew from antique Roman copies.

The museum's life-size *Venus* holds the apple that the Trojan Paris awarded her as the most beautiful of the goddesses. Venus clasps the apple delicately in her right hand, reaching with graceful modesty for the drapery that rests on the tree stump beside her. The surface of the figure, carved of Carrara marble, is finely honed, its smoothness contrasted with the rough-hewn bark and earth at the goddess's feet.

Thorvaldsen's original full-scale plaster model for *Venus* was completed between 1813 and 1816 and is now in the collection of the Thorvaldsen Museum, Copenhagen, the greatest single repository of the sculptor's works.

Marble; height 63¾ in. (161.9 cm).
Museum purchase with funds provided by the Alice Pratt Brown
Museum Fund 85.309

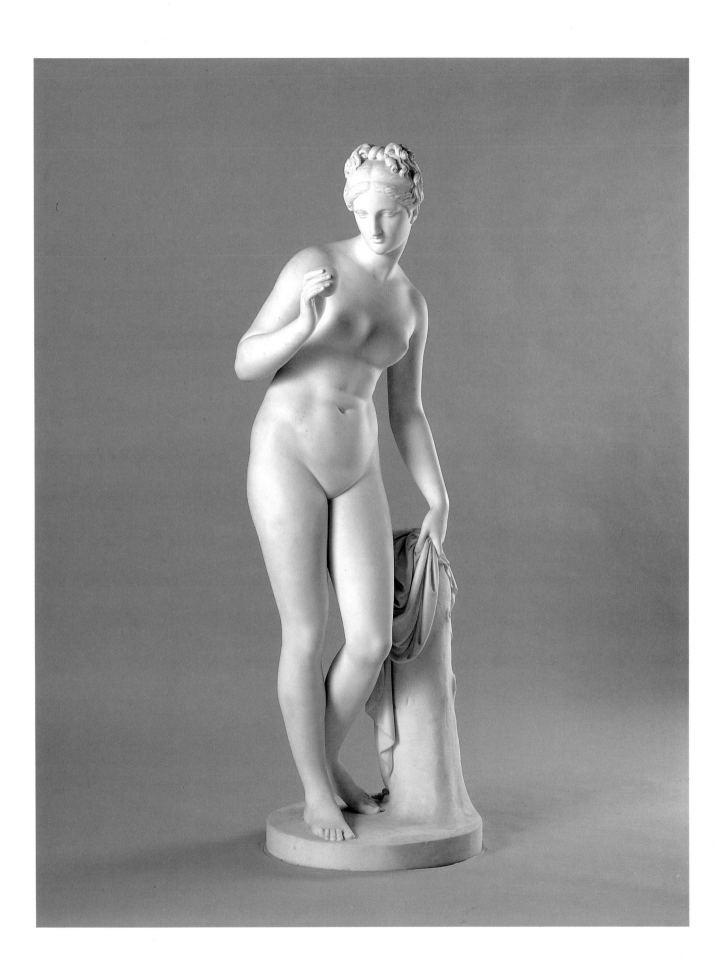

Woman and Little Girl of Constantine with a Gazelle, 1849

S on of a French diplomat to the Antilles, Chassériau came to France, settling in Paris, with his family when he was two. Extraordinarily precocious, Chassériau entered the studio of the great neoclassical painter Jean-Auguste-Dominique Ingres (1780–1867) when he was only eleven. Despite his neoclassical training, he became associated with many romantic artists, including Eugène Delacroix (1798–1863) and Théodore Rousseau (1812–1867), and writers, including Gérard de Nerval and Théophile Gautier.

In 1846 Chassériau, like Delacroix before him, visited North Africa. The museum's picture presumably depicts a subject he saw in the Algerian city of Constantine. Chassériau's mature paintings generally involve a personal amalgam of the otherwise contradictory styles of romanticism and neoclassicism; his North African subjects tend, as here, to a more purely romantic form. Although the painting is small, Chassériau liked it well enough to submit it to the Salon, where it was exhibited in 1850–51. He also made a soft-ground etching after it, published in the magazine *L'Artiste* in 1851.

Oil on panel; 11⁹⁄₁₆ × 14⅝ in. (29.4 × 37.1 cm)
Signed and dated lower right: Th^re Chassériau 1849
*Museum purchase with funds provided by the Agnes Cullen Arnold
Endowment Fund 74.265*

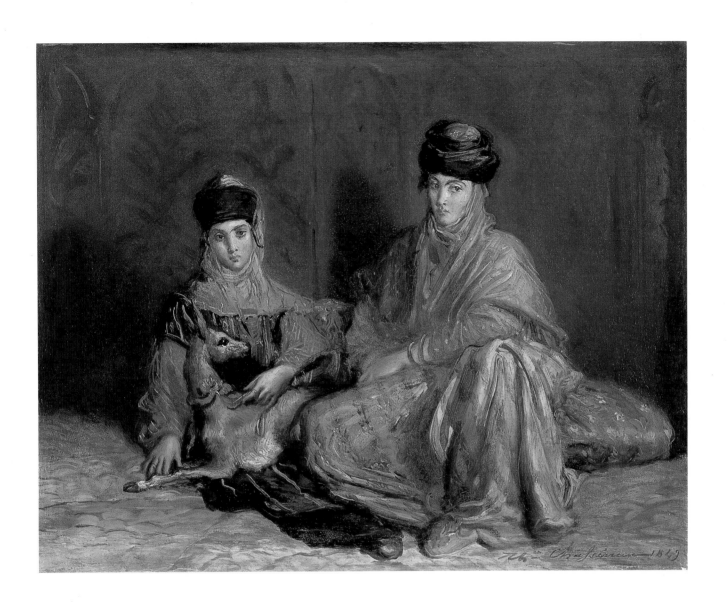

Andromeda, c. 1852

The name Eugène Delacroix is now almost synonymous with French romanticism. The child of a diplomat and his wife, who was descended from an artistic family, Delacroix is widely believed to be the natural son of a family friend, the celebrated statesman Talleyrand. Trained under Pierre-Narcisse Guérin (1774–1833) and a student of Jacques-Louis David (1748–1825), in about 1816 Delacroix befriended the painter Théodore Géricault (1791–1824), who preceded him by a few years as a founding figure in the romantic movement. A trip to North Africa in 1832 awoke in Delacroix a new gift for painting works of complex color harmonies, inspired not only by the observation of the effects of brilliant light but, eventually, by an admiration for the color of the Venetian Renaissance painters and for Peter Paul Rubens (1577–1640).

Andromeda is a work of Delacroix's last period, a glowing, sketchlike canvas in which the painter summarized with unusual economy the lessons of his colorism. Andromeda's body is painted, as Delacroix described it, with "a rather deep mauve beside a rose tone—the *demi-teinte* of a young ingenue; the least bit of green, placed alongside, completes it."

Despite its size, the painting recapitulates the themes and techniques that had preoccupied Delacroix throughout his career: scenes of highly charged emotions and sexual tension; emulation of the masterworks of the past; use of broken, shimmering brushwork; and fascination with brilliant color. Delacroix equally prized his sketches and salon pictures. He wrote to an admirer in 1850: "It seems that some *amateurs* . . . have decided that because I paint big pictures well, I must be inferior at painting small ones. Myself, I do both of them with the same pleasure, and I believe that one can put into a little frame just as much interest as in a whole monument."

Oil on canvas; 12⅞ × 9¾ in. (32.5 × 24.8 cm)
Inscribed (by another hand?) lower left: E.D.
Gift of Mr. and Mrs. Raymond H. Goodrich by exchange 85.1

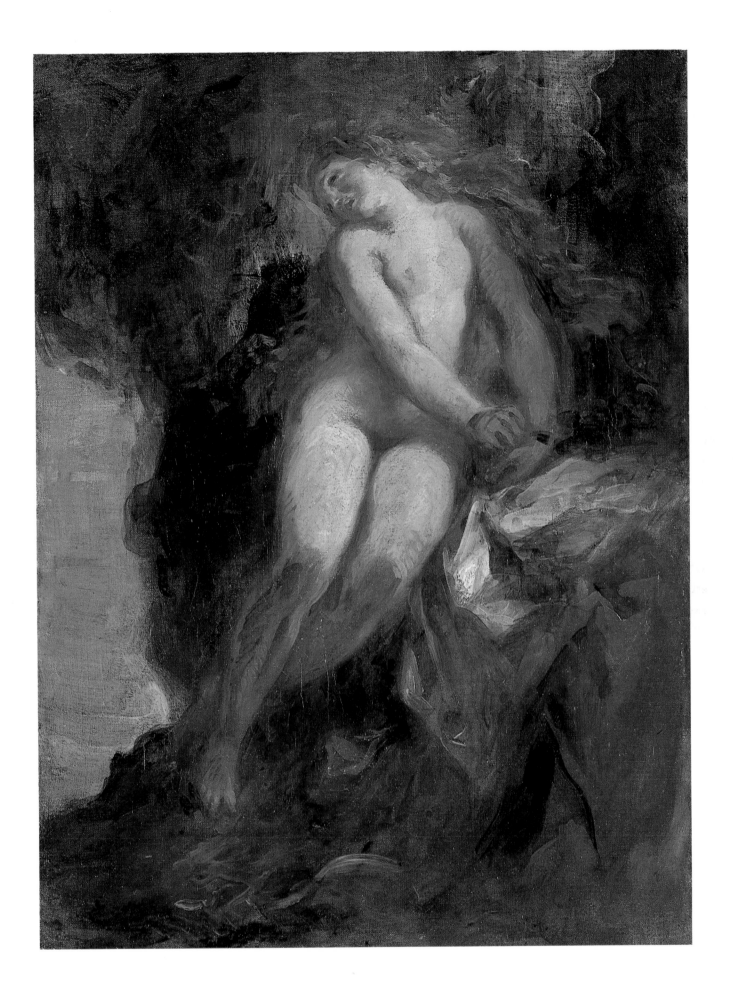

Charles-François Daubigny, who linked the Barbizon-school landscape painters and the impressionists, was the first artist to have his pictures criticized (in 1861) as "mere impressions." Although generally identified with the Barbizon school, he spent only a limited time in the town of Barbizon and the nearby Forest of Fontainebleau, preferring to paint riverbanks along the Oise and the Seine. He was a successful painter: in 1857 he received both the Légion d'honneur and a first-class medal at the Salon. Despite his official success, he was not immune to the appeal of the young impressionists; he was a personal friend of Claude Monet (1840–1926) and even resigned in protest from the Salon jury in 1870 when works by Monet and other impressionists were rejected.

Sluice in the Optevoz Valley illustrates Daubigny's solution to the dilemma presented to an artist who desired official honors but whose preferred brushwork was too free for official success. The painting was commissioned by the French government in 1854. Evidently finding the picture too spontaneous to be acceptable to the state and to the Salon jury, Daubigny refused to weaken it by overfinishing. Instead, he copied the picture on another canvas of substantially identical size. That version, exhibited in the Salon of 1855, is now in the Musée des Beaux-Arts, Rouen.

Oil on canvas; 35½ × 63¼ in. (90.2 × 160.7 cm)
Museum purchase with funds provided by
Anaruth and Aron S. Gordon 79.122

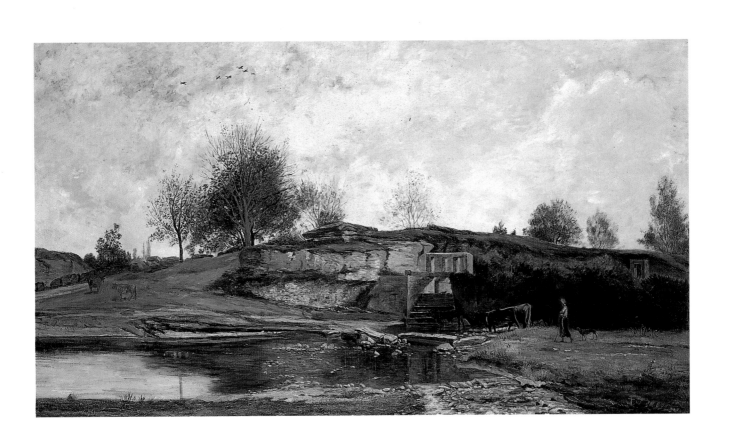

With a career spanning the development of French painting from classicism and romanticism to realism and impressionism, Corot is the most important landscape painter of the generation before impressionism.

Early in his career Corot trained with Achille-Etna Michallon (1796–1822) and Jean-Victor Bertin (1767–1842) and from 1825 to 1828 traveled extensively in Italy, where he painted brilliant views of Rome and the Campagna, the countryside around Rome. Returning to his native France, Corot became known as one of the masters of the Barbizon school. Throughout his career his art was divided between two tendencies: plein air painting—spontaneous sketches made out of doors, evoking the landscape of the Forest of Fontainebleau or the countryside around Paris; and Salon painting—large, finished pictures with themes from mythology, ancient history, and literature, intended to represent the artist at the Salon.

Orpheus Leading Eurydice was first presented at the Salon of 1861. It represents the moment when Orpheus, son of Apollo, reclaims his wife, Eurydice, from the underworld. Eurydice's beauty had inflamed the desire of the shepherd Aristaeus; fleeing from his advances, she had run into a field and been bitten by a snake. Her husband, in his grief, journeyed to the underworld to reclaim her. There, his plaintive songs convinced Pluto and Persephone to allow him to take Eurydice back to the world of the living on the condition that he not look at her during the long journey through the underworld. In Corot's painting Orpheus grasps his wife's arm and forges resolutely ahead toward the light, his lyre held out before him like a shield. The tale has a poignant ending, for just as he was about to reach the upperworld, Orpheus turned to look at his wife and she was lost to him forever.

Oil on canvas; 44¼ × 54 in. (112.3 × 137.1 cm)

Signed lower left: COROT

Museum purchase with funds provided by the Agnes Cullen Arnold Endowment Fund 87.190

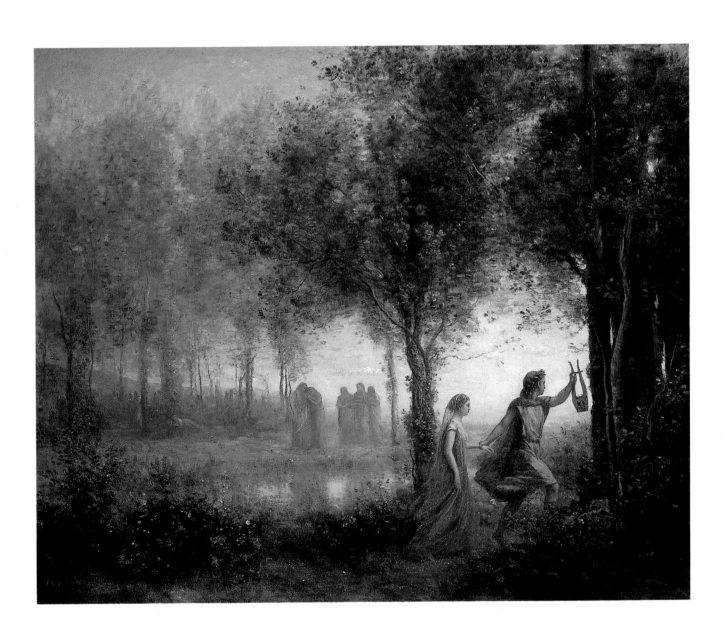

ÉTIENNE-PIERRE-THÉODORE ROUSSEAU

French; Paris 1812–Barbizon 1867

The Great Oaks of Old Bas-Bréau, 1864

Théodore Rousseau began his career as a painter in 1826 under Jean-Charles-Joseph Rémond (1795–1875), a successful landscapist working in a classicizing style. Dissatisfied with Rémond's teaching, Rousseau left to paint in the countryside near Paris; over the years he traveled widely in France and Switzerland. From the 1820s he painted in the Forest of Fontainebleau and eventually settled in the nearby town of Barbizon. Although Rousseau's submissions to the Salon were accepted between 1831 and 1835, from 1836 until after the Revolution of 1848 they were rejected; after 1849 he again exhibited regularly.

His later works were generally well received, in part because Rousseau gradually abandoned the Byronic romanticism characteristic of his youth in favor of a more naturalistic approach, and because the conservative critics had other, younger painters to decry, notably Gustave Courbet (1819–1877) and Edouard Manet (1832–1883).

The Great Oaks of Old Bas-Bréau was painted in 1864, three years before the artist's death. It presents a remarkable surface, in which elements of drawing and painting are interwoven over the ground. Rousseau's painting, with its brushwork resembling strokes of a pen, might at first glance suggest an unfinished picture. The artist's signature, however, indicates that Rousseau deemed *The Great Oaks* finished. Presumably, he kept such pictures for himself or for friends; his submissions to the Salon were never left in such a sketchlike state. More than his Salon entries, however, *The Great Oaks* reveals the temperament of an artist bent on capturing with crayon and brush the grandeur of untouched nature.

Oil on canvas; 35½ × 46 in. (90.2 × 116.8 cm)

Signed lower left: TH Rosseau

Museum purchase with funds provided by the Agnes Cullen Arnold Endowment Fund 72.87

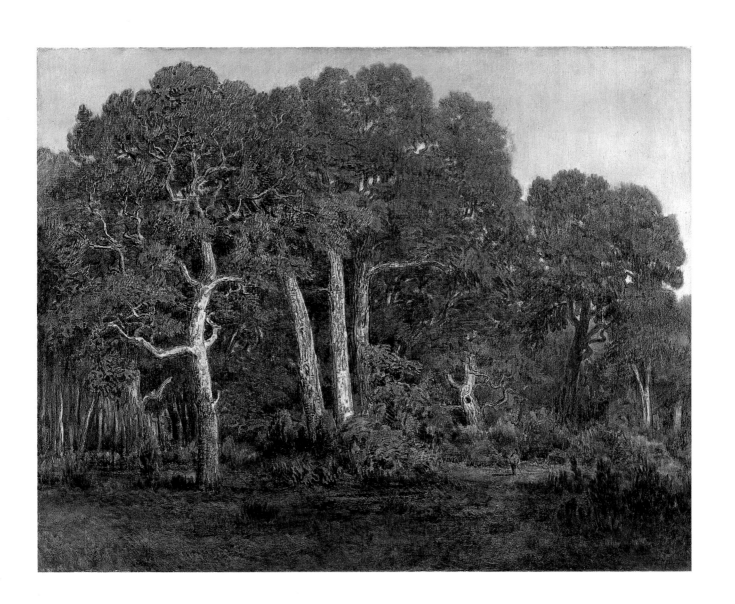

The Seine at Paris, 1871

Armand Guillaumin began his career as a clerk, finding time to enroll at a small art school in Paris and later to draw on his own at the Académie Suisse, where he met Paul Cézanne (1839–1906). Guillaumin exhibited with other artists at the Salon des Refusés, an exhibition in 1863 of works rejected by the Salon. Realizing that he had no future in the official Salon system, he participated in the first impressionist exhibition of 1874, exhibiting three landscape paintings. One, *The Seine at Paris*, originally entitled *Rainy Weather*, is a majestic work of a mundane subject. The painting, surely Guillaumin's masterpiece, is thoroughly modern in its choice of a humble, urban landscape peopled with ordinary Parisians. With its threatening sky, it revealed, perhaps, a preference for melancholy subjects, which he and his friend Cézanne preferred. At the time this canvas was painted Guillaumin shared a studio with Cézanne.

The 1870s and 1880s were difficult for Guillaumin, who held a routine job with the city of Paris to support himself and his family. In 1891 he won a lottery that gave him financial independence, but he continued working another year to secure his pension. He then devoted himself entirely to painting.

Oil on canvas; 49¾ × 71⅜ in. (126.4 × 181.3 cm)
Signed and dated lower right: A Guillaumin 71
The John A. and Audrey Jones Beck Collection 71.5

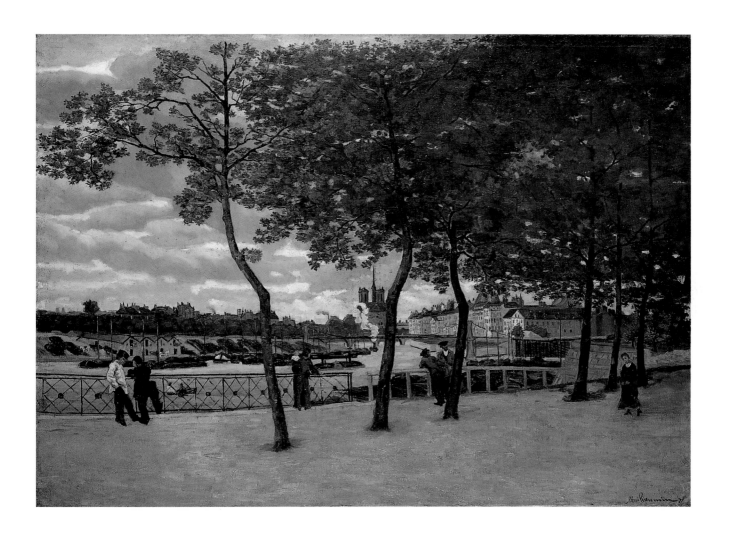

Pierre-Auguste Renoir began his career in the 1850s as a decorator of porcelain and in 1862 enrolled in the studio of Charles Gleyre (1806–1874), where he met Frédéric Bazille (1841–1871), Claude Monet (1840–1926), and Alfred Sisley (1839–1899). Renoir participated in the first impressionist exhibition of 1874 and in some of the subsequent exhibitions. He was unwilling, however, to accept the rule that participants in the impressionist exhibitions should forego exhibiting in the Salon, and his works were shown in official exhibitions from time to time. Renoir's interest in impressionist rendering of atmosphere and free brushwork began to wane in the early 1880s, and by 1884 he broke in some measure with the impressionists in favor of a more linear, tightly brushed style. About 1890 his brushstrokes became broader and freer again, although he was more concerned with rendering weight and mass than with his earlier fervent interest in the transient effects of light.

Still Life with Bouquet is an homage to some of the artist's predecessors: the color scheme, especially the red and green, refers to the work of Delacroix; the print shown on the wall is copied from Manet's etching after a painting then believed to be by Diego Velázquez (1599–1660) and is, therefore, a double homage to both men; and the Japanese fan and oriental vase point to Renoir's interest in *japonisme*, popular among sophisticated artists in France during the 1860s. Despite such references to earlier art, *Still Life with Bouquet* reveals the originality of Renoir's vision. His choice of thinly applied colors on a white ground, partly visible through the translucent paint, heightens the visual effect. The composition subtly plays repeated curvilinear forms—bouquet, fan, and jar—against rectangular objects—print, frame, and books.

Oil on canvas; 28¹³⁄₁₆ × 23³⁄₁₆ in. (73.3 × 58.9 cm)
Signed and dated lower right: A. Renoir.71
The Robert Lee Blaffer Memorial Collection,
gift of Sarah Campbell Blaffer 51.7

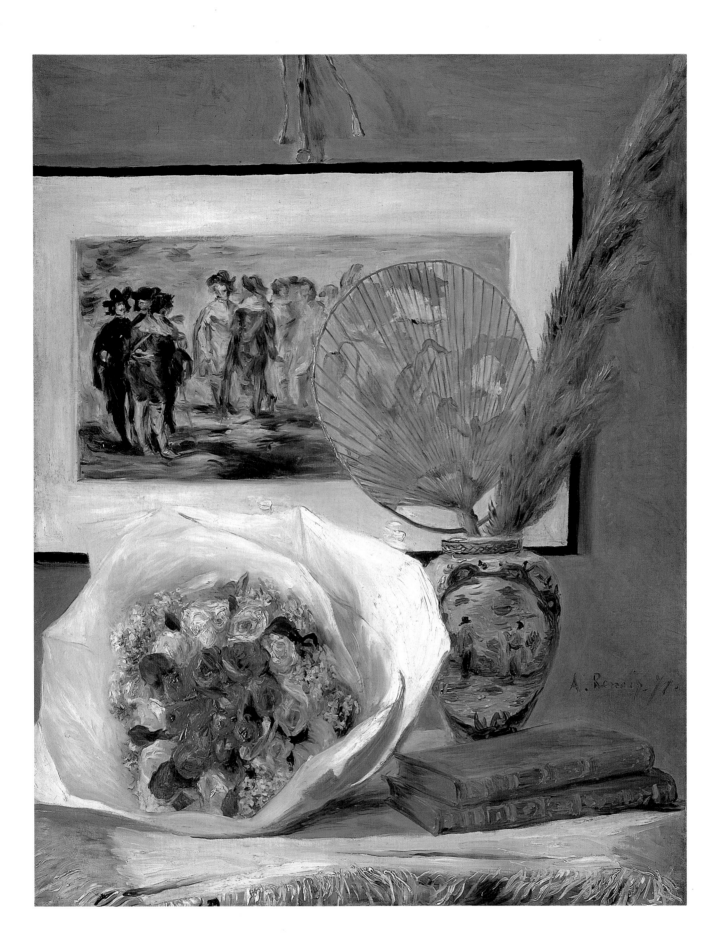

MARY CASSATT

American; Allegheny City, Pennsylvania, 1844–Château de Beaufresne, France, 1926

Susan Comforting the Baby, c. 1881

Mary Cassatt left Philadelphia for Paris in 1868 to become a painter. In 1875 she enrolled in the studio of the academic painter Charles Chaplin (1825–1891) but two years later was invited by Edgar Degas (1834–1917) to join the "Indépendants." Thereafter, she exhibited in several impressionist exhibitions. In addition, she was a friend of Manet, whose free brushwork influenced her just as Degas influenced her composition. Cassatt, like Degas and Manet, was interested in the depiction of modern life and like them eschewed the purely visual effects of nature that interested their colleagues, Monet and Sisley, who are better known for their landscape paintings.

Susan Comforting the Baby reveals Cassatt's sources in its adoption of Manet's free brushwork and Degas's innovative compositional structure. It also illustrates her extraordinary ability to render intimate moments between a woman and a child more convincingly than any other impressionist painter.

Oil on canvas; 25⅝ × 39⅜ in. (65.1 × 100.0 cm)
Signed lower left: Mary Cassatt
The John A. and Audrey Jones Beck Collection 74.136

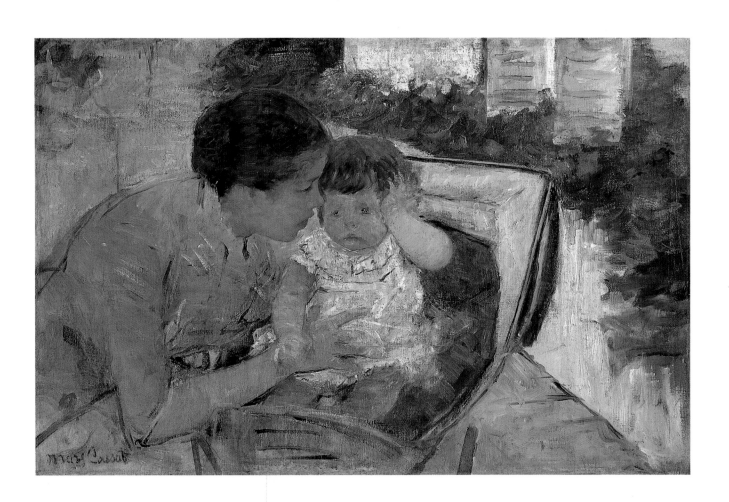

The work of Paul Cézanne has exerted a profound influence on the development of modern painting. First trained in his native Aix-en-Provence, in 1861 Cézanne went to Paris, where he studied at the informal Académie Suisse and met Camille Pissarro (1830–1903), who influenced his development in the first, impressionist, stage of his career. Cézanne sought, in contrast to his impressionist contemporaries, a classicizing, less naturalistic mode of expression, and attempted to realize in his canvases the sensations of light and color that he saw in nature. In his maturity he came to harmonize two seemingly antagonistic styles: he imposed impressionist free brushwork and the high-keyed color of natural light on compositions in which individual elements, including the human form, were reordered and even distorted.

Cézanne was a prolific portrait painter. Of his wife alone there are nearly thirty portraits painted between 1871 and 1895. Marie-Hortense Fiquet, Cézanne's mistress of sixteen years whom he married in 1886, lived apart from her husband most of the year and did not actively participate in his life, except as a model. Despite this indifference, Cézanne's portraits of her reveal a remarkable range of characterizations, from charming to vulnerable, or, as here, calmly dispassionate.

In *Madame Cézanne in Blue* the painter willingly abandoned naturalistic color and form in the interest of an abstract artistic unity. Cézanne has deliberately created an ambiguous pictorial space: the brown band at far right may represent a view into another room or simply more wallpaper. Nonetheless, Madame Cézanne is treated as a relatively tangible volume in space. She is drawn with a primitivism that affirms her reality, although she is described against a background that threatens to advance and negate her physically.

Oil on canvas; 29 9/16 × 24 in. (74.1 × 60.9 cm)
The Robert Lee Blaffer Memorial Collection,
gift of Sarah Campbell Blaffer 47.29

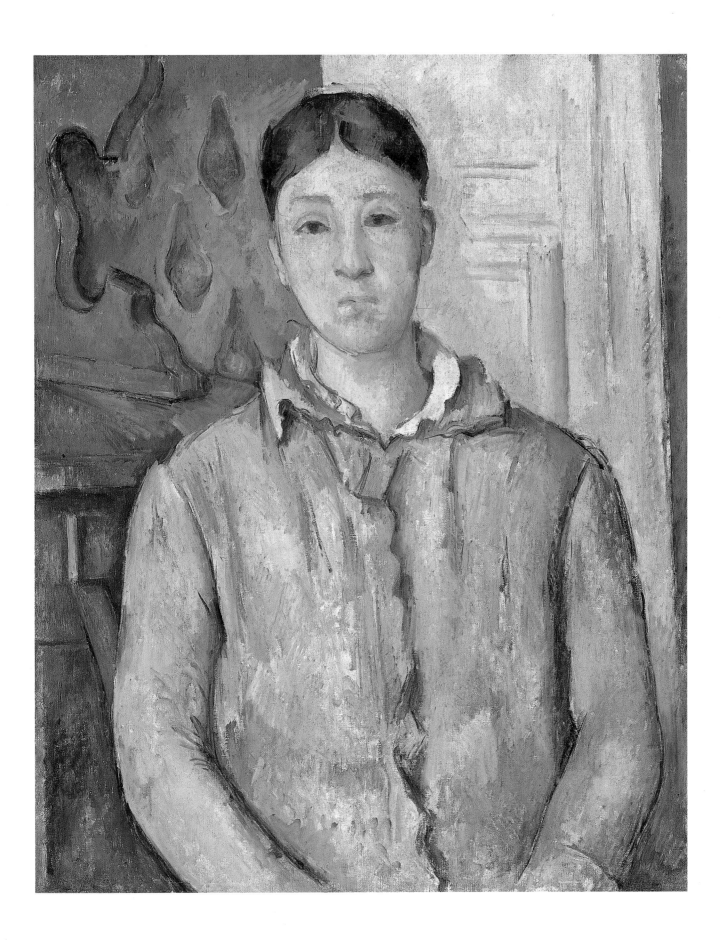

The Rocks, 1888

In his brief life of thirty-seven years Vincent van Gogh was called to both religion and art. He experimented with a variety of careers, all ending in failure. Early in his life he went to preach among the miners near Mons, Belgium, but his identification with their suffering overwhelmed his sensitive spirit. By 1880 he had decided to become a painter. In 1885 van Gogh attended the Royal Academy of Arts in Antwerp and a year later moved to Paris to live with his brother Theo. Theo had faith in his brother's work and supported him throughout his life, making enormous sacrifices in his behalf. In Paris, where he studied in the atelier of Fernand Cormon (1854–1924), van Gogh discovered the work of the impressionists and became friends with the leaders of the movement. In 1888 he left Paris for the southern town of Arles. In the light and landscape of Provence his paintings became brighter and more boldly painted. During the last three years of his life van Gogh entered psychiatric hospitals for treatment of his epilepsy and mental disorders. Shortly after an interim release from care in 1890 van Gogh took his own life.

The artist was preoccupied with the symbolic qualities of nature. Through expressive colors and intense, obsessive structure, his landscapes convey his belief in the mystical forces present in the natural world. *The Rocks*, painted near Arles in the summer of 1888, depicts a gnarled oak tree, shaped by the mistral winds, standing steadfast and alone. We see here the spontaneity of van Gogh's calligraphic brushstroke, thick and tactile, giving a sculptural quality to the rocks and trees. Layers of rich oil paint are built up in relief, revealing the artist's hand forcibly working the pigment to conform to his personal temperament and vision.

Oil on canvas; 21⅝ × 25⅞ in. (54.9 × 65.7 cm)
The John A. and Audrey Jones Beck Collection 74.139

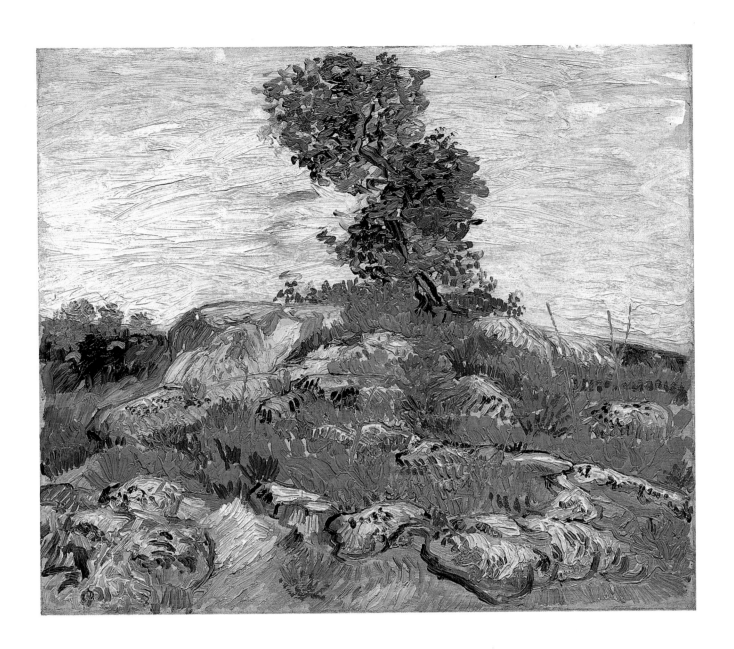

Paul Sérusier attended the Académie Julian in Paris to train himself for a traditional painting career. In 1888, the year he first exhibited in the Salon, he visited Pont-Aven in Brittany and there fell under the influence of Paul Gauguin (1848–1903). The following year Sérusier rejoined Gauguin at Pont-Aven, where they and other painters, including the young Émile Bernard (1868–1941), formulated a new style that they called cloisonnism, or synthetism. Under Gauguin's leadership members of the group sought to synthesize their observations of and feelings about the world by adopting a flattened perspective, intense color, and bold, decorative patterns. After Gauguin's departure for Tahiti, Sérusier became the movement's principal theoretician.

Landscape at Le Pouldu reveals Sérusier at the height of his powers and closest to Gauguin. The painting depicts the rough landscape surrounding the hamlet of Le Pouldu, near Pont-Aven. A Breton peasant woman stands in the landscape, every element of which explodes in brilliant color. The lush trees and grass are painted in intense yellow and emerald green; the muddy soil glows red and pink. The pictorial space suggests a carving in low relief; curvilinear rhythms unite the forms, especially the vegetation, in a decorative, non-naturalistic arabesque. *Landscape at Le Pouldu* epitomizes the pictorial qualities that were to draw the Nabis to the art of Gauguin and Sérusier, qualities noted by the Nabi painter Maurice Denis (1870–1943), who wrote, "A painting—before it is a battlehorse, a nude woman, or some anecdote—is essentially a flat surface covered with colors assembled in a certain order."

Oil on canvas; 29¼ × 36¼ in. (74.3 × 92.1 cm)
Signed and dated lower right: P. Sérusier—1890
Gift of Alice C. Simkins in memory of Alice N. Hanszen 79.255

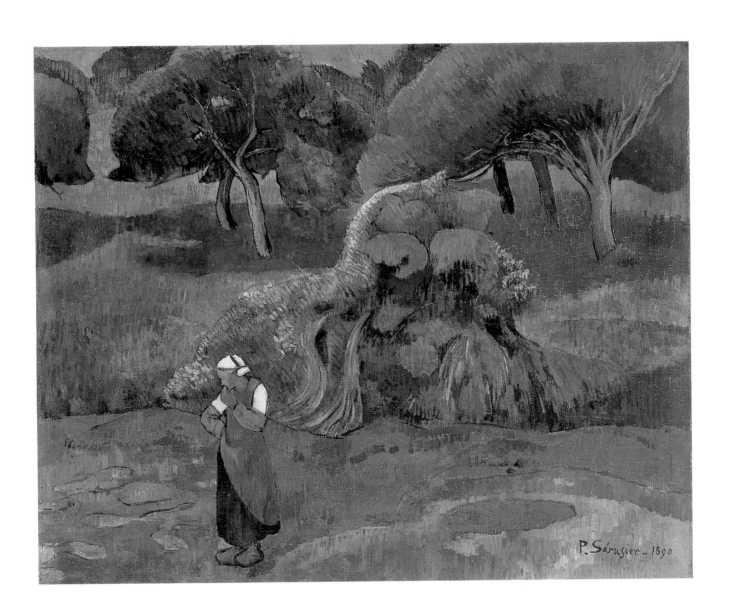

Paul Gauguin did not begin to paint seriously until he was twenty-five years old. By that time he was a successful businessman and had begun to collect impressionist paintings. His own work was first accepted in 1876 at the Salon, and he exhibited in the fifth impressionist exhibition of 1880. When France experienced a financial crash in 1883, Gauguin left his brokerage firm and his family to devote himself entirely to painting. Pissarro greatly encouraged him, and the two artists frequently painted together. During the late 1880s, working first with Bernard in Brittany and later with van Gogh in the south of France, Gauguin not only adopted Bernard's new painting technique, cloisonnism, but evolved a mode of painting in which boldly designed, highly colored figures participate in dramas charged with literary or spiritual meaning. In 1891 Gauguin left France for Tahiti, where he sought a native paradise and inspiration for his art. He lived among the islanders, absorbing their culture and depicting their pure and, to him, unspoiled spirituality.

When Gauguin first arrived in Tahiti he expected to find a primitive people who worshiped wood and stone idols. When he saw that such idols did not exist there, he carved his own figures, including one representing Hina, the spirit depicted in *Arearea II*. The painting, in the shape of a fan—a novel orientalizing format that also inspired Gauguin's friends Degas and Pissarro— derives from a picture called *Arearea*, a Tahitian word that Gauguin translated as "joyeuseté," or "joyfulness." *Arearea* (Musée d'Orsay, Paris) was painted by Gauguin in 1892. Scholars believe that the fan-shaped variant was painted in Paris in the autumn of that year, during Gauguin's stay in France after his first trip to Tahiti. It is the only one of Gauguin's many fans of the period that bears the marks of being folded, as if for actual use.

Gouache and watercolor on linen; 11¼ × 23 in. (28.6 × 58.4 cm)
Inscribed lower left: Brunaud (?)*; signed lower right:* P. Gauguin
The John A. and Audrey Jones Beck Collection 77.372

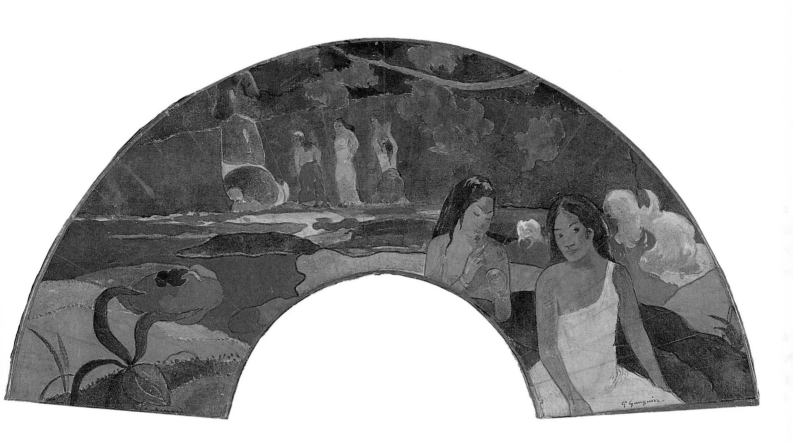

The Bonaventure Pine, 1893

Born into an affluent Parisian family, Signac was financially independent during his life. At the founding of the Salon des Indépendants in 1884 the twenty-one-year-old artist met Georges Seurat (1859–1891), and the two became close friends. It was with Seurat that Signac forged a link in developing the color theory of the style they called divisionism, in which small dots of color are applied in close juxtaposition to simulate the optical effects of light. This style, now commonly known as pointillism, made Signac and Seurat the leaders of the neo-impressionist artists who advanced avant-garde theories in the late 1880s. Signac traveled widely, maintained a studio in Paris, and exhibited at the salons there as well as in Amsterdam, Berlin, Brussels, and London. He wrote articles on neo-impressionism and was the author of *D'Eugène Delacroix au néoimpressionnisme* (1899), a history of nineteenth-century French painting.

Signac left Paris for Saint-Tropez a year after the death of Seurat in 1891. Shortly after he arrived in the south of France, Signac painted this picture of a giant umbrella pine on the property of a Monsieur Bonaventure. Using a pointillist technique developed first by Seurat, Signac captured the tree, native to the area, as an image of shelter and strength. For Signac, the sunlight and coastline of the Mediterranean made southern France a painter's paradise. His villa, La Hune, attracted many artists, including Albert Marquet (1875–1947), Henri Matisse (1869–1954), and Louis Valtat (1869–1952). These visitors, together with Signac and his neighbor, the artist Henri-Edmond Cross (1856–1910), transformed the pointillist style of painting from tiny dots to broader dashes of vivid color. From their early experiments the younger artists went on to found fauvism.

Oil on canvas; 25⅞ × 31⅞ in. (65.7 × 81.0 cm)
Inscribed lower left: Op 239; signed lower right: P. Signac 93
The John A. and Audrey Jones Beck Collection 74.142

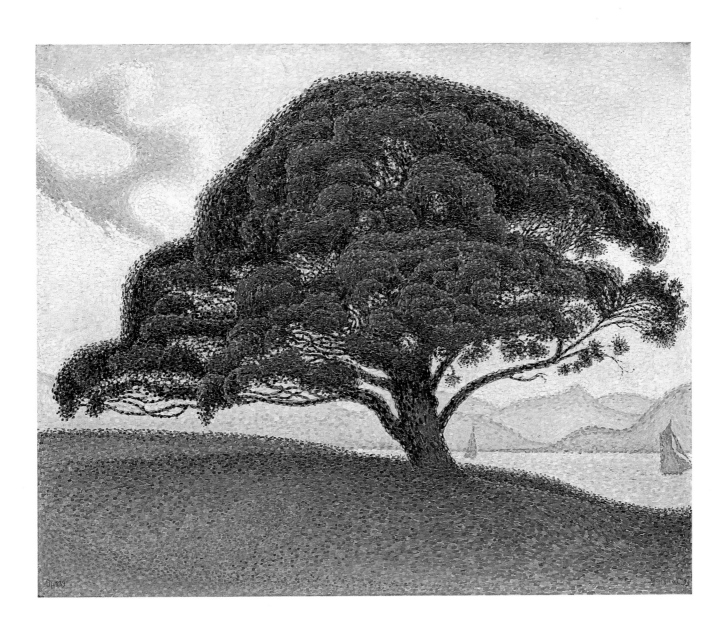

The Promenade, *1894*

Originally intending to follow a military career as did his father, Vuillard became involved with art through friendships with Ker-Xavier Roussel (1867–1944) and Maurice Denis, budding painters and his boyhood schoolmates at the Lycée Condorcet. In 1888 Vuillard attended the Académie Julian, a more liberal institution than the École des Beaux-Arts but, nonetheless, one with an essentially academic program. There he met Sérusier and became part of the Nabi group. The emphasis on two-dimensional design that characterized the art of the Nabis produced a flattening of masses in Vuillard's art as early as 1889. In an extraordinary series of paintings begun at this time Vuillard reduced forms to mere silhouettes. Toward the end of the decade a looser brushwork and three-dimensional rendering reappears in Vuillard's pictures. His later works, although lacking the bold patterns of the canvases of the early 1890s, display a heightened tactile sensitivity.

The Promenade formed part of a nine-panel series commissioned in 1893 by Alexandre Natanson, copublisher of *La Revue blanche,* for the dining room of his Paris apartment. The theme of each panel was an incident of daily life in one of the public gardens of Paris—an often repeated subject in the art of Vuillard. Painted with a variety of brushstrokes and color harmonies, the panels nonetheless imitated the mat surface of commercial wallpaper, a commodity much admired and frequently painted by Vuillard. In composition, however, each panel in the series is unique.

Oil with glue on canvas; 84⅜ × 38⁹/₁₆ in. (214.3 × 97.9 cm)
Signed and dated lower right: E Vuillard 94
The Robert Lee Blaffer Memorial Collection,
gift of Mr. and Mrs. Kenneth Dale Owen 53.9

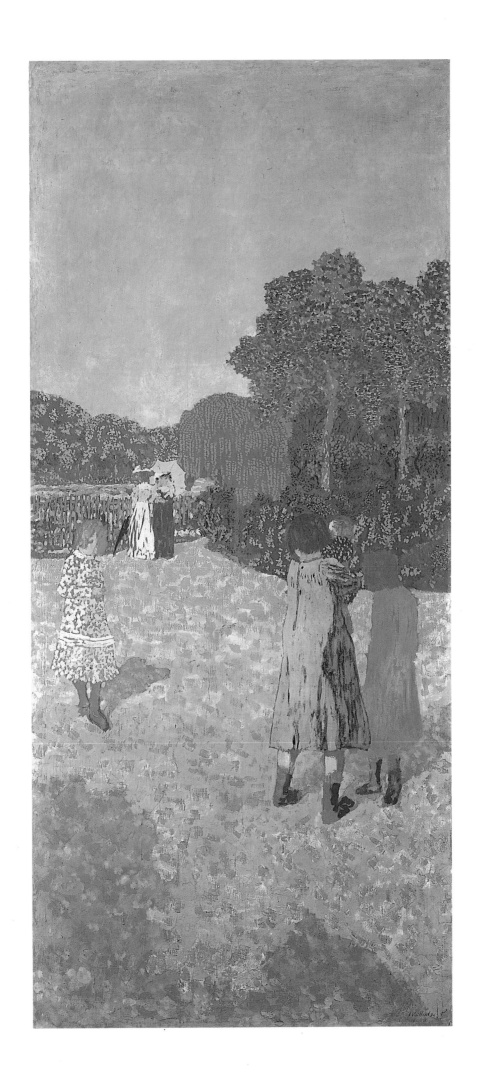

Prints and Drawings

Saint Eustace, c. 1500–1501

Albrecht Dürer learned to use the burin, the engraver's tool, in the studio of his goldsmith father even before he was apprenticed at age thirteen to Michael Wolgemut (1434–1519), a painter and designer of woodcuts. Steeped in the traditions of Jan van Eyck and Rogier van der Weyden, Dürer was among the first influential artists from north of the Alps to visit Italy; he made two visits to Venice, in 1494–95 and 1505–7, and saw there at first hand the art of the Italian Renaissance. Much of Dürer's life was devoted to creating monumental, naturalistically convincing figures set within a measurable geometric space—a goal of many Renaissance artists.

Saint Eustace, produced early in Dürer's career, is his largest engraving and reflects his keen appreciation of the landscape backgrounds of Flemish paintings. It depicts the legendary Roman general who converted to Christianity after seeing a stag with an image of the crucified Christ miraculously suspended between its antlers. In this print Dürer explores the range of tones possible within the medium of engraving and creates atmospheric perspective by contrasting the dark, rich foreground with the lighter, more delicate distant background. In *Saint Eustace* Dürer displayed a concern with ideal proportions, an interest that would preoccupy him throughout his career. In this print the proportions of animals are examined, but in other works Dürer extended his interest to the study of the human body.

Engraving on laid paper; 13¹⁵⁄₁₆ × 10⅜ in. (35.4 × 26.4 cm)
Signed bottom center in plate with monogram
The Edith A. and Percy S. Straus Collection 44.548

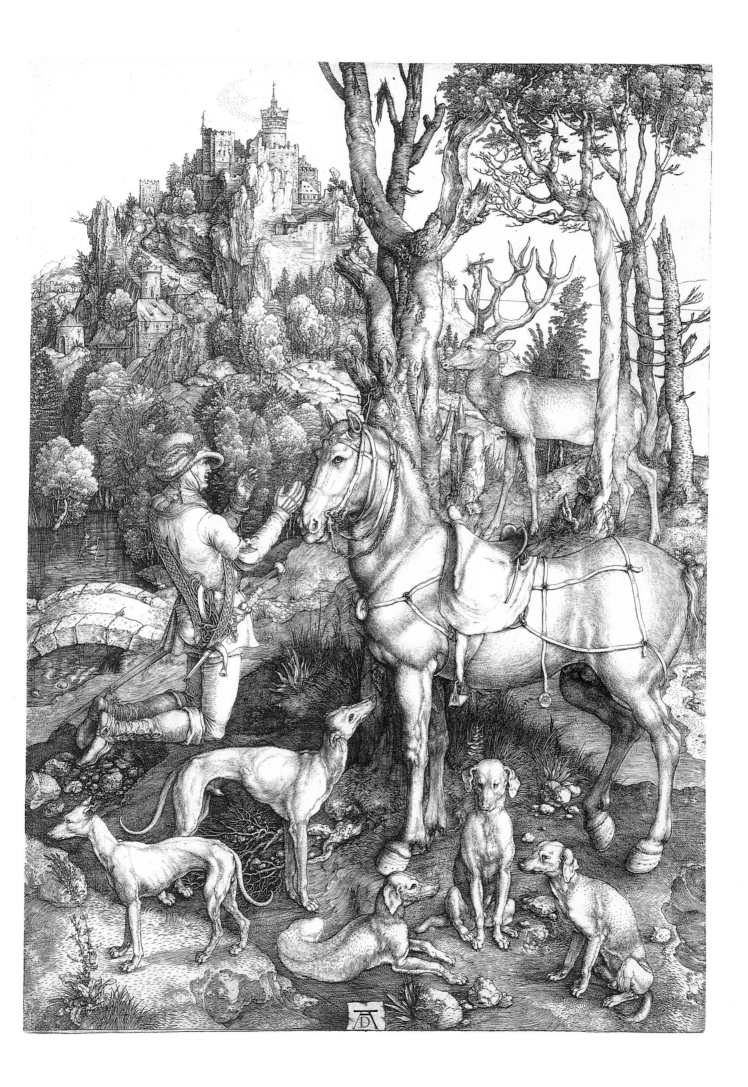

T he long career of Abraham Bloemaert began when mannerism dominated northern art and ended only after the baroque style had been thoroughly established. Bloemaert's early drawings and paintings not surprisingly display the sinuous, elegantly contorted forms characteristic of his mannerist origins. Bloemaert, however, was not immune to the more naturalistic elements of baroque art as it developed in the Netherlands, and his later works reveal this influence. This drawing, delicately heightened with watercolor, depicts a humble subject, the dilapidated gateway to a rough-walled town. Such studies were made late in Bloemaert's career, typically as preparations for background elements of landscape paintings with Old or New Testament themes.

This sheet is rare among Bloemaert's drawings because it bears the signature of the artist. Although Bloemaert did not date the sheet, it can be placed about the year 1630 because of similarities in style and subject with signed and dated paintings by the artist.

Pen and brown ink heightened with watercolor on laid paper;
8¹⁄₁₆ × 12⅛ in. (22.4 × 30.8 cm)
Signed lower left: A. Bloem f
Museum purchase 74.254

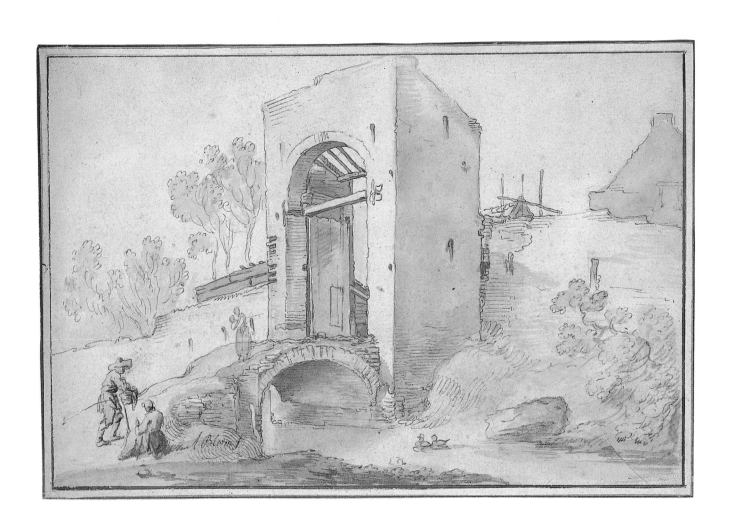

JEAN RESTOUT

French; Rouen 1692–Paris 1768

A Seated Faun, 1750s (?)

One of the most successful painters of historical and religious subjects in the first half of the eighteenth century, Jean Restout was the nephew of the painter Jean Jouvenet (1644–1717), his first teacher. At the age of fifteen Restout arrived in Paris and ten years later was accepted into the Académie Royale. He is best known today for the many religious paintings commissioned for the decoration of Parisian churches, but he also painted subjects drawn from history and mythology.

In its monumental conception and dynamic muscular tension, *Seated Faun* reveals Restout's origins in French baroque art. At the same time its subject matter suggests that Restout was not immune to the playful aspects of rococo painting. Like Restout's *académies*, or nude studies, the figure is drawn from a living model, but the artist has added to his nude the cloven hooves of a bacchic faun.

Black and white chalk on blue paper; 15¾ × 19⁹⁄₁₆ in. (40.0 × 49.7 cm)
Museum purchase with funds provided by the Meadows Foundation 85.100

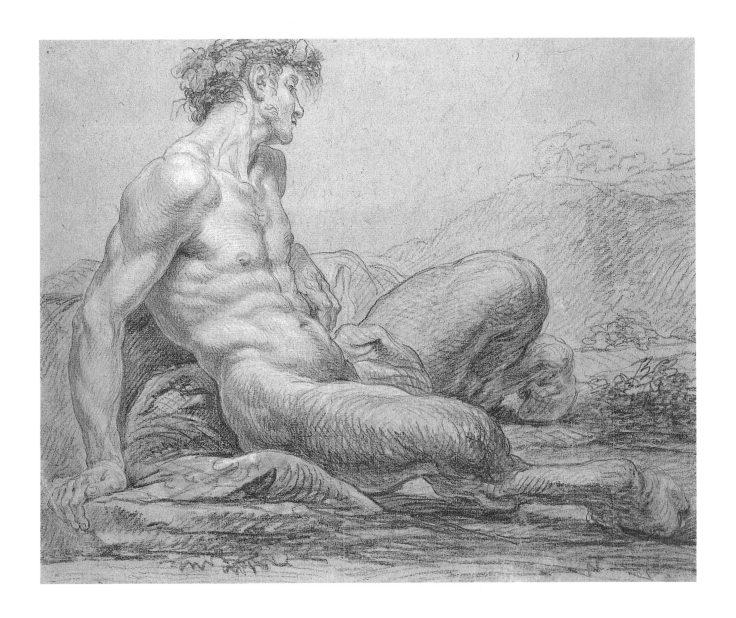

Portrait of a Lady, 1780s (?)

John Hoppner was one of the great portraitists at the end of the reign of George III. Following the tradition of Sir Joshua Reynolds (1723–1792), Hoppner, along with George Romney (1734–1802) and Henry Raeburn (1756–1823), elevated the craft of flattering portraiture to an art. Hoppner was perhaps the most stylish portraitist of his day and accordingly was granted many royal commissions, mostly from the prince regent, later George IV.

This drawing of an elegant Englishwoman is a work of stylish simplicity and charm. Hoppner must have studied the drawings of Jean-Antoine Watteau (1684–1721) and Peter Paul Rubens (1577–1640), the great masters of the two-color drawing style, before setting down this sensitive study of a muslin-clad lady, in which the face, hands, and costume are enlivened by red chalk, while the white tones of the costume are suggested by cooler black chalk.

Black and red chalk heightened with white on buff laid paper;
11¹³⁄₁₆ × 7⅞ in. (30.0 × 20.0 cm)
Museum purchase with funds provided by the Museum Collectors 85.110

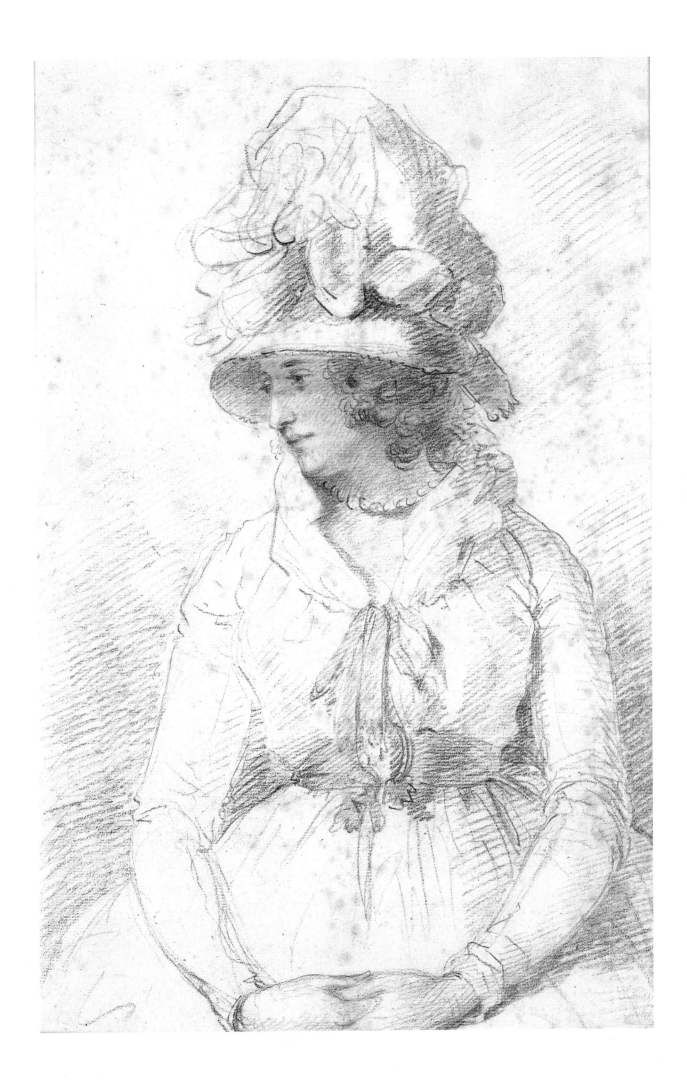

Rodomonte and Mandricardo State
Their Case before Agramante, 1780s

Apprenticed to the rococo master François Boucher (1703–1770) when he was about fifteen, Fragonard was sent shortly thereafter to study under the still-life and genre painter Chardin before returning to Boucher for further instruction. In 1752 Fragonard won the Prix de Rome, and his residence in Italy extended from 1755 until 1761. In addition to Italian art and the French art of his immediate predecessors, Fragonard was much affected by Flemish and Dutch baroque painters, particularly by Rubens. Indeed, Rubens's influence may be related to Fragonard's broadening of the traditional rococo style by his use of a more vigorous brushstroke. Admitted to the Académie Royale in 1765, Fragonard became a highly successful painter of fêtes galantes, landscapes, and portraits, but his popularity waned in the face of neoclassical severity, especially after the French Revolution of 1789.

Rodomonte and Mandricardo State Their Case before Agramante is one of a series of about 150 drawings illustrating *Orlando Furioso* (1516), a tale of knights and sorcerers written by the sixteenth-century Italian poet Ludovico Ariosto. Although the date of the drawings is not certain, their style suggests that they were executed in the 1780s when Fragonard had few patrons. The drawings were designed as book illustrations but were never used as such. Fragonard's brilliant tonal washes and bravura brushstrokes, so evident in this drawing, were probably beyond the technical skills of any engraver of the period.

Pen and brown and gray wash over black chalk on cream laid paper;
15½ × 10¼ in. (39.4 × 26.0 cm)
Museum purchase with funds provided by General and Mrs. Maurice Hirsch 78.64

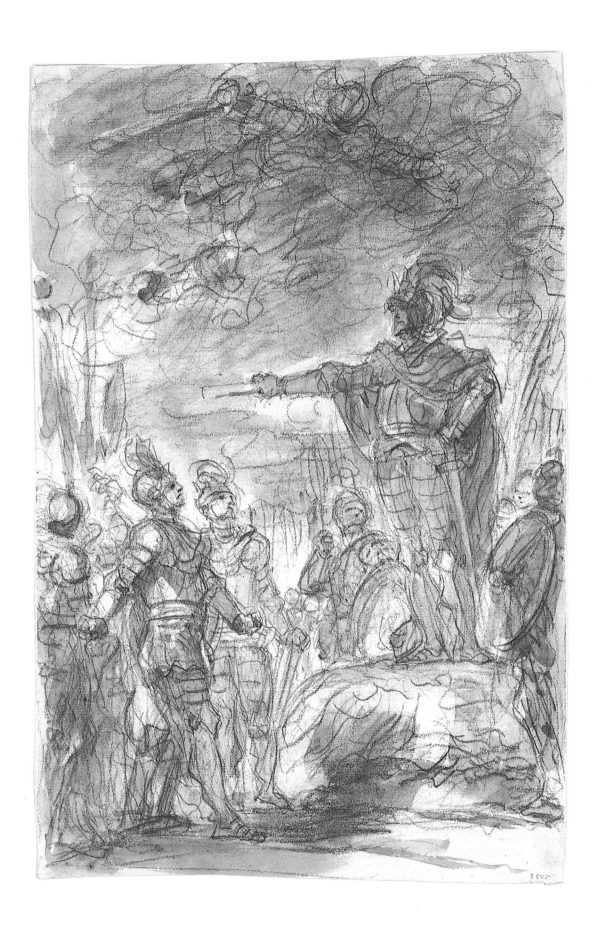

I n the vanguard of the romantic movement in France, the painter
Théodore Géricault is celebrated for his images of soldiers and horsemen
and for his masterpiece, *The Raft of the Medusa*, 1818–19 (Musée du Louvre,
Paris). He was also an early and highly gifted master of lithography, a printing
technique that during his lifetime had only begun to be used by practitioners of
"high" art. In his prints, closely related in subject matter to his paintings and
drawings, he reveals his preoccupation with scenes of war and physical combat,
capturing the muscular power of man and animal alike.

Boxers is among Géricault's early prints and one of his finer achievements. It
depicts the sport that at the time was not yet legal in France. Although it is
possible that the artist had actually witnessed a match between a black and a
white boxer, historians note that the print itself was based on matches arranged
between Géricault's students. Displaying a genius for dynamic composition and
the powerful juxtaposition of forms, Géricault stressed the physical opposition
of the combatants by placing them in near-perfect symmetry against the
background of the carousing audience.

Lithograph; 16¾ × 22³⁄₁₆ in. (42.5 × 56.4 cm)
Museum purchase with funds provided by
Mr. and Mrs. Wallace S. Wilson and "One Great Night in November, 1987,"
additional funds provided by Mr. and Mrs. E. Gregg Wallace, Jr. 87.310

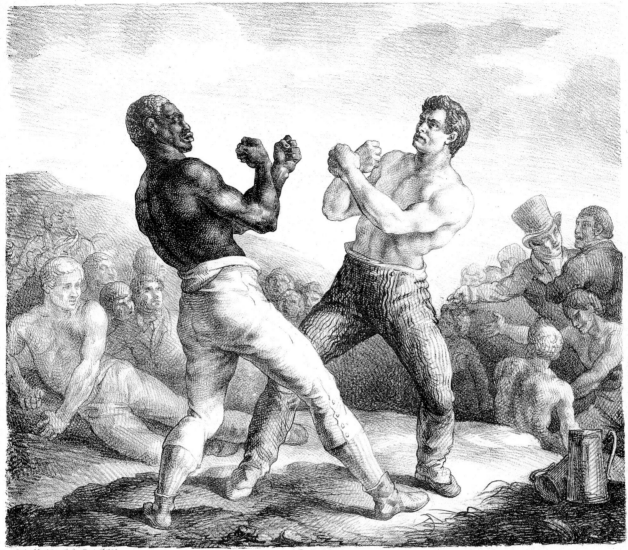

Lithog.ᵉ De C.ᵗ Motte, Rue des Marais f.ˢ.ᵗ.ᵍ. *Boxeurs.*

JAMES ABBOTT McNEILL WHISTLER
American; Lowell, Massachusetts, 1834–London 1903

Black Lion Wharf, 1859

After an unsuccessful experience as a cadet at West Point and a brief career with the drawing division of the U.S. Coastal Survey in Washington, D.C., James McNeill Whistler left for Europe in 1855 to become an artist. Like Monet, he studied under the academic painter Charles Gleyre (1806–1874) but admired the more avant-garde pictures of Gustave Courbet (1819–1877). In 1859 Whistler moved to London, where he spent the rest of his life except for occasional sojourns elsewhere, most notably in Venice from 1879 to 1880. Whistler was successful in both French and English art circles but always considered himself an American and, especially toward the end of his life, had many American patrons.

Although Whistler is renowned for his delicate paintings of exceptionally sensitive color, his etchings are widely regarded as among his finer works. He was one of the first artists to work on his copper plates directly in front of the subject out of doors. *Black Lion Wharf* was one of the Sixteen Views of the Thames series etched by Whistler shortly after his arrival in England. It depicts a working-class neighborhood by the Thames River near Rotherhithe, an area Whistler often portrayed in prints and paintings.

Drypoint etching; 5⅞ × 8¼ in. (14.9 × 22.0 cm)
Signed and dated lower right in plate: Whistler 1859
Gift of Marjorie G. and Evan C. Horning 74.285

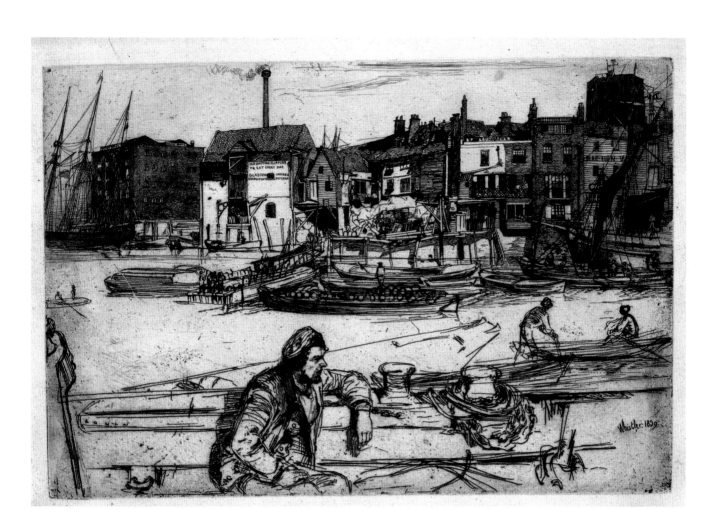

The most popular painter of nineteenth-century America, Winslow Homer was from the beginning of his career involved in printmaking. His artistic apprenticeship began in a printer's workshop where he quickly mastered lithography and moved on to making wood engravings for the popular press. Most of his early illustrations were commissioned by the magazine *Harper's Weekly*, which employed him as a free-lance artist from 1859 until 1875 (the museum owns one of the most complete series of these wood engravings, executed by specialist engravers after Homer's drawings).

In the 1880s Homer's career took an important turn. Following a trip to England, where he sketched and painted in Tynemouth, on the North Sea, he returned to America and embarked on a series of paintings depicting outdoor subjects, sometimes profoundly troubling scenes of man's despair in the face of the elements. These brought him great acclaim, and to reach an even wider audience Homer took up the practice of etching copies of his oils and watercolors. *Fly Fishing on Saranac Lake,* one of his last such prints, reveals his mastery of the related techniques of line etching and aquatint and his sensitivity to the subtlest nuances of light and tone, rivaling even Whistler's most delicate prints of the same decade. The misty background of the work, composed almost entirely of selectively blocked passages of aquatint, maintains much of the transparency of the watercolor study (Art Institute of Chicago) Homer made for the print. In describing the fisherman Homer used pure line applied in close hatchings to render the differing tones and textures of figure, boat, and reflection, arranged in a composition influenced by Japanese prints.

Etching and aquatint; 14⅛ × 20⅚₆ in. (35.9 × 51.6 cm)
Inscribed recto, below image, in pencil: Winslow Homer #31;
recto, in plate, lower left: Winslow Homer 5ᵉ 1889 Copyright
Museum purchase with funds provided by "One Great Night in November, 1986" 86.353

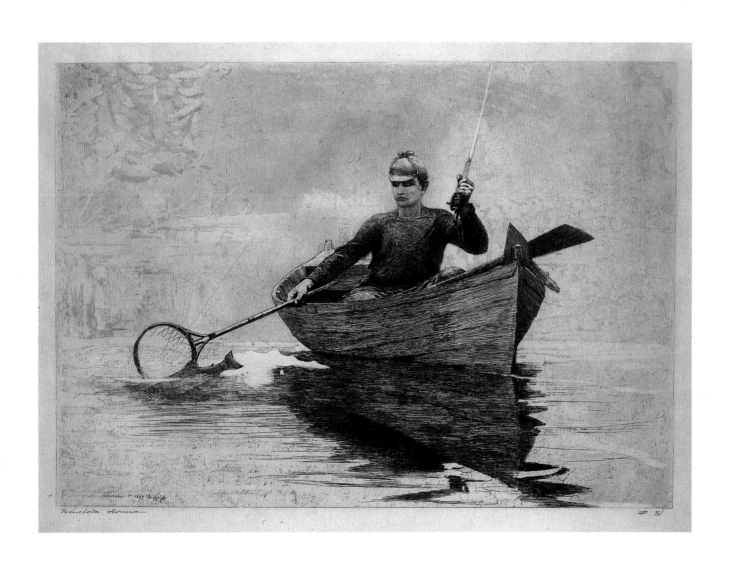

Odilon Redon, born in the provincial capital of Bordeaux, was almost unknown in Parisian art circles until he was nearly forty years old. In 1879 he published his first album of lithographs and during the 1880s occasionally exhibited his mysterious prints and drawings. His friendship with the extraordinary and eccentric printmaker Rodolphe Bresdin (1822–1885) was probably the most important artistic influence in his life, although he also studied under the successful academic painter Jean-Léon Gérôme (1824–1904). In the mid-1860s Redon met the Barbizon-school landscape painter Corot, whose paintings and charcoal drawings, with their mastery of flickering light, exerted a profound influence on his style. From the 1880s Redon became friendly with the leaders of the symbolist movement, most notably the writers Joris-Karl Huysmans and Stéphane Mallarmé, and he made many lithographs depicting subjects taken from Gustave Flaubert's *Temptations of Saint Anthony* (1874).

Despite his brilliance as a colorist, Redon was especially fond of drawing in charcoal. *The Trees* is executed with a deft touch and a variety of surface textures that testify to the artist's mastery of the medium. Although Redon drew a number of somewhat more straightforward renderings of trees, he is best known for his pastels of flowers and renderings in pastel, charcoal, and lithography of fantastic subjects. Even in *The Trees* there is a suggestion of the eerie.

The date of the museum's drawing is difficult to establish. Redon drew similar trees in backgrounds of figural depictions in the 1870s and 1880s, but in terms of finished, securely dated works the drawing is closest to a lithograph published in 1896 entitled *I plunged into solitude. I lived in the tree behind me.*

Charcoal on buff wove paper; 19¾ × 14¾ in. (50.2 × 37.4 cm)
Signed lower right: ODILON REDON
Gift of Mrs. Harry C. Hanszen 72.29

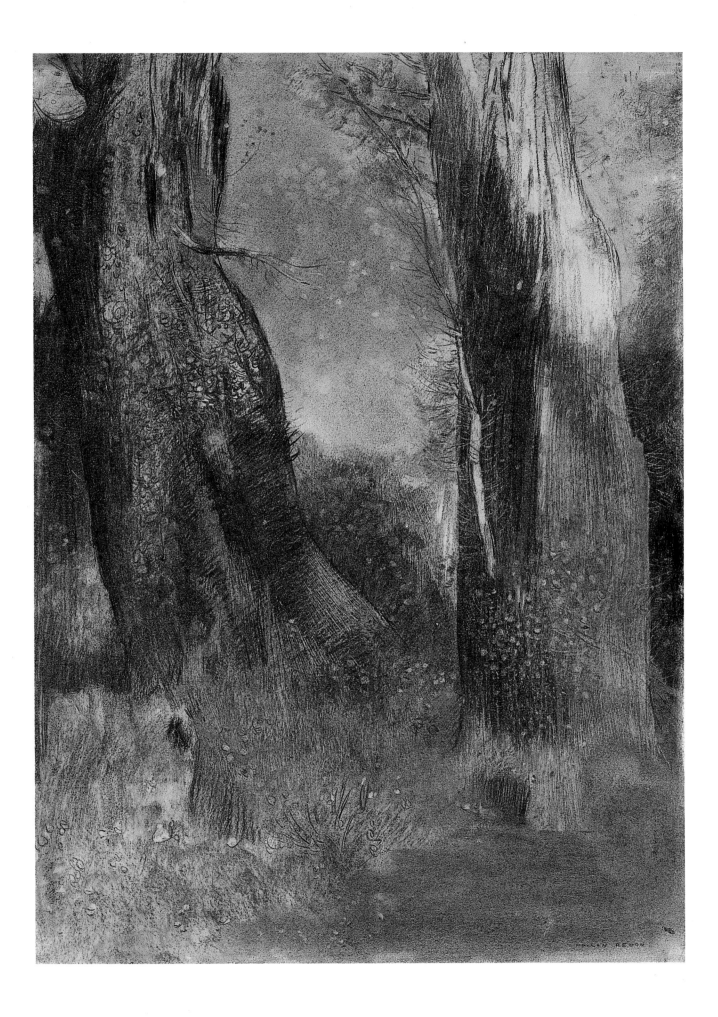

Edgar Degas was born to a wealthy banker and his New Orleans–born wife in 1834. The artist spent almost all his life in Paris and died there, virtually blind, at the age of eighty-three. After a brief attempt at studying law, Degas began his artistic career in the academic system, training to become a painter in the classical tradition. He traveled to Italy to study the great masters and, in Paris, copied paintings in the Louvre and prints in the Bibliothèque Nationale. In 1874 Degas joined in the first of the impressionist exhibitions; after the last of these, in 1886, he held only one exhibition, reserving the greatest part of his work for his own study. The most accomplished draftsman of the impressionists, he was also the most urbane: he preferred to paint the life of Paris, its dancers, milliners, and laundresses or the horse races in the suburbs rather than the countryside of France. Painstaking and analytical, Degas went about making art with deliberation. "Nothing in art must seem an accident," he wrote, "not even movement."

Woman Drying Herself is among Degas's last, most masterful works. It is one of a group of charcoal and pastel drawings of bathers made on tracing paper, the artist's favorite support in his last decades. Compared with others from the series, this pastel is only lightly finished, the sinuous charcoal line reading forcefully against the bare ground. Deftly varying the weight and texture of his charcoal and pastel strokes, hatching and repeating his lines, Degas described the laboring, bending posture of his bather with meticulous care. Gesture and expression are refined and abstracted, made eternal, as the aging Degas strove to perfect, through drawing, what he called "a way of seeing form."

Charcoal and pastel on tracing paper, mounted on wove paper;
31 × 31 in. (78.7 × 78.7 cm)
Stamped lower left: Degas
The Robert Lee Blaffer Memorial Collection, gift of Sarah Campbell Blaffer 56.21

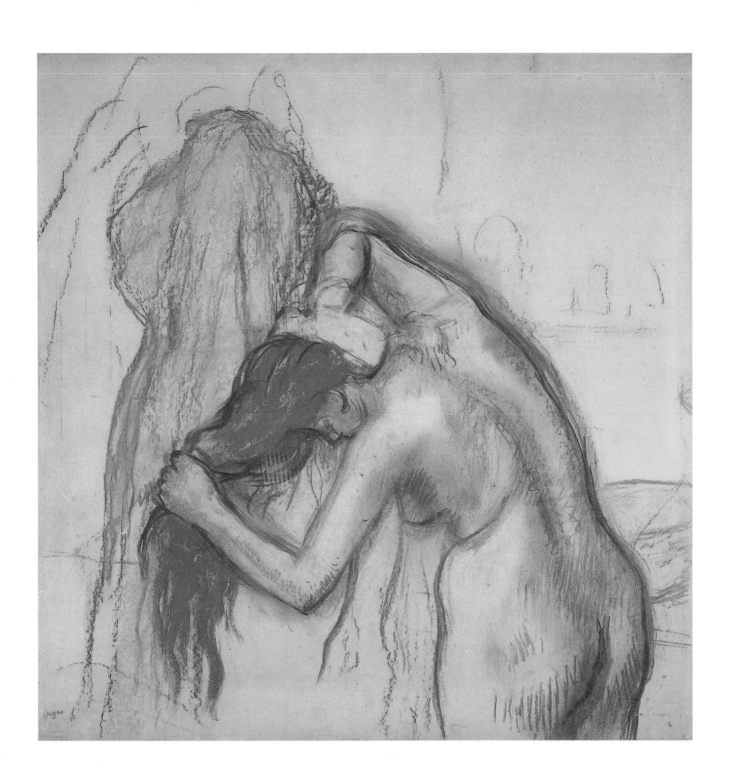

Caryatid, c. 1914

Amedeo Modigliani moved to Paris from his native Italy in 1906. Working as both painter and sculptor, he immersed himself in the bohemian world of Montmartre, choosing for his friends the expatriate community that made up the School of Paris. Of particular importance was his friendship with Constantin Brancusi (1876–1957); the two met about 1909 and Modigliani quickly assimilated the elder sculptor's treatment of simplified volumes, although his interpretation of primitivist sources was always colored by a mannerist elongation of form and a more expressive working of surface.

Caryatid is one of a large series of drawings executed by Modigliani in the years 1914–15 for a monumental sculpture. The compressed figure of the woman supporting an unspecified architectural segment was explored by the artist in drawings that range in scale, color, and medium from austere to exuberant. The present example is exceptional in this series for its cool secondary pastel hues and large scale. Unfortunately, due to lack of funds and materials, Modigliani was unable to realize the sculptural project he envisioned and after 1915 devoted himself exclusively to painting.

Gouache on paper, mounted on canvas; 55⅜ × 26¼ in. (140.7 × 66.7 cm)
Gift of Oveta Culp Hobby 84.412

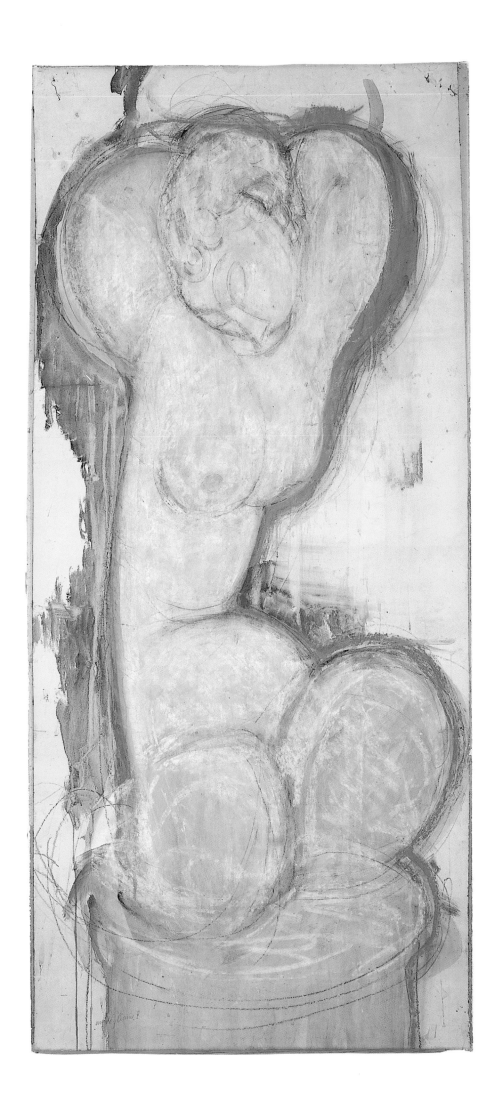

PABLO PICASSO

Spanish; Málaga 1881–Mougins, France, 1973

Three Women at the Fountain, 1921

I n the summer of 1921, while at Fontainebleau, Picasso reintroduced classicism into his work with the series of studies and drawings that culminated in the monumental canvas *Three Women at the Spring*. While the theme may have been inspired by the town itself and the rich decorative cycle of fountains at the royal palace, Picasso found in the image of river goddesses at a spring an allegory of timeless creation and renewal. The painting (Museum of Modern Art, New York) is moodily romantic, with a palette largely composed of grays and earth tones. Conversely, this pastel rendition of the theme is more brightly colored and delicate, presaging in mood the sunny Mediterranean landscapes that Picasso celebrated the following year.

Pastel on blue paper; 25 × 19⅛ in. (63.5 × 48.6 cm)
Gift of Miss Ima Hogg and other trustees of the
Varner–Bayou Bend Heritage Fund 69.2

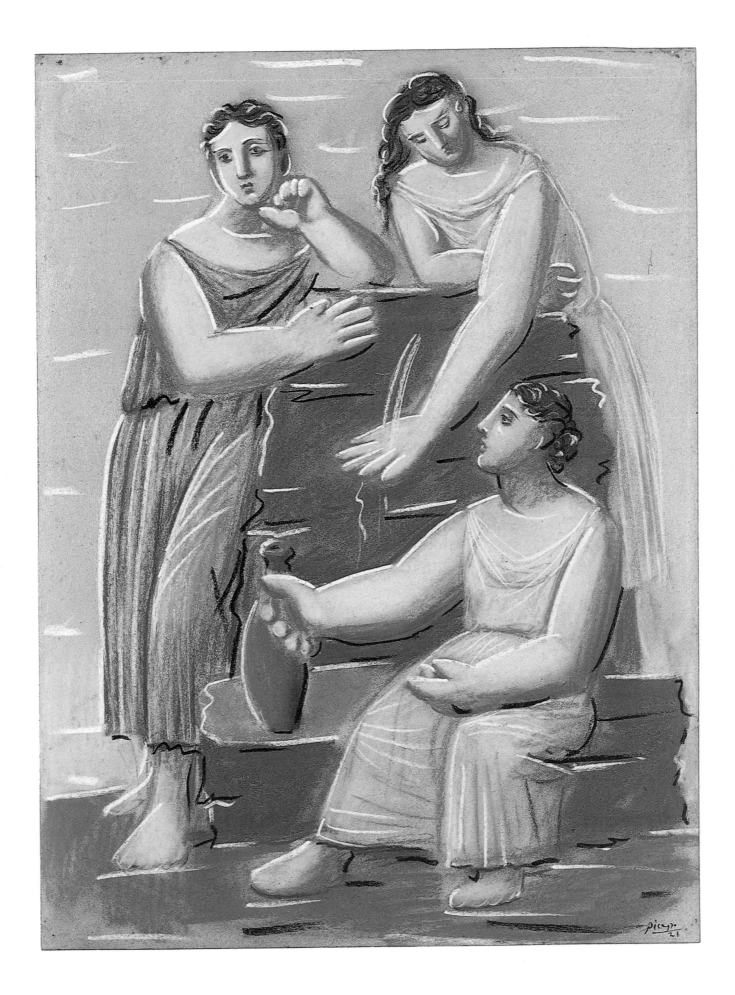

In 1898 Paul Klee left Switzerland to study art in Munich. His early work was influenced by late nineteenth-century symbolism, and he adopted a tense and evocative graphic style that remained a point of departure throughout his career. In 1911 he met Wassily Kandinsky (1866–1944) and with him became a member of the Blaue Reiter group, an association of artists. Although his friendship with Kandinsky guided Klee toward a more radical palette and greater expression of individual emotion, he rarely emulated the Russian artist's advocacy of pure abstraction. Instead, nature, memory, and fantasy infused Klee's work, and he never cut his ties with the objective world.

In 1920 Klee accepted an invitation to join the faculty of the Bauhaus, moving to Weimar, Germany, in 1921. The emphasis on architecture and design promoted by Bauhaus founder Walter Gropius (1883–1969) encouraged Klee's own interest in fantastic structures. *Marjamshausen*, with its evocative cityscape of stacked facades, is part of a larger group of imaginary urban vistas of the Near East and Mediterranean. Klee first traveled to Tunis in 1914; in 1928, the year of this watercolor, he briefly visited Egypt. The vivid blue sky and domed profiles of the buildings recall the climate and architecture of North Africa and the Levant; Klee, however, departs from realism by adding whimsical features to the buildings, transforming doorways and windows into grimacing faces.

Watercolor on paper; 14³⁄₁₆ × 8¹⁄₁₆ in. (36.0 × 20.5 cm)
Signed lower left: Klee; *inscribed lower center:* 1928 0.4 Marjamshausen
Gift of Miss Ima Hogg 39.III

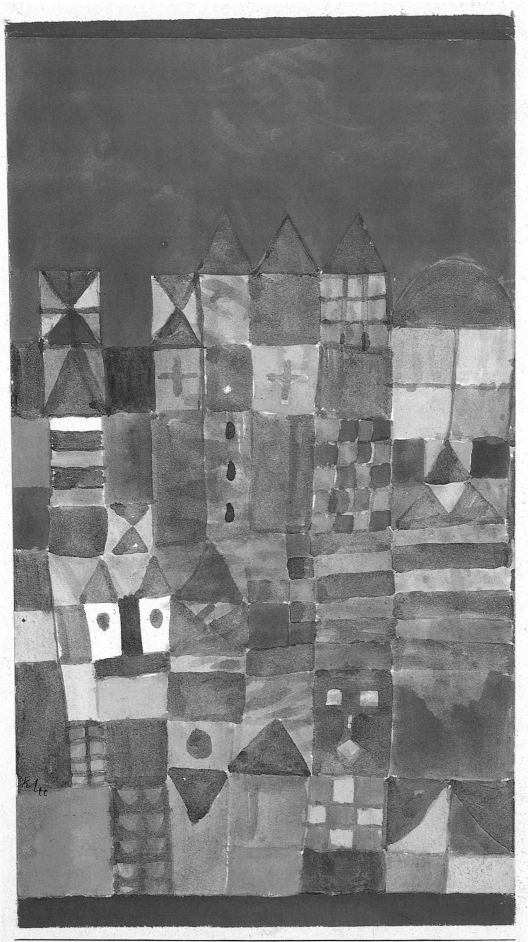

Decorative Arts

JOHN RUSLEN

English; active London, c. 1656–1710

Two-handled Covered Cup, 1672–73

The two-handled cup and cover, also known as a porringer or caudle cup, was a popular drinking vessel in Restoration England (1660–88). Because silver was relatively rare in seventeenth-century England, Ruslen followed accepted Dutch and German fabricating methods of chased, raised, and repoussé decoration. Since these techniques required comparatively thin silver, objects could be larger, if not heavier, than if they were cast. The body of the cup is beautifully proportioned and sensitively decorated with two rams, one a sheep and the other a goat. On the lid a lion pursues a unicorn, each a heraldic support for the monarch's crest. Cast caryatid handles and a grotesque masklike finial complete the form. The cup's decoration is typical of much Caroline silver; it is nonpolitical, nonreligious, nonclassical, and therefore unobtrusively appropriate for the sensitive years when England was caught between Catholic and Protestant forces.

Sterling silver; 8½ × 10¼ in. (21.6 × 26.0 cm)

Marks: IB in oval, P in shield, crowned leopard's head, lion passant

Gift of George S. Heyer, Jr., in honor of Robert D. Straus 83.135

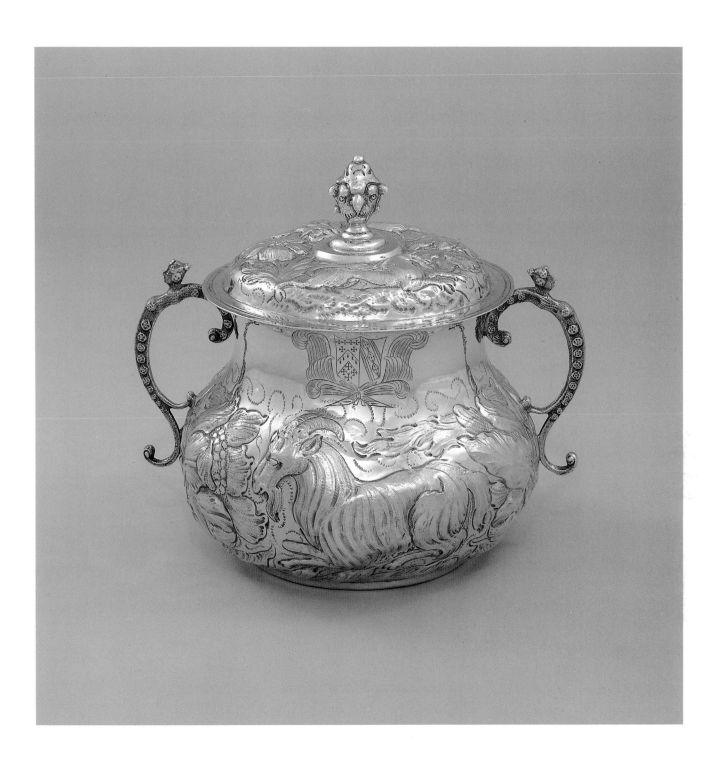

High Chest of Drawers, 1690–1730

The 1690s witnessed a dramatic evolution in the design and methods of construction employed for American furniture. The massive, rectilinear mannerist style was replaced by the lighter, more elegantly proportioned style of the early baroque. These new ideas were introduced to the American colonies through England and, in turn, through the influence that the Dutch and the French exerted on the British.

This sophisticated high chest of drawers is an eloquent example of the early baroque style. An imposing form newly introduced during the period, the high chest was intended for the bedchamber, where it was used to store clothing and linens. This fine example, with its bold cornice and molding surmounting a convex frieze, has fully developed architectonic qualities, while its triple-arched base is reminiscent of the Roman triumphal arch. With the advent of the early baroque style, walnut replaced oak as the fashionable cabinet wood. The chest's boldly turned legs and feet could not be veneered, and it is likely that they were originally painted to simulate burl veneers.

Little is known of the high chest's early history, but its richness suggests that it was made for an individual of great consequence and prominence. It reflects the comments of an Englishman who visited Boston about 1700: "A Gentleman from *London* would almost think himself at home at *Boston* . . . when he observes the Numbers of People, their Houses, their Furniture, their Tables, their Dress, and Conversation, which perhaps is as splendid and showy, as that of the most considerable Tradesmen in *London*."

Walnut, walnut veneer, aspen, soft maple with eastern white pine;
68⅛ × 40¼ × 22¼ in. (173.0 × 102.3 × 56.5 cm)
The Bayou Bend Collection, gift of Miss Ima Hogg B.69.43

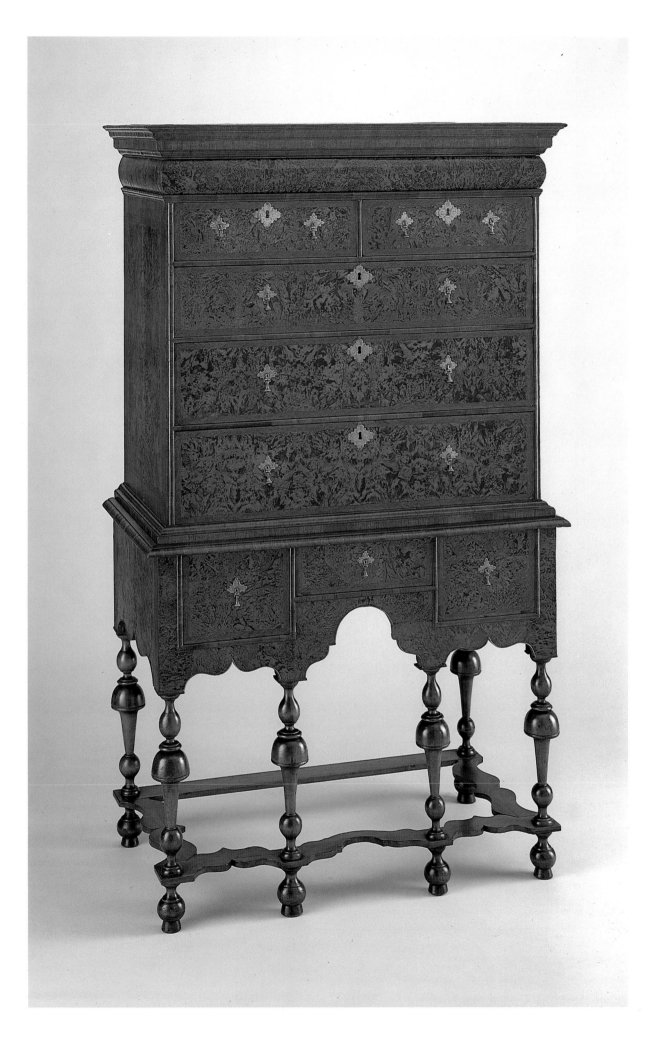

Silver and gold, of intrinsic and symbolic value, always have been highly esteemed in American society. Because the colonies lacked patron-aristocrats, the earliest manifestations of style occurred not in the fine arts of painting or sculpture but in the utilitarian decorative arts, usually in silver. The silversmith, more than any other craftsperson, was keenly aware of the latest stylistic developments through the English-produced vessels he imported to sell along with those of his own manufacture.

The tankard was a popular form of drinking vessel during the colonial period. This unique example was commissioned by John Foster, a prominent Boston merchant whose grandson Thomas Hutchinson was the last royal governor of the Massachusetts colony.

A superb work of early baroque silver, the tankard is an articulate statement of John Coney's remarkable sense of design and masterly control of metal. His ability as an engraver is also readily apparent in the beautifully worked representation of the Foster arms. His known work, in both the mannerist and baroque styles, establishes him as the most accomplished and versatile of all colonial silversmiths.

Silver; 7⅛ × 4¹⁵/₁₆ in. (18.1 × 12.6 cm)
Marks on lid and left of handle: IC *over fleur-de-lis within heart*
The Bayou Bend Collection, gift of Miss Ima Hogg B.74.19

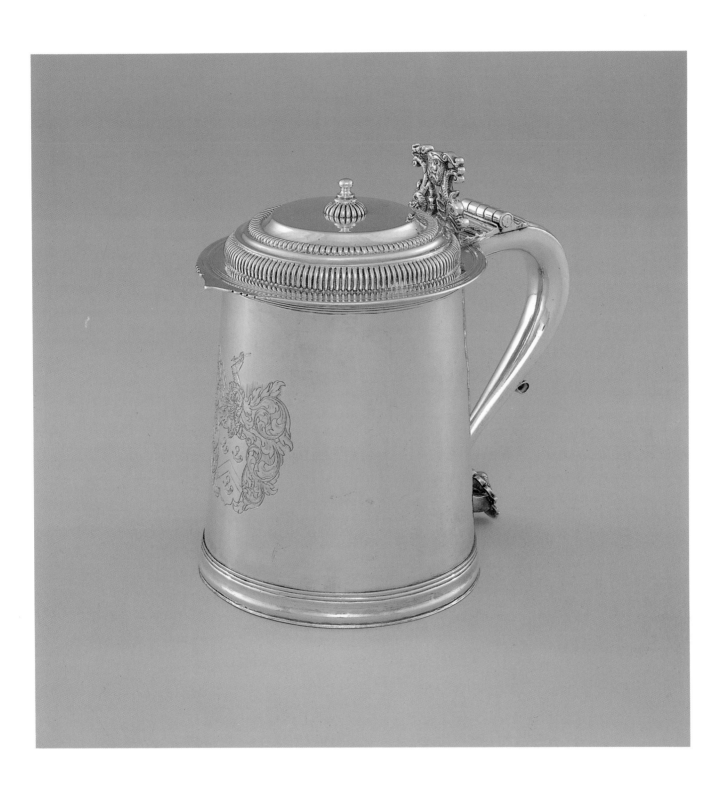

The clock was a rarity in colonial American households. Invariably, if a timepiece was included among domestic furnishings, it was a tall clock. The shape of its upright case was designed in response to a need to accommodate the long, more accurate pendulum developed in England during the 1660s. These earliest clocks had only an hour hand, but by the end of the century both the second and minute hands had been introduced. A movable bonnet was devised to enclose and protect the clock's movement from dust. In the late nineteenth century the popular term "grandfather clock" replaced the more descriptive colonial name.

The museum's superb clock has survived in remarkable condition. Although the casemaker is not known, he produced a successful interpretation of the late baroque style. The movement housed in this example is the work of Peter Stretch. Born in Leek, Staffordshire, Stretch served his apprenticeship with his uncle Samuel Stretch. In 1702 he, along with his young family, emigrated from England to Philadelphia. There the young Quaker appears to have thrived and established a reputation. In 1708, just six years after his arrival in Philadelphia, he became a member of the Common Council and continued to serve in that position until his death. Stretch's son Thomas made the clock for the Pennsylvania State House in 1753.

Black walnut with eastern white pine, brass movement;
104 × 20½ × 9¾ in. (264.2 × 52.0 × 25.0 cm)
The Bayou Bend Collection, museum purchase with funds provided by
the Theta Charity Antiques Show in memory of Betty Black Hatchett B.86.4

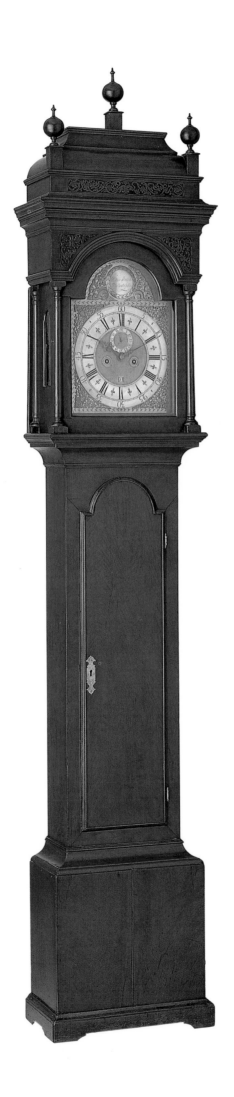

By the mid-1720s the American colonies began to reinterpret the baroque style. The lively turnings, intricate veneered surfaces, and robust carving, inspired by continental designs, succumbed to an English simplification of ornament applied to a series of curvilinear lines. The significance of this "line of beauty" became the subject of the satirical essay "The Analysis of Beauty" (1753) by the artist William Hogarth (1697–1764).

The design concepts of the late baroque are beautifully articulated in the uncomplicated refinement of this card table. The maker has introduced a discreet inlay to accentuate the top and skirt and employed a concertina action rather than the more usual American practice of having the rear leg pivot out to support the flap. The playing surface is fitted with colorful tambour-work of a bouquet of flowers. The pronounced turreted ends, elongated cabriole legs, and flat pad feet are elements inspired by English examples, and in America appear to be characteristic of Boston late baroque furniture.

This card table was originally made for the well-to-do merchant Peter Faneuil, and following his death in 1743 it descended in his sister's family. The earliest American card tables date from the second quarter of the eighteenth century, but card playing, although legislated against, appears to have enjoyed an early popularity in puritan Boston.

Mahogany with eastern white pine; 26¾ × 37 × 32½ in. (67.0 × 94.0 × 82.5 cm)
The Bayou Bend Collection, gift of Miss Ima Hogg B.69.406

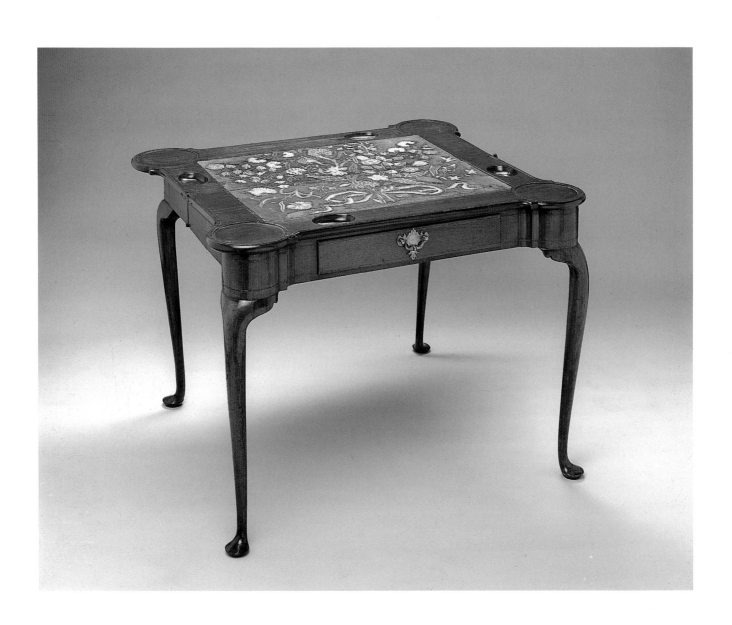

High Chest of Drawers, 1730–50

Westerners have long been fascinated by the cultures of the distant Far East. Early in the sixteenth century Portuguese mariners opened new trade routes to Asia. The treasures that were brought back, such as porcelains and lacquer wares, were not previously known to the Europeans and were immediately recognized as prized commodities. By the 1680s artisans working in England's furniture trade, attempting to satisfy public demand, began producing japanned wares as a less expensive and more readily obtainable imitation of oriental lacquer. Published manuals such as John Stalker and George Parker's *Treatise of Japanning and Varnishing* (1688) provided detailed explanations of how the decoration was to be produced as well as fanciful designs of animals, birds, and plants.

A number of japanners worked in colonial America, the principal concentration in Boston, where as many as ten are known to have been employed. As early as 1734 one of these, William Randall, charged the Boston cabinetmaker Nathaniel Holmes for "japanning a Piddement [pedimented] Chest . . . Tortoiseshell & Gold," which must have been similar in appearance to this richly ornamented example. The Boston japanners simulated tortoiseshell by using a vermilion paint over black. The decoration of the colonial japanners in this period differed from that of their English counterparts who invariably painted the background a solid color.

Japanned eastern white pine, soft maple, black walnut;
87¼ × 41¹⁄₁₆ × 22⅝ in. (221.6 × 104.4 × 58.0 cm)
The Bayou Bend Collection, gift of Miss Ima Hogg B.69.348

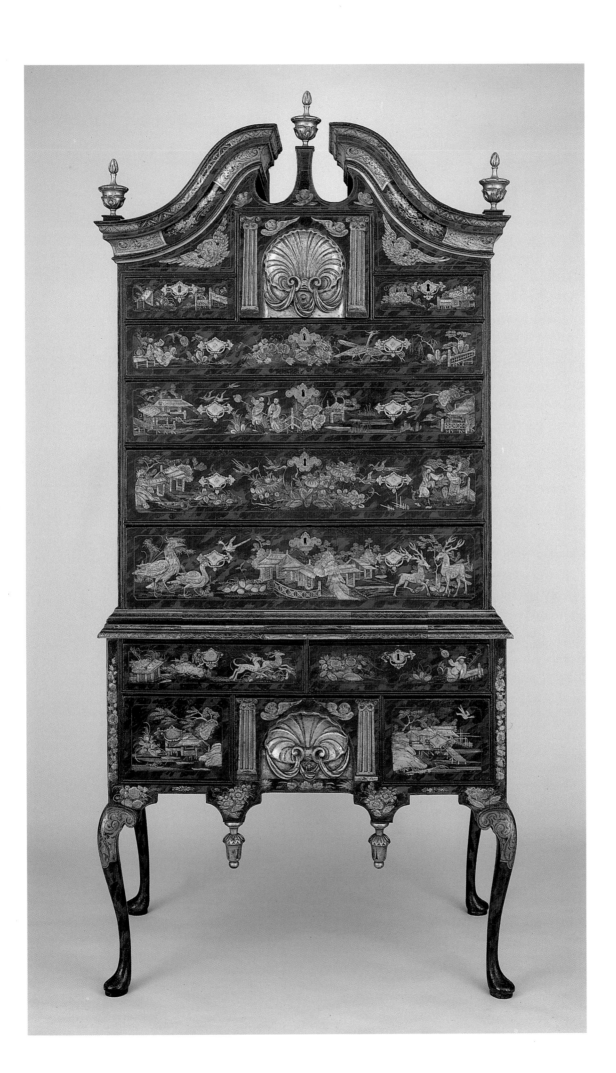

Armchair, 1750–90

Side chairs were the most prevalent furnishing in the colonial household, and large sets were produced for parlors and bedchambers. When required for a specific activity they were drawn out into the center of the room; when not in use they were lined up against the wall. Armchairs were made either en suite with side chairs or in pairs but were never produced in large numbers.

This armchair is one of the richest expressions of the late baroque style in Philadelphia furniture. Its foliate carved strapwork bannister indicates that the chair's maker was also familiar with rococo design. Although the chair's provenance is incomplete, it undoubtedly was produced in a Philadelphia shop, as evidenced by the design and handling of the ornament, distinctive construction features, and indigenous secondary wood employed.

Since the rococo style, which interlaced naturalistic elements, Gothic and Chinese motifs, and delicate scrolls into asymmetrical fantasies, was not introduced into the American colonies until 1750, the chair cannot be dated any earlier. Contemporary references indicate that although both the city's populace and its cabinet trade were familiar with the new style by this time, they did not immediately abandon the late baroque style. As late as the 1780s the city's cabinetmakers continued to produce furniture in the late baroque and rococo styles as well as in the newly introduced neoclassical styles. At times two or even all three styles were combined as in this magnificent example, where the integration of the late baroque and rococo is complete and harmonious.

Mahogany with eastern white pine; 42¼ × 30½ × 18½ in. (107.0 × 77.5 × 47.0 cm)
The Bayou Bend Collection, gift of Miss Ima Hogg B.69.2

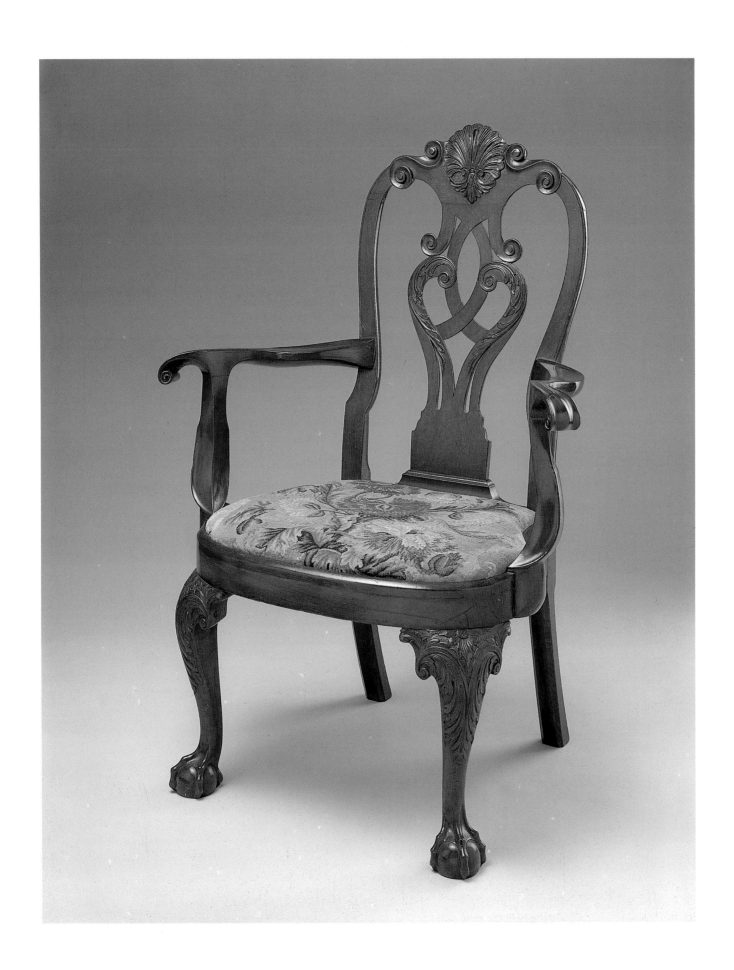

High Chest of Drawers, 1760–75

The publication in 1754 of *The Gentleman and Cabinet-Maker's Director* by Thomas Chippendale (1718–1779) profoundly affected the development of American furniture design. *The Director* was the first important book devoted entirely to furniture design and as such instructed both English and American cabinetmakers in the richest extravagances of the rococo style. Another major factor during this period was the use of mahogany as the primary cabinet wood. Some mahogany previously had been imported into the colonies, but it was not until the second half of the century that the wood came into general use. Unlike walnut, it was worm resistant, and it lent itself to the intricate carving required by the rococo style.

A classic American manifestation in the marriage of the late baroque and the rococo is this great Philadelphia high chest. By the mid-eighteenth century the English high chest was deemed old-fashioned, while in the colonies the form persisted and reached its apogee in Philadelphia. The high chest is essentially an architectural form, and this particular example displays a horizontal as well as a vertical axis. Originally made for Joseph Wharton, this chest was used at Walnut Grove, Wharton's neo-Palladian country house overlooking the Delaware River.

Mahogany and mahogany veneer with Atlantic white cedar, yellow poplar, southern yellow pine; 94½ × 46¾ × 24⅝ in. (240.0 × 118.0 × 62.0 cm)
The Bayou Bend Collection, gift of Miss Ima Hogg B.69.75

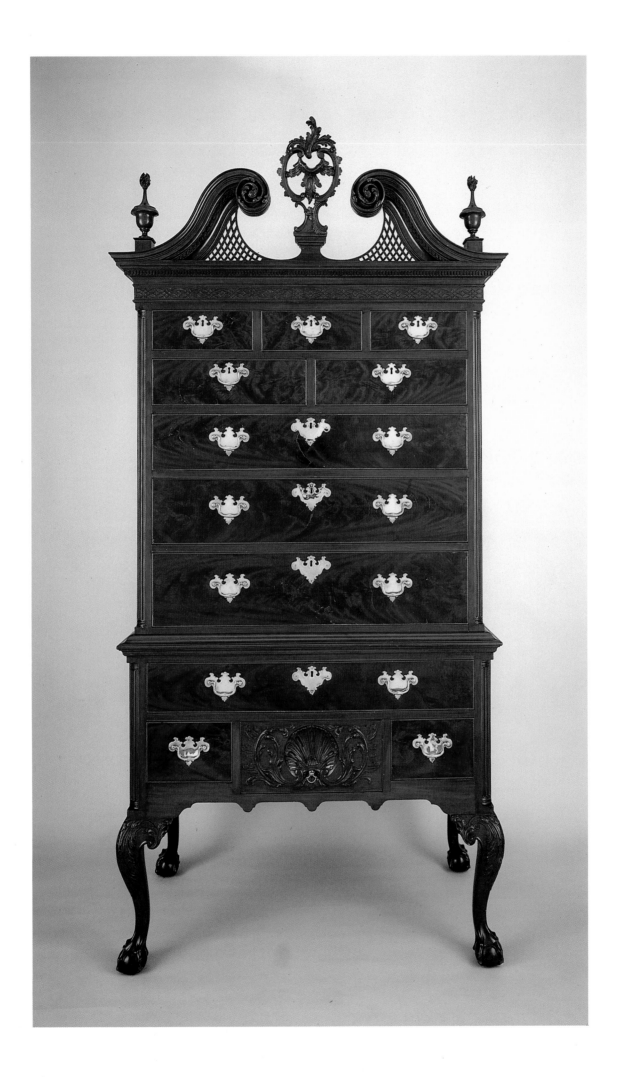

Candlestick with Two Canaries, c. 1770

Since its founding in 1751 the Worcester Porcelain Factory has enjoyed a reputation as one of England's finest ceramic houses. Its eighteenth-century soft-paste porcelain—white, strong, and translucent—took glazes well and lent itself to elegant tableware. While other English factories such as Chelsea and Derby made numerous figures, Worcester was identified so closely with tableware that not until 1922 were any figures firmly attributed to the firm. The museum's candlestick with two canaries is, therefore, all the more remarkable, for both its condition and its rarity.

These two charming birds perched within a floral bower convey the essence of rococo naturalism. The candlestick is oriented toward one side; the back has a white porcelain loop handle and bare white branches. The tall center limb is pierced by a square hole to hold a bobeche (to catch candle drippings) and a candle socket, both probably made of enameled metal. The candlestick is part of the museum's Masterson Collection of Worcester Porcelain, one of the most distinguished collections of Worcester in the United States.

Soft-paste porcelain; 7½ × 6⅞ × 4¾ in. (19.1 × 17.5 × 12.1 cm)
Gift of Mr. and Mrs. Harris Masterson III 84.659

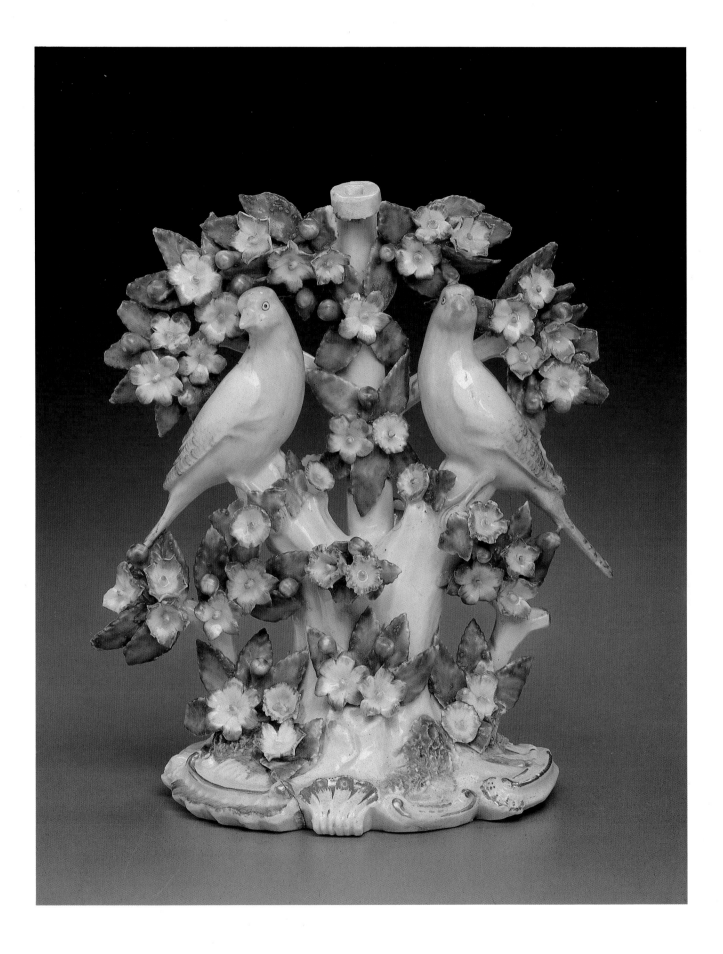

Sauceboat, 1770–72

An ambitious and innovative enterprise, the American China Manufactory was established by Gousse Bonnin (c. 1741–c. 1780) and George Anthony Morris (1742/45–1773) to produce soft-paste porcelain competitive in quality and cost with imported English goods. The partners' timing benefited from the patriotic colonists' nonimportation policies. As a result, the little factory enjoyed the patronage of such prominent Philadelphians as John Dickinson, Benjamin Franklin, the Penn family, and Benjamin Rush.

The production of soft-paste porcelain in Philadelphia was accomplished with the skills of English workers who had been enticed by Bonnin and Morris to immigrate to the colonies. The factory's range of dinner- and tea-wares was comparable in design and quality with that of the contemporary English factories, most notably those at Bow, Lowestoft, and Plymouth.

This diminutive molded sauceboat, notable for its thin, translucent body, attests to the fine work that the factory was capable of producing. Its ovoid shape with scalloped rim and underglaze blue decoration is related most closely to designs utilized at Bow. Despite their production successes, once the colonists' boycott of English goods ended, Bonnin and Morris experienced severe difficulties in competing with the English and meeting the high costs of operating their factory. Today just a few examples of the American China Manufactory's soft-paste porcelain are known, but these vessels testify to the resourcefulness of Americans in establishing their own industry and in freeing themselves from economic dependence on England.

Soft-paste porcelain; 2⅜ × 4⅞ in. (6.1 × 12.4 cm)
Mark on bottom: P
The Bayou Bend Collection, museum purchase with funds provided by the Friends of Bayou Bend B.83.4

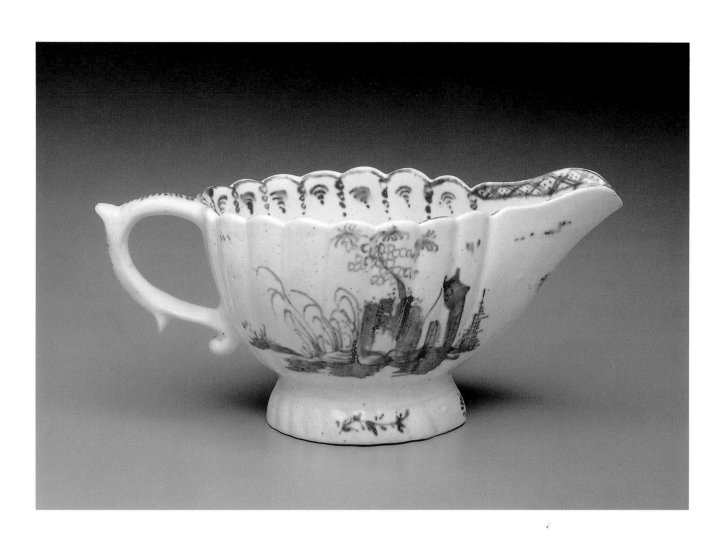

Armchair, c. 1775–78

John Linnell was one of London's most accomplished and colorful late eighteenth-century cabinetmakers, whose designs span rococo and neoclassical styles. He worked on occasion for Robert Adam (1728–1792), Britain's most highly regarded neoclassical architect. Linnell's shop undoubtedly made the museum's generously scaled neoclassical armchair as part of a large suite of furniture intended for a salon. Its proportions, cant of the chair back and rear legs, and ball terminals on the arms are typical of the Linnell workshop. That the chair was made to stand against the wall is certain: the sophisticated carving on the serpentine seat rail continues around the chair but stops at the back. In the minds of the designer and his client, there was no need to decorate part of the chair that was seldom, if ever, seen.

Gilt wood and silk upholstery; 39¼ × 26½ × 22½ in. (100.0 × 67.0 × 57.0 cm)
Museum purchase with funds provided by the
Stella S. and Arch H. Rowan Foundation 87.114

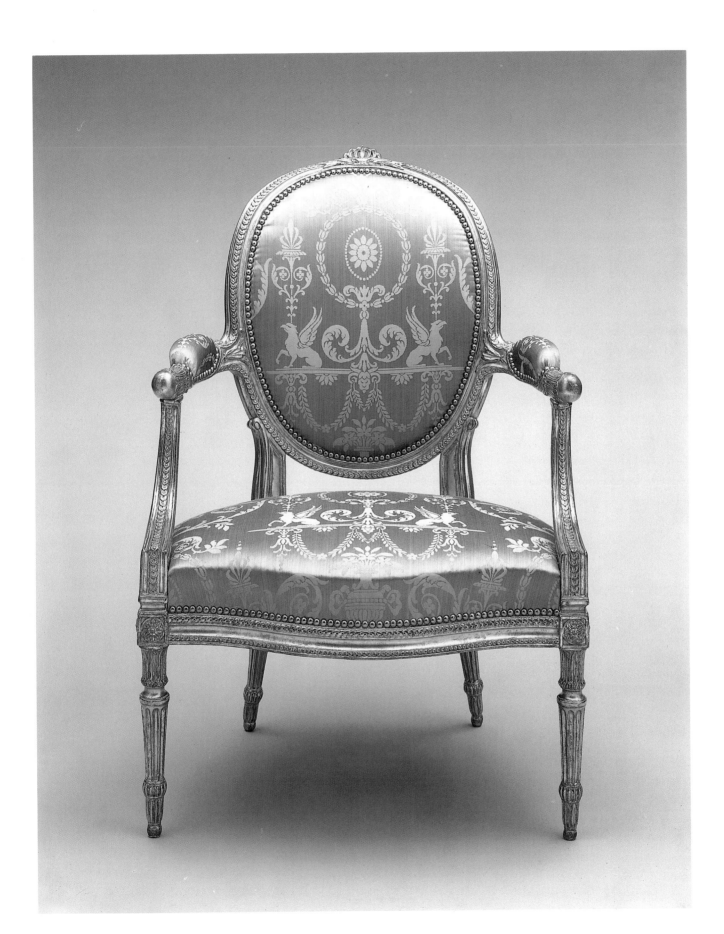

Bureau Table, c. 1785–95

Capital of the Rhode Island colony, Newport was an active coastal trading center for colonial commerce with the West Indies and Europe. During the eighteenth century Newport's cabinet industry greatly benefited from the town's prosperous shipping interests, and artisans produced furniture for the town's wealthy merchants as well as for export. Two Quaker families, the Townsends and the Goddards, dominated the trade, and for more than three generations no fewer than twenty members of these allied families were employed as cabinetmakers.

The distinctive blockfront (a sunken center panel flanked by raised panels) with gracefully carved shells used on eighteenth-century Newport furniture is frequently acknowledged as the most successful design achievement of colonial cabinetmakers. The blockfront had its origins on the Continent and in England; however, the combination of the blockfront with carved late baroque shells is not known to have had a precedent in European furniture. In the American colonies it was introduced to the Boston area sometime during the 1730s. The refinement that it underwent in the Townsend and Goddard cabinet shops represented a culmination of the design's evolution.

This magnificent bureau table exhibits motifs and details of construction that are unique to Townsend's documented work. Beautifully figured mahogany has been carefully selected and then judiciously joined to display its amber color to best advantage. The table was probably made for Samuel Vernon, one of Newport's prominent merchants, and originally was intended to store jewelry, buckles, combs, and brushes, with the kneehole cupboard used to house a wig stand.

Mahogany with yellow poplar and chestnut;
34½ × 38 × 20½ in. (87.7 × 96.5 × 52.0 cm)
The Bayou Bend Collection, gift of Miss Ima Hogg B.69.91

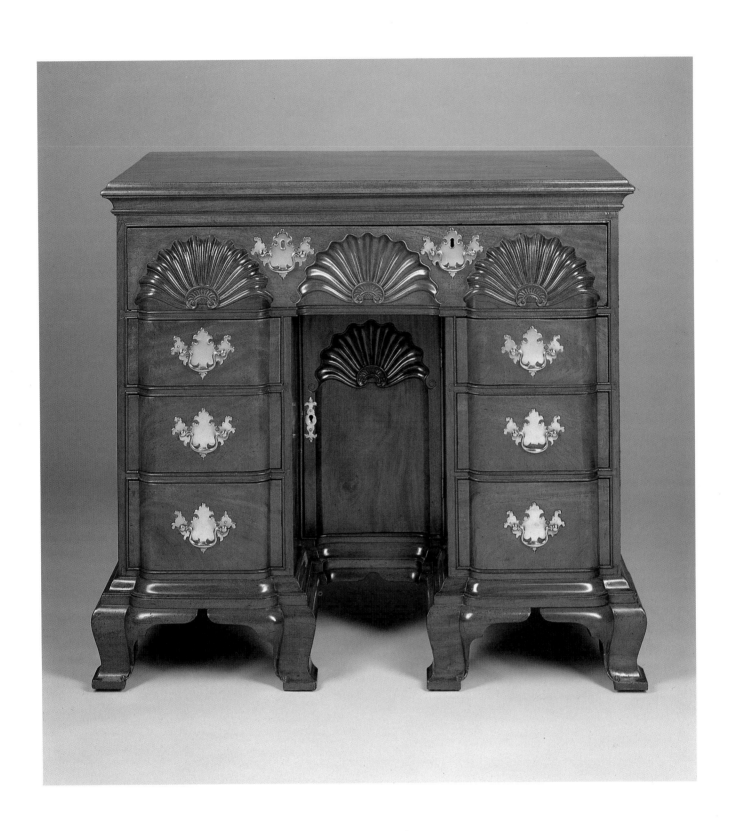

Side Chair, 1790–1800

The Revolution for American political independence concluded with the signing of the Treaty of Paris in 1783. As the political revolution came to an end, however, Americans were experiencing a second revolution, one that would dramatically alter the young nation's artistic direction. This new style, neoclassicism, evolved from the archaeological excavations of the Roman cities of Herculaneum and Pompeii. Robert Adam, the Scottish architect who had studied the classical sites firsthand, became England's most accomplished exponent of the neoclassical style. While Adam's patrons were aristocrats and the well-to-do, others such as George Hepplewhite (died 1786) and Thomas Sheraton (1751–1806) made neoclassical designs available to a wider audience. Their publications were also utilized by the Americans, as evidenced by this handsome side chair, a literal translation from plate 2 of Hepplewhite's *Cabinet-maker and Upholsterer's Guide* (1788).

The chair's design incorporates a diverse group of neoclassical elements, ranging from the shield-shaped back and urn to draped swags, which are echoed in the arrangement of the upholstery tacks repeated along the seat rail. The exquisitely carved chair back and front legs match the carving on a sofa, pair of card tables, urn stand, and related chairs. This suite of furniture was made for Elias Hasket Derby, the Salem merchant who purportedly was America's first millionaire. The furniture may have been ordered by Derby for the great mansion he completed in 1798 that was described as "more like a palace than the dwelling of an American merchant."

Mahogany, ebony, ash, soft maple with eastern white pine;
38 × 24¾ × 20⅞ in. (96.5 × 62.9 × 53.0 cm)
The Bayou Bend Collection, gift of Miss Ima Hogg B.61.92

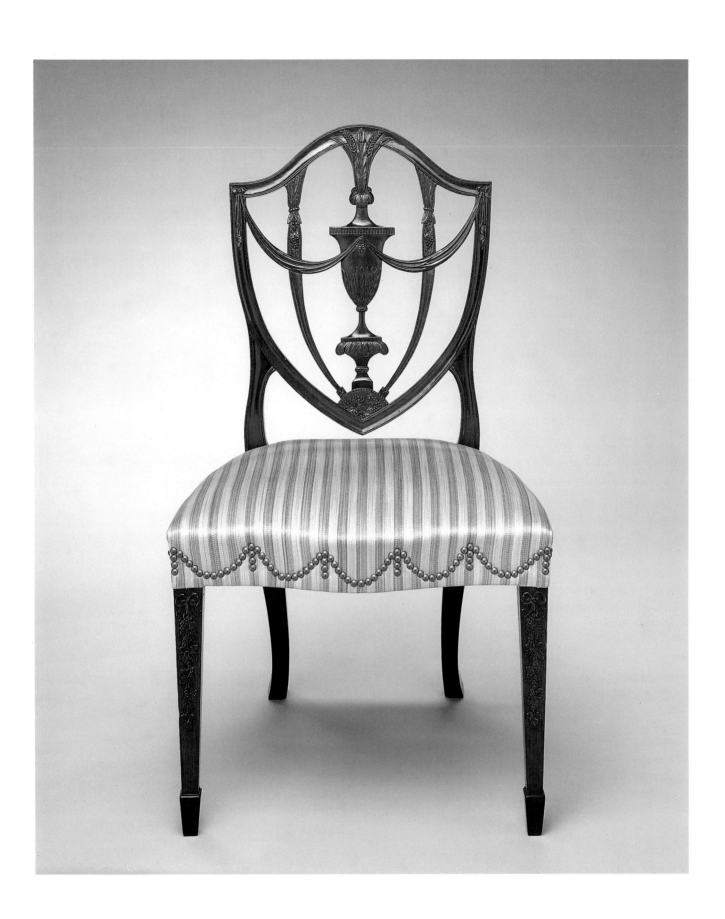

Attributed to JOHN AND THOMAS SEYMOUR

American; Boston, John (1738–1818), Thomas (1771–1848)

Lady's Writing Table with Tambour Shutters, 1790–1810

In her letter of 1797 young Susannah Clarke describes a lady's writing table with tambour shutters: "Dr. Prince has a new kind of desk and I wish Papa would permit me to have one like it—the lower desk that is a parcel of drawers hid with doors made in reeds to slip back and in the middle a plain door, 'tis the handsomest thing in the kind I ever saw." This new and innovative furniture form bears little resemblance to anything depicted in Hepplewhite's or Sheraton's books. Instead of relying on English design, the desk appears to be related to a small group of furniture influenced by contemporary French models, in this particular instance the bonheur du jour, or small writing table of the Louis XVI period (1774–93).

The form enjoyed great popularity in Boston as well as in the cabinetmaking centers north of the city. This particular example bears the script initials *TS* and is similar to a desk with a paper label bearing the names of John and Thomas Seymour. Although these relationships strengthen the attribution to the Seymours' shop, they are not sufficient to form a basis for an attribution to a specific maker because of the collaboration that existed among specialist artisans working in one shop or independently. Thomas Seymour's own advertisements specify that the furniture was made not by but "under the direction of Thomas Seymour." Whether this elegant desk represents the work of an individual or a group, the accomplished results epitomize the cabinetmakers' sensitive interpretations of the neoclassical style in America.

Mahogany with eastern white pine and red oak;
41¾ × 37½ × 19½ in. (105.6 × 95.3 × 49.0 cm)
Signed beneath upper section: TS
The Bayou Bend Collection, gift of Miss Ima Hogg B.65.12

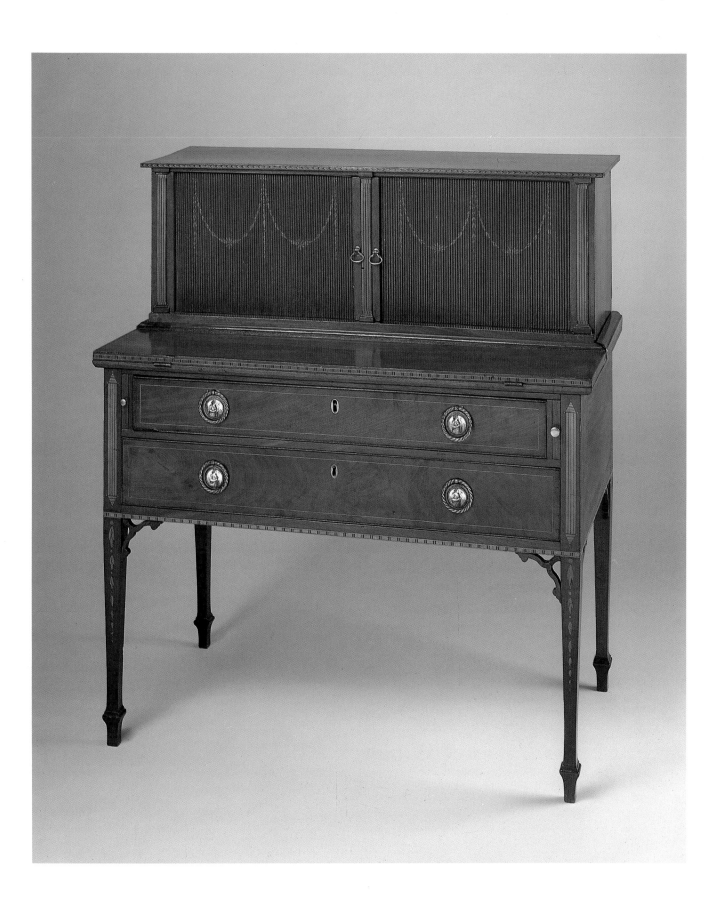

Sofa, 1810–30

The Empire style, a mature phase of neoclassicism, gained prominence during the early nineteenth century. By 1810 Americans were adopting the designs espoused by Sheraton as well as other Englishmen such as Thomas Hope (1770–1831) and George Smith (c. 1786–1826). In addition, Americans experienced a greater direct influence from France, through published designs, imported French furniture and works of art, and the immigration of French artisans to America.

Drawing on these published sources and the skills of émigré artists, Americans expanded their repertoire of antique or classical forms that could be reproduced or adapted for contemporary needs. One form was based on the curule, a folding chair used by Roman magistrates. The chair's inward curving legs were also employed on other forms of seating, including the sofa.

The elegance and exuberance of the Grecian style are integrated into the design of this superb sofa. Made of mahogany, which continued to be the fashionable cabinet wood, it is highlighted with gilding to emphasize the sinuous lines of the dolphin supports. The dolphin motif was closely associated with antiquity and as a result was employed frequently during the period.

Mahogany and gilding with mahogany, oak, cherry, eastern white pine;
35 × 94 × 27 in. (89.0 × 238.8 × 68.5 cm)
The Bayou Bend Collection, museum purchase with funds provided
by the Houston chapter of Kappa Alpha Theta B.78.79

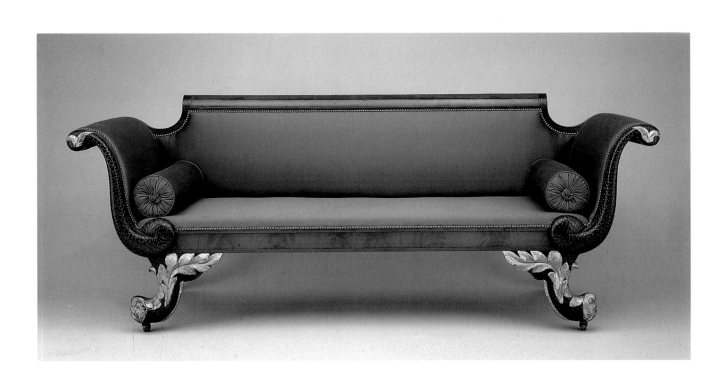

ANDREW E. WARNER
American; Baltimore, 1786–1870

Tureen, 1817

As America entered the nineteenth century the decorative arts flourished with the introduction of new methods of manufacture and an ever-growing market of well-to-do patrons. The Grecian style in silver, as in furniture and other mediums, achieved a new boldness in ornament and scale. With the introduction of the new style virtually coinciding with the War of 1812, it is not surprising that some of its most splendid expressions were a series of silver services commissioned for presentation to the war's heroes.

This boldly executed tureen, resplendent in its classical ornament, originally was part of a fourteen-piece dinner service ordered from Andrew E. Warner and presented to the naval hero Commodore Stephen Decatur by the citizens of Baltimore. The significance of this presentation was such that *Niles Weekly Register* of 1817 reported its completion to its readers: "The rich and tasteful service of plate, intended for presentation to Com. Decatur by the Citizens of Baltimore, is finished, and has been exhibited for the gratification of the people. . . . The work was executed by Mr. A. E. Warner, of Baltimore, and may bear a comparison with anything of a kind. It is truly superb."

Silver; 12¾ × 14½ × 9¾ in. (32.4 × 36.9 × 24.8 cm)
Signed on bottom in rectangle: Andw E Warner Balt;
inscribed: The Citizens of Baltimore to Commodore Stephen Decatur, Rebus gestis insigni: Ob virtutes dilecto *[Renowned for his valor: Beloved for his virtues]*
The Bayou Bend Collection, museum purchase with funds provided by the Theta Charity Antiques Show in honor of Betty Black Hatchett B.80.6

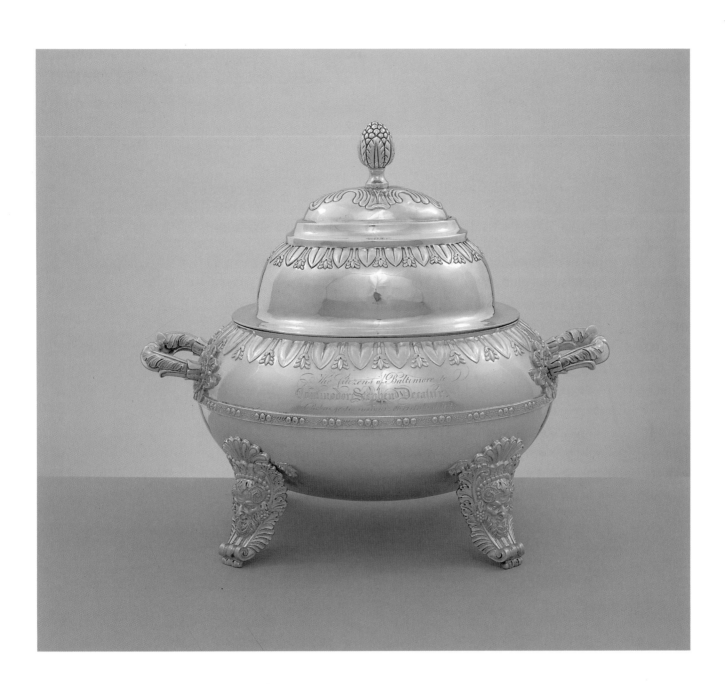

F ew pieces of American furniture from any era are as dramatic or as intricately executed as this sideboard. Although it was produced at the same time and in the same richly sculpted technique as the best New York rococo revival furniture, its historical roots lie in Italian baroque church architecture with which it shares its silhouette, symmetry, weighty base, scrolled brackets, and clearly articulated pediment moldings. Its sumptuously carved upper section follows the tradition of baroque woodcarving as well as popular nineteenth-century hunt trophies as depicted in paintings, sculptures, and furniture. As dining-room decoration, sideboards alluded to the bountiful feasts their owners could provide. The excellent quality of this example, combined with the eagle and shield on its pediment, indicate that it was probably made for competition at an industrial or world's fair before it was used in a home.

American tulip wood, northeast white pine, black walnut, marble;
106 × 69 × 28 in. (269.2 × 175.3 × 71.1 cm)
Museum purchase with funds provided by
Anaruth and Aron S. Gordon 83.46

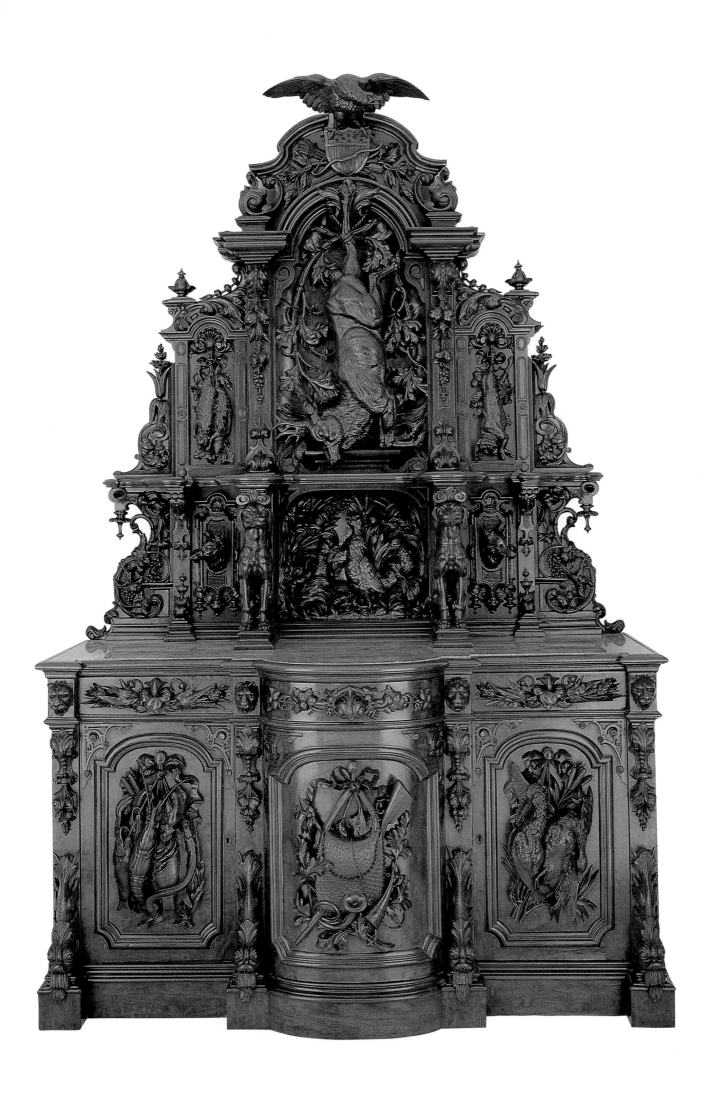

American Art

Mrs. Paul Richard, 1771

John Singleton Copley was the most accomplished painter working in America during the colonial period. Born in the Boston area, Copley was raised by his stepfather, Peter Pelham (1697–1751), an immigrant English mezzotint artist who came to Boston in 1726. Exposed to a world of prints and pictures, the young Copley was active as a painter by the age of fifteen. Although his early work depended stylistically on older Boston painters —John Smibert (1688–1751), Robert Feke (1707–1752?), and Joseph Blackburn (active 1752–74)—Copley rapidly developed his own style of linear, closely observed, penetrating, and realistic characterization. While his work of the 1760s incorporated rococo details and often landscape backgrounds, by the end of the decade Copley began to evolve a more subdued style of dramatically lighted subjects against a plain, dark background.

The portrait of the seventy-one-year-old widow Mrs. Paul Richard, painted in the artist's mature style during his 1771 visit to New York, is one of Copley's superb studies of older women. Mrs. Richard is seated in a blue-damask-covered open armchair, a setting Copley often used for female portraits during this period. The cool blue of the damask pleasurably contrasts with the overall warm brown tones of Mrs. Richard's garments. The artist had an unerring talent for capturing strong, realistic characterizations. Here the viewer's eye is immediately drawn to the powerful face relentlessly but lovingly rendered in precise detail.

Oil on canvas; 50 × 39½ in. (127.0 × 100.3 cm)
The Bayou Bend Collection, gift of Miss Ima Hogg B.54.18

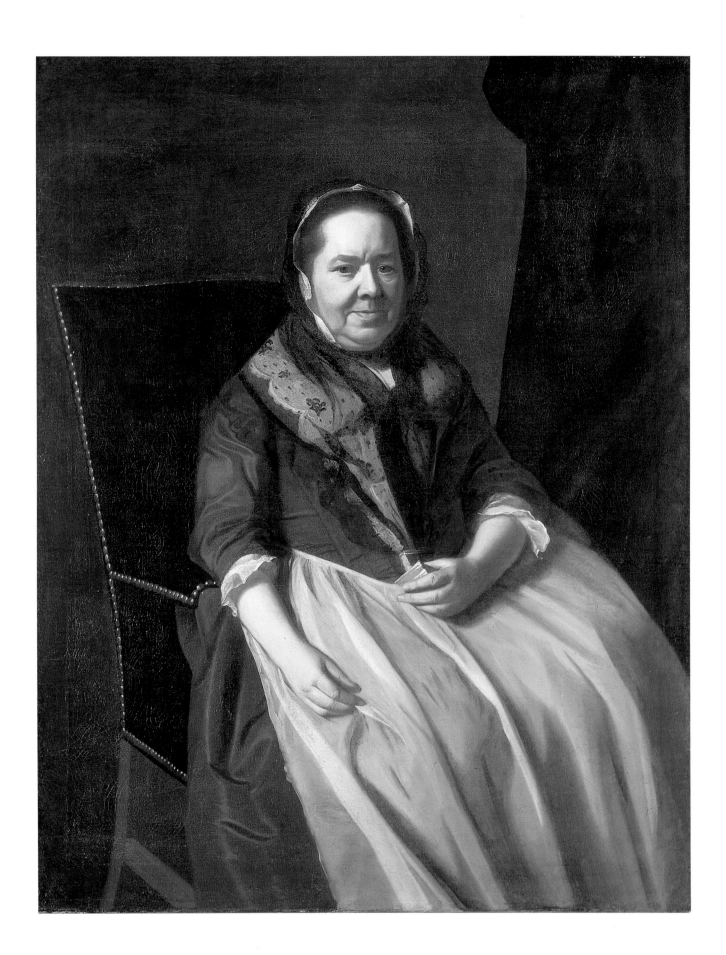

Although apprenticed to a saddler and watchmaker, Charles Willson Peale turned to painting and, through the patronage of the Annapolis planter John Beale Bordley, was sent to London in 1766 to study under Benjamin West (1738–1820). The young Peale spent three years in West's studio but did not absorb the grand neoclassical style espoused by West. He seems rather to have become thoroughly grounded in English rococo portraiture and the small-scale rococo group portrait. In 1769 he returned to America, where he worked in the middle colonies, living in Annapolis until 1775, when he moved to Philadelphia. There, while continuing to paint, Peale became involved in numerous scientific and museological pursuits.

Throughout his life Peale was very close to his large family, as several informal group portraits of family members attest. He also created a series of penetrating self-portraits. Both themes are combined in *Self-Portrait with Rachel and Angelica Peale*. The artist is shown engaging in his everyday business, painting; his daughter, Angelica Kauffmann Peale, stands behind him, and the likeness of his wife, Rachel, appears on the canvas at left. While the concept is decidedly rococo, Peale has painted the picture with the more neoclassic, crisp style that he adopted during the 1780s.

Oil on canvas; 36 × 27 1/16 in. (91.4 × 68.7 cm)
The Bayou Bend Collection, gift of Miss Ima Hogg B.60.49

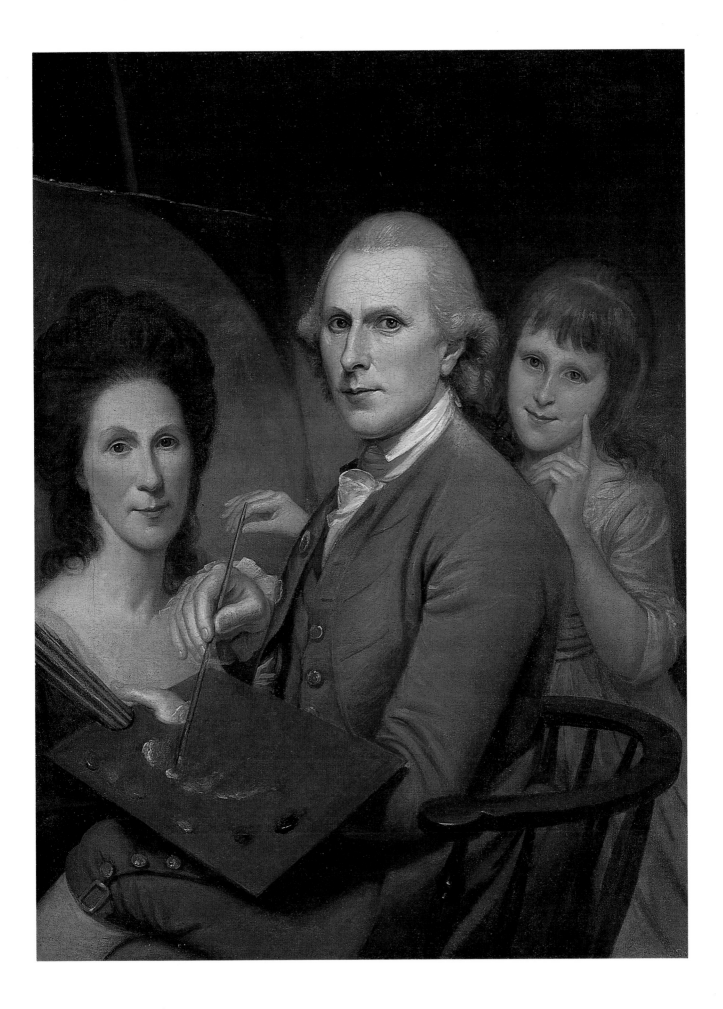

John Vaughan, 1795

Gilbert Stuart studied in Newport and in Edinburgh with the Scottish painter Cosmo Alexander (died 1772) before eventually going to London in 1775, where he lived and where he worked with Benjamin West (1738–1820) for five years. In 1782 he opened his own studio and achieved tremendous success. Stuart's spendthrift life-style, however, caused him such financial difficulties that in 1787 he was forced to flee to Dublin, where he worked for six years before a hasty departure to America to escape further debts. After a year in New York, Stuart moved to Philadelphia, which in 1794 was the nation's capital. He later worked in Washington, D.C., before finally settling in Boston.

While Stuart was in Philadelphia, John Vaughan, the subject of this painting, commissioned him to paint a portrait of George Washington from life. The resultant work, known as the "Vaughan portrait," was the first of Stuart's three studies of Washington and is perhaps the best-known image in American painting. Vaughan's own portrait was also executed in 1795, and in it Stuart incorporated a similar composition—a bust-length figure, timeless and motionless against a sunset glow. Stuart was particularly interested in capturing the luminous radiance of life in high-color flesh passages, a quality superbly rendered in this canvas. His sure, spontaneous brushwork is particularly evident in the sketchy treatment of Vaughan's stock and lace, while the harmonies of warm flesh, green coat, white stock, and gray hair against the sunset red background clearly underline Stuart's skill as a colorist.

Oil on canvas; 30¹/₁₆ × 25 in. (76.4 × 63.5 cm)
The Bayou Bend Collection, gift of Miss Ima Hogg B.61.55

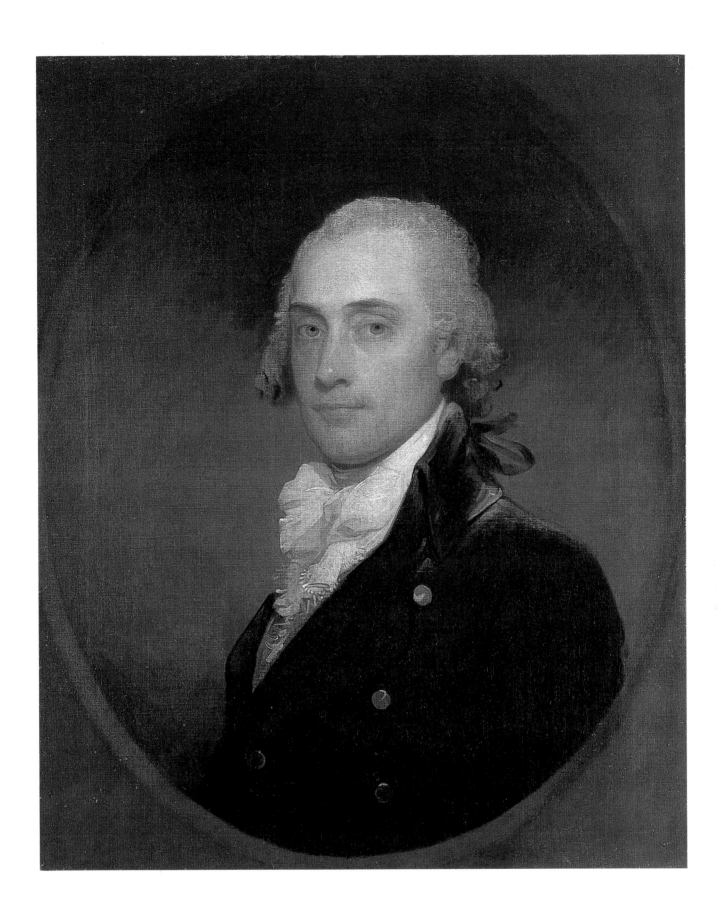

JAMES PEALE

American; Chestertown, Maryland, 1749–Philadelphia 1831

Still Life with Vegetables, 1826

A member of one of the preeminent families of American painting, James Peale was the younger brother of the portrait painter Charles Willson Peale. Known primarily as a miniaturist in Philadelphia, James Peale and his nephew Raphaelle (1774–1825) are regarded as the founders of the still-life painting tradition in America. This painting of turnips, tomatoes, radishes, and squash was owned by Anna Claypoole Staughton, James Peale's daughter.

The informal simplicity of this vegetable still life is enriched by a golden light emanating from the left. It enlivens the rich colors of the vegetables and highlights their leafy, curling tendrils. A copy of this work (Henry Francis du Pont Winterthur Museum, Delaware) was painted by Peale two years later.

Oil on canvas; 26 × 26½ in. (66.0 × 67.3 cm)

Inscribed verso: Property of A. C. Staughton / Painted by James Peale / Philad 1826 Aged 76

The Bayou Bend Collection, museum purchase with funds provided by the Theta Charity Antiques Show in honor of Mrs. Fred Thomson Couper, Jr. B.85.2

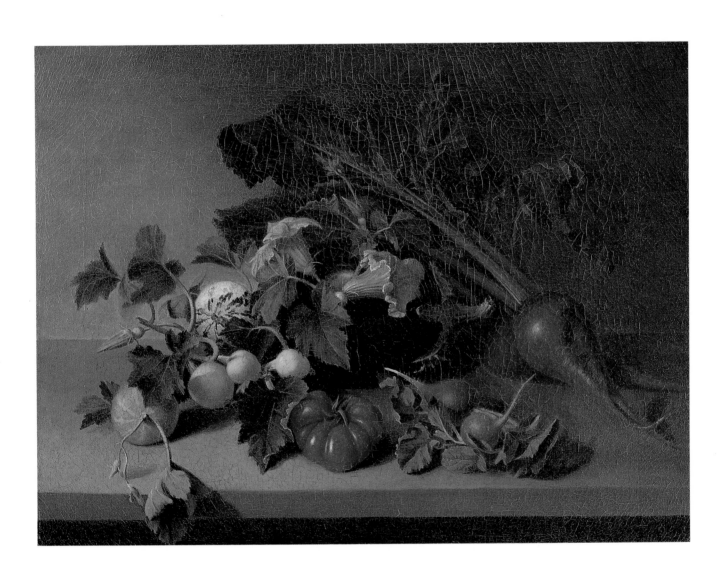

EDWARD HICKS

American; Attleboro, Pennsylvania, 1780–Newton, Pennsylvania, 1849

Penn's Treaty with the Indians, 1830–40

Although employed as a sign and coach painter during most of his adult life, Edward Hicks regarded himself primarily as a Quaker preacher. His seemingly naïve paintings are imbued with the same tenets that he preached within Quaker meeting houses. He is best known for his Peaceable Kingdom series describing the Old Testament prophecy of an ideal era of concord between savage and gentle beasts. Some paintings in the series include William Penn making his treaty with the Indians. Although the subject initially might not appear related to Hicks's Quaker beliefs, Penn's colonization project was widely regarded among Quakers as the establishment of a New World community that would, with its religious tolerance, achieve some measure of a peaceable kingdom on earth.

Hicks's Treaty composition is derived ultimately from Benjamin West's 1772 painting of the subject (Pennsylvania Academy of the Fine Arts, Philadelphia). The composition became known through the print of 1775 by John Hall and Robert Boydell, which was widely circulated for nearly fifty years. Relying on this print, Hicks has adapted West's original composition, reversing the placement of the foreground figures, for instance. Hicks also eliminated the Delaware River, substituting Penn's Landing on Dock Street as reconstructed from yet another print source. The museum's version varies from other Treaty pictures in several details; in particular, to the left of the English servant is a tray of Jew's harps, items known to have been brought by Penn to the New World. Hicks's highly personal naïve paintings often were made as gifts to fellow Quakers.

Oil on canvas; 17½ × 23½ in. (44.4 × 59.7 cm)
The Bayou Bend Collection, gift of Alice C. Simkins in memory of
Alice N. Hanszen B.77.46

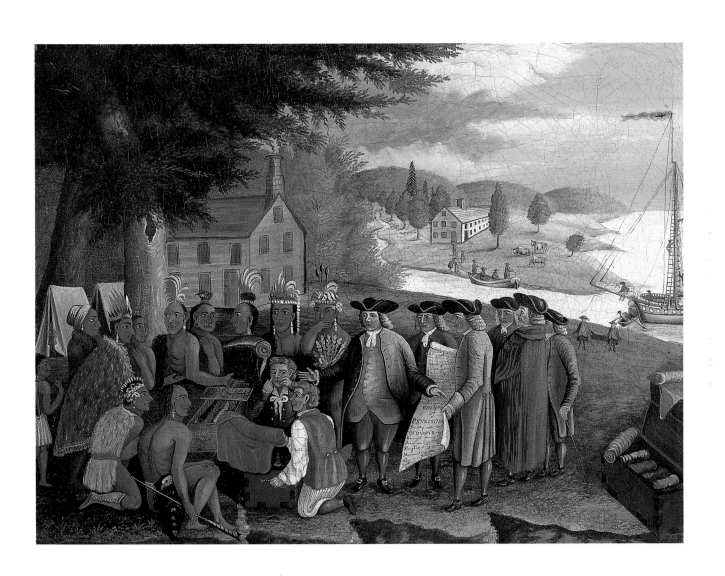

A View of Mansfield Mountain, 1849

Born into a family of engravers, John Frederick Kensett was a member of the second generation of Hudson River school painters, who were known for their romantic landscapes. He earned his livelihood following his family's profession, first in New York, later in New Haven and Albany. His ambition, however, was to become a painter, and, after receiving favorable criticism for a landscape exhibited in 1838 at the National Academy of Design in New York, he decided to study abroad. In 1840 with his close friend and fellow painter Asher B. Durand (1796–1886) he embarked on what would become a seven-year sojourn in Europe. There he studied and painted, supporting himself by engraving, until he received an inheritance giving him financial security. While in England, Kensett was influenced by the atmospheric, dark wooded pastorales of John Constable (1776–1837) and the closely observed landscapes of H. J. Boddington (1811–1865).

A View of Mansfield Mountain was painted in 1849, shortly after Kensett's triumphant return to New York from Europe and the same year he became a full member of the National Academy of Design. After 1848 Kensett traveled to the country each summer, usually to the mountains of New England and occasionally to the West, where he made oil sketches from nature. These served as models for large, finished studio paintings made in New York during the winter. The seated artist in the left foreground of the museum's painting is making such a sketch. Mount Mansfield, rising to an altitude of nearly forty-four hundred feet in the Green Mountains of northwestern Vermont, was a favorite stopping point for artists and tourists alike in the mid-nineteenth century. The composition, with dark, shaded foreground and patches of sunlight, recalls Kensett's English paintings of the mid-1840s, while the large trees at the left echo canvases from the same period by Durand. The distant mountain in the atmospheric, sun-filled background presages the luministic, lyrical landscapes of Kensett's mature work.

Oil on canvas; 48 × 39⅝ in. (121.9 × 100.6 cm)
Signed and dated lower right: JF K 1849
Museum purchase with funds provided by the Hogg Brothers Collection,
gift of Miss Ima Hogg by exchange, Houston Friends of Art,
Mrs. William Stamps Farish; and General Accessions Fund 76.200

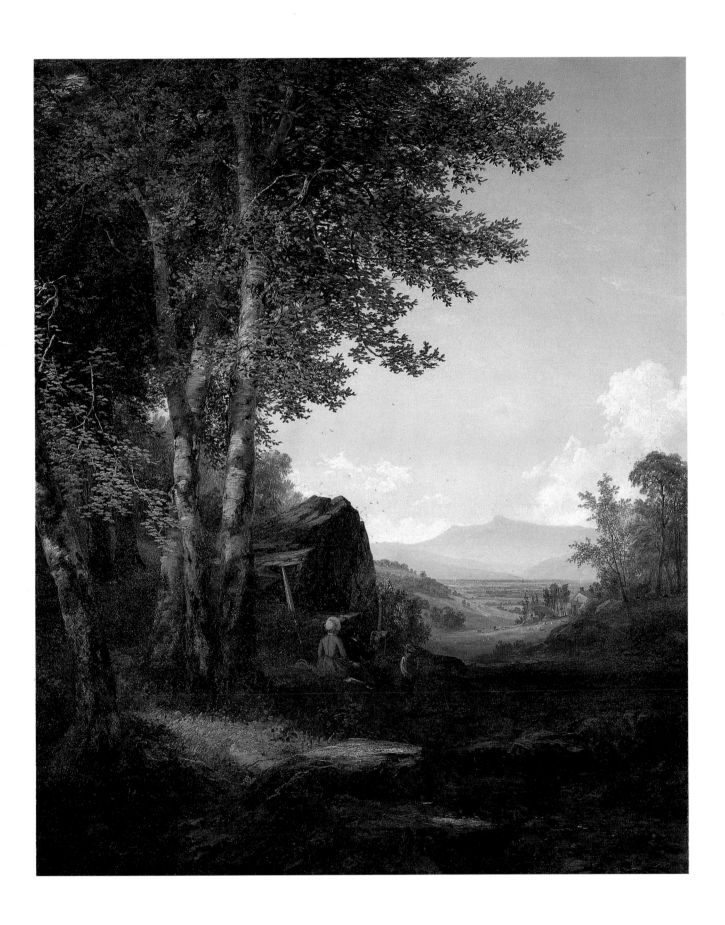

Cotopaxi, 1855

A member of the second generation of romantic landscape painters, Frederic E. Church ranks among the most influential artists in America during the period 1850–75. As a youth Church studied with Thomas Cole (1801–1848), one of the founders of the Hudson River school. For Church and others of his generation, the Hudson River area alone did not provide sufficient aesthetic stimulus, and they turned to more distant places for inspiration. Strongly influenced by the writings of the German naturalist and traveler Alexander von Humboldt, Church first explored the exotic wonders of the Andes of South America and later the arctic north and tropical Jamaica.

Cotopaxi is one of a group of works painted after Church's first visit to South America in 1853. The cone-shaped volcano, located in Ecuador, is a subject that the artist was to paint for nearly a decade. Church's master, Cole, had been fascinated with the Sicilian volcano, Mount Etna, painting it no fewer than four times. A large version, undoubtedly known to Church, may have served as the source for *Cotopaxi*.

Church dramatically juxtaposed the warm, palm-filled tropics with the cold plain and snow-capped mountain, the small scale of the foreground figures with the vast overall panorama, and the Edenic tranquility with the powerful forces of nature suggested by the crashing waterfalls and trail of smoke from the active volcano.

American romantic landscape paintings such as *Cotopaxi*, intended by the artist to invoke awe, had an inherent moralistic message, reminding the viewer of the powerful forces of nature and the smallness of human efforts in the face of nature. In the era before photography and easy travel these pictures also served as documents of distant, exotic sites.

Oil on canvas; 30 × 46⁷⁄₁₆ in. (76.2 × 117.9 cm)
Signed and dated lower right: F. E. Church / 1855
Museum purchase with funds provided by the Hogg Brothers Collection,
gift of Miss Ima Hogg by exchange 74.58

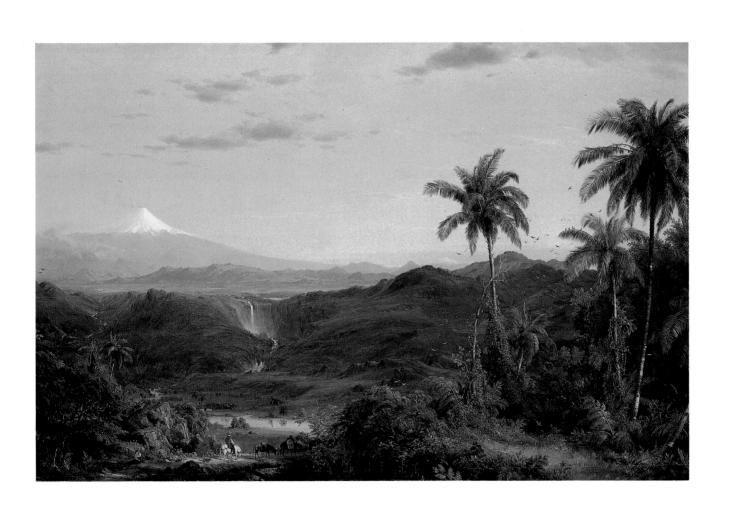

The First Portrait, c. 1888

William Merritt Chase studied in Indianapolis and New York before attending the Munich Academy, where between 1872 and 1878 he absorbed the style of the old masters, especially of the Spanish and Dutch schools. While in Munich, Chase also mastered a bravura, painterly brush technique that was to distinguish his work throughout his life. Returning to New York in 1878, Chase began a long and distinguished career at the Art Students League. As a teacher there and at his own school he exerted an important influence on several generations of American painters.

The First Portrait is Chase's earliest study of his daughter Alice, who was to become a recurring subject in his oeuvre. The artist's wife, Alice Gerson Chase, is depicted with her back to the viewer, holding the infant who looks over her mother's shoulder. Chase's facile brushwork—particularly apparent in the treatment of the glittering surfaces of the coral and bells, white lace gown, and Japanese embroidery on the mother's robe—reflects the artist's familiarity with the old masters. Mrs. Chase's robe is indicative of the artist's aesthetic interest in *japonisme*.

Oil on canvas; 70⅛ × 40⅛ in. (178.1 × 102.0 cm)
Gift of Ehrich Newhouse Gallery, New York 34.81

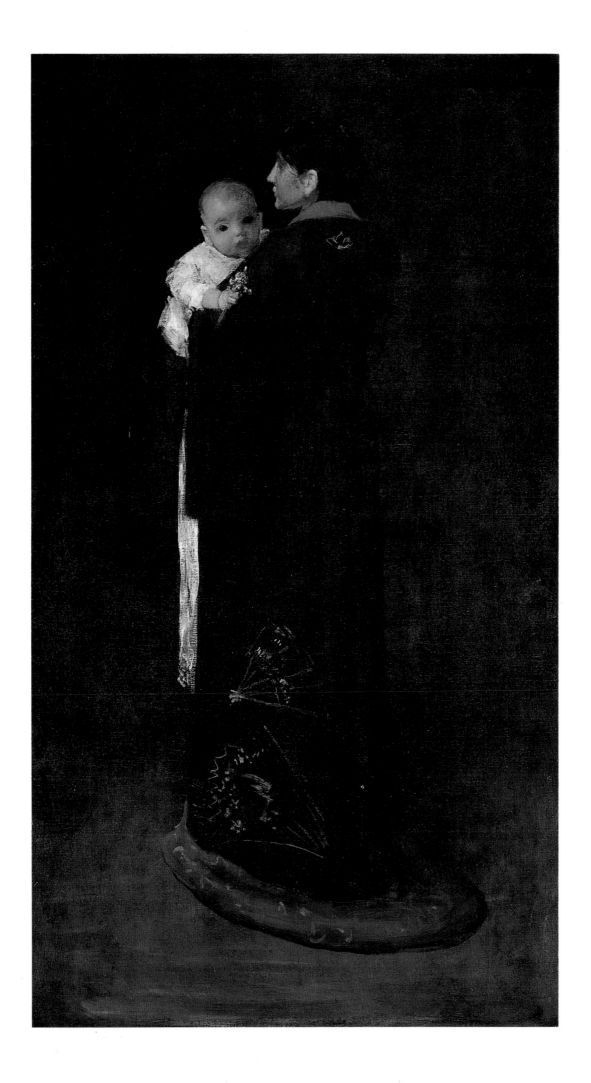

Mrs. Joshua Montgomery Sears, 1899

Born of expatriate American parents living in Florence, John Singer Sargent went in 1874 to Paris, where he briefly attended the École des Beaux-Arts and entered the atelier of Émile Carolus-Duran (1837–1917). Within three years Sargent had achieved success as a portraitist, and he continued to paint for a fashionable Parisian clientele until the scandal surrounding his revealing portrait of *Madame X* (Metropolitan Museum of Art, New York) forced him to move to London in 1884. There Sargent became the leading society portrait painter of the late Victorian and Edwardian eras. He created an extraordinary body of painterly and coloristic pictures depicting his sitters in dramatic and elegant poses and invented a neo-baroque style of aristocratic portraiture.

In 1876 Sargent made his first painting tour of the United States, and it may be then that he met Bostonian Sarah Choate Sears. Sarah, who had married Joshua Montgomery Sears in 1877, had studied under Edmund Tarbell (1862–1938) at the art school of the Museum of Fine Arts, Boston. She achieved a reputation as an accomplished watercolorist and later was recognized as a talented photographer. She and Sargent became friends, and he allowed her to record him at work in Isabella Stewart Gardner's home, Fenway Court.

This portrait is a penetrating psychological study. The sitter's direct gaze and confident smile convey both her intelligence and close personal friendship with the artist. Painted in Sargent's London studio, the portrait of Mrs. Sears is an extraordinary study of whites against a dark background, revealing the intensity and painterly expressiveness of Sargent's art at its best.

Oil on canvas; 58⅛ × 38⅛ in. (147.6 × 96.8 cm)
Signed and dated upper right: John S. Sargent 1899
Museum purchase with funds provided by George R. Brown
in honor of his wife, Alice Pratt Brown 80.144

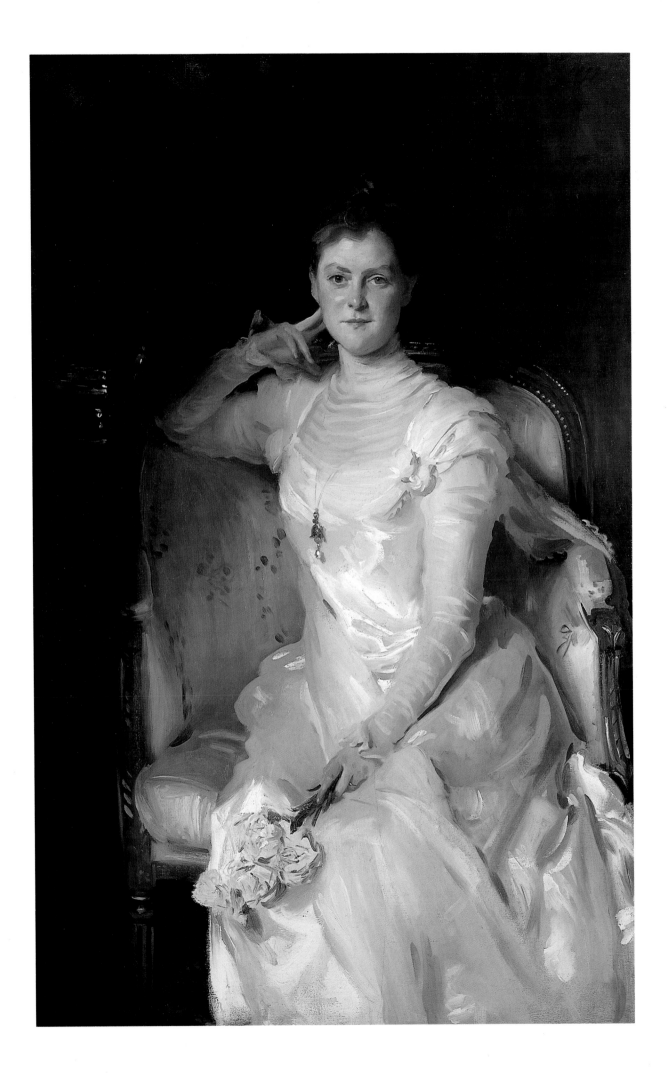

Portrait of Florence Pierce, 1914

Georgetorge Bellows was born in Columbus, Ohio, and attended Ohio State University. His early training in art was with Robert Henri (1865–1929), the influential leader of the revolutionary Ashcan school, which celebrated everyday subject matter in paintings of the urban scene. Bellows's energetic style and broad brushwork won immediate praise and recognition. In 1909, at the age of twenty-seven, he was elected an associate of the National Academy of Design, one of the youngest in its history, and four years later, in 1913, became an academician.

Portrait of Florence Pierce was painted in August 1914, during a summer spent at Monhegan Island off the coast of Maine, where he had joined an artists' colony. Bellows exhibited in the 1913 Armory Show, and his exposure to modern European art is evident here in the heightened color and concern for form and structure. The dramatic lighting and loose paint handling, especially beautiful in the sitter's foreshortened arm and hand draped over the chair back, are characteristic of the powerful, realistic portraits that Bellows painted throughout his career.

Oil on canvas; 38 × 30 in. (96.6 × 76.2 cm)

Gift of Mr. and Mrs. Meredith Long in memory of
Mrs. Agnes Cullen Arnold 74.255

Photography

EDWARD STEICHEN

American; Luxembourg 1879–West Redding, Connecticut, 1973

Trees, Long Island, 1905

As a great discoverer of artistic talent and a renowned photographer, Edward Steichen was a pivotal figure in the history of American art. For him, being a photographer came first, and other roles were assumed in his efforts to have photography recognized as an art form, to nurture all art deemed uniquely American, and, finally, to introduce America to the work of the major European modernists, including Cézanne, Matisse, and Picasso.

The early work of Steichen was pictorial, a turn-of-the-century painterly style, of which *Trees, Long Island* is a masterpiece example. Dense black trees border and contain towering clouds and a luminous chestnut tree. The image evokes an interplay of spiritual and concrete impressions; its vague details and painterly textures provide abstract patterns as well as realistic depictions. Steichen later explored a modernist style characterized by exacting detail, a full range of tonal values, and convincingly solid forms.

Carbon photograph on base of silver paint; image 14⅜ × 13⁹⁄₁₆ in. (36.5 × 34.5 cm)
Signed lower right: Steichen MDCCCCV
Museum purchase with funds provided by the Long Endowment for American Art and the Sarah Campbell Blaffer Foundation 86.1

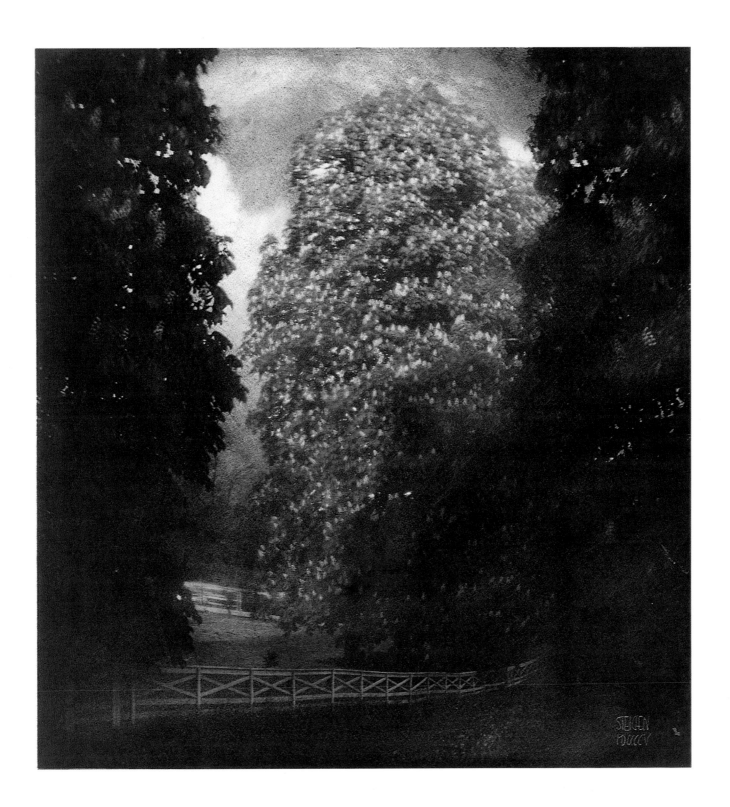

Schadograph, 1918

C hristian Schad took refuge in Geneva, Switzerland, during World War I. With other groups in New York, Berlin, and Paris, artists in Geneva formulated the Dada movement. Its declared purpose was brazenly to announce that all established values, moral or aesthetic, had been rendered meaningless by the war; in Dada's rejection of order and its love of chance, there was also liberation. In 1918 Schad made twenty-two totally abstract photographs without using a camera; the Dada poet Tristan Tzara christened them Schadographs. Inspired by the new Dada technique of collage, Schad placed discarded materials and objects directly on photographic paper, avoiding all identification with recognizable figures and objects. He moved further from traditional prints and photographs by cutting the images into irregular shapes and mounting them on small cards. Each image was unique.

His images influenced the surrealist Man Ray (1890–1976) and the constructivist László Moholy-Nagy (1895–1946), both of whom greatly expanded the imagery of cameraless photography. After this intense experimentation Schad returned to painting and sculpture.

Printing-out-paper Schadograph;
image (irregular) 3⅛ × 2⅜ in. (8.0 × 6.0 cm), mount 6⅜ × 5 in. (16.2 × 12.7 cm)
Museum purchase with funds provided by
Isabell and Max Herzstein 88.15

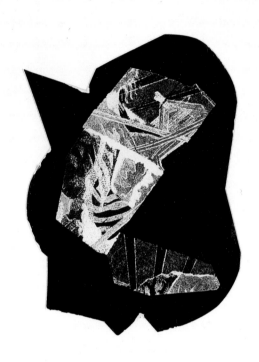

View of the Studio: Column [1918],
The Golden Bird [1919], 1920–22 (?)

Born in Romania, Brancusi moved to Paris in 1904 to study sculpture. He evolved a style characterized by a reduction of subjects to classically simple, biomorphic shapes and by an elegant use of marble, wood, and bronze. He learned photography because he believed that the camera would be a useful tool for him as a sculptor. At Brancusi's request, Man Ray advised him on the purchase of equipment and essential materials. Brancusi then built a darkroom in the corner of his studio. Photography became a means for him to see his sculpture in progress and to experiment with pedestals. After finishing a sculpture he would photograph it on several different bases to record how successfully the sculpture and pedestal worked together.

Brancusi transformed the photograph from utilitarian documentation to aesthetic expression. Like his sculptures, these precise arrangements embody the art of balancing diverse attributes: light and its play on multiple surfaces; a form in relation to space and other forms. For Brancusi, his photographs convey the issues in his art as he perceived them. Ultimately, he insisted that only his own photographs be used as reproductions of his work.

Gelatin silver photograph; 9¹⁵/₁₆ × 7⅞ in. (25.2 × 20.0 cm)
Museum purchase with funds provided by Mrs. Lucille Bowden Johnson
in honor of Frances G. McLanahan and Alexander K. McLanahan 82.159

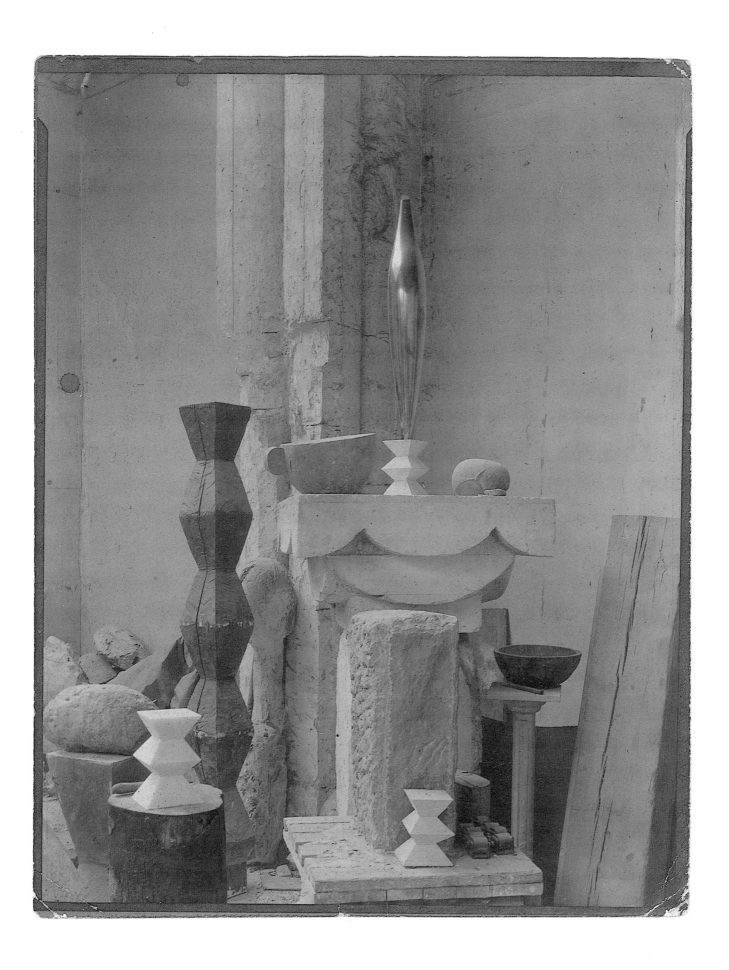

Epilogue, 1919

In 1906 Edward Weston traveled to California to stay with his sister for two months. Except for a year at the Illinois College of Photography in Effingham and three years in Mexico, he remained in California for the rest of his life. In 1912 he opened a portrait studio in Tropico (now Glendale). Three years later he met Margrethe Mather, whom he made a business partner. Together they frequently exhibited in pictorialist salons and published photographs until their partnership dissolved in 1921.

As a pictorialist photographer, Weston made softly focused works, composed in broad tonal masses and illuminated with the diffuse, atmospheric light favored by the impressionists. Shortly after this picture of Mather was made, Weston's style changed radically; like Steichen and Stieglitz, Weston moved from a pictorialist to a modernist style. *Epilogue* represents Weston's work in transition. It utilizes a pictorialist, staged pose with theatrical props, dramatic lighting, and textured backdrop. Its modernist composition is asymmetrical, incorporating a decorative use of negative space in the style of oriental prints.

Platinum photograph; 9⅝ × 7⅜ in. (24.4 × 18.7 cm)

Inscribed recto on mount lower left in pencil: Epilogue; *lower right:*
Edward Weston—1919

The Target Collection of American Photography, museum purchase with funds provided by Target Stores 78.62

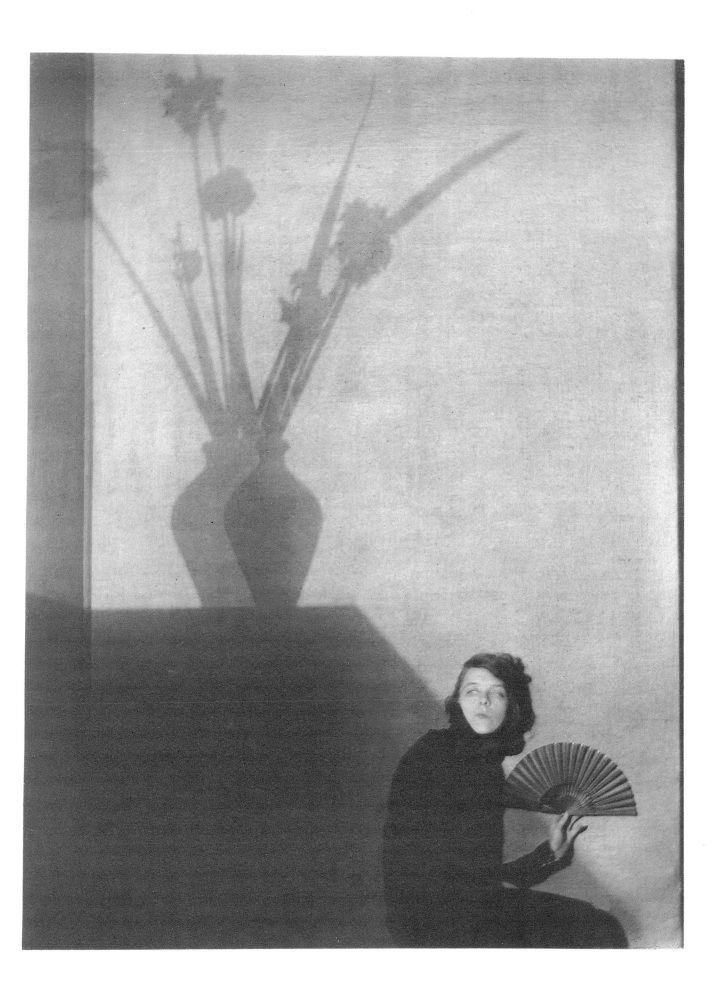

ANDRÉ KERTÉSZ

American; Budapest 1894–New York 1985

In Les Halles, 1929

I n a laconic introduction to one of his monographs written just before his death, André Kertész wrote, "Photography must be realistic." The thousands of photographs taken during his seventy-three-year career disclose how diverse reality was for Kertész. There are realities that he discovered and realities of his invention: journalist's dreams of Budapest, Paris, and New York; nudes reflected in a distorting fun-house mirror; and still-life arrangements photographed in his apartment.

Kertész's style was shaped by two preferences. The first was for a small camera that allowed him to move quickly and unobtrusively amid the subjects that attracted him. He was one of the first serious photographers to work with a 35mm camera, and after 1928 he used it almost exclusively. His second preference was to find and delineate analytic structure. Kertész's compositions have the unity of arrangement and inner rhythm of works by the modern painters who were his friends in Paris. *In Les Halles*, with its clean spare lines of a wheel and its shadow, displays the formalist invention for which Kertész became famous.

Gelatin silver photograph; image 6⅝ × 8¾ in. (16.8 × 22.3 cm)
Signed recto on mount lower left in pencil: A Kertész; lower right: 1929
Museum purchase with funds provided by the Brown Foundation
Accessions Endowment Fund 88.13

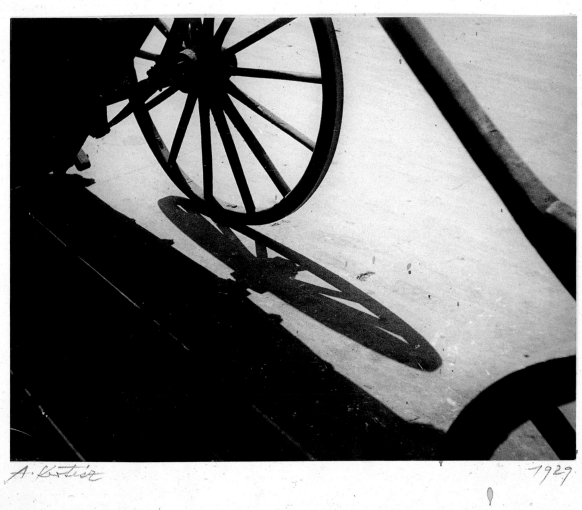

A. Kertész 1929.

Maid Preparing the Evening Bath, c. 1932

Bill Brandt was born in Hamburg to a wealthy English father and German mother. Educated in Germany, he learned photography in Vienna in 1928 and moved to Paris, where he worked in Man Ray's studio. Familiar with the Parisian surrealists, Brandt in his work integrated their innovative interplay between fact and fantasy, transformation of the ordinary, and preference for chance effects and novel techniques.

Between 1931, when he moved to London, and 1938, Brandt produced the photographs for his first two books, *The English at Home* (1936) and *A Night in London* (1938). Curious about his father's country and the life-style of the English, Brandt observed the details and incidents he found to be peculiarly English. He either photographed them directly or dramatized specific scenes for his camera. Brandt's wife, brother, and friends enacted roles in the fine Surrey houses and London drawing rooms of his father's family. The fact that some of the images were staged has only recently been revealed. Their previous status as unvarnished "documents" made Brandt's prewar shift to photographs of nudes quite surprising. Although dramatized, the staged pictures powerfully evoke Brandt's social perceptions. The teasing thread linking fact and fantasy—once considered lacking in this photo series—is now understood to run throughout his work.

Gelatin silver photograph; image 9⅝ × 7⁹⁄₁₆ in. (24.5 × 19.3 cm)
Verso center stamped in ink: Photo Bill Brandt [and address];
inscribed in pencil: Preparing the evening bath; *left edge:* J. W.
Museum purchase with funds provided by the Mundy Companies 85.109

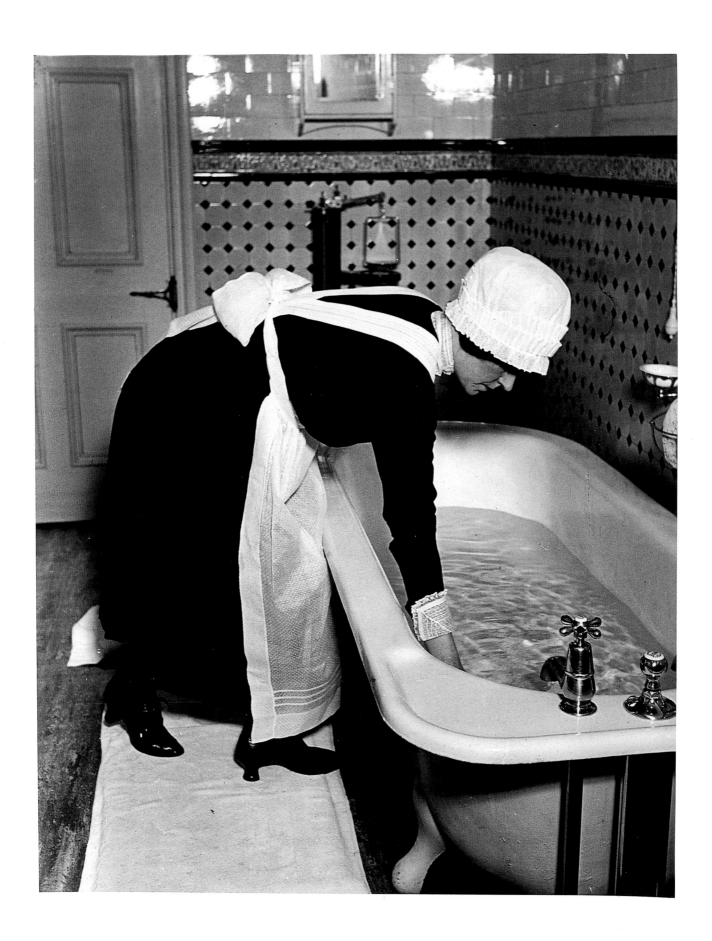

LÁSZLÓ MOHOLY-NAGY

American; Bacsbarsod, Hungary, 1895–Chicago 1946

At Coffee, n.d.

László Moholy-Nagy was a painter, sculptor, photographer, designer, filmmaker, teacher, and theoretician whose art and writing were centrally important to the development of modern art in Europe and America. Hungarian by birth, in 1921 he moved to Berlin, then a major center of avant-garde painting and theater. In 1923 Moholy joined the staff of the Bauhaus. Henceforth, he ceaselessly sought to invent new visual forms and expand the perceived limitations of the mediums in which he worked.

Like Christian Schad and Man Ray, Moholy worked prolifically with the photogram, an abstract photographic image made without a camera. Moholy also sought a new vision of his subjects by photographing them from unconventional angles, directly above or below or at very close range, centering on an evocative detail such as the coffee cups in this print. Laid aside on a sun-dappled patio between two wicker chairs at the feet of their occupants, with minimal other information, the cups hint of discourse, leisure, and style.

Gelatin silver photograph; 11⅛ × 8⅛ in. (28.2 × 20.6 cm)
Verso inscribed and stamped: Bei mokka *[At coffee]*
Museum purchase with funds provided by
Isabell and Max Herzstein 84.231

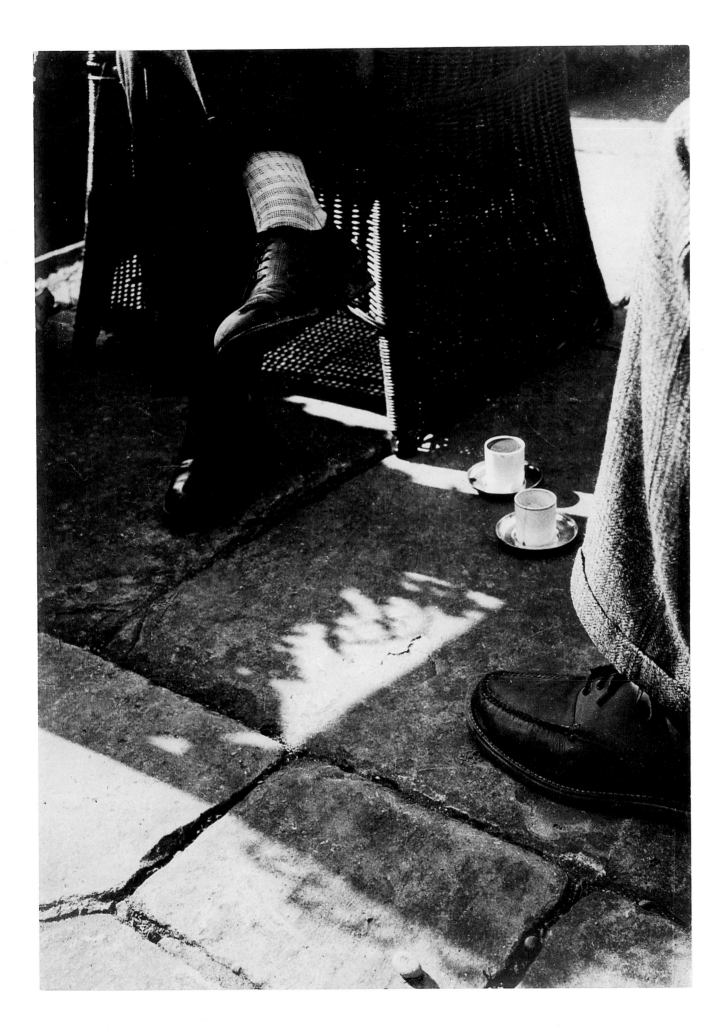

ALFRED STIEGLITZ
American; Hoboken, New Jersey, 1864–New York 1946

Portrait of Georgia O'Keeffe, 1933

I n 1933 Alfred Stieglitz culminated a project entitled Georgia O'Keeffe: A Portrait. The completed portrait consisted of more than five hundred photographs and originally was conceived to extend over the subject's lifetime. "His idea of a portrait," wrote O'Keeffe, "was not just one picture. His dream was to start with a child at birth and photograph that child in all of its activities as it grew to be a person and on throughout its adult life. As a portrait, it would be a photographic diary."

Georgia O'Keeffe: A Portrait is one of the most extensive serial documents in any medium. In 1933 Stieglitz was sixty-nine and O'Keeffe forty-six. They had lived together for fifteen years and been married for nine, and he had exhibited her paintings in his gallery for seventeen. The photographs mark the course of their relationship from its tentative beginnings into a passionate intimacy and finally to the last phase of their marriage, when O'Keeffe began spending almost half of each year in her New Mexico studio, while Stieglitz remained in New York.

Gelatin silver photograph; 8¾ × 7½ in. (22.2 × 19.1 cm)
The Target Collection of American Photography, museum purchase
with funds provided by Target Stores 78.63

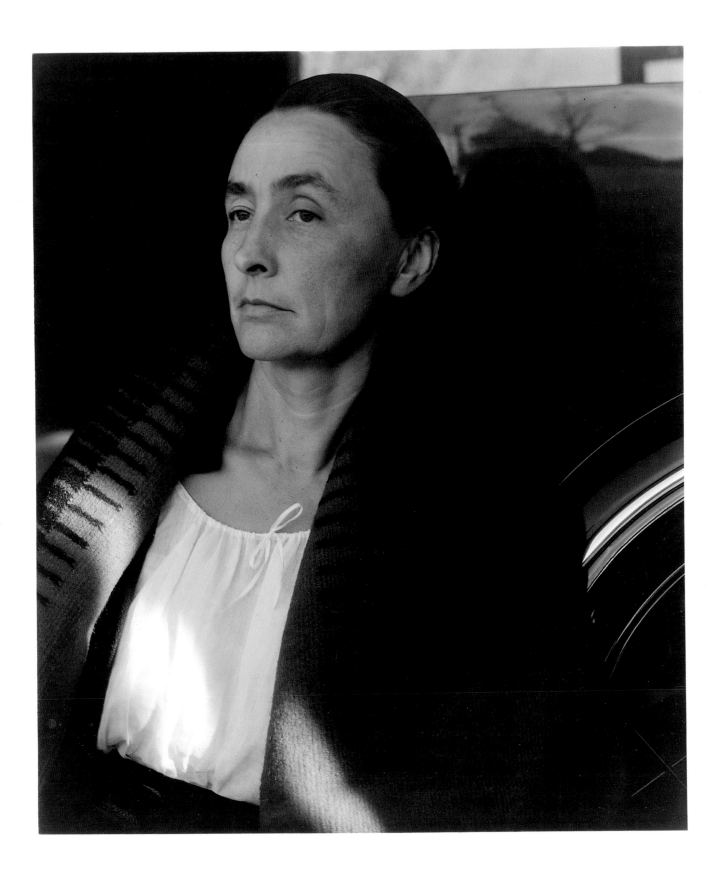

The Thousand-Year Reich, 1934

Trained as a painter, John Heartfield was a founding member of the Berlin Dada group, whose members included George Grosz (1893–1959), Hannah Höch (1889–1979), Raoul Hausmann (1886–1971), and Heartfield's brother Wieland Herzfelde (died 1988). (As a protest against German nationalism, in 1918 Heartfield anglicized his name, Helmut Herzfelde.) In astonishingly diverse ways the Berlin group developed a technique called photomontage. Akin to collage, photomontage combines disparate pictures to form a new visual entity. Having an idea, the artist either finds images in the popular press or stages actions to photograph. Cutouts from various photographs are pasted together in a manner that ignores traditional pictorial rules, such as one-point perspective, comparable scale, or realistic setting, yet a coherent impression is created.

Artists utilizing collage and photomontage had primary purposes ranging from expression of private dreams to political concerns. Heartfield moved steadily away from the Dadaist desire to subvert reality toward a committed political position. Between 1921 and 1939 most of Heartfield's work was published in the newspaper *Arbeiter Illustrierte Zeitung*. Issued first in Berlin and later in Prague, Heartfield's montages conveyed a searing indictment of the Nazi regime.

From Arbeiter Illustrierte Zeitung *XIII:38 (September 20, 1934)*
Rotogravure on newsprint from original photomontage;
sheet 15⅛ × 11⅛ in. (38.2 × 28.2 cm)
Museum purchase with funds provided by
Isabell and Max Herzstein 82.59.10.20

„Die deutsche Lebensform ist für das nächste Jahrtausend endgültig bestimmt." — „In den nächsten tausend Jahren findet in Deutschland keine Revolution mehr statt."

Adolf Hitler auf dem nürnberger Parteitage

Das tausendjährige Reich

WALKER EVANS

American; Saint Louis 1903–New Haven 1975

Roadside Sandwich Shop, Ponchatoula, Louisiana, 1936

From 1935 to 1937 Walker Evans was employed by the Rural Resettlement Administration (later called the Farm Security Administration), best known for its photographs of the Dust Bowl, migrant laborers, and other symbols of the Great Depression and the human suffering, fortitude, and dignity that it engendered. Evans's photographs are drier than most made for the FSA because he sought an intellectual rather than an emotional appeal. In his uncompromising images, he was offering respect, not empathy, for his subjects. His consistently frontal approach to his subjects anchored them within the picture and, in a time of chaos, imposed an enormous sense of physical stability. Evans's photographs were insistently factual. In his work reality is not transformed by heightened perspective or overly dramatic details. He evolved an unobtrusive technical mastery and preferred natural, uncontrived lighting.

George's Place is a roadside sandwich shop of no particular distinction. Oysters, oranges, and poor-boy sandwiches locate the stand in southern Louisiana; the prices place it in time. The viewer is convinced that George's once existed and that this is how it would have looked had the viewer been there. To create this conviction was Evans's intention and pleasure.

Gelatin silver photograph; 7⅝ × 9⅝ in. (19.4 × 24.5 cm)
The Target Collection of American Photography, museum purchase
with funds provided by Target Stores 76.242

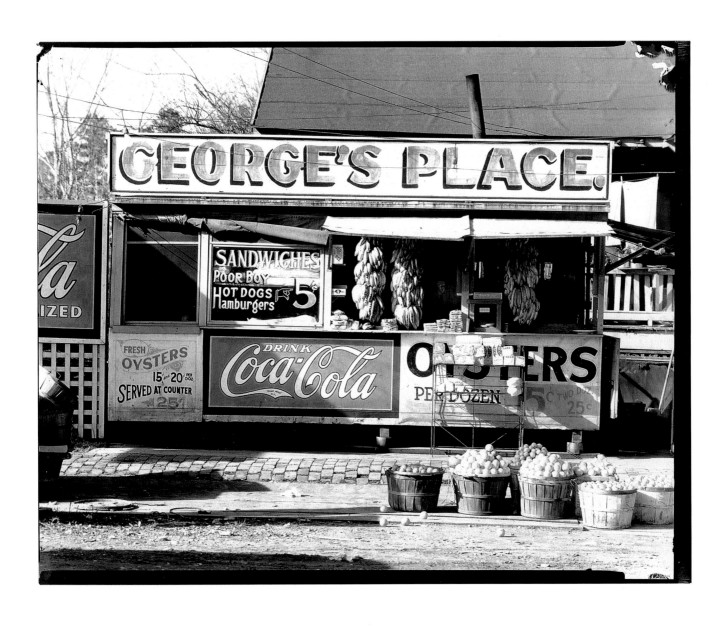

Robert Frank moved to America in 1947 and became in 1955 the first European to receive a Guggenheim Fellowship. The fellowship allowed him to spend two years traveling by car throughout America, photographing mundane scenes in which he found certain recurring images: cars, flags, jukeboxes, politicians, religious figures, and roadside entertainments. He saw these objects and people as American icons and invested them with symbolic power. As Jack Kerouac explained in his introduction to the book *The Americans* (1959), "He sucked a sad poem right out of America onto film."

The subject of *Hoboken* is a political ceremony that has the unenthusiastic attention of a group of middle-aged men on a viewing stand. Two officials in the front row stand out: one, a tall, heavy, hard-eyed man in a cloth coat and felt hat, embodies the stereotype of a political boss; the other wears a silk hat and is a politician described by Walker Evans as "exuding the utmost fatuity that even a small office-seeker can exhibit."

From the series The Americans
Gelatin silver photograph; 8¹/₁₆ × 12³/₁₆ in. (20.5 × 31.0 cm)
Signed recto lower right in ink: Hoboken, 1955 R. Frank
The Target Collection of American Photography, museum purchase with funds provided by Target Stores 76.243

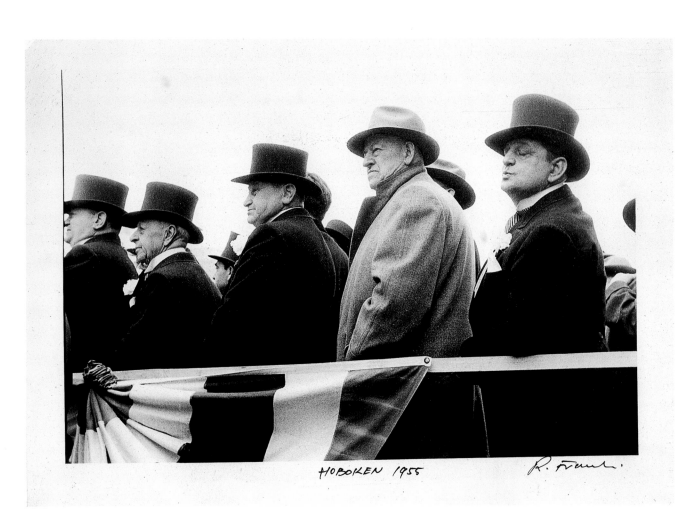

HOBOKEN 1955 R. Frank

Past Recovery, 1979

Esther Parada was trained as a photographer, but her work, in its monumental scale and ambitious nature, is not traditionally photographic. She gathers and blends texts and images, freely altering both. She then forms the composite whole in installations that sometimes encompass an entire room.

In *Past Recovery* she creates a history of her family in one work of one hundred images. She transforms a small photograph of the wedding anniversary of her great-aunt and great-uncle into a giant family scrapbook, with photographs of family members from various periods in their lives superimposed on their images at the banquet. "My sister's face at age two," wrote Parada, "is juxtaposed with her own image thirty years later and with that of a great-aunt whom we never met, although family legend has it that they were cast in the same mold. Similarly, I see other members of that family gathering through the filter of my own cumulative experience." *Past Recovery* is a montage of personal memories, with all stages in life's cycle represented.

100 hand-toned gelatin silver photographs;
each 8¹³⁄₁₆ × 13⅜ in. (22.4 × 35.0 cm), overall 96 × 144 in. (243.8 × 365.8 cm)
The Target Collection of American Photography, museum purchase
with funds provided by Target Stores 82.74.1–100

Twentieth-Century Art

The Turning Road, L'Estaque, 1906

André Derain pursued his formal artistic training from the age of eighteen, when he enrolled at the Académie Camillo in Paris. There he met Henri Matisse (1869–1954) and, following the example of the older artist, began to adopt a palette of unblended colors and vivid contrasts. Seven years later, in 1905, he joined Matisse in the south of France, at Collioure, and together they painted a series of brilliantly colored pictures of the sun-baked Mediterranean landscape. Later that year Derain exhibited these canvases with works by Albert Marquet (1875–1947), Matisse, and Maurice de Vlaminck (1876–1958) at the Paris Salon d'Automne, where they were laughed at as the work of *fauves*, or "wild beasts." Derain, Matisse, and Vlaminck formed the core of the fauves, each pursuing concepts that had evolved during the last decade of the nineteenth century— the juxtaposition of unnaturalistic color and design with an emphasis on decorative rhythm and harmony.

The Turning Road, L'Estaque was painted at the height of Derain's fauvist years and in scale and ambition can be seen as a manifesto of the movement. The landscape was inspired by a 1905 visit to L'Estaque, the Provençal town painted repeatedly by Cézanne; the composition and palette clearly reflect Gauguin's cloisonnist paintings of the 1880s. The monumental scale, flow of movement as the road winds across the composition, and combination of the decorative with the expressive, however, separate Derain's outlook from that of the earlier generation of postimpressionists.

Oil on canvas; 51 × 76¾ in. (129.5 × 195.0 cm)
The John A. and Audrey Jones Beck Collection 74.138

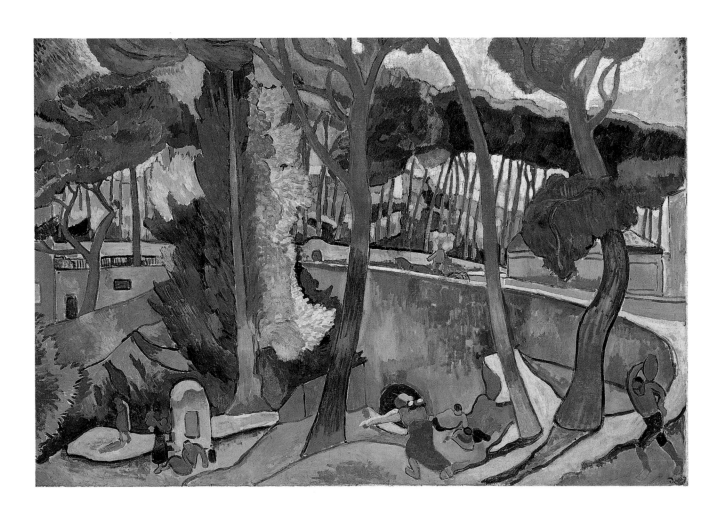

GEORGES BRAQUE

French; Argenteuil 1882–Paris 1963

Fishing Boats, 1909

Georges Braque moved to Paris in 1900 and by 1906 was painting with the high color of fauvism. By the time he met Picasso through the art dealer Daniel Kahnweiler in 1907, his paintings had moved away from the bright palette and shallow spaces of fauvism. Instead, the exploration of perspective and geometry came to the fore as he began to assimilate the influence of Cézanne. Over the next two years Braque and Picasso—working as both collaborators and competitors—devoted themselves to an analysis of form and background that stressed their plastic unity and acknowledged the autonomy of the flat surface of the canvas. The name cubism came about through the writings of Louis Vauxcelles, who described Braque's paintings in the 1909 Salon des Indépendants as *bizarreries cubiques*.

Fishing Boats is among the premier paintings of early cubism. It is characteristic of the movement's first, so-called analytic, phase in its restricted palette and geometric description. The delicately nuanced brushstroke and tonal gradation capture the light playing across a surface and at the same time stress the continual fabric that unites form and space. Despite Braque's deliberate limitation of painterly values, *Fishing Boats* maintains a pictorial brilliance that far surpasses his earlier, more brightly colored canvases.

Oil on canvas; 36¼ × 28⅞ in. (92.1 × 73.3 cm)
The John A. and Audrey Jones Beck Collection 74.135

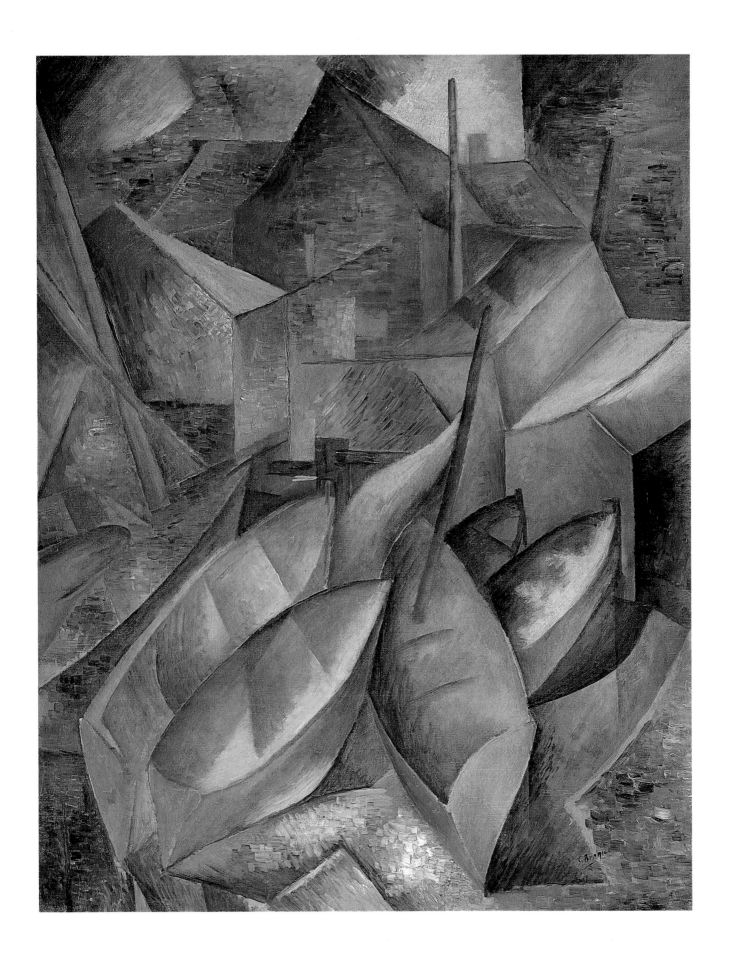

Although perhaps best known as a painter, Matisse was also one of the greatest sculptors of the twentieth century. These four life-size reliefs are his largest sculptures and cover a broad span of his development, from the expressive modeling and complex volumes of *Back I*, 1909, to the simplicity of *Back IV*, c. 1930. Matisse is known to have reworked each successive image from a plaster cast of the preceding one. *The Backs I–IV* were never shown together during Matisse's lifetime and were not conceived as a series or set. They instead should be seen as one work that passed through four stages—an ongoing sculptural clarification of the simplified forms Matisse simultaneously studied in both painting and sculpture.

In *The Backs* Matisse explored the challenge of endowing the human form with expressive power without showing the face. In each succeeding work the figure is progressively straightened and the axis of the spine is emphasized. The evolution demonstrated through *The Backs* thus reflects Matisse's developing aesthetic, from the explosive dynamism that characterized his fauvist period to the graceful monumentality of his later years.

Bronze

I 1909

74⅝ × 45⅝ × 7⅜ in. *(189.6 × 115.9 × 18.8 cm)*

Signed lower left: Henri Matisse; *initialed and numbered lower*
right; HM/9/10; *inscribed on base lower left:* Georges Rudier./Fondeur. Paris.

Gift of Mr. and Mrs. Theodore N. Law in memory of
Mr. and Mrs. Harry C. Wiess 80.68

II 1913

74⅝ × 47¾ × 7⅜ in. *(189.6 × 121.3 × 18.8 cm)*

Signed lower left: Henri Matisse; *initialed and numbered lower*
right: HM/9/10; *inscribed on base lower left:* SUSSE FONDEUR/PARIS

Gift of Mr. and Mrs. Gus Wortham 80.69

III 1916–17

73⅞ × 44¹⁵⁄₁₆ × 7 in. *(187.7 × 114.2 × 17.0 cm)*

Indistinctly signed lower left: Henri M; *initialed and numbered*
lower right: HM/9/10; *inscribed on base lower left:* Georges
Rudier./Fondeur. Paris.

Gift of the Cullen Foundation in memory of Hugh Roy and Lillie Cullen 80.70

IV c. 1930

74½ × 44⁹⁄₁₆ × 6¹⁵⁄₁₆ in. *(189.2 × 113.2 × 17.7 cm)*

Initialed and numbered lower right: HM/9/10; *inscribed on base*
lower left: Georges Rudier./Fondeur. Paris.

Gift of the Brown Foundation in memory of Mr. and Mrs. Herman Brown 80.71

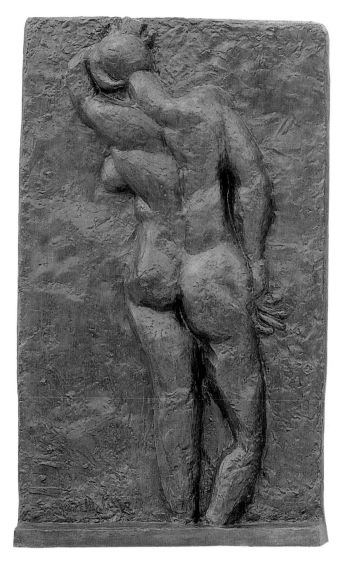

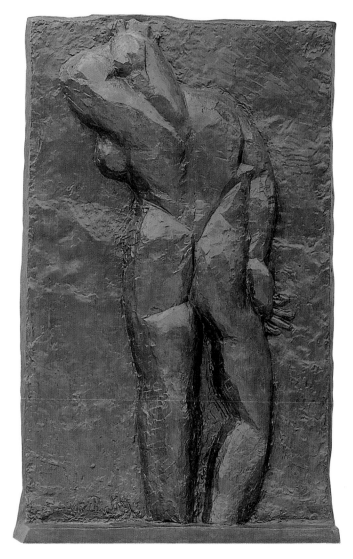

I *1909* *II* *1913*

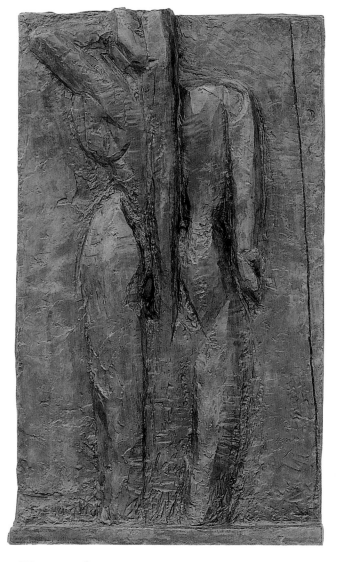 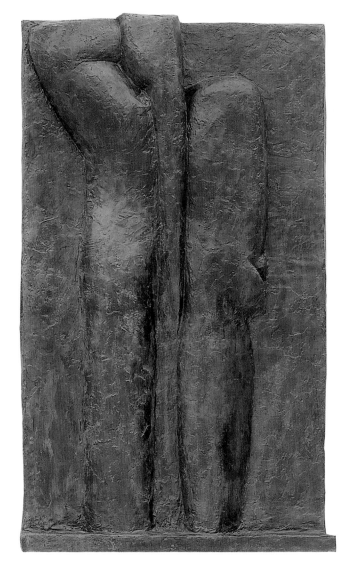

III *1916–17* *IV* *c. 1930*

After initial training in law Matisse embarked on a career as a painter in 1891. In Paris he attended the Académie Julian, but in 1892 he transferred to the École des Beaux-Arts, where he studied under the brilliant colorist and orientalist Gustave Moreau (1826–1898). There, and at the Académie Camillo, he met the young artists with whom he forged a new style of expressive colorism, fauvism.

Portrait of Olga Merson, painted two years after the dissolution of the fauvist movement, expresses the individual strength and inventive genius of Matisse as he entered full maturity. The personality of the sitter is not conveyed through conventional means such as detailed costume or explicit gesture. Instead, Matisse emphasizes the process by which the figure took shape; she emerges from a background of corrections and repainting. The figure fills the frame, and arcing diagonals anchor her to the composition, creating a sense of monumentality. In 1908 Matisse wrote: "Expression to my way of thinking does not consist of the passion mirrored upon a human face or betrayed by violent gesture. The whole arrangement of my picture is expressive. The place occupied by figure or objects, the empty spaces around them, the proportions, everything plays a part."

Oil on canvas; 39¼ × 31¾ in. (99.7 × 80.7 cm)
Museum purchase with funds provided by the Agnes Cullen Arnold
Endowment Fund 78.125

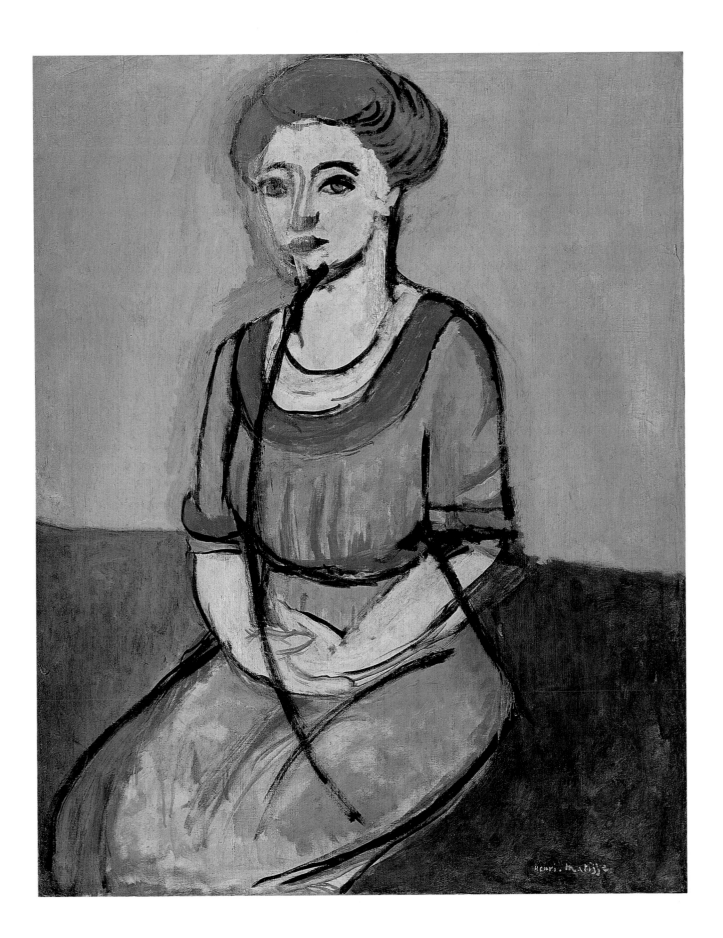

The Rower, 1910

P ablo Picasso first visited Paris in 1900, settling there in 1904. His work emerged from an expressionist graphic tradition exemplified by such artists as Henri de Toulouse-Lautrec (1864–1901), and his early paintings frequently depicted society's outcasts, reflecting his own romantic perception of the artist as an outsider. After 1905 Picasso's imagery began to assimilate non-European and primitive influences as he progressed through the many experiments that led him and Georges Braque to cubism.

The Rower is a perfect complement to Braque's *Fishing Boats* of the previous year. Both works belong to the formative phase of analytic cubism. Where Braque addressed the landscape, Picasso examined the figure, subjecting it to a more radical and abstract breakdown of form. Braque later recalled that he and Picasso were "rather like mountaineers roped together." *The Rower* represents the next step beyond *Fishing Boats* toward formal abstraction. The play of light that is characteristic of Braque's work assumes a lesser role in the paintings of Picasso. Volumetric space instead is of central importance, depicted through horizontal layering and complex perspectival shifts.

Oil on canvas; 28 ⅜ × 23 ½ in. (72.1 × 59.7 cm)
Museum purchase with funds provided by Oveta Culp Hobby,
Isaac and Agnes Cullen Arnold, Charles E. Marsh,
Mrs. William Stamps Farish, the Robert Lee Blaffer Memorial Collection,
gift of Sarah Campbell Blaffer by exchange,
and the Brown Foundation Accessions Endowment Fund 81.29

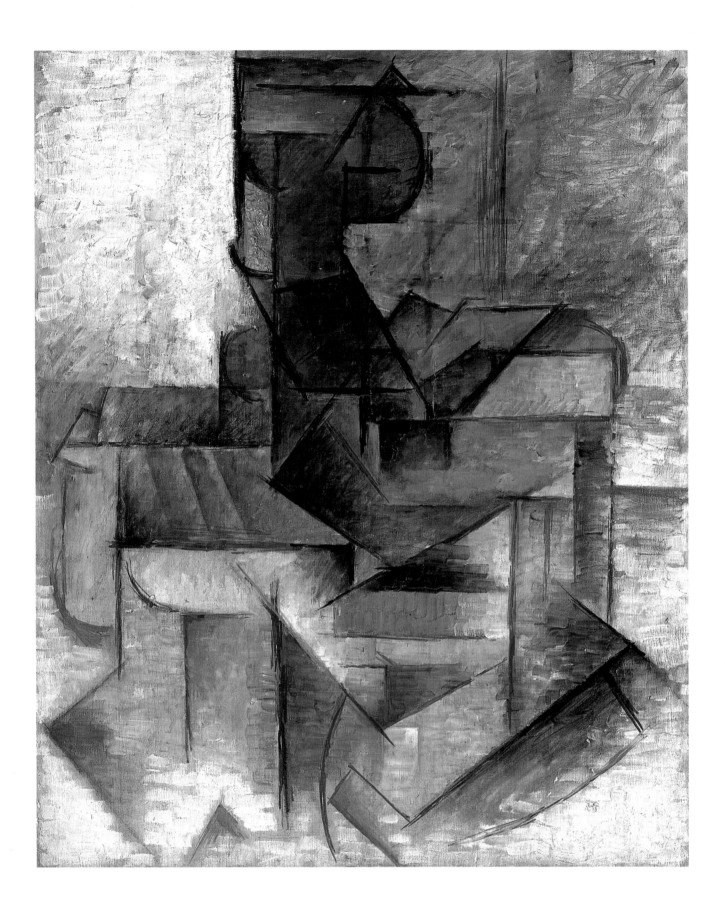

Sketch 160 A, 1912

Wassily Kandinsky was born in Moscow, where his imagination was engaged by the magic of Russian myth, the splendor of the Orthodox church, and the brilliant color and naïve forms of Russian folk art. Following a brief career as a lawyer, he left for Munich in 1896 to study painting. His early work reflects the decorative influence of the Jugendstil, or German art nouveau movement, and after 1909 he gradually moved toward pure abstraction, incorporating romantic idealism with Theosophy and spiritualism. In 1910 he wrote *Concerning the Spiritual in Art* (published 1911), a treatise that summed up his belief in the essential correspondence among music, the spiritual, and art, with every color and form having a distinct meaning and emotional value

In 1911 Kandinsky was a founding member of the Blaue Reiter, an association of artists in Munich that encouraged experimentation and individual development. Kandinsky's work during these years is characterized by a brilliant palette and the gradual transformation of landscape imagery and mythological themes into dynamic abstractions. *Sketch 160 A* was made in preparation for the Composition series, monumental canvases of resonant energy. Its evocative color and line, together with the organic imagery of the fertile landscape and triumphant horseman at top right, can be read as an allegory of the struggle between good and evil. The radical sense of movement and energy distilled in such works overturned many of the conventions of picture making at that time; Kandinsky's Blaue Reiter canvases proved that abstraction could far transcend the decorative to become the vehicle for works that are among the most expressive of our century.

Oil on canvas; 37⅜ × 42½ in. (94.9 × 108.0 cm)
Signed lower left: Kandinsky 1912
The John A. and Audrey Jones Beck Collection 74.140

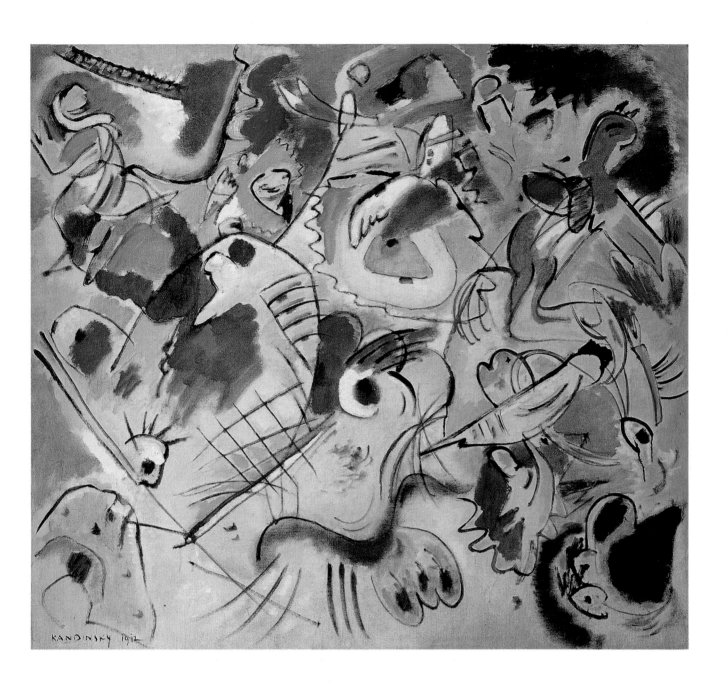

Bonnard reached artistic maturity in Paris in the 1890s. After studying law at his father's insistence, Bonnard chose to pursue a career in the arts. He attended the École des Beaux-Arts and the Académie Julian, where he met and became a member of the Nabi circle of symbolist artists. The Nabis translated Gauguin's concept of pictorial equivalents for emotion and thought into decorative canvases characterized by an emphasis on pattern and flat areas of color. After 1900 Bonnard left behind the posterlike style of his Nabi years. Perhaps influenced by his friend Matisse, he chose instead to brighten his palette, infusing his pictures with the warm light of the Mediterranean.

In this second phase of his career Bonnard repeatedly returned to the subject of a woman bathing or preparing her toilette in the privacy of her bedroom or bath. *Dressing Table and Mirror* might at first seem to be a simple still life of washbowl, brushes, and flowers, but further observation reveals a tableau played out in the mirror above the table: Bonnard's model and future wife Marthe, her head cropped in the reflection, sits draped in a towel, while one of their small dogs rests on another table before an open window. As in many of Bonnard's canvases of this period, the viewer sees two distinct areas of space: the tangible foreground—dominated by the concrete still-life arrangement—and the intangible background—captured in the imaginary reflection of the mirror.

Oil on canvas; 48⅞ × 45¹⁵⁄₁₆ in. (124.1 × 116.7 cm)
The John A. and Audrey Jones Beck Collection 74.134

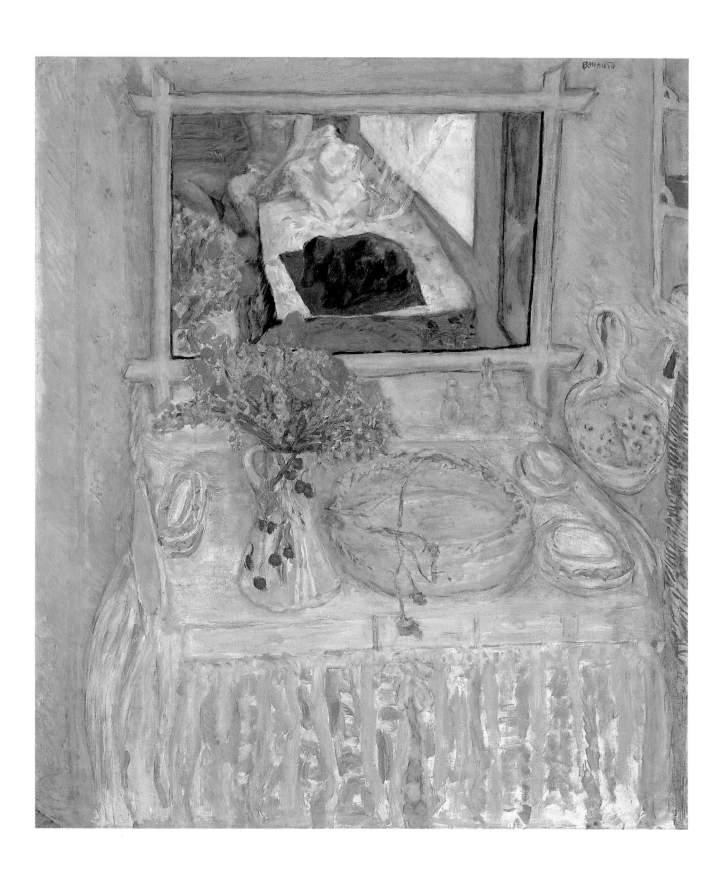

Abstraction, c. 1914

Landscape and still-life compositions dominated Marsden Hartley's early work and continued to be of interest to the artist throughout his career. In 1909 his paintings attracted the attention of the photographer and avant-garde gallery owner Alfred Stieglitz, who later that year exhibited Hartley's work at the Little Galleries of the Photo-Secession (also known as 291). In 1912 Hartley traveled to Paris, supported—like many of his contemporaries—by a stipend from Stieglitz. Although he was introduced to the Paris circle of Leo and Gertrude Stein and through them met Robert Delaunay (1885–1941), Hartley found Paris uncongenial and was drawn instead to the work of Kandinsky and the recently founded Blaue Reiter expressionist group working in Munich. Hartley went to Berlin and Munich in January 1913, and his first impressions are preserved in a postcard to Gertrude Stein: "I like Deutschland. I think I shall like it for long—I feel as if I were rid of the art monster of Paris." Hartley's affiliation with Blaue Reiter artists was confirmed in the autumn of 1913 when he was invited by the group to participate in the first German Autumn Salon at Der Sturm gallery in Berlin.

Abstraction reveals Hartley's dual alliance with the French and German vanguards. Like Delaunay, Hartley synthesized cubist space with a sophisticated palette of primary and secondary colors. The visionary density of the composition, with its suggestion of a mountain landscape through the triangular buildup of forms, is closer, however, to the example of the German expressionists and echoes Kandinsky's 1911–12 canvases. *Abstraction* was most likely painted during Hartley's second visit to Germany in 1914, when emblematic compositions and flat color areas became characteristic of his work.

Oil on paperboard; 24¼ × 20 in. (61.6 × 50.8 cm)
Gift of Mr. and Mrs. Ralph O'Connor in honor of
Mr. and Mrs. George R. Brown 80.82

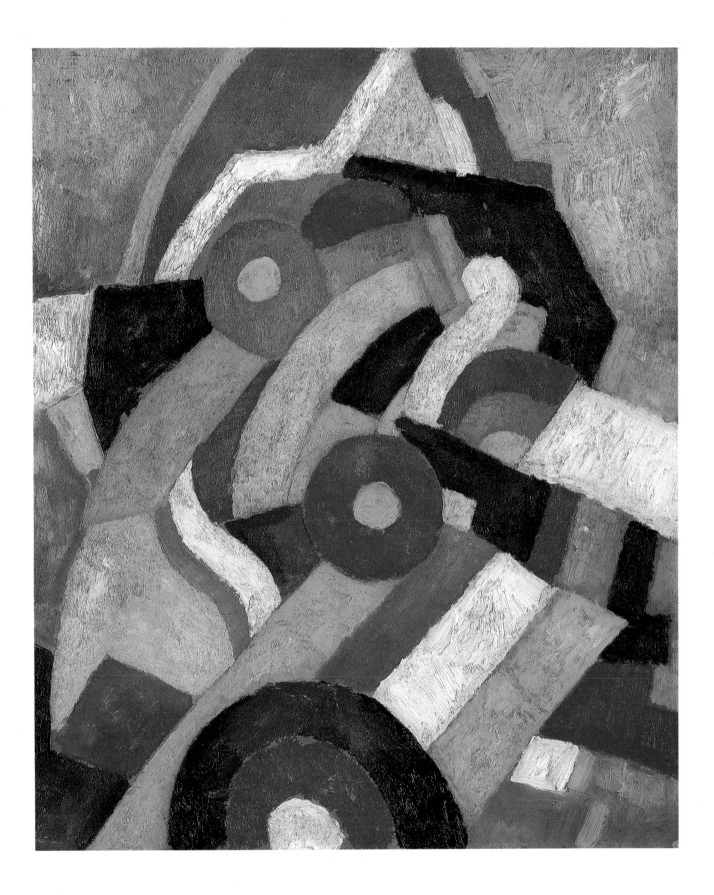

Although the roughly modeled surfaces of Brancusi's early works reveal his esteem for Auguste Rodin (1840–1917), by the end of 1907 Brancusi had adopted simplified forms and volumes, abandoning the academic method of modeling in clay in favor of carving from stone. Brancusi's use of direct carving signals the beginning of his mature style, in which the distinct record of the sculptor's hand is preserved in the decisive marks of the chisel and dramatic silhouette takes precedence over modulated surface.

A Muse exemplifies Brancusi's ongoing ambition to elucidate the essence rather than the exterior form of his subject by eliminating anatomical details and condensing natural forms into minimal, absolute shapes. The idealized figure reflects Brancusi's love of Cycladic sculpture; the highly polished surface and streamlined brilliance of the composition also reflect the machinist aesthetic of the twentieth century. The artist first carved a marble version of *Muse* (Solomon R. Guggenheim Museum, New York) in 1912; the Houston version was commissioned by the American collector John Quinn in 1917. Brancusi did not simply make an identical copy for Quinn; rather, he subjected the figure to reexamination, elongating the bust and arm and modifying the facial features for greater simplicity. The highly polished surface was also of primary concern to the artist; he wrote Quinn: "I wanted to see if I could make a bronze [*sic*] that really would be a bronze and not simply a cast of the marble . . . and for that I had to work a great deal. . . . The bronze will be completely polished and patinated in gold and the work will be done entirely by me."

Polished brass; 19⅝ × 11¹¹/₁₆ × 9⅝ in. (49.8 × 29.7 × 24.4 cm)
Museum purchase with funds provided by Mrs. Herman Brown and
Mrs. William Stamps Farish 62.1

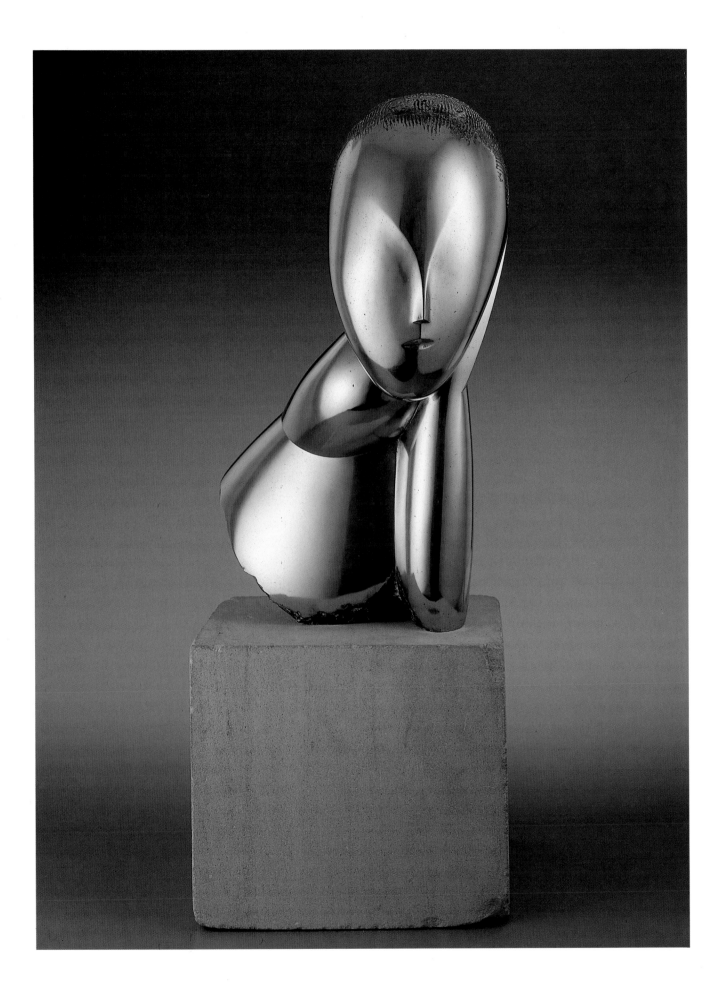

Composition with Gray and Light Brown, 1918

A founder of the de Stijl movement of nonobjective art in 1917, Piet Mondrian subjected his work to rigorous analysis throughout his career. Working in Paris between 1911 and 1914, he initially was drawn to the work of Picasso and Braque. However, Mondrian remained independent of the cubist mainstream, and his early works—landscapes and still-life studies—gradually gave way to pure abstractions. Guided by his personal interpretation of Theosophy, Mondrian sought to express the correspondences between the material and spiritual worlds through pure geometry. In 1937 he stated, "Art has shown that universal expression can only be created by a real equation of the universal and the individual." For Mondrian, his development of the grid-pattern composition was the ideal resolution of these two demands: the grid and the proportionate variations within it provided a universal context for individual expression.

Composition with Gray and Light Brown is one of Mondrian's early compositions dependent on a grid system. Recently, X-ray photography has revealed that under the painting's apparently random sequence of squares and rectangles Mondrian drew a perfectly uniform grid of rectangles based on the golden section. This underlying grid forms the basic unit for the superimposed composition, giving the work an exceptional proportional harmony. A remarkable nuance of mood and tone is established through the delicate variations in the gray and brown glazes so that the ultimate effect is one of subtly shifting planes of color.

Oil on canvas; 31⁹⁄₁₆ × 19⅝ in. (80.2 × 49.9 cm)
Gift of Mr. and Mrs. Pierre Schlumberger 63.16

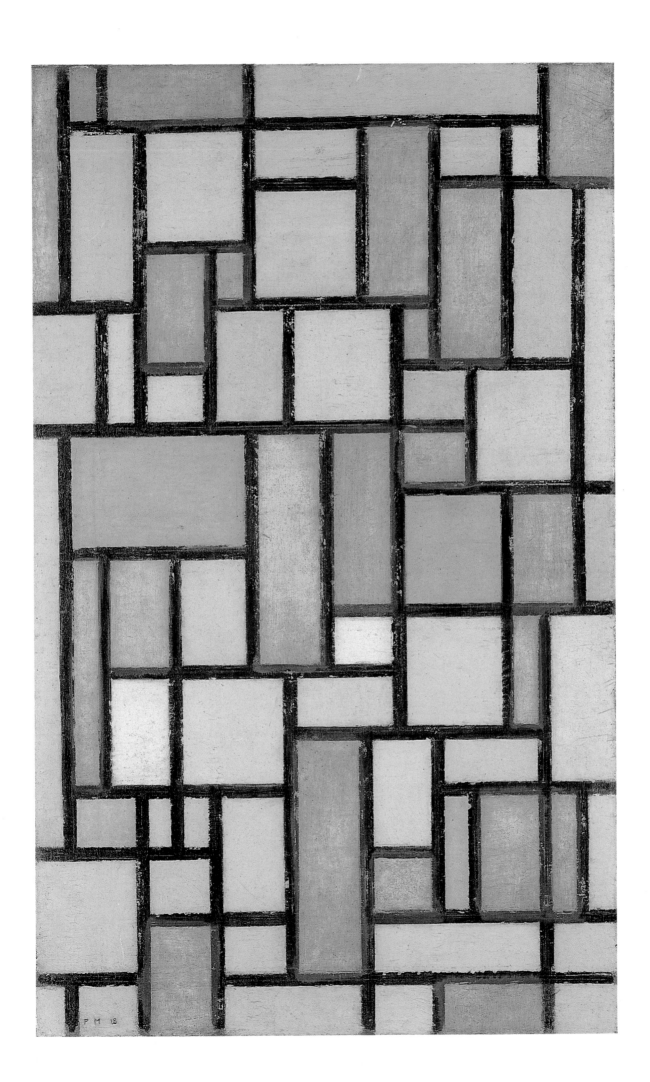

World War I changed the course of European history and profoundly affected the Paris art world. For those who survived the conflict, like Fernand Léger, combat experience wrought basic changes in their work. An abstract painter during the first years of the cubist epoch, Léger was forced after the war to reevaluate his work. As he later recalled, "Once I got my teeth into that sort of reality I never let go of objects again."

Léger's commitment to a new reality was shaped by his previous years of cubist painting. His work immediately following the war combines compressed space, pattern, and color with a new vision of the individual as part of a mechanized urban environment. *Man with a Cane* is a fragmented view of a figure in an urban interior. The image of a dapper man is evoked by the green head, rounded gray shoulders, and red-sleeved arm on the left holding a ball-headed cane. The more abstract passages surrounding the figure suggest an architectural environment composed of industrial components. Color animates the composition in brilliant syncopation, echoing the rhythms of the jazz age.

Oil on canvas; 36¼ × 25½ in. (92.1 × 64.8 cm)
Gift of Mrs. Charles W. Engelhard 84.197

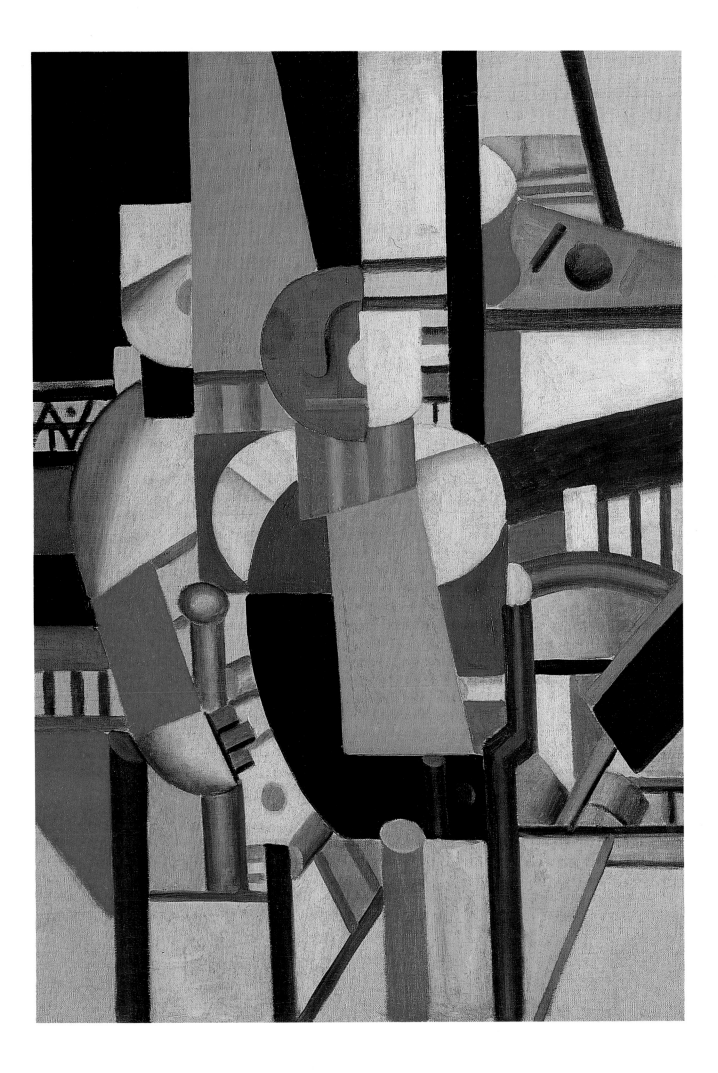

Georgia O'Keeffe's early development was shaped by her first encounter with the landscape of the American Southwest during a year spent teaching in the Texas Panhandle in 1912. In 1914 O'Keeffe moved to New York, where she studied at Columbia University with Arthur Wesley Dow (1857–1922). Prompted by Dow's advocation of music and mysticism as sources of inspiration, O'Keeffe produced in 1917 a series of lyrical abstractions based on the Texas landscape, works that rank among America's most radical contributions to the evolution of abstract art. In 1917 she also had her first solo exhibition of drawings and watercolors at Alfred Stieglitz's 291 gallery in New York.

Gray Line with Black, Blue, and Yellow is one of O'Keeffe's masterpieces. Her richly nuanced blend of colors can be compared with Paris prewar developments; O'Keeffe's vision, however, is intensely personal and independent of European precedents. The precisely delineated, undulating folds and lucid, three-dimensional forms work together to create an image of potent ambiguity suggesting either images of plant life or abstractions based on the female anatomy. The formal and spatial tension of the arching lines is emphasized by the cropping of the frame, a compositional device shared by photographers Paul Strand (1890–1976) and Stieglitz. Like many of the 291 artists, O'Keeffe repudiated pure abstraction. Instead, she identified much of her work as "not abstract. It's quite realistic."

Oil on canvas; 48 × 30 in. (121.9 × 76.2 cm)
Museum purchase with funds provided by the Agnes Cullen Arnold
Endowment Fund 77.331

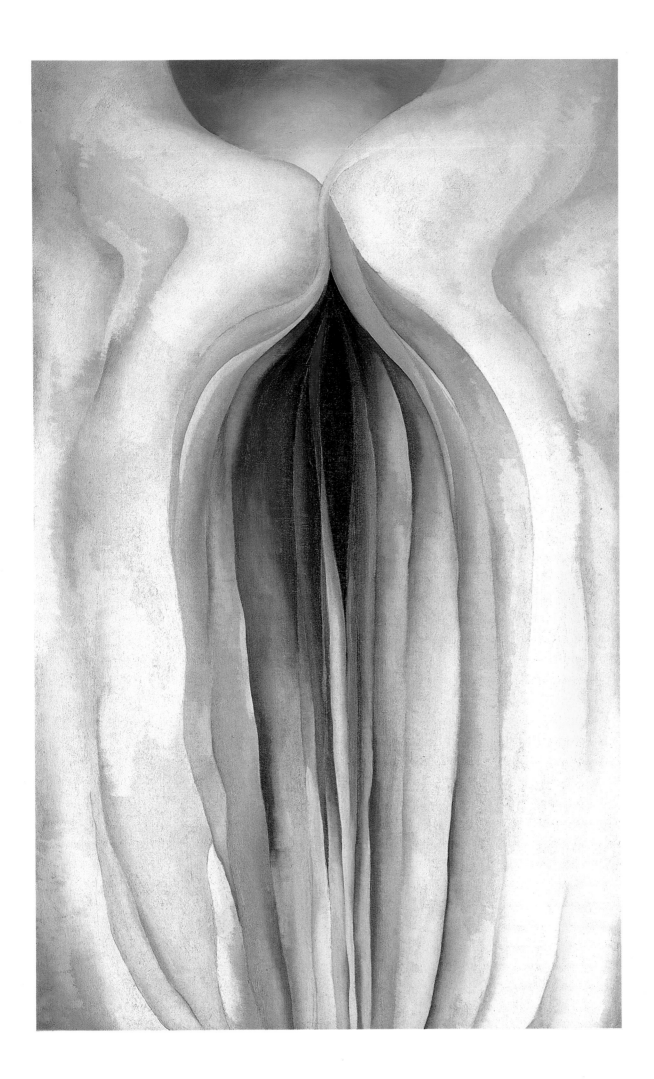

Although Picasso ultimately remained independent of the surrealists, he participated in the first official surrealist exhibition of 1925 and his work of the following decade confronts many of the issues raised by André Breton (1896–1966) and his associates. *Two Women in Front of a Window* brings a cubist vocabulary to the language of surrealism. Picasso has retained the geometric rhythms of analytic cubism, and the window frame echoes the trompe l'oeil framing devices found in many of Picasso's synthetic cubist collages. The freer drawing of the figure on the right, however, reflects the biomorphic and automatic sketches of the surrealists. The content is also sexually charged, as is characteristic of most of Picasso's compositions of the late 1920s. The two women of the title represent opposing principles. The figure on the left is made up of triangular planes, her only feminine features being her profile and two circles for breasts, restrained within a strict geometrical grid. On the right is a more sensuous and ephemeral figure; her softer, rounder form is poetically evoked by shifting, delicate profiles. The figure on the left is concrete, pointed, and somewhat aggressive. The woman on the right, probably a portrait of Marie-Thérèse Walter whom Picasso met in 1927, is inviting, seductive, and ghostlike, appearing as if in a dream.

Oil on canvas; 38½ × 51½ in. (97.8 × 130.8 cm)
Gift of Mr. and Mrs. Theodore N. Law 64.17

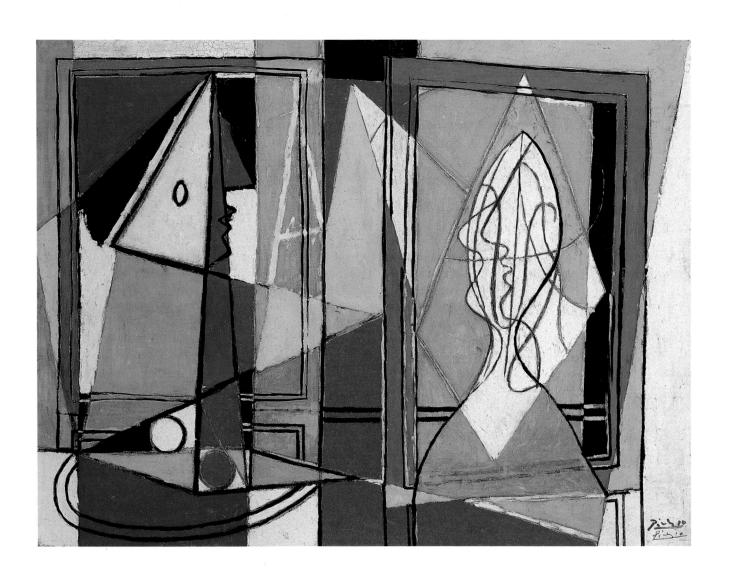

HENRI MATISSE

French; Le Cateau-Cambrésis 1869–Nice 1954

Woman in a Purple Coat, 1937

In 1906 Matisse made the first of many trips to North Africa, and the memory of the bright colors, architectural arabesques, and vivid domestic interiors of the southern Mediterranean would continue to be a source of inspiration throughout his career. *Woman in a Purple Coat* was painted more than thirty years later, as part of a series depicting reclining women in exotic Arabian and orientalizing environments. The model for these paintings was Lydia Delectorskaya, Matisse's secretary and companion from 1935.

The hermetic environment of *Woman in a Purple Coat* is typical of Matisse's work after his move to Nice in 1917. As the artist withdrew from Paris, he concentrated increasingly on interior views. Although the picture recalls earlier images of languorous odalisques, it is representative of the artist's middle years in its vivid unshaded colors, simplified linear patterns, and flattened decorative composition. Naturalism and artificiality are held in delicate balance as the studio setting is given life by a sense of voluptuousness and serenity. Describing these paintings, Matisse stated, "As for odalisques, I have seen them in Morocco, and so was able to put them in my pictures back in France without playing make-believe."

Oil on canvas; 31⅞ × 25¹¹⁄₁₆ in. (81.0 × 65.2 cm)
The John A. and Audrey Jones Beck Collection 74.141

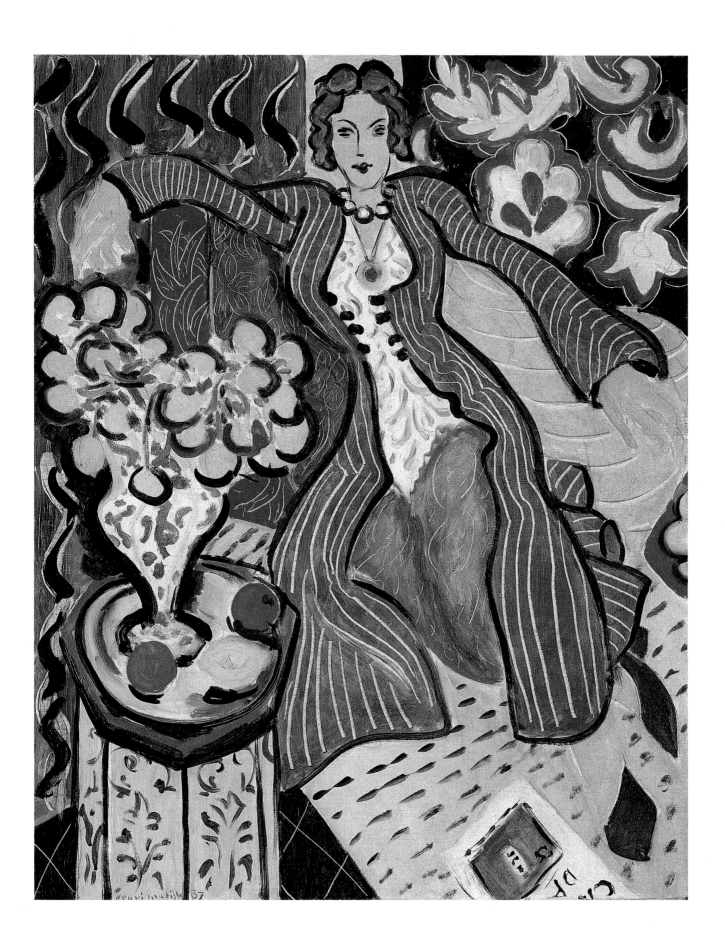

Stuart Davis, whose career spanned more than half a century, uniquely combined cubist syntax with the pulse and ambience of American life, providing a bridge between the first generation of American modernists and the later abstract expressionists. A student of the realist painter Robert Henri (1865–1929), Davis participated in the 1913 New York Armory Show. The exhibition's representation of European painters deeply impressed the young artist, and he later recalled that it was "the greatest shock to me—the greatest single influence I have experienced in my work. All my immediately subsequent efforts went toward incorporating Armory Show ideas into my work."

Davis's assimilation of modernist techniques in general and of cubism in particular was strongly colored by his advocation of realism. *Gloucester Harbor* is a dockside view of Gloucester, Massachusetts, where, with a few exceptions, Davis spent his summers between 1915 and 1934. Boats, piers, houses, and even smoke are rendered in flat colors and brilliant patterns that reduce spatial relationships and contradict illusionism. Nonetheless, Davis maintains a real sense of the bustle and life of a busy harbor. This painting was executed during Davis's tenure as a government-supported artist in the Works Progress Administration program; it was featured in the exhibition of contemporary American art sponsored by the WPA shown at the New York World's Fair of 1939.

Oil on canvas mounted on panel; 23¹/₁₆ × 30⅛ in. (58.6 × 76.5 cm)

Museum purchase with funds provided by the Agnes Cullen Arnold Endowment Fund 77.330

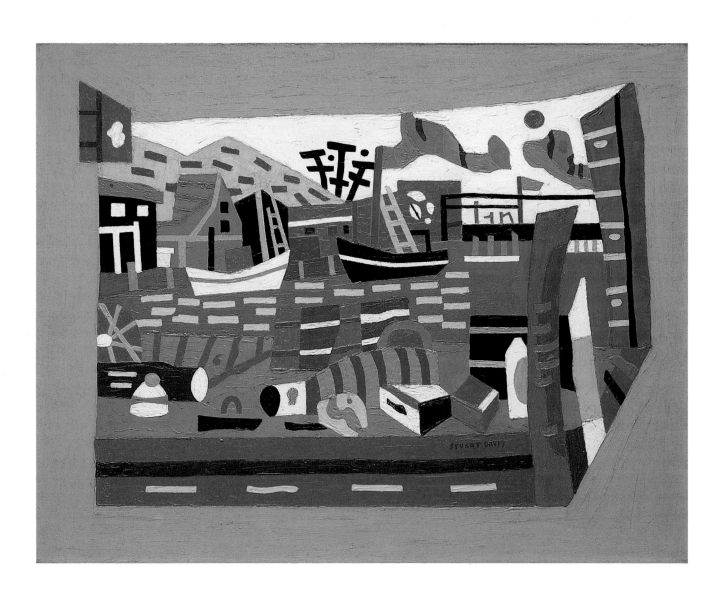

MARINO MARINI

Italian; Pistoia 1901–Viareggio 1980

The Pilgrim, 1939

Aseminal figure in twentieth-century classicism, Marino Marini drew upon both antique and Renaissance traditions to give new life to Italian sculpture. Trained at the Accademia di Belle Arti in Florence, he executed his first mature works in the late 1920s. During the 1930s he traveled extensively in Europe, forging ties with the School of Paris and with such contemporaries as Aristide Maillol (1861–1944) and Picasso. His sculpture of this period was deeply influenced by the recent and extensive excavations of Etruscan sculpture in central and southern Italy.

The Pilgrim embodies Marini's early development of the equestrian theme, an archetype that occupied him throughout his career. After World War II the equestrian became for Marini a symbol of the "twilight of mankind," and he increasingly depicted the rider as an ecstatic yet tragic figure, while the horse came to embody the unrestrained forces of nature. Here, however, reason and balance prevail. Conceived as a freestanding relief, the statue is imbued with a classicizing stasis reflecting Marini's love of Etruscan art as well as of such Roman examples as the monumental equestrian bronze of the emperor Marcus Aurelius, the symbol of ancient Rome and the focal point of Michelangelo's Piazza del Campidoglio in Rome. Yet Marini strips the figure of historical associations: the equestrian is transformed into Everyman and the theme of pilgrimage is addressed as a universal rather than a specific search.

Bronze; 68⅛ × 16½ × 48¾ in. (173.4 × 41.9 × 122.6 cm)
Gift of the Hobby Foundation 88.111

340

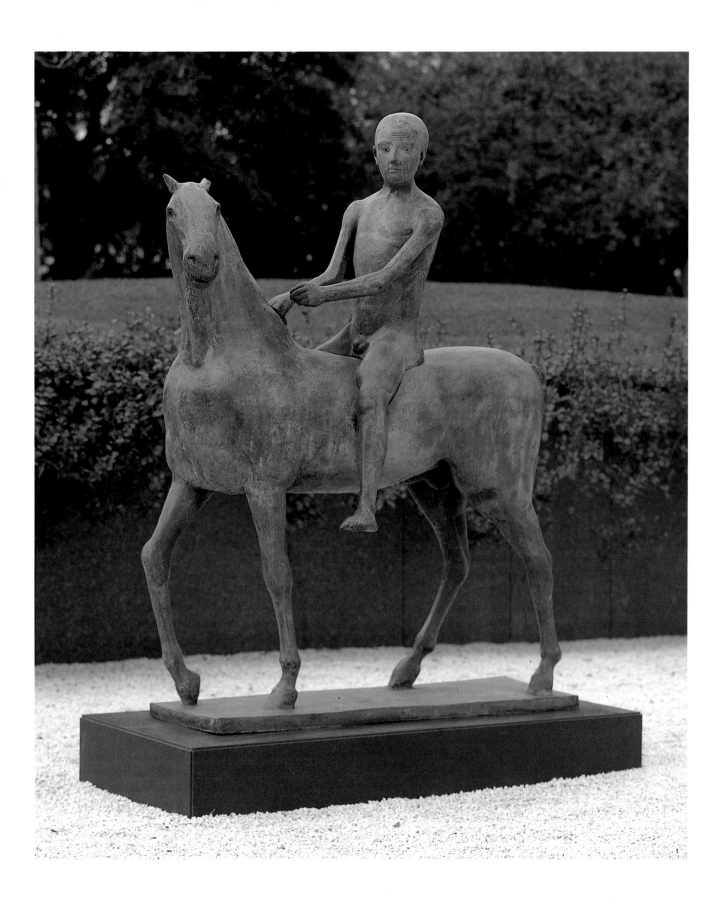

Number 6, 1949

I n 1930 Jackson Pollock moved from the West Coast to New York, where he became a student of the regionalist painter Thomas Hart Benton (1889–1975). Pollock's work of the 1930s is characterized by American-scene imagery and the dramatic content of the Mexican muralists. During the 1940s he became familiar with the work and ideology of the émigré surrealists—André Breton (1896–1966), Max Ernst (1891–1976), and Roberto Sebastián Matta (born 1911)—and his paintings turned toward mythic and totemic subject matter, exploring the imagery of the unconscious mind.

During the winter of 1946–47 Pollock had begun to experiment with an extended form of the automatic technique championed by Breton and Matta, and *Number 6* belongs to the first triumphant period of the "drip" paintings. Taking the canvas off the easel and laying it on the floor, Pollock then poured, dripped, and flung paint on the surface, eliminating the brush or palette knife and literally drawing with paint. The resulting compositions are remarkable for their lyricism and complexity. Unlike earlier generations of American abstract painters, Pollock freed his work from specific connotations and dogma. In 1950 he summed up his approach: "Abstract painting is abstract. It confronts you."

While Pollock's paintings were initially greeted with little sympathy, he nevertheless immediately became the focus of national attention. The famous observation of Willem de Kooning (born 1904) that "Pollock broke the ice" refers not only to the radical leap taken by Pollock in his work but also to his emergence as a cultural hero—a stance that revolutionized the American art scene and ensured new prominence for the American artist.

Duco and aluminum paint on canvas; 44⅜₆ × 54 in. (112.2 × 137.2 cm)
Signed upper left: Jackson Pollock/49
Gift of D. and J. de Menil 64.36

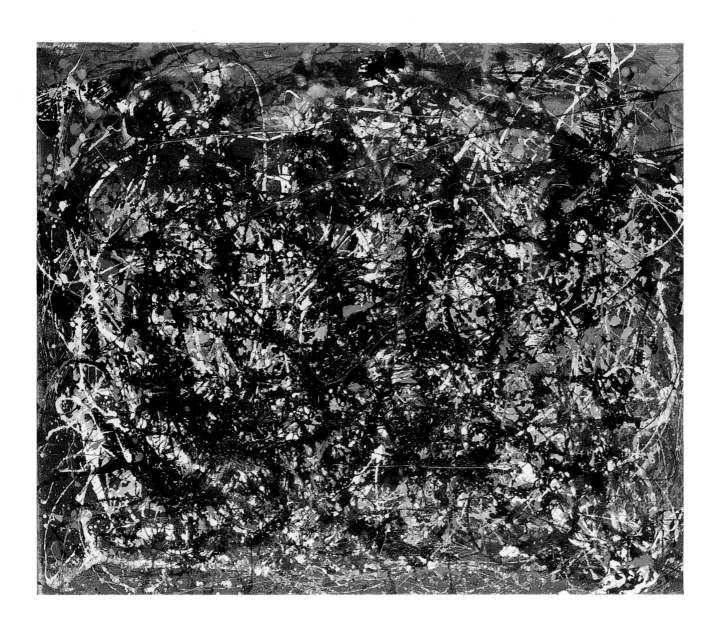

Loam, 1958

I n the 1950s a second generation of postwar artists came of age in America. Their work was less dependent on European sources and instead evolved directly from the experiments of the abstract expressionists. Morris Louis, working for most of his life in the Washington area, responded in a highly individual way to the innovations of the New York gesture painters, creating a body of work that exploited the technique of stain painting in which pigment was thinned in order to soak into the canvas in broad color washes. In this he was influenced by Helen Frankenthaler (born 1928), whose studio he had visited in 1953. Louis later recalled, "She was the bridge between Pollock and what was possible." Louis diluted his paint even more than Frankenthaler had done, uniformly soaking it into the canvas so that texture was almost completely eliminated.

Loam is from a series of large-scale paintings titled Veils. The artist poured the paint in washes across the unprimed canvas, achieving nuanced variations of tone independent of any visible gesture. Louis's work space was smaller than many of the 1957–59 paintings, and he sometimes folded the canvas so that he could work on it in sections, creating the wishbone shape visible in the center of *Loam.* The complementary halves of the composition give the work a sense of monumentality and stasis, and Louis's emphasis on the visual experience, freed from the idiosyncratic character of the artist's gesture, marks a new era in American painting.

Acrylic on canvas; 90¾ × 148 in. (230.5 × 375.9 cm)
Museum purchase with funds provided by the Brown Foundation
Accessions Endowment Fund 76.319

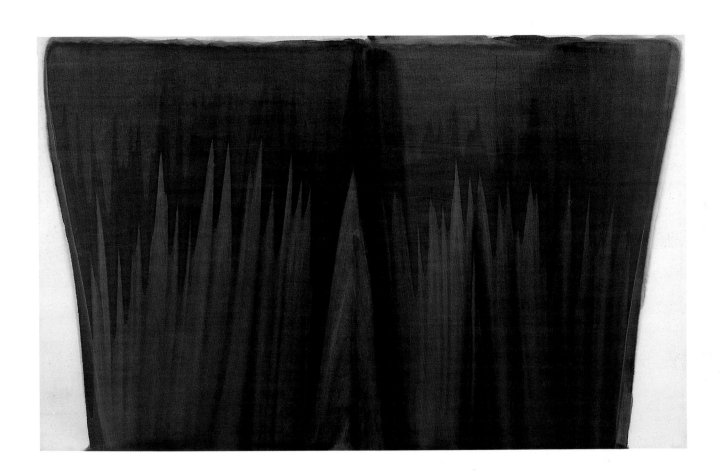

Alberto Giacometti moved to Paris in 1922, and during his first years there he rapidly assimilated cubist and primitive art. By the late 1920s he had evolved a personal language that was invested with a psychological urgency paralleled by the writings and art of the emerging surrealist movement. On Breton's invitation Giacometti joined the surrealists in 1930, an allegiance that lasted over four years. As his artistic development became dominated by a conflict between abstract form and figural representation, Giacometti broke with the surrealists in 1935 and began his attempt to come to terms with the human figure.

Concurrent with Giacometti's changing view of the human figure was a greater awareness of its placement in space. His sculptures after 1945 became characterized by an investigation of contemporary existence represented by figures standing isolated or striding across a featureless plain. In 1950 his work resolved into three major themes: the standing woman, the walking man, and the portrait bust. In 1959 Giacometti was given the opportunity to realize these themes on a grand scale when Chase Manhattan Bank commissioned him to provide sculptures for their new plaza in downtown New York. *Large Standing Woman I* was Giacometti's initial proposal; he cast three subsequent versions as well. Of this group, the first is the most mysterious, hieratic, and totemic, with almost all feminine features suppressed. Unlike Giacometti's earlier images of women, *Large Standing Woman I* is isolated from contemporary life; both idol and victim, lover and goddess, Giacometti's vision of woman moves out of time, gender, and place.

Bronze; 105 1/2 × 12 7/8 × 19 3/4 in. (268.0 × 32.7 × 50.2 cm)
Museum purchase with funds provided by the Brown Foundation
Accessions Endowment Fund 86.397

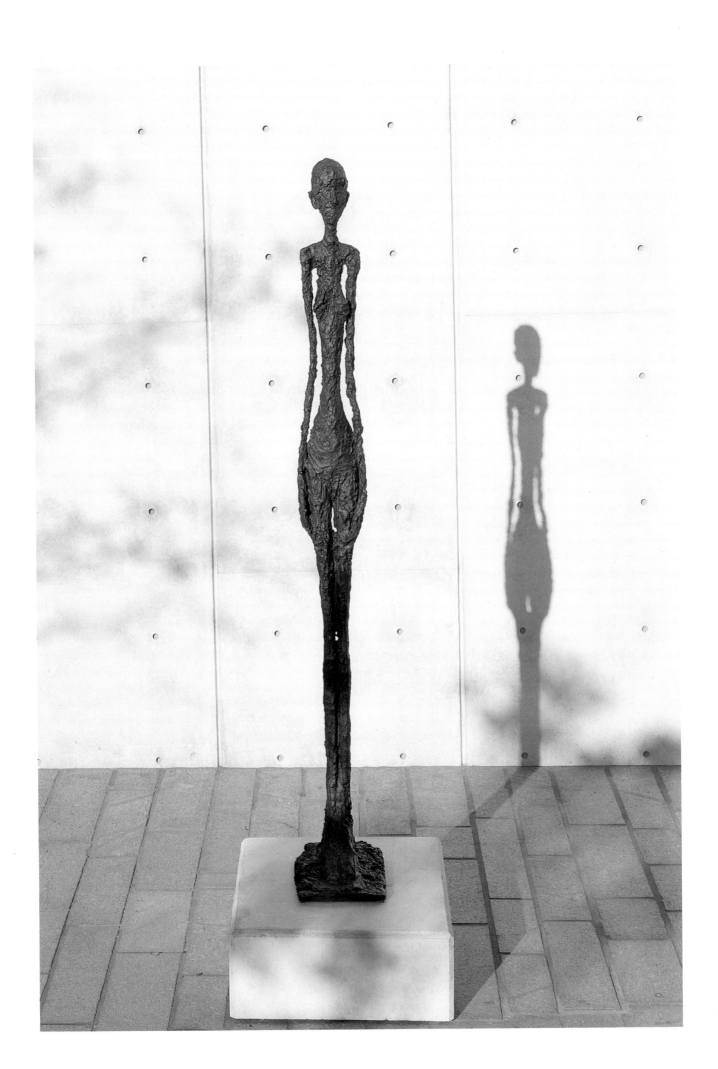

Painting, 1961

Mark Rothko emigrated with his family from Russia to the United States in 1913. He was raised in Portland, Oregon, and attended Yale University before moving to New York, where he studied at the Art Students League. Rothko's work gradually evolved from a moody realism in the 1930s to an abstract evocation of mythological images and themes in the 1940s. Deeply impressed by the émigré surrealists working in New York during World War II, in the mid-1940s he experimented with automatism. After 1945 the artist began to eliminate all traces of drawing, and in 1948 his compositions took on the floating amorphous color areas that became the hallmark of his style.

Painting of 1961 exemplifies his later, more somber approach. While his work of the late forties and fifties frequently is composed of buoyant, delicate colors that appear to shimmer before the viewer's eye, *Painting* addresses a cooler, more tragic vision. Unlike his contemporaries of the New York school, who used a heavy impasto, Rothko worked with thinned pigment, which was applied layer by layer, soaking into the canvas with nuances in tone and value that gradually evolved into distinct color areas. The close-hued palette of this work, which heightens the drama of the isolated red band, demands contemplative study. As art historian Irving Sandler has stated, Rothko's paintings "suggest a desire on his part that the viewer vacate the active self. This can lead to cosmic identification, but that has a tragic dimension, for it evokes the ultimate loss of self—death."

Oil on canvas; 92⅞ × 80 in. (235.9 × 203.2 cm)
Museum purchase 67.19

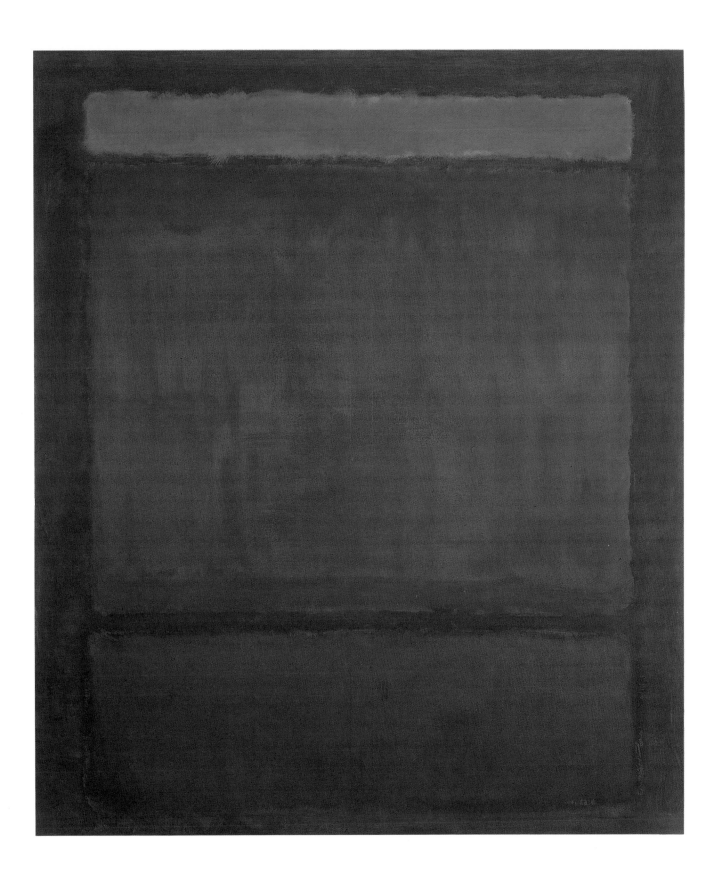

Perhaps more than any other artist of his generation, David Smith brought American sculpture into the international avant-garde. From 1926 to 1932 he attended the Art Students League in New York, gradually moving from painting to sculpture by 1931. In 1933 he forged his first steel work, following the example of Julio González (1876–1942) and Picasso. Steel offered unique qualities for Smith, as he explained: "What it can do in arriving at form economically, no other material can do. The metal itself possesses little art history. What associations it possesses are of this century: power, structure, movement, progress, suspension, destruction, brutality."

Two Circle Sentinel exhibits the mastery and delicacy that Smith brought to his later steel constructions. He began to use burnished stainless steel in isolated examples in the 1940s, but it became his preferred medium only in the late 1950s. This figure is one of four Sentinel sculptures of 1961; it is the first of the series, although the theme also appeared in works of the 1950s. Of the 1961 group, it is most comparable to the human scale. The anatomical references are handled with grace and wit: the open circle that crowns the work can be read as either a head or an eye; the lower circle evokes the curve of a feminine breast or hip. The various planes of the figure capture light and shadow, and each facet of the burnished surface is immediately responsive to every nuance of illumination. Intended for outdoor installation, *Two Circle Sentinel* first was placed on a hillside by Smith at his farm in Bolton Landing, New York.

Welded stainless steel; 86 × 37¼ × 15¾ in. (218.4 × 94.6 × 40.0 cm)
Museum purchase with funds provided by the Brown Foundation
Accessions Endowment Fund in memory of Alice Pratt Brown 84.202

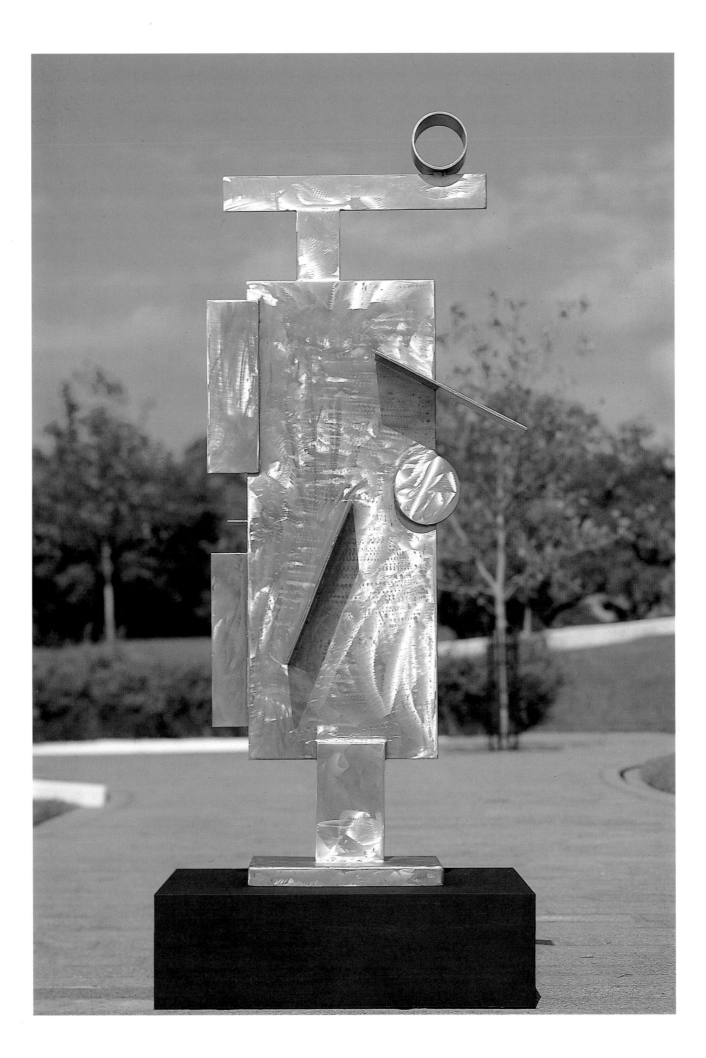

Ocean Park #124, 1980

Educated in northern California, Richard Diebenkorn first was identified with the Bay Area artists of the late 1940s. He received his master's degree from the University of New Mexico in 1952, and his early abstractions represent a transition from the cool light of northern California to the stark grandeur of the Southwestern desert. In 1953 Diebenkorn returned to the Bay Area and in 1955 shifted from abstraction to figural representation. Over the next decade he established an independent realist vision with an expressive handling of paint and nuanced compositional structures reflecting the influence of Bonnard and Matisse.

In 1966 Diebenkorn moved to Santa Monica and in the following year began the Ocean Park paintings. Inspired by a district along the Pacific coast, the series chronicles the artist's response to the vast scale of the Pacific Ocean as it meets the California cliffs. Diebenkorn synthesized his direct experience of the landscape with the example of Matisse's highly structured paintings of 1914; like Matisse, Diebenkorn broke down the landscape into transparent vertical planes without sacrificing the immediacy of natural light and color. *Ocean Park #124* is one of Diebenkorn's more minimal compositions. Architectural space, suggested by the framing elements at the top and side, gives way to the brilliant expanse of light at the center. By stripping away all specific references, Diebenkorn distills an aspect of the Western landscape that is fully contemporary and timeless.

Oil on canvas; 93⅛ × 81⅛ in. (236.5 × 206.1 cm)
Museum purchase with funds provided by George R. Brown
in honor of his wife, Alice Pratt Brown 80.145

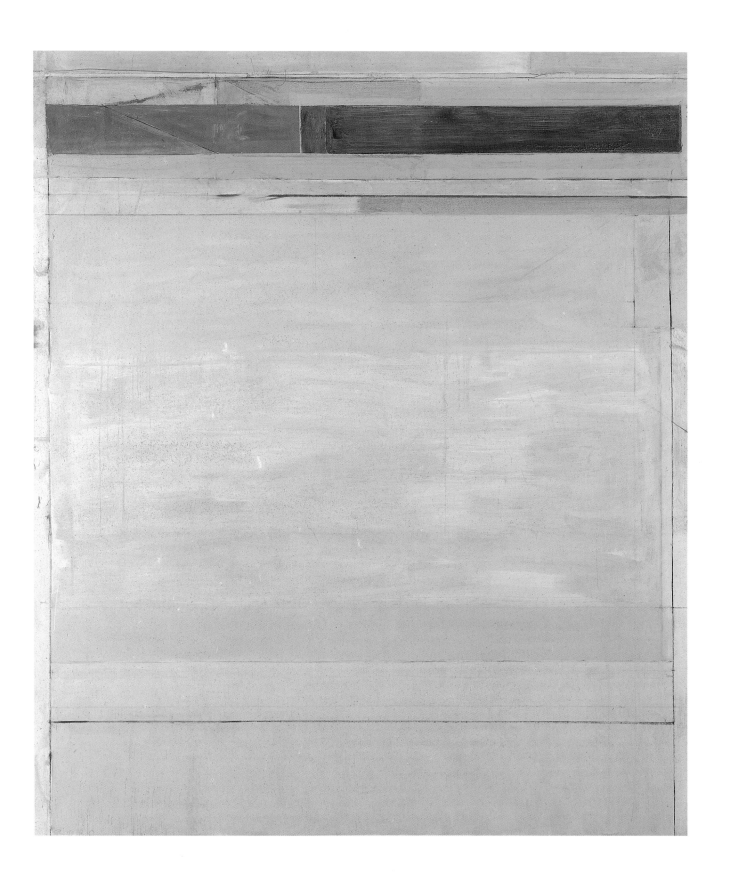

Moral urgency and the quest for spiritual meaning characterize the work of Georg Baselitz. Coming of age in Berlin during the early 1960s, the painter belongs to the postwar generation of German artists who confronted the specter of World War II and its aftermath. His first expressionistic canvases depict tragic and heroic figures caught in a desolate landscape, reflecting the failure of earlier dreams of glory. A related series of studies of scarred and amputated limbs poignantly reflects upon the human condition in an environment devoid of hope or future.

The Lamentation derives both its title and composition from Christian iconography. The inverted figure, a common feature in much of Baselitz's work since 1969, serves as an iconic reference to the Deposition, the scene of the dead Christ being taken down from the cross. While Baselitz first employed the upside-down figure to challenge traditional narrative and compositional devices, here the figure has a more dramatic and emotive force as it sweeps across the canvas. The picture's surface is disrupted by patchlike brushstrokes on the right edge of the composition, adding to the painting's sense of instability and tragedy. Through the brilliant brushwork and monumental scale, the artist makes the experience of the fallen figure a universal rather than a Christian theme, converting the Messiah into an Everyman.

Oil on canvas; 118¼ × 98½ in. (300.4 × 250.2 cm)
Museum purchase with funds provided by the Charles Engelhard Foundation,
The Vaughn Foundation Fund, and Mr. and Mrs. Wallace S. Wilson 86.26

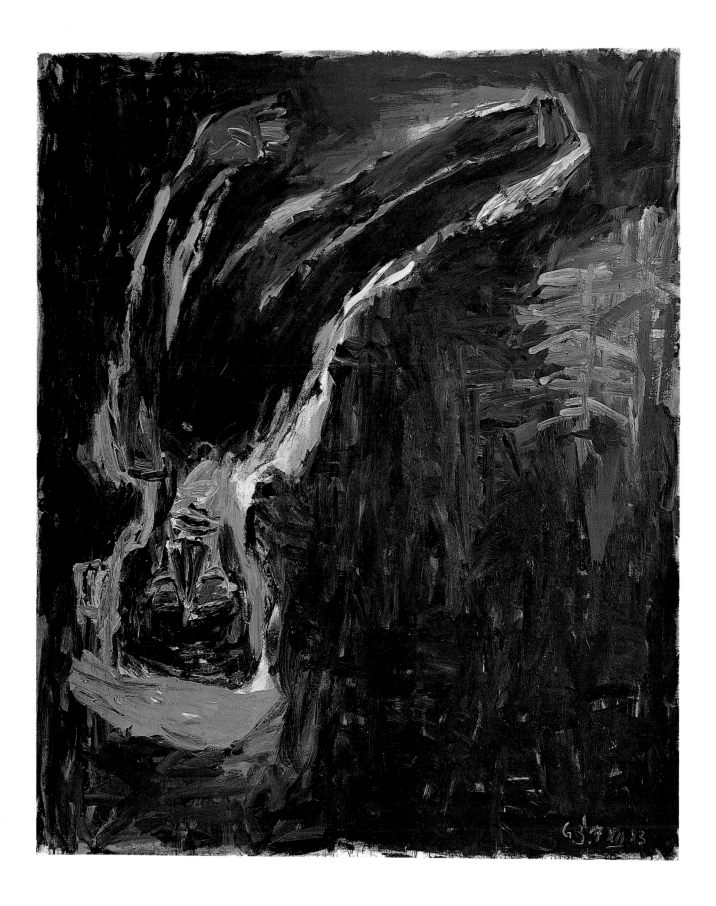

In 1984 Jasper Johns stated in an interview: "In my early work I tried to hide my personality, my psychological state, my emotions. . . . I sort of stuck to my guns for a while, but eventually it seemed like a losing battle. Finally, one must drop the reserve. I think that some of the changes in my work relate to that."

Ventriloquist is among the first of a series of deeply personal and autobiographical paintings, a series in which Johns explores the physical and psychological working environment of the artist. While the painting does not literally depict the artist's studio, it presents an array of images that are self-referential, including quotations of Johns's earlier canvases, works in his collection, and literary references. Each object is executed with a trompe l'oeil mastery, but the flattened interior suggests a dreamlike realm in which objects perceived are juxtaposed with images remembered. The images range from the American flag, the subject of Johns's first iconic works of the mid-1950s, to Barnett Newman's untitled 1961 lithograph (rendered in reverse), to George Ohr pottery, to Melville's *Moby Dick*. The pictorial inversions, the reverse colors of the flags, the concealed profiles in the vase at lower right, and the title itself all underline the legerdemain that is the source of every compositional decision made by the artist.

Encaustic on canvas; 75 × 50 in. (190.5 × 127.0 cm)
Museum purchase with funds provided by the Agnes Cullen Arnold
Endowment Fund 84.87

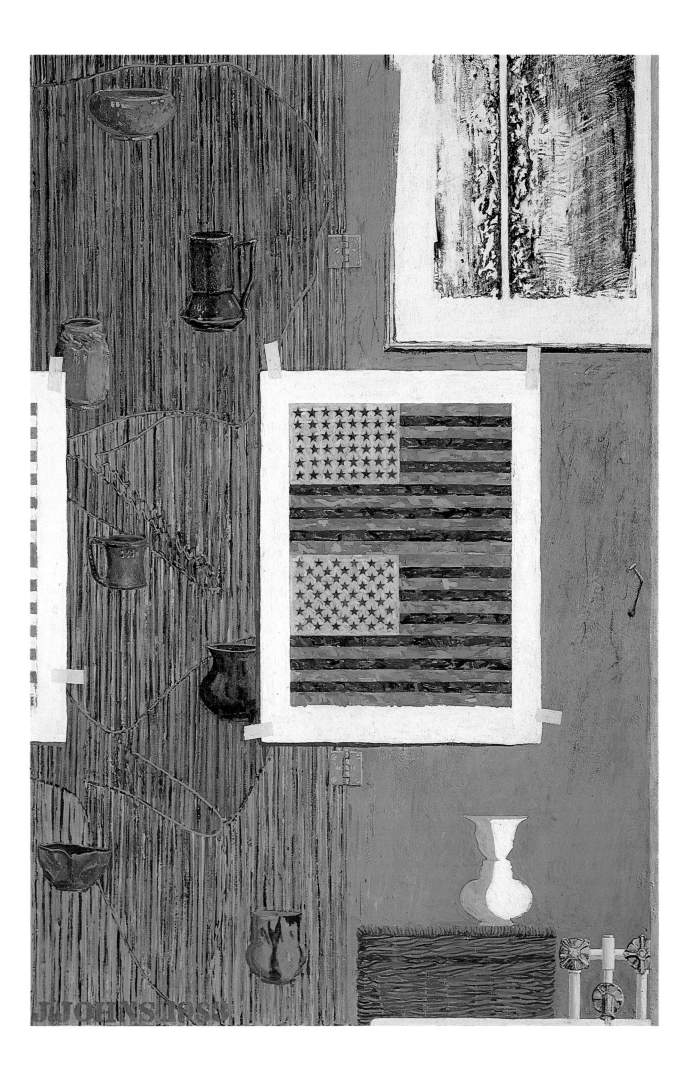

Index

Page numbers in *italics* refer to illustrations.

abstract art, 220, 318; American, 32–33, 324, 332, 338, 342, 344, 348, 350, 352; Blaue Reiter, 320, 324; cubism, 310, 318, 324, 328, 330, 334, 338, 346; de Stijl, 328; photography, 284, 294
abstract expressionism, 338, 342, 344
Abstraction (Hartley), 29, 324, *325*
Académie Camillo, Paris, 308, 316
Académie Française, Rome, 152
Académie Julian, Paris, 186, 192, 316, 322
Académie Royale, Paris, 142, 152, 200, 204
Académie Suisse, Paris, 176, 182
Accademia di Belle Arti, Florence, 340
Adam, Robert, 244, 248
African art, 60; Dogon, 60, *61*
Agee, William C., 32, *32*
Alberti, Leon Battista, 114
Albizzi, Anton Francesco degli, 128
Alechinsky, Pierre, 24
Alexander, Cosmo, 264
Alexander the Great, 88
Alexander with the Lance (Lysippus), 88
Allegory of Prudence (Giordano), 148, *149*
American art, 23, 27, 32–34, 259–79; decorative, 11, 14, 15, 20–22, 34, 226, *227*, 228, *229*, 230, *231*, 232, *233*, 234, *235*, 236, *237*, 238, *239*, 242, *243*, 246, *247*, 248, *249*, 250, *251*, 252, *253*, 254, *255*; 18th-century, 260, *261*, 262, *263*, 264, *265*; 19th-century, 180, *181*, 210, *211*, 266, *267*, 268, *269*, 270, *271*, 272, *273*, 274, *275*, 276, *277*; photography, 282, *283*, 288, *289*, 290, *291*, 294, *295*, 296, *297*, 300, *301*, 302, *303*, 304, *305*; prints and drawings, 208, *209*, 210, *211*; Southwest, 15, 34, 54, 56, *57*, 58, *59*; 20th-century, 11, 32–34, 278, *279*, 324, *325*, 332, *333*, 338, *339*, 342, *343*, 344, *345*, 348, *349*, 350, *351*, 352, *353*, 356, *357*
American China Manufactory, 242; *Sauceboat*, 22, 242, *243*
American Revolution, 248
Americans, The (Frank), 302
Americas, Art of the. *See* Art of the Americas and Tribal Arts
Amsterdam, 140, 190
"The Analysis of Beauty" (Hogarth), 232
analytic cubism, 310, 318, 334
Ancient and Early European Art, 82–133. *See also specific artists; countries; cultures; mediums*
Anderson, Clayton Company, 13
Andromeda (Delacroix), 168, *169*
Anne of Austria, 142
Antico, 17, 120; *Hercules Resting after Slaying the Nemean Lion*, 120, *121*
Antonine dynasty, 88
Apache tribe, 56
aquatint, 210
Arbeiter Illustrierte Zeitung (newspaper), 298
Arch Falls (Hunt), 30
Arearea (Gauguin), 188
Arearea II (Joyfulness) (Gauguin), 31, 188, *189*
Argentine (Caro), 30
Ariosto, Ludovico, *Orlando Furioso*, 204
Arles, 184
Armchair (American), 21, 236, *237*
Armchair (Linnell), 244, *245*
Armory Show (1913), 278, 338
Arnold, Isaac, Jr., 27
Art Institute of Chicago, The, 210
Artiste, L' (magazine), 166
art nouveau, German, 320

Art of the Americas and Tribal Arts, 15, 25, 39–63. *See also specific cultures*
Art Students League, New York, 274, 348, 350
Ashcan school, 278
Ashmolean Museum, Oxford, 158
Ashurnasirpal II, King of Assyria, 66
Asian art, 20, 35, 72–79. *See also* Chinese art; Japanese art
Assyrian art, 27, 66; *Eagle-Headed Winged Deity*, 66, *67*
At Coffee (Moholy-Nagy), 33, 294, *295*
Augustus, Emperor of Rome, 88
automatism, 342, 348
avant-garde movements, 30, 294, 350
Avery, Milton, 32
Aztec art, 48; *Standard-Bearer*, 48, *49*

Babylon, 66
Bacchanal (Natoire), 152, *153*
Backs I–IV, The (Matisse), 29, 30, 312–13, *314–15*
Baltimore, 21, 254
Barbizon, 170, 174
Barbizon school, 170, 172, 212
Barnard, Henry, 12
baroque art, 18, 21, 136, 198, 200, 204, 256; early decorative, 21, 226, 228; French, 200; late decorative 21, 230, 236, 238, 246; Neapolitan, 146, 148
Baselitz, Georg, 354; *The Lamentation*, 28, 354, *355*
Batoni, Pompeo, 158; *Portrait of William Fermor*, 19, 158, *159*
Bauhaus, 220, 294
Bazille, Frédéric, 178
Beaker (Sicán), 52, *53*
Beck, Audrey, 30–31
Beck, John, 30, 31
Beck (Audrey Jones) Galleries, 31
Bélâbre, 96
Bell, Larry, 33
Bellini, Gentile, 126
Bellini, Giovanni, 128
Bellotto, Bernardo, 154; *The Marketplace at Pirna*, 19, 154, *155*
Bellows, George, 32, 278; *Portrait of Florence Pierce*, 27, 278, *279*
Benin culture (Nigeria), 27
Bening, Simon, 122; *Triptych with the Virgin and Child and Saints Catherine and Barbara*, 122, *123*
Benton, Thomas Hart, 342
Berenson, Bernard, 16
Berlin, 190, 194, 324, 354; Dada movement, 298
Bernard, Émile, 186, 188
Bertin, Jean-Victor, 172
Bess, Forrest, 34
Bibliothèque Nationale, Paris, 214
Biggers, John, 34
Blackburn, Joseph, 260
Black Lion Wharf (Whistler), 208
Blaffer, Mr. and Mrs. John, 18
Blaffer, Robert Lee, 13, 17–18
Blaffer (Robert Lee) Memorial Wing, 18, *18*
Blaue Reiter group, 220, 320, 324
Bloemaert, Abraham, 198; *The Gateway to a Town*, 198, *199*
Boddington, H. J., 270
Bol, Ferdinand, 140; *Portrait of Saskia*, 25, 140, *141*
Bolotowsky, Ilya, 32

Bonaventure Pine, The (Signac), 31, 190, *191*
Bonnard, Pierre, 322, 352; *Dressing Table and Mirror*, 31, 322 *323*
Bonnin, Gousse, 242
Bordeaux, 212
Boshier, Derek, 34
Boston, 20, 21, 226, 228, 232, 234, 246, 250, 260, 264, 276
Boucher, François, 152, 204
Bourdelle, Antoine, 30
Bourgeois, Louise, *Quarantania I*, 30
Bow factory (England), 242
Boxers (Géricault), 206, *207*
Boydell, Robert, 268
Brancacci Chapel, Florence, 104
Brancusi, Constantin, 216, 286, 326; *A Muse* (bronze version), 27, 326, *327*; *A Muse* (marble version), 326; *View of the Studio: Column (1918), The Golden Bird (1919)*, 286, *287*
Brandt, Bill, 292; *The English at Home*, 292; *Maid Preparing the Evening Bath*, 292, *293*; *A Night in London*, 292
Braque, Georges, 310, 318, 328; *Fishing Boats*, 31, 310, *311*, 318
Bresdin, Rodolphe, 212
Breton, André, 334, 342, 346
Bril, Paul, 138
British art. *See* English art
Brittany, 186, 188
Brown, Alice, 27–28, *28*, 29
Brown, George R., 27, 28, *28*, 29
Brown, Herman, 27, *28*, 30
Brown, Margaret, 26
Brown & Root construction firm, 25, 27
Brown Pavilion, 28, *28*, 29, 32, 33
Bruce, Patrick Henry, 32
Bruges, 112
Brussels, 108, 112, 136, 142, 190
Buisson-Boissier, Jean-Louis, 160
Bureau Table (Townsend), 21, 246, *247*
Burgundy, 96
Buxton, Mary Hancock, 26
Byzantine art, 90; *Plaque with the Koimesis*, 90, *91*

Cabinetmaker and Upholsterer's Guide (Hepplewhite), 248
Calder, Alexander, *International Mobile*, 25
California, 288, 352
Callot, Jacques, 138
Cambrai, *Notre-Dame-de-Grâce*, 108
Campin, Robert, 108, 110
Canada, 56
Canal, Bernardo, 150
Canaletto, 18, 150, 154; *Grand Canal, Entrance Looking West*, 150, *151*; *Grand Canal, Looking Southwest fron near Rialto Bridge*, 150, *151*
Candlestick with Two Canaries (Worcester Porcelain Factory), 240, *241*
Canova, Antonio, 164
Caracalla, Emperor of Rome, 86
Caravaggio, 146
Card Table (American), 21, 232, *233*
Caro, Anthony, *Argentine*, 30
Caroline silver, 224
Carolus-Duran, Émile, 276
Caryatid (Modigliani), 26, 216, *217*
Casas Grandes art, 54; *Effigy Bowl in the Form of a Macaw*, 54, *55*
Cassatt, Mary, 180; *Susan Comforting the Baby*, 31, 180, *181*
ceramics, 20, 22, 34; American porcelain, 18th-century, 22, 242, *243*; Casas Grandes, 54, *55*;

Chinese, 20, 35, 72, *73*; English porcelain, 18th-century, 240, *241*, 242; French, 18th-century, 162, *163*; Greek, 82, *83*; Japanese, 74, *75*; Maya, 42, *43*; Moche, 50, *51*; Olmec, 29, 40, *41*; Pueblo, 56, *57*, 58, *59*
Ceremonial Trough (Dogon), 25, 60, *61*
Cézanne, Marie-Hortense Fiquet, 182
Cézanne, Paul, 15, 176, 182, 282, 308, 310; *Madame Cézanne in Blue*, 18, 182, *183*
Chained Satyr (Riccio), 124, *125*
chalk on paper, 202; English, 18th-century, 202, *203*; French, 18th-century, 200, *201*, 204, *205*
Champaigne, Philippe de, 142; *The Penitent Magdalen*, 27, 142, *143*
Chan-Bahlum (Palenque), 44
Changan, 72
Chaplin, Charles, 180
charcoal on paper, 19th- to 20th-century French, 212, *213*, 214, *215*
Chardin, Jean-Baptiste-Siméon, 156, 204; *The Good Lesson*, 28, 156, *157*
Charles II, King of Spain, 148
Chartres, 94
Chase, Alice Gerson, 274
Chase, William Merritt, 12, 274; *The First Portrait*, 274, *275*
Chase Manhattan Bank, 346
Chassériau, Théodore, 27, 166; *Woman and Little Girl of Constantine with a Gazelle*, 166, *167*
Chelsea factory (England), 240
Chillida, Eduardo, 24
Chillman, James H., Jr., 14, 15, 17, *18*, 23, 27
Chimú culture, 52
Chinese art, 20, 35, 72, 236; *Standing Court Lady*, 35, 72, *73*
Chippendale, Thomas, *The Gentleman and Cabinet-Maker's Director*, 238
Church, Frederic Edwin, 272; *Cotopaxi*, 272, *273*
classicism, 172, 174, 218, 252, 254; 20th-century, 340
Claude Lorrain, 27, 138; *Pastoral Landscape with a Rock Arch and a River*, 138, *139*
Clayton, William L., 13
Clodion, 162; *Infant Satyrs*, 162, *163*
cloisonnism, 186, 188, 308
Cole, Thomas, 272
collage, 284, 298, 334
Composition (Huszár), 24
Composition with Gray and Light Brown (Mondrian), 328
Concerning the Spiritual in Art (Kandinsky), 320
Coney, John, 21, 228; *Tankard*, 21, 228, *229*
Constable, John, 270
Constantine, 166
Constantinople, 90, 160
constructivism, 284
Contemporary Arts Museum, Houston, 22, 24
Copley, John Singleton, 160, 260; *Mrs. Paul Richard*, 260, *261*
Cormon, Fernand, 184
Corot, Jean-Baptiste-Camille, 27, 172, 212; *Orpheus Leading Eurydice from the Underworld*, 172, *173*
Cortona, Pietro da, 148
Cossa, Francesco del, 114
Costume Institute, 35
Cotopaxi (Church), 272, *273*
Courbet, Gustave, 174, 208
Cremona, 126
Critical and Historical Corpus of Florentine Painting (Offner), 16
Crocodile (Karawa), 62, *62–63*
Cross, Henri-Edmond, 190
Crozier Head with Saint Michael Trampling the Serpent (French), 92, *93*
Crucifixion, The (Master of Georg Muehlich's Meisterlin Chronicle), 24, 110, *111*
cubism, 310, 318, 324, 328, 330, 334, 338, 346; analytic, 310, 318, 334; synthetic, 334
Cullen, Hugh Roy, 27, 29
Cullen, Lillie, 29

Cullen (Lillie and Hugh Roy) Sculpture Garden, 28, 29, *29*, 30, *34*
Cullinan, Joseph S., 13, 19
Cullinan, Nina, 19, *19*
Cullinan Hall, 19, *19*, 20, 23, *25*
Cycladic sculpture, 326

Dada movement, 284; Berlin, 298
Dames-du-Saint-Sacrément, 142
Danish art, 19th-century, 164, *165*
Daubigny, Charles-François, 170; *Sluice in the Optevoz Valley*, 170, *171*
Daumier, Honoré, *Lawyers' Meeting*, 31
David, Gerard, 122
David, Jacques-Louis, 168
Davis, Stuart, 27, 32, 338; *Gloucester Harbor*, 338, *339*
Dead Christ with Angel and a Donor as Saint Francis, The (Veronese), 130, *131*
Decanter (Stella), 30
Decatur, Commodore Stephen, 254
Decorative Arts, 223–57. *See also* American art, decorative; European art, decorative; *specific countries; mediums; periods*
Degas, Edgar, 18, 26, 180, 188, 214; *Woman Drying Herself*, 214, *215*
de Kooning, Willem, 342
Delacroix, Eugène, 166, 168, 178; *Andromeda*, 168, *169*
Delaunay, Robert, 324
Delectorskaya, Lydia, 336
de Montebello, Philippe, 26, *26*, 27, 32
Denis, Maurice, 186, 192
Derain, André, 308; *The Turning Road, L'Estaque*, 31, 308, *309*
Derby, Elias Hasket, 248
Derby factory (England), 240
Der Sturm gallery (Berlin), 324*
de Stijl movement, 328
Dickinson, John, 242
Diebenkorn, Richard, 352; *Ocean Park #124*, 28, 352, *353*
divisionism, 190
Dogon art, 25, 60; *Ceremonial Trough*, 25, 60, *61*
Double Mazer Cup (North German), 116, *117*
Douglas, Langton, 16
Dow, Arthur Wesley, 332
drawings. *See* Prints and Drawings
Dresden Gemäldegalerie Alter Meister, 154
Dressing Table and Mirror (Bonnard), 31, 322, *323*
Durand, Asher B., 270
Dürer, Albrecht, 196; *Saint Eustace*, 196, *197*
Dutch art, 144, 146, 204, 224, 226, 274; prints and drawings, 198, *199*; 17th- to 19th-century, 140, *141*, 144, *145*, 156, 184, *185*; 20th-century, 328, *329*
Dyck, Anthony van, 142

Eagle-Headed Winged Deity (Assyrian), 66, 67
Early Classic Maya, 42
Early European Art. *See* Ancient and Early European Art
École des Beaux-Arts, Paris, 192, 276, 316, 322
Effigy Bowl in the Form of a Macaw (Casas Grandes), 54, *55*
Effigy Container in the Form of a Woman (Moche), 50, *51*
Effigy Vessel in the Form of a Duck (Olmec), 29, 40, *41*
Egyptian art, 14
Einden, Ferdinand van den, 146
Emaki, Japanese, 76
Empire style, 252
English art, 15, 23, 208, 228, 262; decorative, 11, 224, *225*, 228, 232, 234, 238, 240, *241*, 242, 244, *245*; photography, 292, *293*; prints and drawings, 202, *203*
English at Home, The (Brandt), 292
engraving, 196, 204; German, early, 196, *197*; wood, 210
Epilogue (Weston), 33, 288, *289*

Ernst, Max, 342
Este family, 114, 120
etching, 19th-century American, 208, *209*, 210, *211*
Etruscan art, 340
Eugène Delacroix au néoimpressionnisme, D' (Signac), 190
European Art: Ancient and Early, 82–133; decorative, 11, 20, 34–35, 224, *225*, 228, 232, 234, 238, 240, *241*, 242, 244, *245*; Later, 135–93; 20th-century, 11, 282, 308, *309*, 310, *311*, 312–13, *314–15*, 316, *317*, 320, *321*, 322, *323*, 324, 330, *331*, 336, *337*, 338, 340, *341*, 346, *347*. *See also specific artists; countries; periods*
Eutin, counts of, 116
Evans, Walker, 300; *Roadside Sandwich Shop, Ponchatoula, Louisiana*, 300, *301*
expressionism, 31; abstract, 338, 342, 344; German, 320, 324, 354
Eyck, Jan van, 108, 110, 112, 196

Faneuil, Peter, 232
Fantin-Latour, Henri, *A Vase of Chrysanthemums*, 24
Far Eastern Art. *See* Near and Far Eastern Art
Farish, William Stamps, 13
Farm Security Administration, 300
fauvism, 30, 190, 308, 310, 313, 316
Feininger, Lyonel, 15
Feke, Robert, 260
Ferber, Herbert, 33
Fermor, William, 158
Ferrarese art, 114, *115*
Finnigan, Captain John C., 14
First Portrait, The (Chase), 274, *275*
Fisher, Vernon, 34
Fishing Boats (Braque), 31, 310, *311*, 318
Flanders, 108, 112, 118, 122
Flaubert, Gustave, *Temptations of Saint Anthony*, 212
Flemish art, 15, 132, 142, 146, 196, 204; early (13th- to 16th-century), 108, *109*, 110, 112, *113*, 122, *123*; later (17th- to 19th-century), 156
Florence, 98, 104, 106, 120, 128, 132, 148, 340
Fly Fishing on Saranac Lake (Homer), 210, *211*
Fontana, Lucio, 24
Forest of Fontainebleau, 170, 172, 174
Foster, John, 228
Fountain Figures #1, #2, #3 (Graham), 30
Fouquières, Jacques, 142
Fra Angelico, 17, 104; *Saint Anthony the Abbot Tempted by a Lump of Gold*, 104, *105*
Fragonard, Jean-Honoré, 36, 204; *Rodomonte and Mandricardo State Their Case before Agramante*, 204, *205*
Franco-Netherlandish art, 100; *God the Father*, 100, *101*
Frank, Robert, 34, 302; *The Americans*, 302; *Hoboken*, 302, *303*
Frankenthaler, Helen, 33, 344
Franklin, Benjamin, 242
French art, 15, 23, 27, 30–31, 204, 208, 226, 252; decorative, 250, 252; early (13th- to 16th-century), 92, *93*, 94, *95*, 96, *97*, 100, *101*; later (17th- to 19th-century), 138, *139*, 142, *143*, 152, *153*, 156, *157*, 162, *163*, 166, *167*, 168, *169*, 170, *171*, 172, *173*, 174, *175*, 176, *177*, 178, *179*, 182, *183*, 186, *187*, 188, *189*, 190, *191*, 192, *193*; prints and drawings, 200, 201, 204, *205*, 206, *207*, 212, 213, 214, *215*; romanticism, 166, 168, 172, 174, 206; 20th-century, 308, *309*, 310, *311*, 312–13, *314–15*, 316, *317*, 322, *323*, 330, *331*, 336, *337*
French Revolution, 162, 204
Friends of Bayou Bend, 35
furniture. *See* Decorative Arts

Gaddi, Agnolo, 98
gardens, 22
Gardner, Isabella Stewart, 276
Gateway to a Town, The (Bloemaert), 198, *199*

Gauguin, Paul, 186, 188, 308, 322; *Arearea*, 188; *Arearea II (Joyfulness)*, 31, 188, *189*
Gautier, Théophile, 166
Gentleman and Cabinetmaker's Director, The (Chippendale), 238
George III, King of England, 202
George IV, King of England, 202
Georgia O'Keeffe: A Portrait (Stieglitz), 296
Géricault, Théodore, 168, 206; *Boxers*, 206, *207*; *The Raft of the Medusa*, 206
German art, 15, 26, 146, 224; early (13th- to 16th-century), 102, *103*, 110, *111*, 116, *117*; photography, 284, *285*, 298, *299*; prints and drawings, 196, *197*; 20th-century, 320, 324, 354, *355*
German Autumn Salon, Berlin, 324
Gérôme, Jean-Léon, 12, 212
Giacometti, Alberto, 346; *Large Standing Woman I*, 30, 346, *347*
Giambologna, 132
Giordano, Luca, 27, 146, 148; *Allegory of Prudence*, 148, *149*
Giorgione, 128
Giotto, 98
Glasco, Joseph, 34
Glassell, Alfred C., Jr., 29
Glassell School of Art, Houston, 28, 29
Gleyre, Charles, 178, 208
Gloucester Harbor (Davis), 338, *339*
Goddard cabinet shop, 246
God the Father (Franco-Netherlandish), 100, *101*
Goes, Hugo van der, 122
gold, 52, 84, 102, 228; German, early, 102, *103*; Greek, 84, *85*; Sicán, 52, *53*
Gonzaga, Gianfrancesco, 120
González, Julio, 350
Good Lesson, The (Chardin), 28, 156, *157*
Gothic art, 94, 102, 116, 236
Graham, Robert, *Fountain Figures #1, #2, #3*, 30
Grand Canal, Entrance Looking West (Canaletto), 150, *151*
Grand Canal, Looking Southwest from near Rialto Bridge (Canaletto), 150, *151*
Graves, Nancy, 33
Gray Line with Black, Blue, and Yellow (O'Keeffe), 332, *333*
Great Depression, 14, 300
Great Oaks of Old Bas-Bréau, The (Rousseau), 174, *175*
Grecian style, in decorative arts, 252, 254
Greek art, 14, 36, 82, 84, 124; *Hydria* (Painter of the Yale Oinochoe), 36, 82, *83*; *Laurel Wreath*, 84, *85*
Gris, Juan, 26
Gropius, Walter, 220
Grosz, George, 298
Guatemala, 26, 42
Guelph Treasure, 26, 102; *Reliquary Monstrance from the*, 102, *103*
Guérin, Pierre-Narcisse, 168
Guggenheim Fellowship, 302
Guggenheim (Solomon R.) Museum, New York, 23, 326
Guillaumin, Jean-Baptiste-Armand, 176; *The Seine at Paris*, 31, 176, *177*
Guston, Philip, 29
Guzmán, Diego Felipez de, 136

Hakubyō technique, 78
Hall, John, 268
Haniwa Warrior (Japanese), 74, *75*
Hanszen, Harry C., 25
Harper's Weekly, 35, 210
Hart, Allen, 32
Hartley, Marsden, 32, 324; *Abstraction*, 29, 324, *325*
Hausmann, Raoul, 298
Head of an Apostle (French), 94, *95*
Heartfield, John, 298; *The Thousand-Year Reich*, 33–34, 298, *299*
Heda, Willem Claesz., 144; *Still Life*, 26, 144, *145*

Heian period (Japan), 78,
Hellenistic period (Greece), 84
Hennings, E. Martin, 32
Henri, Robert, 278, 338
Hepplewhite, George, 248, 249; *Cabinetmaker and Upholsterer's Guide*, 248
Herculaneum, 248
Hercules Resting after Slaying the Nemean Lion (Antico), 120, *121*
Hermann, George, estate of, 13
Herzfelde, Wieland, 298
Hicks, Edward, 268; *Penn's Treaty with the Indians*, 21, 268, *269*
High Chest of Drawers (American, 1690–1730), 21, 226, *227*
High Chest of Drawers (American, 1730–50), 234, *235*
High Chest of Drawers (American, 1760–75), 238, *239*
High Renaissance, 118
Hill, William James, 35
Hobby, William P., 26
Hoboken (Frank), 302, *303*
Höch, Hannah, 298
Hodsoll, Frank, *32*
Hogarth, William, "The Analysis of Beauty," 232
Hogg, James Stephen, 14
Hogg, Mike, 15, 25
Hogg, Sarah Stinson, 14
Holmes, Nathaniel, 234
Holy Family with Saint Catherine (Lotto), 18
Homer, Winslow, 35, 210; *Fly Fishing on Saranac Lake*, 210, *211*
Honduran art: Ulúa, 46, *47*
Honen Shonin Eden (Biography of the Monk Honen) (Japanese), 76, *77*
Hope, Thomas, 252
Hoppner, John, 202; *Portrait of a Lady*, 202, *203*
Horenbout, Gerard, 122
Houston Art League, 12–13, 36, 37
Houston Art Museum, 37
Houston Chronicle, 16, 17
Houston Endowment, 16, 24, 31
Houston Public School Art League, 12, 35
Houston Symphony Society, 14
Hudson River school, 270, 272
Humble Oil Company, 13, 17
Hunt, Bryan, *Arch Falls*, 30
Huszár, Vilmos, *Composition*, 24
Hutchinson, Thomas, 228
Huysmans, Joris-Karl, 212
Hydria (Painter of the Yale Oinochoe), 36, 82, *83*
Hyre, Laurent de la, *The Rape of Europa*, 24

Île-de-France, 94, 96
impressionism, 30, 31, 170, 172, 176, 178, 180, 182, 184, 188, 214
"Indépendants," 180, 190
Indian art, 35, 68, 70; *Siva Nataraja*, 35, 70, *71*; *Vishnu and His Avatars*, 68, *69*
Infant Satyrs (Clodion), 162, *163*
Ingres, Jean-Auguste-Dominique, 166
ink on paper: Dutch, early, 198, *199*; French, 18th-century, 204, *205*; Japanese, 76, 77
In Les Halles (Kertész), 34, 290, *291*
International Mobile (Calder), 25
International Style, 98, 100
Italian art, 15, 16–17, 23, 146, 204; early (13th- to 16th-century), 98, *99*, 104, *105*, 106, *107*, 114, *115*, 118, *119*, 120, *121*, 124, *125*, 126, *127*, 128, *129*, 130, *131*, 132, *133*; later (17th- to 19th-century), 146, *147*, 148, *149*, 150, *151*, 154, *155*, 158, *159*, 256; prints and drawings, 216, *217*; 20th-century, 340, *341*
Italo-Byzantine icons, 108
ivory, 90, 96, 100; Byzantine, 90, *91*; Franco-Netherlandish, 100, *101*

Japanese art, 74, 76, 78, 178; *Haniwa Warrior*, 74, *75*; *Honen Shonin Eden* (Biography of the Monk

Honen), 76, 77; prints, 210; *The Tale of Genji*, 78, *79*
japanned wares, 234
japonisme, 178, 274
Jar (Martinez and Martinez), 58, *59*
Jar (Pueblo), 56, *57*
"Jodo," 76
Johns, Jasper, 356; *Ventriloquist*, 356, *357*
John Vaughan (Stuart), 21, 264, *265*
Jones, Jesse H., 16, 18, 20, 24, 31
Jones, Mary Gibbs, 20, 24
Jouvenet, Jean, 200
Judd, Donald, 33
Jugendstil, 320
Junior League Docent Program, 17

Kahnweiler, Daniel, 310
Kandinsky, Wassily, 220, 320, 324; *Concerning the Spiritual in Art*, 320; *Sketch 160 A*, 31, 320, *321*
Karawa art, 62; *Crocodile*, 62, *62–63*
Kelly, Ellsworth, 29
Kensett, John Frederick, 270; *A View of Mansfield Mountain*, 270, *271*
Kerouac, Jack, 302
Kertész, André, 290; *In Les Halles*, 34, 290, *291*
Klee, Paul, 220; *Marjamshausen*, 15, 220, *221*
Krasner, Lee, 32

lace collection, 14
Lady's Writing Table with Tambour Shutters (Seymour), 21, 250, *251*
La Live de Jully, Ange-Laurent de, 152
Lambayeque culture, 52
Lamentation, The (Baselitz), 28, 354, *355*
Landscape at Le Pouldu (Sérusier), 186, *187*
Large Standing Woman I (Giacometti), 30, 346, *347*
Later European Art, 135–93. *See also specific artists; countries; mediums*
La Tour, Georges de, 138
Laurel Wreath (Greek), 84, *85*
Lawyer's Meeting (Daumier), 31
Layard, Sir Austen Henry, 66
Léger, Fernand, 330; *Man with a Cane*, 28, 330, *331*
Légion d'honneur, 170
Le Nain, Antoine, 156
Le Nain, Louis, 156
Le Nain, Mathieu, 156
Leone, Giovanni Battista de, 124
Lidded Bowl (Maya), 26, 42, *43*
Limoges crozier heads, 92, *93*
Linnell, John, 244; *Armchair*, 244, *245*
Liotard, Jean-Étienne, 160; *Portrait of Jean-Louis Buisson-Boissier*, 160, *161*
lithography, 206, 210; French, 19th-century, 206, *207*, 212
Little Galleries of the Photo-Secession. *See 291 gallery*
Loam (Louis), 28, 344, *345*
London, 35, 190, 208, 226, 244, 262, 264, 276, 292
Lotto, Lorenzo, *Holy Family with Saint Catherine*, 18
Louis, Morris, 32, 344; *Loam*, 28, 344, *345*; *Veils*, 344
Louis XIII, King of France, 142
Louis XIV, King of France, 142
Louis XVI period, 250
Lower Saxony, 26, 102
Lowestoft factory (England), 242
Lyon, Corneille de, 17
Lysippus, *Alexander with the Lance*, 88

Macdonald-Wright, Stanton, 32
Macy & Co., R. H. (New York), 16
Madame Cézanne in Blue (Cézanne), 18, 182, *183*
Madame X (Sargent), 276
Madhya Pradesh, 68
Madonna and Child (Master of the Straus Madonna), 98, *99*
Madonna and Child (Susini), 132, *133*

Maid Preparing the Evening Bath (Brandt), 292, *293*
Maillol, Aristide, 30, 340
Mallarmé, Stéphane, 212
Malone, Lee H. B., 23, 26, 27
Manet, Edouard, 174, 178, 180
Mangold, Robert, 33
Mann, Horace, 12
mannerism, 130, 132, 226, 228
Man Ray, 284, 286, 292, 294
Mantegna, Andrea, 120
Mantua, 120
manuscript illumination, 110, 118, 122; Flemish, 122, *123*
Man with a Cane (Léger), 28, 330, *331*
Marcus Aurelius, Emperor, 340
Marin, John, 32
Marini, Marino, 340; *The Pilgrim*, 30, 340, *341*
Marjamshausen (Klee), 15, 220, *221*
Marketplace at Pirna, The (Bellotto), 19, 154, *155*
Marquet, Albert, 190, 308
Martinez, Julian, 58; *Jar*, 58, *59*
Martinez, Maria, 58; *Jar*, 58, *59*
Martyrdom of Saint Paul, The (Preti), 26, 146, *147*
Marzio, Peter C., *34*
Masaccio, 104
Massachusetts, 12, 21, 228. *See also* Boston
Master of Georg Muehlich's Meisterlin Chronicles, 24, 110; *The Crucifixion*, 24, 110, *111*
Master of the Straus Madonna, 17, 98; *Madonna and Child*, 98, *99*
Masterson, Carroll, 20
Masterson, Harris, III, 20, *20*
Masterson Collection of Worcester Porcelain, 240
Mather, Margrethe, 288
Mathura region (India), 68
Matisse, Henri, 26, 27, 190, 282, 308, 312–13, 316, 322, 336, 352; *The Backs I–IV*, 29, 30, 312–13, *314–15*; *Portrait of Olga Merson*, 316, *317*; *Woman in a Purple Coat*, 31, 336, *337*
Matta, Roberto Sebastián, 24, 342
Mauve, Anton, 12
Maya art, 26, 42–45, 46; *Lidded Bowl*, 26, 42, *43*; Relief of a Figure Holding an Offering, 44, *45*
Meeting of Solomon and the Queen of Sheba (Italian), 114, *115*
Meisterlin, Sigmund, 110
Melville, Herman, *Moby Dick*, 356
Memling, Hans, 17, 112; *Portrait of an Old Woman*, 112, *113*
Mengs, Anton, 158
metals collection, 20, 21, 34–35. *See also* gold; silver
Metropolitan Museum of Art, New York, 26, 112, 276
Mexican art, 40, 44, 48, 54; Aztec, 48, *49*; Casas Grandes, 54, *55*; Maya, 44, *45*; mural painting, 342; Olmec, 40, *41*
Michallon, Achille-Etna, 172
Michelangelo, 128, 132, 340
Middle Ages, 15, 90, 116. *See also* Early European Art; *specific artists; countries*
Mies van der Rohe, Ludwig, 19, *19*, 20, 28
Miller, Melissa, *34*
Mimbres culture, 54
Moby Dick (Melville), 356
Moche art, 50, 52; *Effigy Container in the Form of a Woman*, 50, *51*
modelli, 148
modernism, 30, 182, 282, 338; photography, 282, 288, 294. *See also* abstraction; *specific periods; styles*; Twentieth-Century Art
Modigliani, Amedeo, 216; *Caryatid*, 26, 216, *217*
Moholy-Nagy, László, 34, 284, 294; *At Coffee*, 33, 294, *295*
Mondrian, Piet, 328; *Composition with Gray and Light Brown*, 328, *329*
Monet, Claude, 170, 178, 208

monochrome ontbijt, 144
Moreau, Gustave, 316
Morris, George Anthony, 242
Motherwell, Robert, 33
Mrs. Joshua Montgomery Sears (Sargent), 28, 276, *277*
Mrs. Paul Richard (Copley), 260, *261*
Muehlich, Georg, 110
Munich, 220, 274, 320, 324
Muse, A (Brancusi, bronze version), 27, 326, *327*
Muse, A (Brancusi, marble version), 326
Musée des Beaux-Arts, Rouen, 170
Musée d'Orsay, Paris, 188
Musée du Louvre, Paris, 206, 214
Museo Nacional de Antropología, Mexico City, 44
Museum Collectors, 35
Museum Guild, 17
Museum of Fine Arts, Boston, 276
Museum of Fine Arts, Houston, *12*, *19*, 20, *25*, *29*; name changes, 37; origin and history of, 11–37
Museum of Modern Art, New York, 23, 32, 218
Museum School of Art, Houston, 29

Nabis, 186, 192, 322
Naples, 146, 148
Natanson, Alexandre, 192
National Academy of Design, New York, 270, 278
National Bank of Commerce (now Texas Commerce Bank), 16
National Endowment for the Arts, 33
Native American art, 15, 25, 56, 58; Pueblo, 15, 56, *57*, 58, *59*
naturalism, rococo, 236, 240
Navajo art, 15, 56
Neapolitan baroque, 146, 148
Near and Far Eastern Art, 65–79, 234. *See also specific cultures*
neoclassicism, 164, 166, 262; decorative arts, 244, 248, 250, 252, 254
neo-impressionism, 190
Nerval, Gérard de, 166
Netherlandish sculpture, early, 100
New Guinea art, 62; Karawa, 62, *62–63*
Newman, Barnett, 356
New Mexico, 56, 58, 296
Newport, R.I., 20, 21, 246, 264
New York, 16, 20, 21, 33, 264, 270, 274, 296, 332, 342, 344, 348, 350; World's Fair (1939), 338
New York school, 342, 344, 348
Nigeria, Benin culture, 27
Night in London, A (Brandt), 292
Niles Weekly Register, 254
Noguchi, Isamu, 29, *34*
Noland, Kenneth, 32
Nolde, Emil, 15
Norman sculpture, 26, 96, *97*
North Africa, 166, 168, 220, 336
North German art, 116; *Double Mazer Cup*, 116, *117*
Notre-Dame-de-Grâce (Cambrai), 108
Notre-Dame-de-Montroud (Benedictine figure), 96
Number 6, 1949 (Pollock), 25, 342, *343*

Ocean Park #124 (Diebenkorn), 28, 352, *353*
O'Connor, Susan, 28
Offner, Richard, 16
Ohio State University, 278
Ohr, George, 356
O'Keeffe, Georgia, 27, 32, 296, 332; *Gray Line with Black, Blue, and Yellow*, 332, *333*
Oldenburg, Claes, 24
Olmec art, 25, *25*, 28, 29, 40; *Effigy Vessel in the Form of a Duck*, 29, 40, *41*
Orlando Furioso (Ariosto), 204
Orpheus Leading Eurydice from the Underworld (Corot), 172, *173*

Padua, 120, 124
Painter of the Yale Oinochoe, 82; *Hydria*, 36, 82, *83*
Painting (Rothko), 348, *349*
Palenque art, 44
Palladio, Andrea, 130, 238
Panini, Giovanni, 150
Paolo, Giovanni di, 17, 106; *Saint Clare Saving a Child Mauled by a Wolf*, 106, *107*
Parada, Esther, 304; *Past Recovery*, 33, 304, *305*
Paris, 30, 94, 142, 152, 166, 172, 176, 178, 180, 182, 184, 186, 188, 190, 192, 200, 212, 214, 216, 276, 286, 290, 292, 308, 310, 316, 318, 322, 324, 330, 332, 340, 346. *See also specific artists; museums; schools*
Pasadena Art Museum, 32
pastel on paper, 160; French, 19th- to 20th-century, 212, 214, *215*; Spanish, 20th-century, 218, *219*; Swiss, 18th-century, 160, *161*
Pastoral Landscape with a Rock Arch and a River (Claude Lorrain), 138, *139*
Past Recovery (Parada), 33, 304, *305*
Peale, Charles Willson, 262, 266; *Self-Portrait with Rachel and Angelica Peale*, 21, 262, *263*
Peale, James, 266; *Still Life with Vegetables*, 21, 266, *267*
Peale, Raphaelle, 266
Pelham, Peter, 260
Peloponnesus, 84
Penitent Magdalen, The (Champaigne), 27, 142, *143*
Penn, William, 268
Penn family, 242
Penn's Treaty with the Indians (Hicks), 21, 268, *269*
Pennsylvania Academy of the Fine Arts, Philadelphia, 268
Pennsylvania State House, Philadelphia, 230
Perkins, F. Mason, 16
Peruvian art, 50, 52; Moche, 50, *51*; Sicán, 52, *53*
Petén (Guatemala), 42, 46
Philadelphia, 20, 21, 22, 180, 230, 236, 238, 242, 262, 264, 266
Photo Forum, 35
photography, 11, 33–34, 35, 272, 281–305. *See also specific artists; countries*
photomontage, 298
Picasso, Pablo, 15, 24, 26, 218, 282, 310, 318, 328, 334, 340, 350; *The Rower*, 318, *319*; *Three Women at the Fountain*, 218, *219*; *Three Women at the Spring*, 218; *Two Women in Front of a Window*, 24, 334, *335*
Piero della Francesca, 114
Pigalle, Jean-Baptiste, 162
Pilgrim, The (Marini), 30, 340, *341*
Pissarro, Camille, 182, 188
Planiscig, Leo, 16
Plaque with the Koimesis (Byzantine), 90, *91*
Plautilla, 86
Plymouth factory (England), 242
pointillism, 30, 190
Pollock, Jackson, 32, 342; *Number 6, 1949*, 25, 342, *343*
Pompeii, 248
Pont-Aven, 186
porcelain. *See* ceramics
Portrait Head of Plautilla (Roman), 86, *87*
Portrait of a Gentleman (Veneto), 126, *127*
Portrait of a Lady (Hoppner), 202, *203*
Portrait of an Old Woman (Memling), 112, *113*
Portrait of Anton Francesco degli Albizzi (Sebastiano), 19, 128, *129*
Portrait of a Ruler (Roman), 88, *89*
Portrait of Florence Pierce (Bellows), 27, 278, *279*
Portrait of Georgia O'Keeffe (Stieglitz), 33, 296, *297*
Portrait of Jean-Louis Buisson-Boissier (Liotard), 160, *161*
Portrait of Olga Merson (Matisse), 316, *317*
Portrait of Saskia (Vanitas) (Bol), 25, 140, *141*
Portrait of William Fermor (Batoni), 19, 158, *159*

postimpressionism, 308
pottery. *See* ceramics
Poussin, Nicolas, 152
pre-Columbian art, 25, 29
Preti, Mattia, 146; *The Martyrdom of Saint Paul,*
 26, 146, *147*
Prints and Drawings, 35, 195–221. *See also specific*
 artists; countries; mediums; techniques
Prix de Rome, 152, 162, 204
Promenade, The (Vuillard), 192, *193*
Proto-Historic period (Japan), 74
Pueblo art, 15, 56, 58; *Jar,* 56, *57; Jar* (Martinez
 and Martinez), 58, *59*
Pure Land arts, 76

Quarantania I (Bourgeois), 30
Quinn, John, 326

Raeburn, Henry, 202
Raft of the Medusa, The (Géricault), 206
Randall, William, 234
Rape of Europa, The (de la Hyre), 24
Raphael, 128
Ray, Man. *See* Man Ray
realism, 172
Red Banner (Rothenberg), 24
Redon, Odilon, 212; *The Trees,* 25, 212, *213*
Relief of a Figure Holding an Offering (Maya), 44,
 45
Reliquary Monstrance from the Guelph Treasure
 (German), 102, *103*
Rembrandt van Rijn, 140
Remington, Frederic, 13, 15, 32
Rémond, Jean-Charles-Joseph, 174
Renaissance art, 11, 15, 16–19, 98, 104, 106,
 112, 114, 120, 124, 126, 196; High, 118. *See*
 also Early European Art; *specific artists; countries*
Renoir, Pierre-Auguste, 26, 178; *Still Life with*
 Bouquet, 18, 178, *179*
Restout, Jean, 200; *A Seated Faun,* 200, *201*
Revue blanche, La, 192
Reynolds, Sir Joshua, 202
Ribera, Jusepe de, 146, 148
Riccardi, Marchese Francesco, 148
Riccio, 17, 124; *Chained Satyr,* 124, *125*
Rice Institute, Houston, 19, 23, 27
Richelieu, Cardinal, 142
River Oaks Garden Club, 22
Roadside Sandwich Shop, Ponchatoula, Louisiana
 (Evans), 300, *301*
Rocks, The (van Gogh), 31, 184, *185*
rococo art, 152, 200, 204, 260; decorative,
 236, 238, 240, 244, 256
Rodin, Auguste, 326; *The Walking Man,* 28
Rodomonte and Mandricardo State Their Case before
 Agramante (Fragonard), 204, *205*
Rogier van der Weyden, 17, 108, 110, 112, 196;
 Virgin and Child, 108, *109*
Roman art, 14, 15, 25, 26, 86, 88, 124, 248,
 252, 340; *Portrait Head of Plautilla,* 86, *87;*
 Portrait of a Ruler, 88, *89*
romanticism: American landscape painting, 272;
 French, 166, 168, 172, 174, 206
Rome, 86, 88, 102, 128, 138, 146, 150, 152, 154,
 158, 164, 172, 340
Romney, George, 202
Roosevelt, Franklin D., 16
Rothenberg, Susan, 33; *Red Banner,* 24
Rothko, Mark, 24, 32, 348; *Painting,* 348, *349*
Rousseau, Théodore, 27, 166, 174; *The Great*
 Oaks of Old Bas-Bréau, 174, *175*
Roussel, Ker-Xavier, 192
Rower, The (Picasso), 318, *319*
Royal Academy of Arts, Antwerp, 184
Rubens, Peter Paul, 162, 168, 202, 204
Rural Resettlement Administration, 300
Rush, Benjamin, 242
Ruslen, John, 35, 224; *Two-handled Covered Cup,*
 224, *225*
Russell, Laura, 32
Russian art, 20th-century, 320, *321*

Saint Anthony the Abbot Tempted by a Lump of
 Gold (Fra Angelico), 104, *105*
Saint Clare Saving a Child Mauled by a Wolf
 (Giovanni di Paolo), 106, *107*
Saint Eustace (Dürer), 196, *197*
Saint-Gaudens, Augustus, 11, 13, 14
Saint-Jacques-de-Néhou, 96
Saint-Omer, 94
Salon (Paris), 166, 170, 172, 174, 176, 178,
 186, 188
Salon d'Automne (Paris), 308
Salon des Indépendants (Paris), 180, 190, 310
Salon des Refusés (Paris), 176
Salviati, Jacopo, 132
Sánchez-Cotán, Juan, 136
Sandler, Irving, 348
Sargent, John Singer, 15, 276; *Madame X,* 276;
 Mrs. Joshua Montgomery Sears, 28, 276, *277*
Sauceboat (American China Manufactory), 22,
 242, *243*
Schad, Christian, 284, 294; *Schadograph,* 33,
 284, *285*
Schadograph (Schad), 33, 284, *285*
Schlumberger, Conrad, 24, 25
Schlumberger, Marcel, 25
School of Paris, 216, 340
sculpture: Assyrian, 66, *67;* Aztec, 48, *49;*
 Chinese, 35, 72, *73;* Danish, 164, *165;* Dogon,
 25, 60, *61;* Franco-Netherlandish, 100, *101;*
 French, early, 92, *93,* 94, *95,* 96, *97,* 100,
 101; French, 18th-century, 162, *163;* German,
 102, *103;* Greek, 84, *85;* Indian, 35, 68, *69,*
 70, *71;* Italian, 120, *121,* 124, *125,* 132, *133;*
 Japanese, 74, *75;* Karawa, 62, *62–63;* Maya,
 42, *43,* 44, *45;* Moche, 50, *51;* Olmec, 25, 29,
 40, *41;* Roman, 86, *87,* 88, *89;* 20th-century,
 29, 30, 286, 312–13, *314–15,* 326, *327,* 340,
 341, 346, *347,* 350, *351*
Sears, Joshua Montgomery, 276
Sears, Sarah Choate, 276
Seated Faun, A (Restout), 200, *201*
Sebastiano del Piombo, 128; *Portrait of Anton*
 Francesco degli Albizzi, 19, 128, *129*
Seine at Paris, The (Guillaumin), 31, 176, *177*
Selden, Marjorie, 18
Self-Portrait with Rachel and Angelica Peale (Peale),
 21, 262, *263*
Septimus Severus, Emperor of Rome, 86
Sérusier, Paul, 186, 192; *Landscape at Le Pouldu,*
 186, *187*
Seurat, Georges, 190
Severan dynasty, 88
Seymour, John and Thomas, 21, 250; *Lady's*
 Writing Table with Tambour Shutters, 21, 250, *251*
Sheraton, Thomas, 248, 249, 252
Shikibu, Lady Murasaki, 78
Sicán art, 52; *Beaker,* 52, *53*
Sideboard (American), 256, *257*
Side Chair (American), 248, *249*
Sienese art, 106, *107*
Sigisbert-Adam, Lambert, 162
Signac, Paul, 190; *The Bonaventure Pine,* 31, 190,
 191
silver, 20–21, 228; American, 17th- to 19th-
 century, 228, *229,* 254, *255;* English, 17th-
 century, 224, *225,* 228
Sisley, Alfred, 178, 180
Siva Nataraja (Indian), 35, 70, *71*
Sixteen Views of the Thames series (Whistler),
 208
Sketch 160 A (Kandinsky), 31, 320, *321*
Sluice in the Optevoz Valley (Daubigny), 170, *171*
Sluter, Claus, 100
Smibert, John, 260
Smith, David, 350; *Two Circle Sentinel,* 29, 350, *351*
Smith, George, 252
Smith, Joseph, 150
Sofa (American), 21, 252, *253*
soft-paste porcelain, 22, 242
Spanish art, 14, 23, 146, 274; later (17th- to
 19th-century), 136, *137;* prints and drawings,
 218, *219;* 20th-century, 318, *319,* 334, *335*

Stack, Gael, 34
stain painting, 344
Staley, Earl, 34
Stalker, John, and George Parker, *Treatise of*
 Japanning and Varnishing, 234
Standard-Bearer (Aztec), 48, *49*
Standing Court Lady (Chinese), 35, 72, *73*
Staughton, Anna Claypoole, 266
Steichen, Edward, 282, 288; *Trees, Long Island,*
 34, 282, *283*
Stein, Gertrude and Leo, 324
Stella, Frank, 33; *Decanter,* 30
Sterling, Frank Prior, 13, 19
Sterling Wing, 19
Stieglitz, Alfred, 288, 296, 324, 332; Georgia
 O'Keeffe: A Portrait, 296; *Portrait of Georgia*
 O'Keeffe, 33, 296, *297*
Still, Clyfford, 32
Still Life (Heda), 26, 144, *145*
Still Life (van der Hamen), 19, 136, *137*
Still Life with Bouquet (Renoir), 18, 178, *179*
Still Life with Vegetables (Peale), 21, 266, *267*
Storrs, John, 32
Strand, Paul, 332
Straus, Mr. and Mrs. Isidor, 16
Straus, Percy S., Jr., 16, *18*
Straus, Percy S., Sr., 15–17
Stretch, Peter, 21, 230; *Tall Clock,* 230, *231*
Stretch, Samuel, 230
Stretch, Thomas, 230
Stuart, Gilbert, 264; *John Vaughan,* 21, 264, *265*
Surls, James, 34
surrealism, 284, 292, 334, 342, 346, 348
Susan Comforting the Baby (Cassatt), 31, 180, *181*
Susini, Antonio, 17, 132; *Madonna and Child,* 132,
 133
Sweeney, James Johnson, *19,* 23, *23,* 24, 25, 26, *27,*
 28, 32
Swiss art: pastels and watercolors, 160, *161,* 220,
 221; 20th-century, 346, *347*
symbolist movement, 212, 220, 322
synthetic cubism, 334
synthetism, 186, 188

Tale of Genji, The (Japanese), 78, *79*
Tall Clock (Stretch), 21, 230, *231*
Tang dynasty, 35, 72
Tankard (Coney), 21, 228, *229*
Tarbell, Edmund, 276
Tassi, Agostino, 138
Temptations of Saint Anthony (Flaubert), 212
Terborch, Gerard, 156
Texas, 34, 332
Texas Company (now Texaco), 13
textiles collection, 20
Thérouanne sculpture, 94, *95*
Theta Charity Antiques Show, 35
Thorvaldsen, Bertel, 164; *Venus,* 29, 164, *165*
Thorvaldsen Museum, Copenhagen, 164
Thousand-Year Reich, The (Heartfield), 33–34, 298,
 299
Three Women at the Fountain (Picasso), 218, *219*
Three Women at the Spring (Picasso), 218
Tinguely, Jean, 24
Titian, 142, 152
Tobey, Mark, 32
Tosa school, 78
Toulouse-Lautrec, Henri de, 318
Tournai, 108
Townsend, John, 21, 246; *Bureau Table,* 246, *247*
travertine vases (Ulúa), 29, 46, *47*
Treatise of Japanning and Varnishing (Stalker and
 Parker), 234
Trees, Long Island (Steichen), 34, 282, *283*
Trees, The (Redon), 25, 212, *213*
Tribal Arts. *See* Art of the Americas and Tribal
 Arts
Tri-Delta Art Show, 35
Tripod Vase (Ulúa), 46, *47*
Triptych with the Virgin and Child and Saints
 Catherine and Barbara (Bening), 122, *123*

Triumph of Amphitrite (Natoire), 152
"Tumulus," 74
Tura, Cosimo, 114
Tureen (Warner), 21, 254, *255*
Turkish art, 14
Turning Road, L'Estaque, The (Derain), 31, 308, *309*
Twentieth-Century Art, 11, 23, 24, 30, 32, 307–57. *See also* Photography; *specific artists; countries; periods*
Two Circle Sentinel (Smith), 29, 350, *351*
two-color drawing style, 202
Two-handled Covered Cup (Ruslen), 224, 225
291 gallery (New York), 324, 332
Two Women in Front of a Window (Picasso), 24, 334, *335*
Tzara, Tristan, 284

Ufer, Walter, 32, 36
Ulúa art, 29, 46; *Tripod Vase*, 29, 46, *47*
Urban IV, Pope, 102

Valtat, Louis, 190
van der Hamen y Léon, Juan, 136; *Still Life*, 19, 136, *137*
van Gogh, Theo, 184
van Gogh, Vincent, 184, 188; *The Rocks*, 31, 184, *185*
Vasari, Giorgio, 128
Vase of Chrysanthemums, A (Fantin-Latour), 24
Vauxcelles, Louis, 310
Velázquez, Diego, 178
Venetian art, 126, 130, 148, 154, 168; early (13th- to 16th-century), 126, *127*, 128, *129*; later (17th- to 19th-century), 150, *151*
Veneto, Bartolommeo, 126; *Portrait of a Gentleman*, 126, *127*

Veneziano, Domenico, 104
Venice, 126, 128, 130, 148, 150, 196, 208
Ventriloquist (Johns), 356, *357*
Venus (Thorvaldsen), 29, 164, *165*
Vernon, Samuel, 246
Veronese, 130, 148; *The Dead Christ with Angel and a Donor as Saint Francis*, 130, *131*
vessels: American, 18th- and 19th-century, 228, *229*, 242, *243*, 254, *255*; Casas Grandes, 54, *55*; Dogon, 25, 60, *61*; English, 17th-century, 224, *225*; Greek, 82, *83*; Maya, 26, 42, *43*; Moche, 50, *51*; North German, early, 116, *117*; Olmec, 29, 40, *41*; Pueblo, 56, *57*, 58, *59*; Ulúa, 29, 46, *47*
Vienna, 154, 292
View of Mansfield Mountain, A (Kensett), 270, *271*
View of the Studio: Column (1918), The Golden Bird (1919) (Brancusi), 286, *287*
Virgin and Child (French), 26, 96, *97*
Virgin and Child (Rogier van der Weyden), 108, *109*
Virgin and Child Enthroned with Saints Michael, Catherine, Cecilia, and Jerome, The (Zaganelli), 25, 118, *119*
Vishnu and His Avatars (Indian), 68, *69*
Vlaminck, Maurice de, 308
von Humboldt, Alexander, 272
Vuillard, Édouard, 18, 192; *The Promenade*, 192, *193*

Walking Man, The (Rodin), 28
Walter, Marie-Thérèse, 334
Warner, Andrew E., 21, 254; *Tureen*, 21, 254, *255*
War of Austrian Succession, 150
War of 1812, 254
Washington, D.C., 12, 264
Washington, George, 264
watercolor and gouache, 210; Dutch, early, 198, 199; Italian, 20th-century, 216, *217*; Swiss, 20th-century, 220, *221*

Watkin, William Ward, 19
Watteau, Jean-Antoine, 202
Werve, Claus de, 100
West, Benjamin, 262, 264, 268
Weston, Edward, 288; *Epilogue*, 33, 288, *289*
Wharton, Joseph, 238
Whistler, James Abbott McNeill, 208, 210; *Black Lion Wharf*, 208, *209*
Wiess, Mr. and Mrs. Harry C., 13, 20, 24, 30
Wiess, Olga Keith, 20
Wiggins, Bill, 32
Winterthur (Henry Francis du Pont) Museum, Delaware, 266
Wolgemut, Michael, 196
Woman and Little Girl of Constantine with a Gazelle (Chassériau), 166, *167*
Woman Drying Herself (Degas), 214, *215*
Woman in a Purple Coat (Matisse), 31, 336, *337*
wood engraving, 210
Worcester Porcelain Factory, 34, 240; *Candlestick with Two Canaries*, 240, *241*
Works Progress Administration (WPA), 338
World War I, 284, 330
World War II, 15, 16, 17, 32, 348, 354

Yale University, 348
Yamato, 74

Zaganelli, Bernardino, 118; *The Virgin and Child Enthroned with Saints Michael, Catherine, Cecilia, and Jerome*, 25, 118, *119*
Zaganelli, Francesco, 118
Zuni pottery, 56, *57*

Index of Donors

This index also includes individuals in whose honor or memory works of art have been donated or acquired. Page numbers in *italics* refer to illustrations.

Alexander, Mr. and Mrs. Stanford, 34
Anonymous, in memory of James H. Chillman, Jr., 110
Arnold, Agnes Cullen, Endowment Fund, 26–27, 32, 33, 66, 68, 74, 138, 142, 148, 166, 172, 174, 316, 332, 338, 356
Arnold, Agnes Cullen, gift of Mr. and Mrs. Meredith Long in memory of, 278
Arnold, Isaac and Agnes Cullen, 318
Arnold, Mr. and Mrs. Isaac, Jr., 29, 30, *32*
Arnold, Mr. and Mrs. Isaac, Jr., gift of, in memory of Hugh Roy and Lillie Cullen, 130

Bayou Bend Collection, 15, 17, 20, *20*, 21–22, 23, 32, 34, 226, 228, 230, 232, 234, 236, 238, 242, 246, 248, 250, 252, 254, 260, 262, 264, 266, 268
Bayou Bend Heritage Fund, Varner–, 218
Beck, John A. and Audrey Jones, Collection, 30–31, 176, 180, 184, 188, 190, 308, 310, 320, 322, 336
Beck, John A. and Audrey Jones, Fund, 31
Bernstein, Raphael, 34
Blaffer, Robert Lee, Memorial Collection, 17–18, *19*, 22, 31, 150, 178, 182, 192, 214, 318
Blaffer, Sarah Campbell, 17–18, 150, 178, 182, 214, 318
Blaffer, Sarah Campbell, Foundation, 34, 282
Brown, Alice Pratt, in memory of, 350
Brown, Alice Pratt, Museum Fund, 29, 30, 40, 46, 164
Brown, George and Alice, 27–28, *28*, 29, 52, 156, 276, 352
Brown, George and Alice, gift of Mr. and Mrs. Ralph O'Connor in honor of, 324
Brown, Mr. and Mrs. Herman, 27, 28, *28*, 30, 326
Brown, Mr. and Mrs. Herman, gift of the Brown Foundation in memory of, 313
Brown Foundation, 28–29, 30, 32, 33, 42, 313
Brown Foundation Accessions Endowment Fund, 30, 32, 33, 290, 318, 344, 346
Brown Foundation Accessions Endowment Fund, in memory of Alice Pratt Brown, 350

Chillman, James H., Jr., anonymous gift in memory of, 110
Coates, Mr. and Mrs. William, Jr., 78
Continental Oil Company, 78
Couper, Mrs. Fred Thomson, Jr., 21
Couper, Mrs. Fred Thomson, Jr., in honor of, 266
Cullen, Hugh Roy and Lillie, gift of Cullen Foundation in memory of, 313
Cullen, Hugh Roy and Lillie, gift of Mr. and Mrs. Isaac Arnold, Jr., in memory of, 130
Cullen Foundation, 27, 29, 30, 32, 33, 313

Dayton Hudson Foundation, 33
de Menil, Dominique and John, 24, *24*, 25, 48, 60, 342

de Menil, Dominique and John, gift of, in memory of Conrad Schlumberger, 88
Detering, Carl, 78
Dickson, George M., 12–13

Engelhard, Charles W., Foundation, 28, 30, 33, 354
Engelhard, Mrs. Charles W., 28, 330

Farish, Mrs. William Stamps, 27, 270, 318, 326
Favrot, Laurence H., 26
Favrot, Laurence H., Bequest, 86, 90, 92, 96, 102, 116, 146
Finnigan, Miss Annette, 14, 84
Friends of Bayou Bend, 22, 242

Garden Club of Houston, 14, 29
General Accessions Fund, 270
Goodrich, Esther Florence Whinery, Foundation, 26
Goodrich, Raymond H. and Esther, 26, 144, 168
Gordon, Anaruth and Aron S., 34, 168, 256

Hanszen, Alice N., gift of Alice C. Simkins in memory of, 186, 268
Hanszen, Alice Nicholson, 21, 25, 31, 118, 140, 212
Hatchett, Betty Black, funds provided by the Theta Charity Antiques Show in honor of, 230, 254
Herzstein, Isabell and Max, 33–34, 284, 294, 298
Heyer, Dr. George S., Jr., 34–35
Heyer, Dr. George S., Jr., gift of, in honor of Robert D. Straus, 224
Hill, William James, 29, 34
Hirsch, General and Mrs. Maurice, 36, *36*, 82, 204
Hobby, Oveta Culp, *23*, 26, 31, 42, 216, 318
Hobby Foundation, 30, 31, 340
Hogg, Ima, *12*, 13, 14–15, 20, *20*, 21–22, 31, 32, 54, 56, 58, 218, 220, 226, 228, 232, 234, 236, 238, 246, 248, 250, 260, 262, 264, 270, 272
Hogg, William C., *12*, 13, 15
Hogg Brothers Collection, 270, 272
Horning, Drs. Marjorie G. and Evan C., 35, 208
Houston Endowment, Inc., 16, 62
Houston Friends of Art, 270

Johnson, Mrs. Lucille Bowden, in honor of Frances G. McLanahan and Alexander K. McLanahan, 286

Kappa Alpha Theta, Houston chapter of, 21, 252
Kelsey, Mavis P. and Mary Wilson, 35
Kress, Samuel H., Collection, 17, 18–19, 22, 31, 128, 136, 154, 158
Kress, Samuel H., Foundation, 18, 23

Law, Mr. and Mrs. Theodore N., 24, 29, 30, *32*, 36, 334
Law, Mr. and Mrs. Theodore N., gift of, in memory of Mr. and Mrs. Harry C. Wiess, 312
Levering, Mr. and Mrs. Gary, 78
Long, Mr. and Mrs. Meredith J., 27, 29, 30, 33, 278
Long Endowment for American Art, 33, 282

Marsh, Charles E., 318
Marshall, Douglas B., Jr., 29
Marvins, Sonia and Kaye, 34
Masterson, Harris, III, and Carroll, 34, 78, 240
McAshan Educational and Charitable Trust, 33, 74
McCormick, Harry W., in honor of Ursula DeGeorge McCormick, 94
McDannald, Arthur T., 25
McLanahan, Frances G. and Alexander K., Mrs. Lucille Bowden Johnson in honor of, 286
Meadows Foundation, 200
Moran, Mr. and Mrs. John R., 78
Morris, Mr. and Mrs. S. I., 34
Mundy Companies, 34, 292
Museum Collectors, 202

Newhouse (Ehrich) Gallery, New York, 274

O'Connor, Ralph and Maconda, 29
O'Connor, Ralph and Maconda, gift of, in honor of Mr. and Mrs. George R. Brown, 324
"One Great Night in November," 35, 206, 210
Owen, Mr. and Mrs. Kenneth Dale, 192

River Oaks Garden Club, 29
Romansky, Alvin, 35
Rowan, Stella S. and Arch H., Foundation, 244

Sandy, Mrs. Barbara K., 78
Sarofim, Louisa Stude, 28, 34
Schlumberger, Conrad, gift of D. and J. de Menil in memory of, 88
Schlumberger, Mr. and Mrs. Pierre, 328
Shell Oil Company, 33
Simkins, Alice C., 21, 186, 268
Sterling, Frank Prior, 34
Stone, Mr. and Mrs. Lee B., 78
Straus, Carol and Robert D., 35, 70, 72
Straus, Edith A. and Percy S., Collection, 15–17, 22, 31, 98, 100, 104, 106, 108, 112, 114, 120, 122, 124, 126, 132, 162, 196
Straus, Robert D., gift of George S. Heyer, Jr., in honor of, 224
Stude, Mr. and Mrs. M. S., 29, 78

Target Collection of American Photography, 288, 296, 300, 302, 304
Target Stores, 33, 288, 296, 300, 302, 304
Tenneco, 33
Texas Eastern Corporation, 34
Texas Pipe and Supply Company, 78
Theta Charity Antiques Show, 21, 230, 254, 266
Thomas, Mr. and Mrs. J. R., 78

Varner–Bayou Bend Heritage Fund, 218
Vaughn Foundation Fund, 354

Wallace, Mr. and Mrs. E. Gregg, Jr., 206
Wiess, Mr. and Mrs. Harry C., gift of Mr. and Mrs. Theodore N. Law in memory of, 312
Willour, Clint, 34
Wilson, Mary Alice, 78
Wilson, Mr. and Mrs. Wallace S., 50, 206, 354
Wintermann, Mr. and Mrs. David, 33
Wortham, Gus and Lyndall, 30, *30*, 312
Wortham Foundation, 30, 36

A *Permanent Legacy* has been made possible by
The Guild, Volunteers of the Museum of Fine Arts, Houston

MRS. BLAKE TARTT, PRESIDENT 1987-1988; MS. JEAN D. HARPER, PRESIDENT 1988-1989

Honor Roll of Contributors to *A Permanent Legacy*

Major Benefactor
MR. WILLIAM A. SMITH
in memory of Kathryn Lynch Cummings
in memory of Marcita Drouet Link

Benefactors
MR. AND MRS. D. KENT ANDERSON
GLADYS MADIGIN ANDREWS
AUDREY JONES BECK
MR. AND MRS. JACK S. BLANTON
EARL P. BURKE, JR.
LOUIS B. CUSHMAN
JEANEANE B. DUNCAN
MR. AND MRS. JAMES W. GLANVILLE
OLIVER AND MARY HEARD
MR. AND MRS. MAX H. HERZSTEIN
MRS. MAURICE HIRSCH
OVETA CULP HOBBY
MRS. RONALD E. HUEBSCH
MR. AND MRS. JOHN M. HUGGINS
MR. AND MRS. JOSEPH D. JAMAIL
BRENDA DENNISTON KEEN
MR. AND MRS. WILLIAM S. KILROY
FRANCES AND PETER MARZIO
MR. AND MRS. HARRIS MASTERSON III
in honor of Mr. and Mrs. Theodore N. Law
MRS. LaVIRLE McCRARY
LOUISA S. SAROFIM
MR. AND MRS. MATTHEW R. SIMMONS
MRS. STUART WEST STEDMAN
BARBARA AND BLAKE TARTT
MR. AND MRS. FRANK M. VARNER, JR.
MRS. WESLEY WEST
MR. AND MRS. WALLACE S. WILSON

Sponsors
JOAN G. ALEXANDER
MR. AND MRS. MAURICE J. ARESTY
MR. AND MRS. JAMES J. ARKET
ALICE S. ATKINSON
DR. AND MRS. CHARLES W. BAILEY, JR.
MRS. RAY B. BAILEY
HEATHER P. BERNHEIM
DR. AND MRS. JULES BOHNN
TERRY A. BROWN
LAURA CAMPION
MS. TERRI L. CASTANO
in honor of Teresa Anne and Thomas Caton Hayes
SHIRLEY AND DALE CHEESMAN
MR. AND MRS. PETER R. CONEWAY
ERIN A. CONNALLY
MR. AND MRS. NELSE A. DAVIS
SARA AND CHAD DODD
in honor of Sara Niles Flowers Georges
THE ANNE AND C.W. DUNCAN, JR., FOUNDATION
MRS. RUTH EISENSTADT
SARA K. GARCIA
NOEL "GIB" GIBBONS
MARY ANN GILCHRIST
MR. AND MRS. MELBERN G. GLASSCOCK
JEAN D. HARPER
in honor of Katherine F. and Will M. Harper
WILLIAM HILL LAND AND CATTLE CO.
JOSEPH W. HOPPE
MARJORIE G. AND EVAN C. HORNING
MR. AND MRS. WILLIAM H. HOWARD, JR.
ROSEMARIE J. HUGHES
ANN JORDA
MR. AND MRS. RICHARD D. KINDER
MR. AND MRS. PHILIP C. KOELSCH
MR. AND MRS. MEREDITH J. LONG

MARY RALPH LOWE
MR. AND MRS. JAMES H. McDONALD
MR. AND MRS. JOHN E. McFARLANE
MR. AND MRS. MARVIN H. McMURREY, JR.
DR. AND MRS. G. WALTER McREYNOLDS
MR. AND MRS. RALPH H. MINCHEN
JERI NORDBROCK
MR. AND MRS. DEE S. OSBORNE
PAMELA OTT
MR. AND MRS. THOMAS W. POUNDS
FAIRFAX AND RISHER RANDALL
DORTHA SMITH READE
MARTELIA BREWER ROBBINS AND FAMILY
MR. AND MRS. R. A. SEALE, JR.
DR. AND MRS. HAROLD M. SELZMAN
MISS ALICE C. SIMKINS
MARGARET AND LOUIS SKIDMORE
MR. AND MRS. C. K. STEPHENSON
MR. AND MRS. KARL STORK
MIKE AND ANITA STUDE
BLAKE TARTT III AND COURTNAY MOORE TARTT
MARTHA BROOKS TAYLOR
MARTHA B. TAYLOR
in memory of Everett William Taylor
GAYE ULMER TULLOS
MR. AND MRS. J. MIKE WALKER
MR. AND MRS. PETER S. WAREING
DAVID WINTERMANN
MRS. F. G. WINTERS
MR. AND MRS. JOHN F. WOODHOUSE

Donors
MRS. BEN M. ANDERSON
MR. AND MRS. ALEX BARAZANDEH
MRS. ANNE R. BOGEL
MRS. LARRY BURROW
MRS. ALLEN H. CARRUTH
ROBERT AND SUE COLLETT
CONNIE REID COLLEY
RUBY RUE COOK
JENNY JONES CRAIG
MR. AND MRS. C. BAKER CUNNINGHAM III
in honor of Margaret B. and
Charles Baker Cunningham IV
MR. AND MRS. W. R. DEAN
MR. AND MRS. JOHN DEAN
DR. AND MRS. HYMAN DITTMAN
BARBARA, DINA, AND LISA
in honor of Dorothy Dominicus
JERRY AND DEBORAH SARKAS EASTMAN
LILLI ELSAS
in honor of Peter F. Elsas
MR. AND MRS. JOHN T. EUBANK
in honor of John T., Marshall M., Stephen W.,
and Laura A. Eubank
MR. AND MRS. MARK FISHER
DR. AND MRS. MIGUEL FRANCO
KATHLEEN GAMMILL
ALICE D. GARDNER
GWENDOLYN H. GOFFE
BARRY AND SUSAN GOODMAN
SHARON B. GORDON
in memory of Pearl LaMae Alexander and Irene Rose
MR. AND MRS. MICHAEL J. GROGAN
MR. AND MRS. WILLIAM F. GUEST
MRS. ROBERT BARRY HAMILTON
MR. AND MRS. JESSE B. HEATH, JR.
MR. AND MRS. JESSE B. HEATH, JR.
in honor of Heather Heath
MRS. A. CLARK JOHNSON
MR. AND MRS. JOHN W. JOHNSON
PEARL KAHAN

TAMMIE KAHN AND ANGELA PETERMAN
in honor of Noel "Gib" Gibbons, Henry Roos,
and Jessica Younger
MRS. C. E. KENDALL, JR.
DINA MARIE KOHLEFFEL
in honor of Dorothy and Raymond Kohleffel
PAUL AND CONNIE KOOMEY
MARY K. KYGER
DR. AND MRS. DARWIN R. LABARTHE
LUCY AND LIN LAMME
KATE SAYEN LEADER
DR. AND MRS. WM. RUGELEY LIVESAY
MRS. DANIEL B. LOVEJOY
ALEXANDRA R. MARSHALL
MARILYN MOOD McDOWELL
JEANNE McGRANE
MR. AND MRS. RALPH H. MINCHEN
in honor of Mr. Scott Minchen
MR. AND MRS. RALPH H. MINCHEN
in honor of Mr. Steven Lloyd Minchen
MR. AND MRS. RALPH H. MINCHEN
in honor of Mr. and Mrs. Louis H. Rubin
MRS. HELEN F. MINTZ AND FAMILY
MRS. GRAY MUZZY
NORMA R. ORY
in memory of Ruth Pershing Uhler
DR. AND MRS. CRISTO PAPASAKELARIOU
MRS. CHARLES E. PERRY
SUE ROWAN PITTMAN
CHRISTINE PLOESER
EVELYN H. PLOTKIN
in honor of Mindy, Tammy, and Jody Plotkin and
Arden and Lindsey Seigle
JOHN AND MARY SUE RATCLIFF
MR. AND MRS. MARK S. RAUCH
ELIZABETH REAP
MR. AND MRS. H. A. RICARDS, JR.
in honor of Andrea Ricards Lapsley
MRS. THOMAS H. ROUTT, SR.
DR. AND MRS. BERNARD N. SCHICH
PETTY SCHOELMAN
in honor of Jennifer Rebecca Stephenson
ANN SCHULTZ
SALLY TUCKER SOLITO
MR. AND MRS. NEALE SULLIVAN
MR. AND MRS. GEORGE S. TALLICHET
in honor of Isabel P. Faris
DOROTHY E. TAYLOR
in honor of Dr. Denton Cooley and the Heart Institute
RUTH MacMAHON TELEKI
MERCEDES RILEY TERRY
SANDRA C. TIDWELL
GUILLERMO AND PAMPA TROTTI
JAMESENE T. WALLACE
MR. AND MRS. DAVID B. WARREN
MR. AND MRS. DONALD E. WEST
MRS. SARA E. WHITE
in honor of Mrs. Wynne White Routt
MRS. SARA E. WHITE
in honor of Mr. Anderson B. White
MRS. SARA E. WHITE
in honor of Mrs. Hill P. White II
MRS. SARA E. WHITE
in honor of Waverly E. White
HUGH AND GLADYS WILLIAMS
in memory of Chelle Surles
SHIRLEY G. WILLIAMS
MRS. WALTER C. WILSON
MRS. R. W. WORTHAM, JR.
R. W. WORTHAM III
MRS. R. SCOTT ZIEGLER
MARIE H. ZINNANTE
AN ANONYMOUS DONOR

The Museum of Fine Arts, Houston

Board Presidents/Chairmen

JOHN T. SCOTT
December 1924–May 1928

A. C. FORD
June 1928–May 1930

HERBERT GODWIN
June 1930–May 1932

WILLIAM D. CLEVELAND, JR.
June 1932–May 1934

JOHN F. DICKSON
June 1934–May 1936

GEORGE A. HILL, JR.
June 1936–May 1939

J. VIRGIL SCOTT
June 1939–May 1941

RAY L. DUDLEY
June 1941–May 1943

JOHN P. BULLINGTON
June 1943–May 1946

JOHN WILEY LINK, JR.
June 1946–May 1947

JOHN HAMMAN, JR.
June 1947–May 1950

THOMAS D. ANDERSON
June 1950–May 1953

FRANCIS G. COATES
June 1953–May 1958

THEODORE E. SWIGART
June 1958–May 1960

S. I. MORRIS, JR.
June 1960–May 1963

EDWARD ROTAN
June 1963–May 1967

S. I. MORRIS, JR.
June 1967–May 1968

EDWARD ROTAN
June 1968–May 1969

ALEXANDER K. McLANAHAN
June 1969–May 1975

HARRIS MASTERSON III
(position changed from president
to chairman in March 1978)
June 1975–May 1979

ISAAC ARNOLD, JR.
June 1979–present

Directors

JAMES H. CHILLMAN, JR.
April 1924–April 1954

LEE H. B. MALONE
May 1954–June 1959

JAMES H. CHILLMAN, JR.
(Interim Director)
July 1959–1960

JAMES JOHNSON SWEENEY
1961–1968

PHILIPPE DE MONTEBELLO
September 1969–January 1974

WILLIAM C. AGEE
April 1974–January 1982

PETER C. MARZIO
October 1982–present

Curators

RUTH PERSHING UHLER
Curator
1937–1966

ADALENE WELLBORN BRUHL
Curator
1939–1943

CORINNE CRAWFORD McNEIR
Acting Curator
1943–1945

EDMUND B. NIELSON
Research Associate
1958–1960

DAVID B. WARREN
Bayou Bend/Decorative Arts
1965–present

JACK L. SCHRADER
Chief Curator of Collections
1970–1973

DEAN F. FAILEY
Bayou Bend
1970–1974

E. A. CARMEAN, JR.
Twentieth-Century Art
1971–1974

THOMAS P. LEE, JR.
Associate Curator
1971–1976

ALVIA WARDLAW
Primitive Art
1972–1974

KENT SOBOTIK
Chief Curator of Collections
1973–1978

LINDA D. HENDERSON
Modern Art
1974–1977

BARRY A. GREENLAW
Bayou Bend
1974–1980

KATHERINE S. HOWE
Decorative Arts
1975–present

ANNE WILKES TUCKER
Photography
1976–present

JOHN MINOR WISDOM
Painting and Sculpture
1978–1981

J. PATRICE MARANDEL
Painting and Sculpture
1979–1980

JUDITH McCANDLESS
Twentieth-Century Art
1979–1983

CELESTE MARIE ADAMS
Oriental Art
1980–present

MICHAEL K. BROWN
Bayou Bend
1980–present

BARBARA ROSE
Twentieth-Century Art
1981–1984

CAROLYN NEWMARK WILSON
Research Curator/Renaissance Art
1983–present

ALISON DE LIMA GREENE
Twentieth-Century Art
1984–present

GEORGE T. M. SHACKELFORD
European Painting and Sculpture
1984–present

ANNE-LOUISE SCHAFFER
Arts of Africa, Oceania, and
the Americas
1986–present